In Harmony

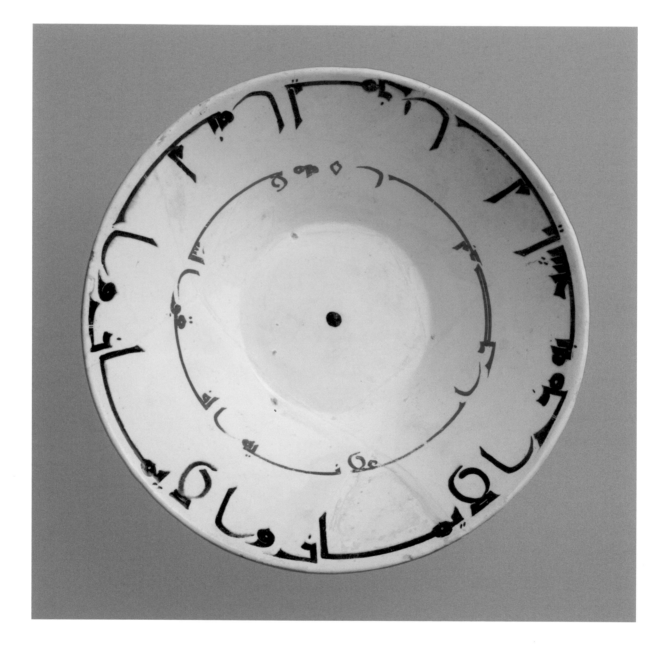

In Harmony:
The Norma Jean Calderwood Collection of Islamic Art

Edited by
Mary McWilliams

with essays by
Jessica Chloros and Katherine Eremin
Walter B. Denny
Penley Knipe
Oya Pancaroğlu
David J. Roxburgh
Sunil Sharma
Anthony B. Sigel
Marianna Shreve Simpson

Harvard Art Museums
Cambridge, Massachusetts

Distributed by Yale University Press
New Haven and London

In Harmony: The Norma Jean Calderwood Collection of Islamic Art accompanies an exhibition organized by the Harvard Art Museums and shown at the Arthur M. Sackler Museum January 31–June 1, 2013. Both catalogue and exhibition have been made possible through the generous support of the late Stanford Calderwood.

Published by the Harvard Art Museums
www.harvardartmuseums.org

Managing editor: Marsha Pomerantz
Manuscript editor: Julia Bailey
Art director: Steven Waldron
Design: Becky Hunt, Zak Jensen
Production: Becky Hunt
Typesetting: Duke & Company, Devon, PA
Printed by Capital Offset Company, Concord, NH

Cover and frontispiece: *Bowl inscribed with sayings of the Prophet Muhammad and 'Ali ibn Abi Talib,* cat. 13.

Distributed by Yale University Press
New Haven and London
www.yalebooks.com/art

Library of Congress Cataloging-in-Publication Data

Arthur M. Sackler Museum.
 In harmony : the Norma Jean Calderwood collection of Islamic art / edited by Mary McWilliams ; with essays by Jessica Chloros and Katherine Eremin, Walter B. Denny, Penley Knipe, Oya Pancaroğlu, David J. Roxburgh, Sunil Sharma, Anthony B. Sigel, and Marianna Shreve Simpson.
 pages cm
 In Harmony: The Norma Jean Calderwood Collection of Islamic Art accompanies an exhibition organized by the Harvard Art Museums and shown at the Arthur M. Sackler Museum January 31–June 1, 2013.
 Includes bibliographical references and index.
 ISBN 978-1-891771-62-0 (harvard art museums : alk. paper)–ISBN 978-0-300-17641-4 (yale university press (distributor) : alk. paper) 1. Islamic art—Exhibitions. 2. Art, Iranian—Exhibitions. 3. Calderwood, Norma Jean—Art collections—Exhibitions. 4. Art—Private collections—Massachusetts—Cambridge—Exhibitions. 5. Arthur M. Sackler Museum—Exhibitions. I. McWilliams, Mary, editor of compilation. II. Harvard Art Museums. III. Title.

N6263.C36A745 2013
704'.0882970747444–dc23
 2012030304

Contents

Director's Foreword

Recent decades have witnessed exponential growth in the study of Islamic art, once the almost exclusive province of a small number of dealers, adventurous collectors, generalist scholars, and students. A new generation of well-trained scholars is developing a range of interests and a degree of specialization previously unimaginable. This would have delighted Norma Jean Calderwood, who had an insatiable interest in new—and new forms of—information.

Harvard University and the Harvard Art Museums have been at the forefront of this movement, with faculty, curators, students, and celebrated collections providing fertile ground for the field—made all the richer with this recent addition of the Calderwood Collection. Although the collection has its share of masterpieces, it was assembled with more than aesthetic concerns in mind. It demonstrates engagement with the social and literary contexts of its works of art, in part the result of influences at Harvard such as Oleg Grabar, Stuart Cary Welch, and Wheeler Thackston. It also reveals a prescient awareness of the technical aspects of Islamic artistic production—both materials and process—ranging across ceramics, lacquer, and the arts of the book. This is a reflection of the strong tradition of scientific research and treatments at the Art Museums' Straus Center for Conservation and Technical Studies, the oldest art museum conservation laboratory in the United States.

Mary McWilliams, the Norma Jean Calderwood Curator of Islamic and Later Indian Art, has adopted a masterful and thoughtful approach to the collection in this catalogue and the exhibition it accompanies. Assembling a team of Islamic scholars—all Harvard affiliated—with an impressive array of specialties and methodologies, McWilliams has essentially constructed a series of case studies, combining broad cultural overviews, in-depth analyses, and technical research that together reflect the concerns of the field today and generate new insights into many of the creative impulses behind Islamic art. We are deeply indebted to John Cornish and Bill Lowell of the Calderwood Charitable Foundation for their support and encouragement of this important undertaking.

Objects from the Calderwood Collection will also figure prominently in the Islamic galleries of the Harvard Art Museums' long-awaited new facility, scheduled to open in late 2014. Those objects will be enlisted in a concerted effort to train students and emerging scholars in a variety of disciplines, allowing them to develop a set of skills—visual literacy, critical thinking, and the ability to "spatialize" arguments by assembling works in an exhibition—that advance the production of knowledge in a university context. These experiences lie at the heart of the educational mission of the Harvard Art Museums, and we are deeply grateful to Norma Jean Calderwood for her lasting contribution to that goal.

Thomas W. Lentz
Elizabeth and John Moors Cabot Director
Harvard Art Museums

Foreword from the Calderwood Charitable Foundation

As Trustees of the Calderwood Charitable Foundation, we are deeply pleased to see the Norma Jean Calderwood Collection of Islamic Art presented in a major exhibition and scholarly catalogue at Harvard University. Were Stanford and Norma Jean Calderwood still living to witness the fruition of this project, they would surely have joined us in thanking Harvard Art Museums director Thomas W. Lentz and, especially, the Norma Jean Calderwood Curator of Islamic and Later Indian Art, Mary McWilliams, for their efforts in bringing this project to such a successful realization.

The Belmont, Massachusetts, home of Stan and Norma Jean was a visible manifestation of their interest in art and education. All the walls, shelves, and cabinets in the living room, dining room, foyer, library, hallways, and even powder room were laden with magnificent works of art from distant lands and eras. While their private collection was the most tangible and personal expression of the Calderwoods' lifelong involvement in the arts, there was little public knowledge of its existence. With this exhibition and catalogue, the Norma Jean Calderwood Collection of Islamic Art can finally be appreciated by a wider audience. It was Stan Calderwood's stated wish that his gift of the collection to Harvard might inspire others to contribute their own collections and resources for public benefit.

The Calderwoods' energetic commitment to education and the arts produced an outpouring of philanthropy to some of the finest nonprofit organizations in our community. Institutions that benefited directly from the generosity of these two Colorado natives include the Boston Athenaeum, Boston College, WGBH, the Cambridge Art Association, the Harvard Art Museums, the Huntington Theatre, the Isabella Stewart Gardner Museum, the MacDowell Colony, and the Museum of Fine Arts, Boston, to name just a few. The Calderwood Charitable Foundation is proud to continue the philanthropic tradition of Stan and Norma Jean in sustaining and enriching the cultural life of the greater Boston area that they came to call home. This catalogue and the exhibition it accompanies serve as a testament to their generosity, spirit, and legacy.

John M. Cornish, Esq., Trustee
William A. Lowell, Esq., Trustee
The Calderwood Charitable Foundation

Acknowledgments

The Norma Jean Calderwood Collection of Islamic Art was born of the vision and determination of one individual, but this catalogue is the work of many minds and hands. It could not have been otherwise. As a collector, student, teacher, and museum volunteer and supporter, Calderwood stood at the intersection of many professions. In researching the collection, we have pursued avenues she would have found familiar, but also ventured in new directions, freely and frequently calling on colleagues in a wide variety of fields. All have generously shared both time and knowledge; any errors in the catalogue are mine alone.

The catalogue and exhibition of the Calderwood Collection have drawn on the changing cast of characters that make it all work in a university museum. The project could not have succeeded without the inspired leadership and support of Harvard Art Museums director Thomas W. Lentz; of Bradford Voigt, Director of Principal Gifts for the Arts at Harvard; and of Susanne Ebbinghaus, curator of Ancient Art and head of the Division of Asian and Mediterranean Art. Our work has depended greatly on the expertise—and seemingly inexhaustible good will—of Straus Center for Conservation and Technical Studies director Henry Lie and his colleagues Angela Chang, Susan Costello, Anne Driesse, Charlotte Karney, Penley Knipe, Narayan Khandekar, Barbara Owens, and Anthony Sigel. Special recognition is due the ever-gracious Katherine Eremin, whose analyses undergird both catalogue entries and essays. Valuable assistance in the conservation treatments was provided by Paula Artal-Isbrand, Carol Snow, and Nina Vinogradskaya.

One could imagine no finer colleagues than assistant curator Mika Natif and Calderwood Curatorial Fellow Ayşin Yoltar-Yıldırım. Although both came on board less than a year before the manuscript deadline, they penned most of the catalogue entries and contributed invaluable knowledge, insights, and ideas that now permeate the entire project. Special thanks are due to David Sturtevant, Chris Linnane, Katya Kallsen, Junius Beebe III, and Julie Swiderski for photography; to Steven Waldron, Becky Hunt, and Zak Jensen for design; and to Marsha Pomerantz for editorial advice and guidance. A multitude of tasks were flawlessly coordinated and carried out by Amy Brauer, Karen Manning, and Yan Yang in the Division of Asian and Mediterranean Art and by Jennifer Allen, Karen Gausch, and their colleagues in the Collections Management Division.

Inevitably, many individuals who were essential in the earlier stages of the project are no longer at Harvard. These include Jim Cuno, Mary Rose Bolton, Kimberly Masteller, Jeff Spurr, Nancy Lloyd, Stephanie Beck, Erin Hyde, Patricia O'Connell, and the late Craigen Bowen. Since the collection came to Harvard in 2002, it has constantly served our teaching, training, and educational missions. Research and work on Calderwood objects have been an indispensable part of the training of interns and fellows, whose efforts have in turn expanded our understanding of these works of art. We are grateful for the contributions of former Straus Center fellows Sanchita Balachandran, Sara Bisi, Diana Galante, and Holly Salmon, and to the full cast of talented scholars who have served as Calderwood Curatorial Fellows—Afsaneh Firouz-Ardalan, Rajeshwari Shah, Anne-Marie Doyle, Yasmine Hilloowala, and Maliha Noorani. Sadly, neither Oleg

Grabar nor Stuart Cary Welch was able, as initially proposed, to write for the catalogue, although their influence on Norma Jean Calderwood was profound.

Much help came from outside the Art Museums. We are deeply grateful to John Cornish and William Lowell of the Calderwood Charitable Foundation; Sheila Canby of the Metropolitan Museum of Art; Massumeh Farhad of the Freer and Sackler Galleries; Kjeld von Folsach of the David Collection; Richard Frye, professor emeritus, Harvard University; Amy Landau of the Walters Art Museum; Robert Mason of the University of Toronto; Natsu Oyobe of the University of Michigan Museum of Art; András Riedlmayer of the Fine Arts Library, Harvard University; and Alain Touwaide of the Institute for the Preservation of Medical Traditions. We have benefited significantly from the advice and knowledge of Wasma'a Chorbachi, Elizabeth Ettinghausen, Bruce Fudge, Mahdokht Banu Homaee, Ulrike al-Khamis, Nawal Nasrallah, Matthew Smith, Himmet Taşkömür, Wheeler Thackston, and Zeynep Yürekli-Görkay. For sharing insights and information about these works of art, we are deeply indebted to Simon Ray, Sam Fogg, Marcus Fraser, Francesca Galloway, Mansur Mokhtarzadeh, Christine Ramphall, and Rabi Soleimani.

All who wrote for the catalogue contributed far more than the texts associated with their names. Of course, this volume would never have become a reality without the inspired and energetic editing of curator-of-words Julia Bailey.

To Andrew, Daphne, and Ian McWilliams are due heartfelt thanks for unflagging encouragement and support; and to Carl and Wanda Anderson, a lifetime debt of gratitude for those first steps in Iran so long ago. An undertaking with so many moving parts could only have come to completion through the combined efforts and good will of countless individuals and institutions. Those of us privileged to work on this project owe profound thanks to Stan and Norma Jean Calderwood, whose generosity has been, in Firdawsi's words, "like a cloud that rains down pearls."

Mary McWilliams
Norma Jean Calderwood Curator of Islamic and Later Indian Art

Note to the Reader

Dates, Transcription, and Transliteration

The year 1 in the Islamic calendar corresponds to 622 CE. Throughout the catalogue, dates are given in CE years, unless otherwise indicated. When *hijrī* (AH) dates are provided, they are placed first, followed by CE dates in parentheses.

Persian, Turkish, Arabic, and Chinese

Foreign words and proper nouns that have entered the language or have a generally recognized English form are anglicized in the text. Place names follow English usage, and false English plurals for Persian, Arabic, and Turkish words are used. Place names and names of historical personages with no English equivalent are transliterated, but aside from *ʿayn* (ʿ) and *hamza* (ʾ), diacritical marks are omitted. Quoted passages and titles of published works are fully transliterated, as are specific foreign words or phrases, which are followed or preceded by their English equivalent. *Iżāfas* have been omitted from the spelling of personal names, unless they appear in a transliterated passage.

Arabic and Persian are transliterated according to the system used in the *Encyclopaedia of Islam*, with the omission of subscript bars and with the substitution of *q* for *ḳ* and *j* for *dj*. Diphthongs are indicated by *aw* and *ay*. For Persian and Ottoman words, *v* is used for the consonantal *wāw*. For Ottoman Turkish, authors were given the choice of the *EI* system or the use of modern Turkish orthography. For medieval Persian poetry, contributors' choices have been respected. Each author is responsible for the consistency and accuracy of the system he or she has applied to the transliterations provided; minor variations may therefore appear. Translations are the work of the individual authors, unless otherwise indicated. Chinese transliteration follows the pinyin system.

Since Arabic script (also used for Persian and, before 1928, for Turkish) is written from right to left, the first page of a double-page configuration appears on the right, and in this catalogue is designated A. The second page, designated B, appears on the left. "Verso" and "recto" designate right- and left-hand pages, respectively.

Geographical and Place Names

In catalogue captions and entries, the names of modern countries have been used when possible in place of older cultural and dynastic designations. Thus, for example, Persian objects have been assigned to Iran, Afghanistan, or Uzbekistan; Ottoman objects to Turkey (as appropriate), and Mughal and Rajput objects to India or Pakistan. Broader geographical designations (e.g., Central Asia) are used to avoid listing several modern countries.

Catalogue Entries

Entries are presented in three categories: three-dimensional objects, works on paper, and the study collection. This last category is a group of objects that, for a variety of reasons, are more suitable for hands-on teaching than for exhibition. Within each section, objects are ordered in approximate chronology and then according to medium, technique, or format. For a given subset, such as monochrome glazed wares of the Seljuk-Atabeg period, the entry for the first example offers brief general remarks about the group. In

some instances, the images of manuscript folios have been minimally cropped to square up the edges.

Despite its official name, the Calderwood Collection includes a number of works that were made beyond the temporal and spatial boundaries of Islamic lands.

Measurements for three-dimensional objects are height by width/diameter by depth. Where a dimension varies, the maximum is recorded. For works on paper, the dimensions are for the entire folio, including mounting pages and margins, unless otherwise indicated.

Media have been determined through examination and analysis by staff of the Harvard Art Museums' Straus Center for Conservation and Technical Studies: Katherine Eremin, Patricia Cornwell Conservation Scientist; Narayan Khandekar, Senior Conservation Scientist; and Penley Knipe, Philip and Lynn Straus Conservator for Works of Art on Paper. Media are defined as follows:

> For ceramic bodies, *earthenware* is composed of clay, *faience* is crushed quartz and an alkali material, and *fritware* (sometimes called "stonepaste") is a blend of crushed quartz, ground glaze mixture, and white clay.

> The description of ceramic glazes indicates the relative amount of lead oxide and alkali (potassium and/or sodium) oxides. *Lead glaze* contains more than 40 percent lead oxide, *lead alkali glaze* 20–40 percent, *alkali lead glaze* 5–20 percent, and *alkali glaze* less than 5 percent.

> In lusterwares the luster is created with copper and/or silver salts. The main metal salt is listed first.

> *Shellac* is a resinous substance excreted by the female lac insect, *Laccifer lacca*, native to India.

Authors of Catalogue Entries

SE	Susanne Ebbinghaus
MMcW	Mary McWilliams
RDM	Robert D. Mowry
MMN	Mika M. Natif
DJR	David J. Roxburgh
AYY	Ayşin Yoltar-Yıldırım

Website

The Harvard Art Museums' online collection search function (harvardartmuseums. org/art) provides additional information and images for many of the objects in the Calderwood Collection.

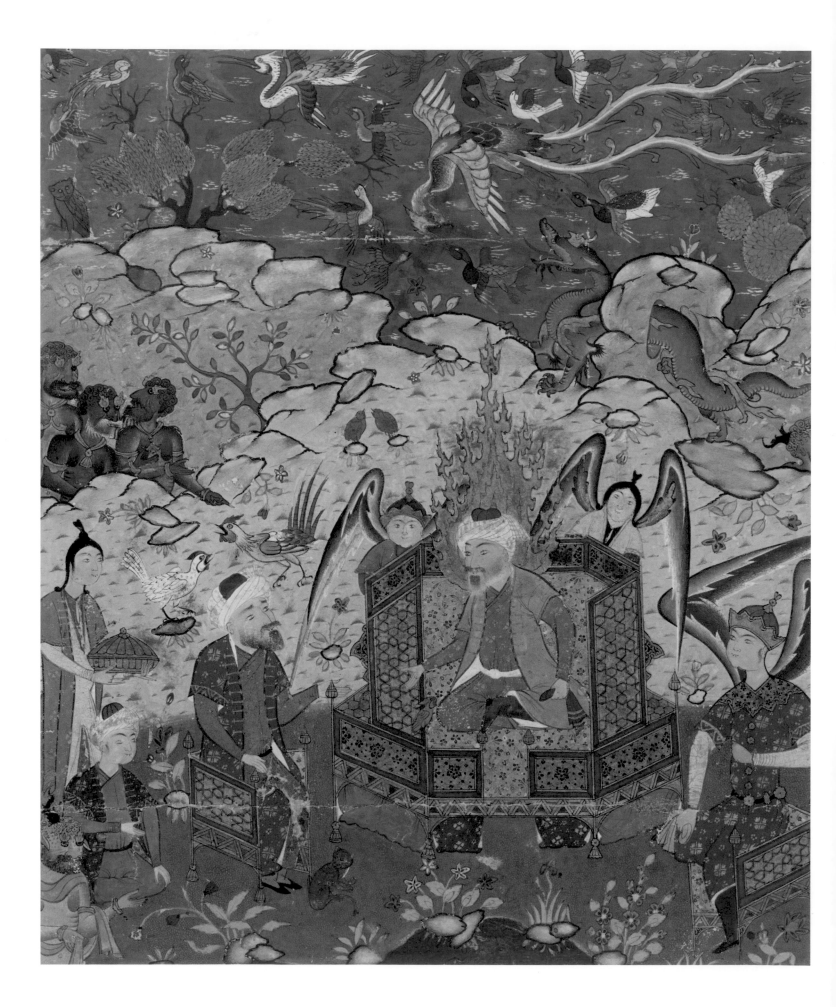

Preface:
A Harmony of Purposes

Mary McWilliams

To convey to her students the cumulative effect of a Persian painting, Norma Jean Calderwood once stated that its many visual elements all "united to form a harmony."[1] In many ways, the phrase describes aspects of the Calderwood Collection itself, for a harmony between Norma Jean and her husband, Stanford Calderwood, led to its creation, and a congruence of purposes led to its donation to the Harvard Art Museums in 2002.[2] The theme is eloquently expressed in some of the finest objects and paintings in the collection and, we hope, in the catalogue itself. In its varied essays and eclectic congregation of contributors, this catalogue attempts to bring together a range of approaches to enhance understanding of the works of art and the cultures in which they were created.

A successful businessman with no background in Islamic art, Stan Calderwood attached only minimal requirements to the donation of a collection that he recognized as the major achievement of Norma Jean's career. He asked for an exhibition and catalogue that would present the collection and also briefly examine his wife's development as a collector. He wanted the catalogue to inspire other collectors (or their descendants) to donate intact to museums or libraries the collections to which they had devoted so much of their lives. A well-formed collection is itself a work of art, expressing an internal logic beyond personal taste. Its varied objects work in concert to create dialogues that resonate through contrasts and connections. Maintaining the integrity of a collection hence means more than celebrating the achievement of the individual who assembled it, for it inevitably reflects the intellectual, political, and economic moment of its creation.

By gathering contributions from a wide range of university colleagues, this catalogue attempts to demonstrate not only our deep gratitude for the gift but also the value of such a collection for an educational institution. Rather than employ the collection to construct a survey of Persian art, the essayists were asked to respond to the objects in the context of their own current interests and research. The catalogue contributors all share with Norma Jean Calderwood an affiliation with Harvard University, whether past or present—as graduates, faculty members, research associates, curators, conservators, fellows, or interns—as well as an intense engagement with Islamic art.

Solomon Enthroned,
cat. 94, detail.

The Calderwood Collection

Norma Jean Calderwood (fig. 1) devoted much of her life to studying and teaching Islamic art and the complex of cultures in which it arose. A popular and gifted lecturer, she taught for many years at the Museum of Fine Arts, Boston, and at Boston College, and over a period of three decades quietly and systematically acquired examples of the artistic tradition that captivated her.[3] During her lifetime, only a lucky few who visited the Calderwood residence in Belmont, Massachusetts, knew of her collecting efforts. Perhaps her discretion reflected an appreciation of the potential conflict of interest between her collecting and her activities as an instructor and museum supporter.[4]

Numbering more than 170 individual objects, the Calderwood Collection ranges from the beginning of the first millennium BCE (cat. 59) to the mid-twentieth century (cat. 52). Its geographic range is narrower, since Calderwood's overriding focus was on works of art made in the Persian cultural sphere, which she defined in her lectures as encompassing "Iran, Mesopotamia, and southern Russia."[5] Overall, the objects in the collection, whether ceramics, painting, drawing, or lacquerware, reflect a preference for figural designs.

Fig. 1
Norma Jean Calderwood.

There is nothing in Calderwood's early life to predict the intensity of her involvement with Islamic art or the time and treasure she would allocate to its study and pursuit. A native of Sterling, Colorado, she had concentrated on music and Romance languages as an undergraduate.[6] No obvious factor emerges to suggest what might have motivated a middle-aged woman living in suburban Boston to immerse herself in an artistic tradition that was neither easily mastered nor at the time broadly popular. Clues can perhaps be found in her gift for languages, passion for travel, and enduring involvement with museum collections.[7]

Andalusia first opened Calderwood's eyes to the beauty of Islamic art. During a semester she spent studying Spanish at the University of Barcelona in 1958, her letters to her husband reveal that her interest was piqued by a lecture, "Eight Centuries of Arab Art in Spain," given by "a funny little man in a very wrinkled suit."[8] On that first trip to Spain, she traveled to Toledo, Seville, Granada, Ronda, and Algeciras, and, crossing the Strait of Gibraltar, to Tangier. Calderwood would eventually travel frequently and widely across North Africa, the Middle East, and Central Asia, studying the art and architecture of Islamic lands. Early on, the arts of Iran became her primary interest.

It was on a trip to Iran in 1968, on a tour organized by the Museum of Fine Arts, Boston, that she acquired her first works of Islamic art: two twelfth-century bowls from a dealer in Tehran.[9] Calderwood's collecting career falls into two broad phases, divided somewhat arbitrarily by the first appraisal of her collection in the fall of 1978, but also roughly coinciding with a shift from one medium to another.[10] In the first stage, from 1968 until 1978, she focused on ceramics; in the second stage, from about 1978 until her last purchase in 1997, she concentrated on the arts of the book. This division into unequal periods of about ten and twenty years also approximates two stages in her training in Islamic art.

The first period represents a phase of largely self-guided learning. As a volunteer at the Museum of Fine Arts, Boston, Calderwood studied the collection intensively, beginning with Islamic and Asian ceramics. In lecturing and writing labels for installations, she developed an intimate knowledge of the MFA's holdings but also looked well beyond them. In this decade, she traveled four times to Iran, hiring guides and off-road vehicles to study monuments in remote regions. She also explored Syria, Lebanon, Iraq, Yemen, Turkey, Egypt, Afghanistan, and Central Asia. An insatiable and disciplined reader, Calderwood amassed an impressive private library for the study of Islamic and Asian art.[11] By the end of this period, she had acquired five works on paper and at least fifty-seven examples of Islamic ceramics.

When appraised in 1978, Calderwood's collection represented nearly all the major achievements of Persian ceramics from the tenth through the early eighteenth century, as they were defined in the major art-historical surveys then available.[12] Among the highlights of the collection at this early stage must be counted the figural and epigraphic wares of potters working during the reign of the Samanid dynasty (819–999) in northeastern Iran and Central Asia (cats. 8–19). Acquired before 1974, a vibrant bowl (fig. 2) brilliantly blends figural and epigraphic impulses: painted across the diameter is the Arabic word for harmony (*al-wifāq*),

Fig. 2
Bowl with inscription and birds,
cat. 15.

Fig. 3
Fragmentary star tile with lovers,
cat. 37, detail.

as animated in its rendering as the birds that flutter above and below it. But the largest share of the collection was given over to luster-painted ceramics, frequently singled out in art-historical literature as the most important innovation of Islamic potters. Calderwood's luster ceramics include tenth-century monochrome wares from Basra (cats. 4–7) and a varied selection of twelfth- through fourteenth-century vessels and tiles (cats. 29–38). Although only fragmentary, a luster star tile depicting two lovers (fig. 3) must have been a particular favorite, for alone among Calderwood's ceramics it was not installed in a glass cabinet but kept on a stand in her library. The tile subtly expresses the perfect concord between the lovers by uniting their serene faces within a single nimbus.

A significant event in this early phase of her collecting was Calderwood's decision in 1973 to submit ten ceramics for testing by thermoluminescence.[13] She dispensed with two "tenth-century" bowls that tested modern, but retained the imposing turquoise and black albarello, or medicine jar (cat. 52), whose test results were ambiguous. Although purchased as a medieval work, the albarello in all likelihood represents the revival of historical styles during the Pahlavi era.[14] Such experiences surely led to deeper understanding of Islamic ceramics, which are usually fragmentary and often substantially restored. By removing fakes from her collection, Calderwood signaled tighter standards. By retaining the albarello, she demonstrated a broader appreciation of the art form.

In the fall of 1974, Calderwood began taking courses in Islamic art at Harvard University, studying primarily with Oleg Grabar and Stuart Cary Welch.

Harvard's tradition of teaching with original works of art surely delighted her. In the words of her husband, "Year after year, Harvard curators and professors sharpened her eye for quality and refined her taste. This was in the classroom and in face-to-face consultations in which Harvard experts happily and generously shared their expertise."[15] Calderwood returned the favor, allowing her rarely glimpsed collection to be used in the qualifying exams of doctoral candidates.

The second phase of Calderwood's collecting career saw a dramatic shift in medium. Between 1978 and 1997, she acquired more than eighty works on paper, but no more than six ceramics. Calderwood's experiences at Harvard undoubtedly influenced the change in direction. At the time, the strength of the Harvard Art Museums' holdings in Islamic art was not in ceramics but in works on paper—painting, drawing, and calligraphy. Furthermore, years of studying Persian with Wheeler Thackston must have motivated her to pursue manuscript paintings from the great works of Persian literature, such as Abu'l-Qasim Firdawsi's *Shāhnāma*; from this work alone she acquired sixty-three folios dating from the fourteenth to the seventeenth century. Her determined efforts to reassemble folios from dispersed manuscripts surely reflects her participation in Grabar's pioneering seminar in the spring of 1975, which set out to document, reconstruct, and understand the totality of the Great Mongol *Shāhnāma*.[16] Her choice of a dissertation topic—illuminated frontispieces from Safavid manuscripts—was mirrored in her collecting of this art form (cats. 73, 102 A–B, 112).

The energetic reassessment of late Safavid art brought about by the Isfahan Colloquium held at Harvard in 1974 may well have motivated Calderwood's ambitious acquisition of Riza 'Abbasi's *Young Dervish* (cat. 122, and fig. 5 in David J. Roxburgh's essay "Beyond Books: The Art and Practice of the Single-Page Drawing in Safavid Iran," 135–45).[17] And finally, Cary Welch's long preoccupation with and masterful publication of the Tahmasp *Shāhnāma* may have inspired one of Calderwood's most costly purchases, *Afrasiyab and Siyavush Embrace* (fig. 4) from the celebrated manuscript.[18] This monumental painting illustrates a fleeting moment of accord between the warring peoples of Iran and Turan. At the heart of the composition, the Turanian king embraces an Iranian prince, their temporary alliance a brief respite in the ancient enmity that drives much of the *Shāhnāma*'s legendary narrative.[19]

Calderwood's later collecting differed qualitatively from her earlier efforts, reflecting her significant growth and confidence as a scholar. During this second phase, she taught Islamic art at Boston College and Simmons College and developed an independent voice in the field. In an unconventional move, her collecting shifted to manuscript paintings produced in the south-central Iranian city of Shiraz, an underappreciated tradition at that time. With admirable prescience, she assembled examples of the major phases of Shiraz painting from the fourteenth through the sixteenth century. Among her finest acquisitions of Shiraz manuscript painting is *Solomon Enthroned* (cat. 94, and fig. 7a of Marianna Shreve Simpson's essay, "The Illustrated *Shāhnāma* in Sixteenth-Century Shiraz," 77–113), which depicts the famously polyglot king presiding wisely over a heterogeneous retinue of humans, demons, angels, and animals.

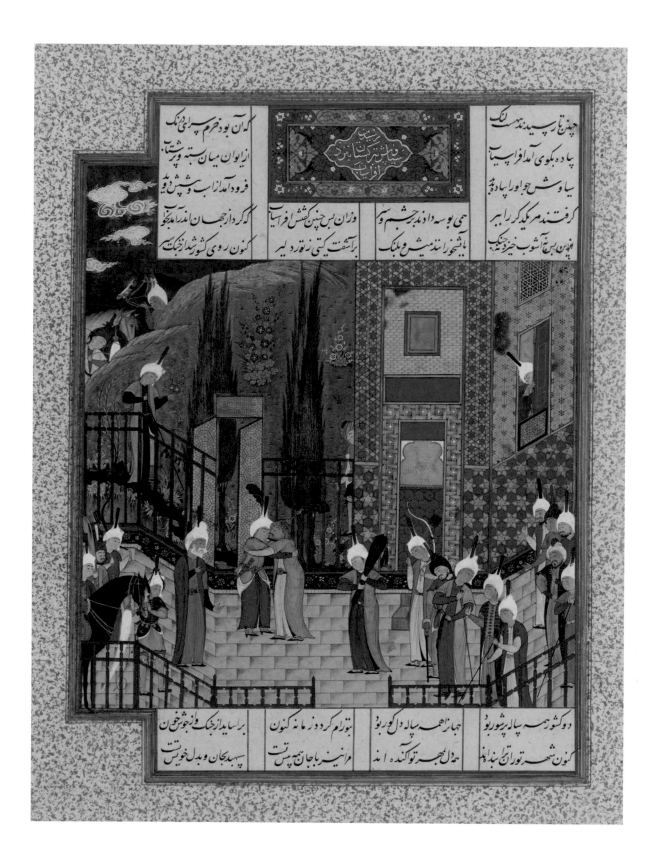

"With Quite Different Eyes"

In many lectures, Calderwood stressed that a full appreciation of Islamic art required approaching it "with quite different eyes."[20] We have over the years called upon many and different eyes to help us understand the varied objects in her collection.[21] The essays and entries in this catalogue are gathered from a wide net, with offerings from specialists in Islamic art, Ancient Near Eastern art, East Asian art, Persian literature, paper and objects conservation, and analytical chemistry. In this we follow Calderwood's own inclinations, for commensurate with her appreciation of the poetic beauty and cultural expressions of these works, she always maintained a persistent grounding in their physicality. Working with instruments in the Straus Center for Conservation and Research, we have extended our examination beyond the reach of human eyes, into the frequencies of ultraviolet, infrared, and X-ray technology. With Calderwood's 1973 foray into analytical testing as precedent, we submitted additional ceramics from the collection to thermoluminescence analysis.[22] In some instances, attributions have changed several times as the field of art history expands and diversifies and new kinds of information are made available.

The range of perspectives offered in this catalogue includes an exploration of the impact of new image-making technologies on traditional media; a microscopic examination of workshop practices; a theoretical inquiry into the nature of single-page images; an investigation of the cultural heterogeneity of a single region; a broad consideration of influences between East and West Asia; the patient analysis of mineral components in ceramic glazes; and an explication of the strategies of imperial identity. While one essay attempts to reconnect the dispersed folios of two different manuscripts, another seeks to differentiate between original and "alien" fragments in ceramic vessels "restored" for the twentieth-century art market. In language and structure, these essays inevitably reflect their authors' diverse disciplines and approaches. We hope that Stan and Norma Jean would have appreciated the blending of voices.

Fig. 4
Afrasiyab and Siyavush Embrace,
cat. 72, detail.

Notes

1. From a 1994 lecture to students at Boston College, where Calderwood taught Islamic and Asian art from 1983 to 1996: "What is the secret of the classic art of the Persian miniature? The effect is built up from a combination of closely focused, intensely felt images, some human, many of plants or animals, or architecture. The compositions are a combination of visual types, all united to form a harmony, with patterns of line and color covering the whole surface of the picture space ... There is masterly control of what seem like unmanageable elements, together with wonderful inventiveness." Typed drafts of some of Calderwood's lectures are preserved in the Archives of the Harvard Art Museums.

2. The generous donation of the Calderwood Collection to Harvard University is but one of the philanthropic acts of Stanford (d. 2002) and Norma Jean (d. 2006) Calderwood to cultural institutions in the Boston area. The Stanford Calderwood Pavilion at the Boston Center for the Arts was named in 2004 to honor their many contributions to theater in the Boston area. In tribute to his wife's teaching and long involvement with museums and collecting, Calderwood endowed positions at Boston College, the Museum of Fine Arts, Boston, the Isabella Stuart Gardner Museum, and the Harvard Art Museums.

3. From the incomplete documentation that accompanied the collection to Harvard, it appears that the objects were purchased on the international art market from established dealers based in London, Tehran, and Frankfurt. Her first documented acquisition was in 1968, her last about 1997.

4. Because the slides with which Calderwood illustrated her lectures have not been preserved, it is not possible to know for certain whether she used objects from her own collection in teaching. In the margins of an undated lecture on Islamic ceramics, she handwrote the words "mine" and "NJ's bowl." From the context, it is possible she was referring to cats. 3, 13, and 49.

5. Inevitably, our examination of the collection has led to some changes in attribution. For example, when acquired by Calderwood, the small Asian dish (cat. 50) was thought to be an example of green-glazed Umayyad wares, then little known or studied. Undoubtedly, some of the attributions offered in this catalogue will also change as new information becomes available.

6. Calderwood studied music, French, and German at the University of Colorado (1939–42) and Spanish at the University of Barcelona and University of Madrid (1958). She completed her bachelor's degree in Romance Languages and Literature at Boston University in 1963.

7. Calderwood began a long volunteer association with the Museum of Fine Arts, Boston, in 1967, and was a dedicated supporter of the Harvard Art Museums.

8. McWilliams 2004, 2.

9. Handwritten invoice dated 15 May 1968 from Hadji Baba Rabbi House of Antiquities, Tehran, Iran. It is not possible to link with certainty the twelfth-century bowls with specific objects in the Calderwood Collection.

10. This sketch of Calderwood's collecting history can be only approximate, based as it is on an incomplete paper trail. Multiple invoices survive from dealers, but it is not always possible to connect the object described with a specific object in the collection. Appraisals of the collection conducted in 1978, 1992, and 1995 help to chart the collection's growth. An incomplete set of snapshots dated February 1974 are numbered 1–48.

11. Calderwood's library of more than 2000 volumes was donated to Boston College in 2001.

12. Described in McWilliams 2003.

13. An invoice from the Museum of Fine Arts, Boston, dated August 1973, lists ten objects for which thermoluminescence tests were conducted. It is not always possible to identify the descriptions in the invoice with objects presently in the collection. Where we are confident of a match, that information appears in the catalogue entry for the object. It seems that Calderwood returned to dealers at least two blue-and-white bowls that tested modern. A thoughtful assessment of both the usefulness and pitfalls of thermoluminescence dating can be found in Bassett 2007.

14. Had fraud been the potter's intention, he would probably have employed a white frit body, and not the albarello's pink fritware covered in white plaster.

15 Quoted in a press release from the Harvard Art Museums, March 2002.

16 Grabar and Blair 1980.

17 Holod 1974.

18 Dickson and S. C. Welch 1981a.

19 Priscilla Soucek first expressed insights into Harvard's impact on Calderwood's collecting in the 2004 Calderwood Lecture in Islamic Art, "Reading Pictures, Telling Tales: Text and Image in Sixteenth-Century Iran."

20 From an undated lecture, "Islamic Art": "[Islamic art] makes enormous demands on the viewer. Its miniatures are small and fragile and need detailed examination. Many works of art are broken and fragmentary . . . the result of repeated and destructive invasions . . . Its decoration requires the eye to participate and explore . . . Every comparison with the idea of art as the Western world conceives it should be thrown out, abandoned, and then it should be looked with quite different eyes."

21 Despite her great knowledge of the field, Calderwood's collection arrived at Harvard in 2002 with little cataloguing information, undoubtedly due to the illness that marred her final years.

22 Results for the Calderwood ceramics that have so far been tested by thermoluminescence analysis are given as endnotes in the individual catalogue entries. For the purposes of this catalogue, we have chosen to accept these analyses at face value, although a few of the results are ambiguous, even controversial, and merit further research and analysis. Objects for which thermoluminescence testing indicated a manufacturing date significantly later than was suggested by stylistic analysis are included among the artworks that, in this catalogue, are grouped in the study collection.

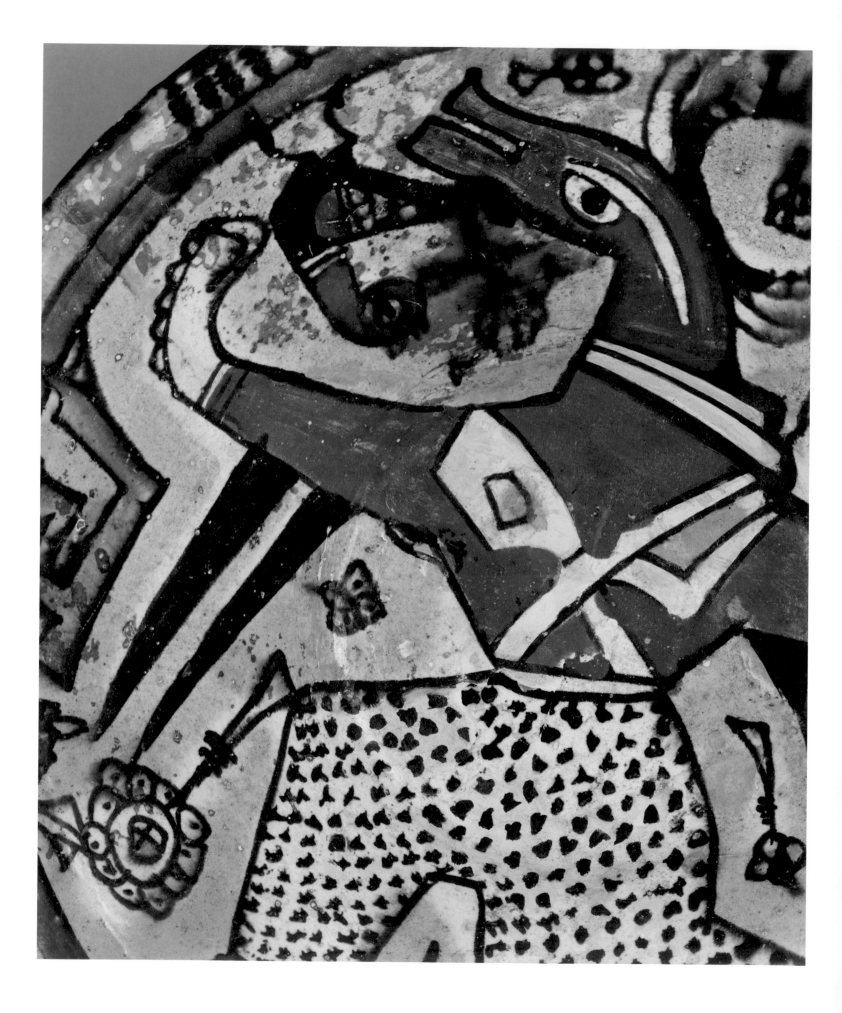

Feasts of Nishapur: Cultural Resonances of Tenth-Century Ceramic Production in Khurasan

Oya Pancaroğlu

One of the more remarkable objects in the Calderwood Collection is a bowl depicting a figure with a horned animal head (fig. 1). Its vivid color scheme of green, black, white, and red-brown on a bright yellow background instantly identifies this bowl as a well-known ceramic type. Numerous examples of such ware, with both figural and abstract decoration, were found in Nishapur during excavations led by the Metropolitan Museum of Art in the latter half of the 1930s.[1] Commonly dated to the tenth century, "Nishapur polychrome ware" may well have been produced across the larger region of Khurasan (eastern Iran) and Central Asia.[2] Examples with figural decoration depict standing or sitting personages, usually proffering cups or fruits or playing instruments; hunters and warriors, either on foot or on horseback; and stylized animals such as birds, antelopes, cheetahs, and horses. A mainstay of the style is the animation of the background with small motifs of vegetal, animal, abstract, or calligraphic derivation.

Nishapur polychrome ware represents an early instance of multicolor glaze technology, suggesting that its reception in the tenth century involved aesthetic fascination. It is, in fact, emblematic of the trend toward the amplification of glazed ceramic decoration in the Islamic world during the ninth and tenth centuries, when the importation of fine Chinese ceramics and innovations in glazing technology in Iraq resulted in unprecedented demand for and production of radiantly deluxe tableware in Iraq and beyond. Nishapur polychrome ware should therefore be seen as part of a complex series of artistic achievements and, judging by the recurrence of its unusual figural imagery, as a testament to an equally complex cultural heritage in eastern Iran.

The importance of Nishapur, which had been established as a Sasanian imperial city, continued after the Arab-Muslim conquest of Iran. Counted alongside Merv,

Bowl with masked dancing figure, cat. 19, detail.

25

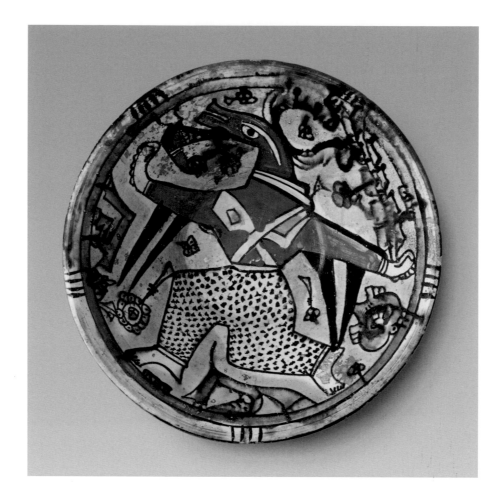

Fig. 1
Bowl with masked dancing figure,
cat. 19.

Herat, and Balkh as one of the four great cities of Khurasan,³ Nishapur grew in
political and cultural significance and after the conquest became a frequent player
in the often turbulent course of the history of the region. As a major urban center,
it dominated numerous villages that supplied agricultural wealth, and it boasted
vibrant commercial markets with both imported and locally manufactured goods,
especially fine textiles.⁴ Nishapur, like other parts of Khurasan in the aftermath
of conquest, had received a large influx of Arab settlers, whose descendants, by the
tenth century, were largely assimilated into the culture of eastern Iran. In addition
to the descendants of Arabs, among whom were prominent families who traced
their lineage from the Prophet's son-in-law 'Ali, the population of Nishapur con-
sisted of indigenous Iranians, most of whom, by the tenth century, were Muslims,
although Zoroastrians, Christians, and Jews were also present, either in the city
or in nearby villages.⁵ In these villages, the Iranian nobility of the *dihqān* (landed
gentry) continued to hold sway, maintaining Iranian traditions even as the pace
of conversion to Islam accelerated, especially during the tenth century.⁶ The imag-
ery on Nishapur polychrome ware can be effectively correlated with the mixture
of cultural values in tenth-century eastern Iran.

The Bull and the Feast

The horned head of the figure on the Calderwood bowl may be identified as that of a bull, cow, or ox.[7] In contrast to his unusual head, the figure's trousers and sleeved waistcoat are typical of clothing depicted on Nishapur polychrome ware.[8] The leafy branch held in his left hand and the double black strands descending on two sides below his outstretched arms are also common features. The leafy branch is highly reminiscent of the *thyrsus*, an attribute of Dionysiac iconography in both Roman and Sasanian art and a probable late survivor of Hellenistic visual language in medieval Iran.[9] The nature of the double black strands remains unresolved, but they are generally held to be either tresses or the ribbon-like extensions of a scarf.[10] To judge by his hands and bare feet, the figure appears to be human rather than bovine; the position of his arms and legs suggests that he is dancing, presumably while wearing a mask.[11]

Animal-masked (or animal-costumed) dancers and actors were sporadically represented visually and mentioned textually, apparently as entertainers, in the medieval and post-medieval periods in the Near East.[12] The most explicit representations can be seen in sixteenth-century Safavid drawings, in which figures dressed in goatskins are depicted dancing to the accompaniment of musicians and non-masked dancers. An early version of such a performance, involving an actor dressed as a monkey reciting poetry, is said to have taken place for the Umayyad caliph al-Walid II (r. 743–44).[13] It is possible that depictions of animal musicians in the paintings of the Umayyad bathhouse of Qusayr 'Amra, in Jordan, also represent human entertainers dressed as animals.[14] Numerous textual references to masked actors and dancers from the Abbasid period employ the Arabic term *samāja* to denote a variety of spectacles undertaken for the entertainment of both court and public audiences.[15] While the form of *samāja* masks is not always clear from texts, they appear to have been imbued with an element of the grotesque and often combined with slapstick performances intended to amuse the people. Frequently, these spectacles are described as part of Nawruz, or New Year, festivities at the spring equinox, which was celebrated not only in Iran but also in Iraq, Syria, and Egypt—non-Iranian societies whose use of the term *nayrūz*, the arabicized form of the Persian *nawrūz*, reveals the Iranian source of the practice.

Such performances were probably rooted in rituals of ancient Indo-Iranian cults and evolved alongside celebrations tied to the natural cycle of seasons. Almost as popular as Nawruz was Mihragan, the festival marking the autumn equinox, which had similarly ancient cultic roots and was celebrated in post-conquest Iran by Zoroastrians and Muslims alike.[16] The name of this festival indicates its dedication to Mihr or Mithra, the Zoroastrian deity of covenants and the protector of pastures and cattle.[17] The Zoroastrian creation myth maintained the significance of the primordial bull (*gāw ī ēw-dād*), describing its slaying as an act that resulted in the bringing forth of beneficent animal and plant life in the world.[18] The *Mihr Yasht*, one of the twenty-one ancient Zoroastrian hymns, has been interpreted as an early indication of the sacrifice of cattle both small and large, as well as of birds and fowl, in connection with the worship of the deity.[19] As late as the mid-twentieth century in Iran, Zoroastrian observance of Mihragan comprised the sacrifice of goats and

sheep and their ritual consecration to Mihr. Feasting and merrymaking with music and dance notably included dancers with animal masks.[20] The offering of fruits such as pomegranates and quinces particularly identifies Mihragan as an autumnal harvest feast.[21]

At the Sasanian court, Mihragan, like Nawruz, involved the exchange of gifts of value as confirmation of imperial grandeur and might.[22] Along with dancing, an elaborate court ritual of wine consumption was made public.[23] The endurance of Mihragan in eastern Iran is apparent from the extensive references to its celebration at the courts of Khurasan in the period between the Arab-Muslim conquest and the Mongol invasions. The historian Tabari (d. 923), for example, refers to the Arab governor of the province, Asad ibn 'Abdallah, convening a feast at his court in the city of Balkh in the year 738.[24] Describing this event as a ritual confirmation of loyalty between Arab-Muslim rulers and their Iranian subjects, Tabari highlights the exchange of opulent gifts—gold and silver vessels and models of fortresses, in addition to valuable garments—probably in conscious emulation of Sasanian imperial precedent. Later court poets and chroniclers of the Samanid, Ghaznavid, and Seljuk dynasties also characterize Mihragan with vivid descriptions of musical merrymaking and offerings of fruit and wine.[25]

References to wine offered at feasts such as Mihragan suggest the endurance of the memory of ritual bull sacrifice and blood libation. This conceptualization is reflected in poetic mentions of bull-shaped wine vessels, of which numerous ceramic examples from medieval Iran have survived,[26] including one in the Calderwood Collection (cat. 24). A pitcher surmounted by a bull's head was found in the course of excavations in Nishapur by the Metropolitan Museum of Art (fig. 2);[27] a fragment of another vessel, in the form of a bovine painted with two dancers, further strengthens the proposition that themes relevant to the celebration of Mihragan were familiar to the makers of Nishapur polychrome ware.[28]

Fig. 2
Animal-spouted pitcher.
Iran, Nishapur, 9th–10th century.
Earthenware with polychrome decoration under a transparent glaze, 26.7 cm (10½ in.).
The Metropolitan Museum of Art, Rogers Fund, 38.40.247.

The Iranian epic tradition, represented by the poet Firdawsi's *Shāhnāma* (completed in 1010), brought another bovine association to bear on the meaning of Mihragan: the victory of the mythic Iranian king Faridun over the thousand-year tyranny of Zahhak. Faridun, entrusted by his mother to a beneficent cow named Barmaya, who raised the child far from the reaches of the bloodthirsty tyrant, eventually led a successful uprising and avenged Zahhak's countless innocent murder victims. The story of Faridun, as told by Firdawsi, constituted an archetypal representation of the restoration of divine justice on earth; it was in celebration of this cosmic renewal that Faridun is said to have established the festival of Mihragan.[29] The eastern Iranian scholar Biruni (d. 1048) likewise emphasized the connection between Faridun's victory and the celebration of the festival, adding that Mihragan was conceived "as a sign of resurrection" and, in keeping with its autumnal character, as the time when "that which grows reaches its perfection."[30] Thus, the Zoroastrian veneration of Mihr and the Iranian epic representation of Faridun's victory coincided in the autumnal feast, binding deity, hero-king, and animal in a celebratory framework of interrelated identities and eternal ideals such as justice, renewal, and prosperity.[31] This coincidence is also reflected in the extension of the bovine motif to the bull-headed mace (*gurz-i gāwsar*), mentioned

in the *Mihr Yasht* as the mace of the deity and in the *Shāhnāma* as the weapon
that granted Faridun victory.[32]

A discrete cult of Mihr prevalent among certain Parthian dynastic families of
northern and eastern Iran continued to be practiced in these regions well into
the Sasanian period.[33] One of the three great sacred fires of ancient Iran had been
established under the Parthians at a site near Nishapur and was known as Burzin
Mihr ("exalted is Mihr").[34] In the Sasanian ranking of the great sacred fires, Burzin
Mihr was said to belong to the estate of herdsmen and farmers.[35] There appears to
be no evidence for the physical survival of this temple after the Arab-Muslim con-
quests, but the fact that it is mentioned by name in both the *Shāhnāma*[36] and *Vīs va
Rāmīn*,[37] an eleventh-century romance by the poet Gurgani, indicates that its mem-
ory remained alive in later medieval literary milieux. In addition, the thirteenth-
century cosmographer Qazwini mentions a fire temple in Sistan, a region south of
Khurasan; called Karkoy, this temple had double domes surmounted by "horns like
that of a great bull," which suggests the strong likelihood of a Mithraic component
to the local Zoroastrian tradition.[38] The cult of Mihr in eastern Iran thus infused
the region with legends and symbols of remarkable longevity.[39]

The Ethos and the Feast

The image of the bull-masked dancer on the Calderwood bowl can be perceived as
possessing multiple and mixed layers of meaning that reveal the depth of the cul-
tural concepts informing feasting in tenth-century Khurasan. This is not to imply
that the maker or owner of the bowl would have been aware of all the cultural and
cultic implications discussed above, nor that the vessel had to be produced for the

Fig. 3
Bowl with plowing scene.
Iran (Khurasan) or Central Asia,
10th–11th century.
Earthenware with slip, pigment, and slip
decoration under a transparent glaze,
7 × 18.3 cm (2¾ × 7³⁄₁₆ in.).
Musée du Louvre, purchased 1991, MAO 858.

feasts of Mihragan or Nawruz. Given the lack of any indication of its audience, it is impossible to make a more precise suggestion for its intended or perceived meaning. Nonetheless, the rich context of feasting traditions through which this object and its imagery acquire particular significance also aids the interpretation of other seemingly curious examples of iconography on Nishapur polychrome ware. Thus, a bowl depicting a pair of oxen harnessed to a plow and driven by a farmer (fig. 3) may well evoke the spring season epitomized by the Nawruz festival, when such a vessel could have captured the spirit of the season by its imagery and represented the rituals of feasting by its function. Indeed, some form of reference to feasting activities can be detected on most vessels of Nishapur polychrome ware with figural decoration. Figures holding up pomegranates or quinces (fig. 4)[40] or cups[41] encapsulate the formal gesture of offering and evoke a ritually festive ambience. Musicians[42] and wrestlers (fig. 5) belong to the traditional realm of entertainment, in which the animal-masked dancer occupied a particular niche with a rich array of associations. Still other images on Nishapur polychrome ware, such as a horse carrying a cheetah (fig. 6), recall the courtly pastime of hunting with trained animals, a prerogative of the ruler that can be traced to the Sasanian imperial tradition.[43] Hunting expeditions typically culminated in lavish feasts, with both activities functioning as affirmation of royal power and generosity.

Studying the imagery found on Nishapur polychrome ware yields the cumulative impression of a vibrant consumer society interested in visually recording the motions and notions surrounding traditional feasting. The makers of these ceramic vessels appear to have aimed at both amplifying the actual experience of feasting and preserving the memory (or ideals) of that social and ritual experience. Whether these vessels themselves were also the object of gift exchange on festive occasions cannot be determined; accounts of gift giving in the medieval

Fig. 4
Bowl with standing figure, cat. 18.

Fig. 5
Bowl with two wrestlers.
Iran, Nishapur, 10th century.
Earthenware with slip and polychrome decoration under a transparent glaze, 9 × 21.5 cm (3 9/16 × 8 7/16 in.).
The David Collection, 13/1975.

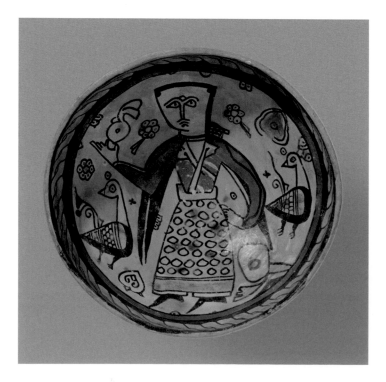

Fig. 6
Bowl with a cheetah standing on the back of a horse, cat. 16.

courts of eastern Iran make specific mention of vessels in precious metals, but not in ceramics. Nevertheless, it is quite possible that Nishapur polychrome ware, with its typically brilliant yellow background color, was perceived as a cheaper alternative to gold vessels, or to the silver vessels with gilt decoration whose production continued from the Sasanian into the early Islamic period. Such an emulative relationship is exemplified by numerous other aspects of medieval Islamic ceramics, from the overglaze technique of luster painting to the replication of metal forms.[44]

Closely related to the study of material inspiration is that of consumption, which, however, is hampered by the absence of archaeological and textual evidence for the use of these vessels. Given this state of knowledge, the objects themselves have to be reconsidered for indication of their social context. In the case of Nishapur polychrome ware, the existence of a small number of objects clearly made for a Christian clientele is particularly important. These include vessels with the unmistakable sign of the cross;[45] one example is a bowl decorated on the outside

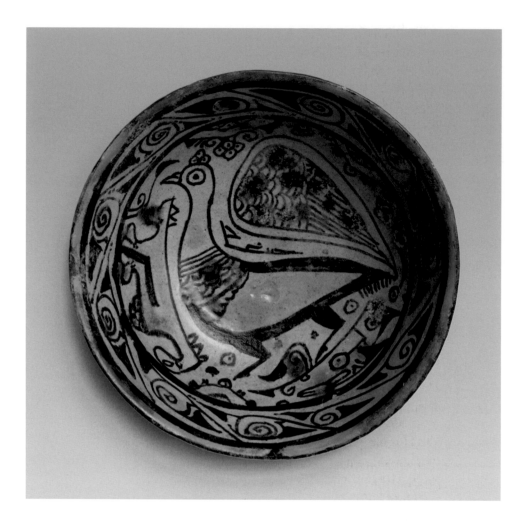

Fig. 7
Small bowl with peacock, cat. 17.

with crosses alternating with peacocks,[46] thus combining two symbols established in early Christianity—the cross representing the suffering and resurrection of Christ, and the peacock conveying the idea of immortality. The form of the cross, with bifurcated arms ending in round "pearls," reveals the Nestorian identity of the community for which this bowl was made.[47] Besides the cross, further evidence for Nestorian consumption of Nishapur polychrome ware comes from inscriptions in Syriac: a bowl in the National Museum of Iran, for example, is decorated in a rather plain manner with a series of Nestorian crosses framing a three-line inscription consisting of a short prayer in Syriac.[48] A Syriac word is also inscribed on a peacock-decorated bowl in the Calderwood Collection (fig. 7). The word may be read as ʿaynā, meaning either "eye" or "fount."[49] Both meanings can be related to the image, since the peacock was not only appreciated for the beauty of the "eyes" on its tail feathers but in early Christian imagery was also depicted drinking from a fount, standing for the revival and rebirth symbolized by baptism.

Although examples with Christian decoration constitute only a small fraction of the known corpus of Nishapur polychrome ware, they attest to the significant fact that Nestorian Christians demanded vessels of this type and probably used them in liturgical or private contexts. Nishapur was an important center for Nestorian Christianity, which spread into Asia especially in the aftermath of the Council of

Ephesus in 431, when the Nestorian position on the nature of Christ was condemned as heresy, forcing the church to carry its mission beyond the borders of the Byzantine Empire. Nishapur was the seat of a Nestorian bishopric as early as 410, followed soon thereafter by the nearby town of Tus, as well as by Herat and Merv, two of the four major cities of Khurasan, which later became metropolitan sees.[50] Whether or not Nestorian Christian consumption of at least some of the products of Nishapur polychrome ware should also be seen as evidence that Christian ceramic artists were engaged in some or all of the production cannot now be resolved. This corpus of vessels raises a further question: was the involvement of the Nestorian community in the consumption of Nishapur polychrome ware limited only to vessels with Christian imagery? While these may have been decorated specifically for the purpose of liturgical use or pious expression, they do not preclude the possibility that members of the Nestorian community also used vessels with other kinds of decoration, whether figural or non-figural, in secular contexts.

It is, of course, plausible that certain types of images were addressed to specific communities, and that makers of Nishapur polychrome ware catered to the discrete needs and preferences of various consumer groups. Apart from the distinct case of the vessels with Christian imagery, however, there is no reasonable means to exclude any confessional group from the production or consumption of the entire visual repertoire of Nishapur polychrome ware. Rather, the visual allusions to feasting or to allied activities such as hunting belong to a social ethos that had a common ground in the continuity of ancient Iranian norms and mores, preserved especially in festivals celebrated with or without religious intent. Thus, a bowl decorated with the image of a figure holding a cup or fruit could have a range of festive associations, depending on its audience. For a Zoroastrian, it may have signified the specific ritual dimension and evoked the religious import of Mihragan or Nawruz, whereas for a Muslim or a Christian, it may simply have been part of Iranian festive traditions and their attendant ritual behavior, divested of Zoroastrian meaning.

The study of Nishapur polychrome ware, as of most other ceramics from the medieval Islamic lands, is unfortunately disadvantaged by the lack of sources that could shed light on the meanings implicit in the design and use of these vessels. Even more regrettable is the state of archaeology, which is inadequate for illuminating the context of the majority of surviving objects and fragments. Nevertheless, the wealth of visual and material output represented by Nishapur polychrome ware, both on its own and in relationship to other wares, constitutes an invaluable testament to the communal experiences of the society that produced and consumed it.[51] Discerning the connections between an object, its imagery, and the probable occasion of its use sheds light on the identities and interests inherent in communal experiences that otherwise may be perceived only dimly. For any assessment of the tenth century in the eastern half of the Islamic lands, a grasp of the continuity and revival of Iranian traditions is of paramount importance. A wide-angled study of Nishapur polychrome ware is certain to add to the array of cultural impressions gained from the reading of literary milestones of the period, such as the *Shāhnāma*, and to impart a sense of those festal traditions in which the communal ethos was most potently expressed.

Notes

1 Wilkinson 1973, 3–53; see also Wilkinson 1986. Excavations in Nishapur resumed in 2005 as a joint Iranian-French project: see France Diplomatie 2008. The site of medieval Nishapur was long exposed to both commercial digging and illegal plunder.

2 A comprehensive investigation of the petrographic and decorative characteristics of known examples, as well as further archaeological data, may qualify the current assumptions about the provenance of this ware. Indeed, the Metropolitan excavations yielded no conclusive evidence for production in Nishapur, while examples—apparently in much lesser quantities—were found at other sites in eastern Iran and Central Asia. The label "Nishapur buff ware" was coined in the excavation publications in reference to the frequent occurrence of a buff-color fabric, but not all examples found at Nishapur have such a fabric. This bowl, like a few others excavated in Nishapur, has a reddish fabric. This essay is therefore written on the assumption that this bowl could have been found in Nishapur, rather than on the premise that it was produced there. Its type will be referred to here as "Nishapur polychrome ware" to underline its most distinctive characteristic.

3 For the geography and history of medieval Nishapur, see Le Strange 1905, 383–88; Bulliet 1972, 3–19; Bosworth 2010. For a broad perspective on Khurasan in the post-conquest period, see Daniel 1979.

4 Stillman 2003, 44, 46.

5 Bulliet 1972, 15. On the ʿAlids of Nishapur, see Bernheimer 2005.

6 Tafazzoli 1994. On the fortunes of Zoroastrians specifically, see Choksy 1997.

7 A single Persian word, gāw, can be used for cow, bull, and ox alike, avoiding the distinctions conveyed by the English terms. The painting style prevents a more precise identification, and other possible species—perhaps bovid—cannot be entirely ruled out. In this essay, the animal will be referred to as a bull.

8 The prominent "lapels" on the waistcoat and the collar below the head have been overpainted. Such lapels, however, are common on Nishapur polychrome ware and probably reflect what is beneath the overpainting.

9 Shepherd 1960.

10 Wilkinson 1973, 18, argued for the scarf identification in general but allowed for cases of "complete confusion between hair and scarf." That men (as well as women) could wear their hair long in medieval eastern Iran is evident from passing mentions of such coiffure in the early medieval sources; see Tafazzoli 1994 and Zakeri 1995, 281. This is also confirmed by numerous depictions of men with long strands of hair on Iranian mīnāʾī and luster-painted wares from the twelfth and thirteenth centuries.

11 A human-headed but otherwise rather similar figure is depicted on a bowl in the Kuwait National Museum, Kuwait City: see Watson 2004, 248. At least one other example of such a masked figure has been published (see Kiyānī 2001, unnumbered color plate), and others may come to light in the future.

12 Ettinghausen 1965; Gaffary 1984; Moreh 1992, 44–63; Floor 2005, 13–61.

13 Moreh 1992, 44–45.

14 Fowden 2004, 68.

15 Moreh 1992, 45–54.

16 Boyce 1975a; Boyce 1975b, 172–73; Boyce 1983a; Calmard 1993. Muslim celebration of Mihragan appears to have declined after the Mongol period.

17 Boyce 1975b, 22–38. The Zoroastrian deity derived from the Indo-European cult of Mitra; in the West it evolved into the Mithras cult (or Mithraism) of the Roman world, featuring the god as sun and bull slayer: Clauss 2000, 3–8. For the highly complex relationship between the Iranian and Roman cults, see Beck 2002.

18 Malandra 2000.

19 Schmidt 2006.

20 Boyce 1975a, 108–9. Roman Mithraism, inasmuch as it followed its own trajectory of religious development independent of Zoroastrian traditions, defined Mithras as the sacrificer of the Bull but, remarkably, placed great emphasis on the ritual meal at which some participants apparently wore animal masks: Clauss 2000, 108–13, 116, figs. 69, 74.

21 Boyce 1975a, 110–12. As a result of official changes in the calendric system in the Sasanian period, Mihragan was not always celebrated in the autumn: see Boyce 1970.

22 Calmard 1993.

23 De Jong 1997, 372-75.

24 Blankinship 1989, 167-69.

25 Calmard 1993; Melikian-Chirvani 1992, 107-11; Hanaway 1988.

26 Melikian-Chirvani 1991.

27 Wilkinson 1973, 24-25, no. 72a, b.

28 Ettinghausen 1969, figs. 1-4; this fragmentary object was published as part of an unidentified private collection.

29 Amanat 2006, 53.

30 Sachau 1879, 208.

31 Pourshariati 2008, 370-75.

32 Doostkhah 2002.

33 Pourshariati 2008, 351, 369-70.

34 Boyce 1983b; Pourshariati 2008, 362, 364-66.

35 Pourshariati 2008, 363.

36 Boyce 1983b.

37 Morrison 1972, 76, 349.

38 Pourshariati 2008, 364n2079.

39 Ibid., 397-452.

40 For a very similar bowl, excavated in Nishapur, with a figure holding up a cup, see Wilkinson 1973, 17-19, no. 59.

41 See, for example, a bowl in the Harvey B. Plotnick Collection, Chicago (Pancaroğlu 2007, cat. 38). Of the five figures on this bowl, two are represented holding pomegranates and two are shown with shallow cups like the ancient Greek libation vessel known as *phiale* (whence comes the Persian word *piyāla*, or drinking cup). The object held up by the fifth figure cannot be identified but looks like a ritual implement.

42 See, for example, a plate in the Harvey B. Plotnick Collection, Chicago (Pancaroğlu 2007, cat. 42).

43 An example with a more sophisticated version of this iconography, including a rider, was excavated in Nishapur and is in the collection of the National Museum of Iran, Tehran: see Wilkinson 1973, 20-22, no. 62. On hunting with cheetahs as depicted in later ceramics from Iran, see Pancaroğlu 2012, 400-403.

44 For the relationship between silver and ceramics in the Samanid realms, see Raby 1986.

45 For two such examples excavated in Nishapur, see Wilkinson 1973, 15-16, nos. 48, 49. For other examples, see Wilkinson 1969 and Pancaroğlu 2007.

46 Pancaroğlu 2007, 82, cat. 41. The Harvey B. Plotnick Collection, Chicago, includes a second, identical, example of this bowl, although only one was published in the catalogue.

47 Parry 1996.

48 Wilkinson 1969, 82.

49 I thank Dr. Igor Dorfmann-Lazarev (University of London, School of Oriental and African Studies) for this reading. The word appears to be followed by the Syriac letter *tāw*, which might suggest that the inscription was imperfectly copied onto the bowl from another source.

50 Hunter 1992, 364. See also Fiey 1973.

51 The tenth-century luster-painted wares in Iraq and slip-painted wares in eastern Iran and Central Asia constitute perhaps the most relevant material for perceiving Nishapur polychrome ware within the wider ceramic production of the time, but they remain beyond the scope of this essay. For two different attempts to correlate Nishapur polychrome ware with the slip-painted ware (especially of the so-called Samanid epigraphic variety), see Bulliet 1992 and Pancaroğlu 2002.

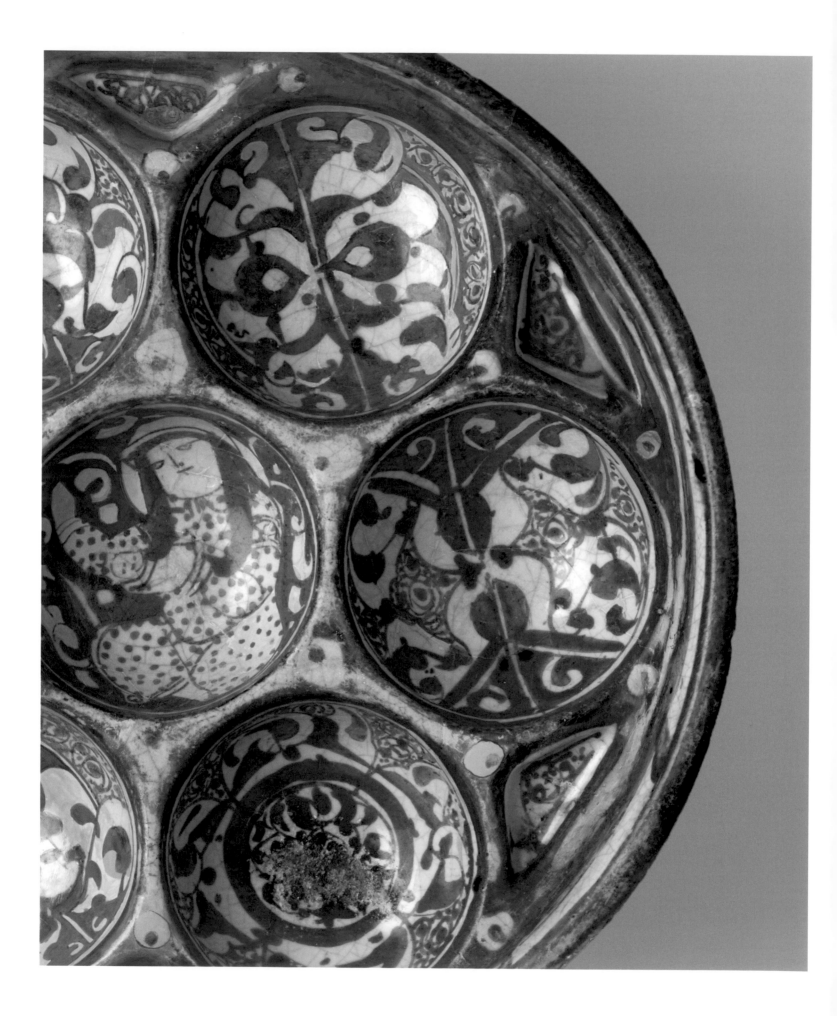

History in Pieces: Conservation Issues in Islamic Ceramics

Anthony B. Sigel,
with introduction by
Mary McWilliams

"We get sherds and we put them together. We're not doing anything the museums don't do." Thus does Richard Frye, distinguished scholar of Iranian Studies, recall the working philosophy of a "restoration factory" manager he met in southern Tehran in 1953. As a representative of a major antiquities dealer, Frye gained access to this and other facilities during a brief involvement in the international art world.[1] The manager, photographed holding a fragmentary slip-painted bowl in its "before treatment" condition (fig. 1), gave him a partial tour of the facility, which worked in multiple media: stone carving, carpets, and ceramics.[2]

Unlike some other establishments that Frye encountered on a long trip through the Middle East that summer, this Tehran factory did not manufacture entirely new "antiquities" but made use of original, albeit fragmentary or damaged, works of art. Its ceramic business relied on a stockpile of sherds supplied by dealers around the country. Iranians who found bits and pieces of pottery by accident— or by illicit digging—knew they could bring the fragments to the dealers, who would pay in cash. Dealers would also go to the villages and ask the inhabitants what antiquities they had; some of the dealers had runners to procure objects or fragments of objects from peasants. Thus this factory appears to have both benefitted from and fostered an active business of finding and ferreting out ceramic fragments.

While not admitted to the workshops proper on that long-ago summer day, Frye saw separate rooms for ceramics from the pre-Islamic, early Islamic, and later Islamic eras. Each room contained an extensive library, including technical manuals about clays, glazes, and fluxing agents. He particularly noted the room for pre-Islamic ceramics, the floor of which was "covered with sherds"; men sat on the floor piecing vessels together from these fragments, which had been sorted by type, color, and shape. Frye understood that the factory workers would then further shape and assemble the composite vessels, make plaster fills as necessary, and paint over the losses.

Sweetmeat dish,
cat. 35, detail.

Fig. 1
The manager of a "restoration factory,"
holding a fragmentary slip-painted bowl
in its "before-treatment" condition,
Tehran, 1953.

Still vivid after sixty years, Frye's recollection offers a context for the unusual restoration practices we sometimes encountered when examining the Calderwood Islamic ceramics.[3] As described by Anthony Sigel below, fragments from different but stylistically similar vessels have sometimes been ingeniously fitted together to create a single object. There is no information to connect any of the Calderwood objects to the Tehran factory, nor is it known how widespread this restoration technique may have been within, and perhaps beyond, Iran. Clearly, it relied on an abundant and varied supply of sherds.

The conundrum presented by these vessels as assemblages of disparate fragments runs counter to the more familiar challenge encountered in Islamic art history. Scholars in the field have long struggled to piece back together—at least in virtual form—works of art and architecture that have been broken apart, dismembered, and dispersed. To recover the implications of the whole, we seek to locate and understand the relationships among all surviving bits and snippets of a given textile, manuscript, album, or tile revetment, however widely the pieces may have traveled. These composite ceramics challenge us in the opposite way: we seek to deconstruct the amalgamated pieces and study them separately, to better understand the original. The ceramic pastiches also challenge our notions of authenticity: by replacing the non-original, but perhaps equally old, sherds with a modern but anonymous fill, have we made an object more or less authentic?

Sigel's meticulous discussion below of a sweetmeat dish (cat. 35) has succeeded beyond the initial goal of identifying and removing alien components. The painstaking disassembling and examination of the many fragments has yielded an understanding of the methods and steps by which the medieval Persian potter originally constructed this complicated vessel from separate parts.

MMcW

Conservation Issues in Islamic Ceramics

The conservation of Islamic ceramics that have been restored in the past is an undertaking unlike any other facing the ceramics conservator, since it addresses not only the alterations of time, accident, and burial but also previous restorations of a character not often found on other archaeological and decorative ceramic materials. With the acquisition of the Norma Jean Calderwood Collection, object conservators in the Straus Center for Conservation and Technical Studies encountered new and perplexing treatment problems.

Conservation issues presented by ancient ceramics from all cultures typically have to do with appearance and stability. Most common and straightforward is simple breakage, often with loss of original elements. Long-term burial frequently leads to contamination by materials that stain and accrete, or by soluble salts such as chlorides or nitrates, the latter from fertilizers percolating down and into the pores of ceramic bodies while they are underground. Even years after excavation, these

salts can mobilize during changes in relative humidity, crystallizing at the surface, often with damaging results. We in the West normally encounter Islamic ceramics not in their original archaeological contexts but rather after they have passed through restoration studios and workshops and into the world of commercial galleries and auction houses.[4] From there, in a progression typical of antiquities in general, they enter private and sometimes museum collections.

These archaeological Islamic ceramics share condition issues with all collected ceramics restored before the era of modern, science-based conservation. On many reassembled objects, the unstable adhesives holding them together have now deteriorated to the point where the joins have loosened and are vulnerable to collapse and further damage. A simple tap on such an afflicted vessel yields not a resounding "ring" but a loose rattle. Animal glue adhesives, often encountered in earlier restorations, swell and shrink with changes in humidity, and in doing so can tear away original ceramic at the break edges. Shellac adhesive can stain these edges, migrate under the glaze, and become all but impossible to extract; shellac also becomes both brittle and increasingly insoluble over time. Cellulose-based adhesives, in use until recently, likewise grow more brittle as their plasticizers are lost, and can shrink and pull ceramic apart. Where pieces are missing, the losses may have been filled with poorly shaped, unsealed plaster or other unstable materials, and the filled areas overpainted extensively to hide the damage. Such overpaint, even if originally well executed, has by now often become unstable and darkened, discolored, or flaked. Usually composed of pigments ground in a medium of oil or shellac, it often proves to have been applied broadly to hide evidence of damage or repair for the commercial market, and may conceal large areas of substantially undamaged original surface. One can imagine the pleasure of the conservator in removing such disfiguring restorations to find the area of actual loss to be relatively small. A far more disturbing problem is the permanent damage inflicted by earlier restorers. This is most often found where a vessel has been assembled with the joins in poor alignment and out of plane with one another, and the restorer has filed down the raised areas with a rasp or coarse abrasives to create an even surface.

This litany of vices is typical of the range of problems conservators expect to encounter when treating any ceramics with older restorations. What proved so startling as we engaged with the large group of early Islamic ceramics in the Calderwood Collection was not simply the degree of loss and restoration and the damage from the above-mentioned vices, but, much more unusually, the extent to which original sherds from *different* vessels were repurposed and reshaped to fill losses. That these sherds were "alien" to the original vessel could be determined from disparities in ceramic fabric, glaze, surface pattern, or profile.

We have also identified, in areas of loss, modern restorations made of fired clay, with appropriate-looking decoration and glaze. A high degree of expertise and technical ability in controlling and manipulating such variables as clay-body composition and shrinkage, glaze chemistry, and kiln-environment cycling and temperature was required for producing these wholly created "sherds." The restorations incorporating them are often so convincing that their presence is disclosed only when the vessel is dismantled for re-treatment.[5]

In this group of Islamic ceramics, the more conventional loss-filling materials—the plaster of paris or gesso-like putty made of chalk and animal glue found in restored ceramics across other cultures—are used only sparingly, in losses too small to be fitted with ceramic replacements. Fashioning fills out of plaster or putty is far less labor intensive than creating wholly new ceramic sherds or repurposing old ones. Clearly, in the ethos of the restoration workshops, a genuine glazed-ceramic surface was prized over a plaster simulation. This trumped the originality of the sherds to the vessel being restored, and even fidelity to the correctness and meaning of the decoration. Indeed, the sherd piles described by Frye must have been viewed as raw material, having value only when adapted to become restorations. The restorers were willing to grind down and reshape the edges both of the vessel being restored and of any sherds that displayed compatible calligraphy, tonality, decorative scheme, color, gloss, or thickness.

Modern Conservation Practice

Modern conservation practitioners, in stark contrast to the restorers that Frye observed, follow an accepted code of ethics.[6] Intentionally damaging cultural material, even a few disparate sherds, is considered unacceptable, as is simulating originality by filling losses with antique, alien material. The concept of reversibility—how to design a conservation treatment so that it can be reversed in the future with minimal damage or negative change to the original artifact— guides the conservator at every step. This underscores the difference between restoration, in which the goal is to recreate an original and undamaged *appearance*, and conservation, which is first and foremost concerned with preservation of the artifact and the cultural information it contains.

Today, the ceramics conservator begins work with an examination, a written condition report, and a treatment proposal, which is then discussed with and agreed upon by the owner or curator of the object. "Before treatment" photos are taken, and the entire treatment process is photographically documented through to completion; the conservator is charged with maintaining the viability of these records for future generations. Typically, a poorly restored vessel is disassembled using water or solvents to remove unstable, damaging adhesives; the original and replacement sherds are identified; and stains and soluble salts are extracted by careful poulticing and desalination techniques. The vessel is then reassembled with modern, stable adhesives, and the areas of loss are isolated with resin and filled with stable, inert fillers. The fills are shaped, avoiding abrasion to the surrounding surfaces, and then inpainted, also with stable, lightfast materials. Inpainting differs from overpainting in that color is painstakingly applied only to the filled loss and does not intrude upon an original surface. The treatment can be reversed in the future, and all the conservation materials can be removed with minimal effect on the original. Genuine but non-original sherds—and even modern, purpose-manufactured ones—are retained and catalogued for future study.

Case Studies

Two vessels in the Calderwood Collection illustrate the practice of restoring with alien sherds taken to an extreme degree. The first example is a small bowl from twelfth- or thirteenth-century Iran decorated with luster painting (fig. 2). Now nicknamed the "E Pluribus Unum Bowl" by curators and conservators, it was found, once the overpaint was removed, to contain sherds from five different vessels (fig. 3). At this level of compositeness, such a vessel may cease to have a unique, verifiable identity.

The second example, a shallow bowl with epigraphic decoration from the Samanid era (819–999), initially appeared to have only limited areas of restoration. As the overpaint was removed, however, it became apparent that the restoration incorporated recut and shaped sherds from eleven different vessels (fig. 4).

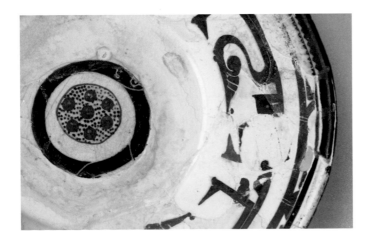

Fig. 4
Fragmentary bowl,
cat. 134, detail.

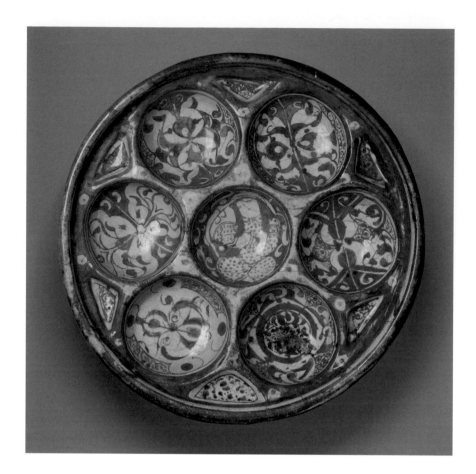

Fig. 5
Sweetmeat dish, cat. 35,
before treatment.

For museum conservators and curators seeking to treat and present these ceramics in a proper context, such composite restorations present practical, aesthetic, and ethical challenges. With these two examples, we determined that disassembly would yield only a pile of disassociated, damaged sherds, unexhibitable and signifying nothing. Far better to preserve the vessels intact, with their repurposed sherds retained and exposed. Both bowls were cleaned and stabilized, with small losses filled and inpainted, preserving their composite nature as a physical document of a mode of restoration for the art-market sale of Islamic ceramics in the twentieth century.

A Dish for Sweetmeats: Deconstruction and Reconstruction

A sweetmeat dish made in Iran in the late twelfth or early thirteenth century (fig. 5) provided an opportunity for revealing, in-depth study during its complex treatment. This large, heavy vessel incorporates multiple small bowls in its upper surface. It was fabricated so that hot water could be introduced into its hollow interior to

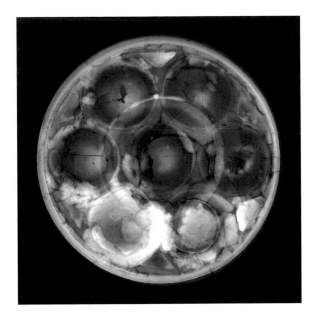

keep food warm. The initial examination under visible and ultraviolet (UV) fluorescence illumination (which can cause restoration materials to fluoresce in different colors) revealed numerous restored areas, with cracks appearing through the discolored, broadly applied overpaint. The vessel was markedly unstable and failed the tap-tone test with a dry rattle. Extensive craqueleur in the cobalt-blue glazed exterior masked numerous break lines and repaired joins. The interiors of many of the smaller bowls were partially or completely overpainted. Conspicuously missing on the side was the inlet through which heated water would have been introduced.[7]

An X-radiograph was made to reveal the true condition of the object and guide its safe disassembly. Rather than clarifying the structure of the vessel, the resulting

X-ray (fig. 6) made it seem even more confusing. The X-ray image disclosed hundreds of break lines and dozens of losses, as well as unexpected shapes and amorphous blobs of unknown material. Previous experience suggested that the cloud-like accretions of material were likely to be plaster of paris. Many assembled sherds had large, irregular gaps and were clearly unrelated to one another or to the surrounding original ceramic forms.

A computerized tomography (CT) scan of the vessel was made next.[8] This imaging technique differs from a conventional X-radiograph in that it makes a series of "image slices" through an object, allowing structures within the object to be visualized in three dimensions (fig. 7). The X-ray "slices" helped disentangle the clutter of the overall X-ray image and made it clear that while the majority of the pieces making up the dish were original, there were substantial losses and numerous non-original pieces, with heaps of plaster and unrelated sherds scattered throughout the interior. Seen in the CT-scan cross sections, the glaze on the exterior was more radio-opaque, and therefore appeared as a whiter skin. It was far more startling to see sherds with such "white-skinned" glazed exterior surfaces on the *inside* of the hollow vessel, used as filler material (fig. 8).

The combination of the X-ray, CT-scan, and overpaint-removal tests helped guide the disassembly, clarifying the nature of the earlier restoration and revealing the extent to which many of the small bowls had been reconstructed of original sherds put back in the wrong location, or alien sherds from another vessel entirely (fig. 9 a–c). The solubility of the overpaint, fills, and adhesives was tested, and these proved readily removable using steam, warm water, and organic solvents. The principal adhesive found was an animal-based glue, soluble in hot water. The adhesive on the back of the vessel was softened with poultices and the sherds lifted away, revealing details of the previous restoration (fig. 10). The top of the dish with its recessed bowls had been reconstructed using animal glue and strips of Persian-language newspaper as "bandages." Plaster was added to plug gaps from behind.

Fig. 9, a–c
Sweetmeat dish, cat. 35, details.
a. Before treatment, completely overpainted bowl.
b. X-radiograph of same area.
c. Same area after removal of overpaint. There are many original sherds, but they have been inserted into the bowl almost at random.

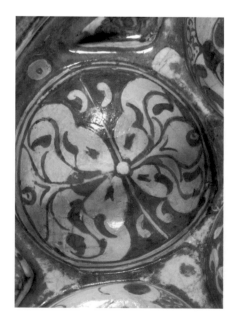

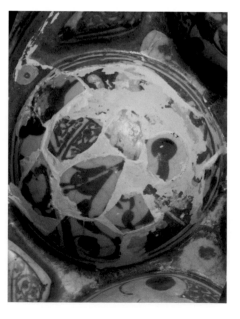

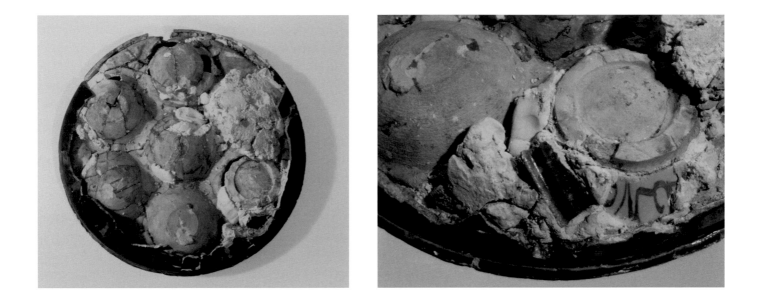

In another area, a somewhat more chaotic approach was taken, using sherds of an unrelated blue rim and the entire foot of a different vessel. This foot was embedded in plaster and served to fill the losses in the bottom of one of the bowls (fig. 11).

The sherds were cleaned of old adhesive residues, fill materials, and overpaint, and the vessel was reassembled using Acryloid B-72 adhesive,[9] a stable, reversible acrylic resin. After the interior and exterior shells were reconstructed, all the losses were filled with carefully shaped plaster of paris and then consolidated and sealed with dilute B-72 resin (figs. 12 and 13). The upper section and outer shell were rejoined, and the join lines filled. The final step was a collaborative one between curator and conservator: deciding how, and to what extent, to inpaint the filled losses. The missing designs were determined by carefully analyzing preserved areas of the bowl, and by researching comparative examples in other collections (fig. 14). Twenty-one alien sherds remain from the previous restoration; these will be retained for future study and teaching (fig. 15).

Fig. 10
Sweetmeat dish, cat. 35. Removing sherds on the back of the vessel exposes heaps of plaster used to support the reconstruction. Plaster, hide glue, and paper strips were used to reconstruct the bowl sections.

Fig. 11
Sweetmeat dish, cat. 35. An unrelated blue rim-sherd and the foot and side of another vessel were used to replace the bottom of a missing small bowl. The flattened remnant of a ball of clay that served as a spacer between upper and lower sections of the dish can be seen at upper left.

Evidence of Manufacturing Techniques

The comprehensive analysis and complex treatment of the sweetmeat dish yielded far more than a newly stable ceramic vessel. Among other discoveries, access to the interior of the dish facilitated documentation of the many steps by which the original potter constructed the vessel.[10] The seven small bowls were individually wheel thrown with great skill, giving each a small flat bottom three to four centimeters in diameter. Trimmed to height, the wall thickness at the top of each bowl

was only 1 to 2 millimeters. When dried leather hard, the bowls were turned upside down and arranged in a circle, with one in the center, all about 5 millimeters apart. Five small triangular finger bowls were hand formed and placed between the adjacent small bowls and the outer wall. A rolled "rope" of clay 3 to 5 millimeters in diameter was pressed and smoothed with the fingers into an even fillet in each of the interstices between the bowls (fig. 16). The assembled upper section was turned face-up, and all the exterior joins were dressed and smoothed. The potter then measured the diameter of this upper section and threw the shell of the lower section to fit it. A small ball of clay (see fig. 11) was placed on the bottom exterior of each small bowl, to serve as a spacer. The upper, multi-bowled section was lowered into the bottom shell, slightly compressing the balls of clay. The two sections were joined together with another soft fillet of clay, and the join smoothed with a small rounded tool and the potter's fingers.

Evidence for one aspect of the resulting vessel remains missing: how the hot water was introduced. Another, almost identical, sweetmeat dish in the collection of the Nelson-Atkins Museum[11] has a small hole (3 to 5 centimeters in diameter) in its side, near the upper rim. This opening is original: it is surrounded by rust stains and accretions resembling hard-water deposits, undoubtedly from the hot water poured from a spouted kettle or funnel. The Calderwood vessel has no such opening or stains, but several sherds are missing from the same area of the side wall,

Fig. 12
Sweetmeat dish, cat. 35, during treatment, showing the exterior shell of the vessel with losses filled.

Fig. 13
Sweetmeat dish, cat. 35, during treatment. Inner bowl assembly attached to outer shell of vessel, with losses filled.

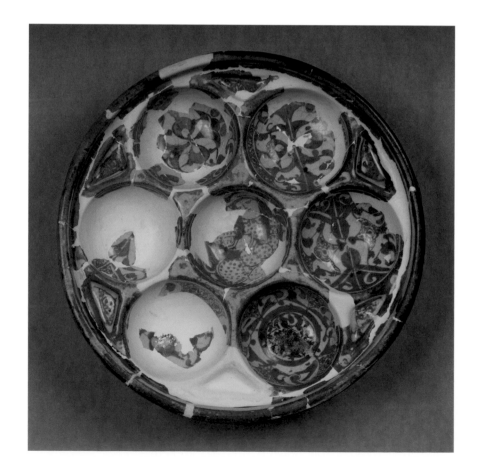

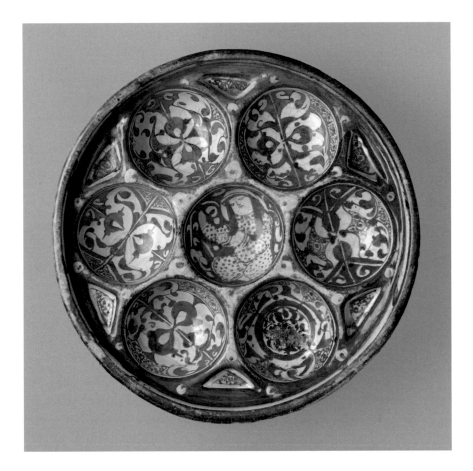

where the water hole could have been located. Although not all of our questions have been answered, the conservation treatment of the sweetmeat dish has produced valuable knowledge and documentation of the production techniques for an unusual—and unusually complex—type of medieval Iranian ceramic vessel.

Conclusion

As we hope to have demonstrated in this essay, the Iranian factory manager's 1953 statement, "We're not doing anything the museums don't do," is far from true. Our actions and aims are different, and our respect for the original material is paramount. While striving to represent in the appearance of the object the intention of the artist who made it, we take care to differentiate what is original from what is restored. We seek opportunities to identify media and working methods as a means to deepen our understanding of an art object and its artist's choices and working environment.

Fig. 14
Sweetmeat dish, cat. 35, after treatment.

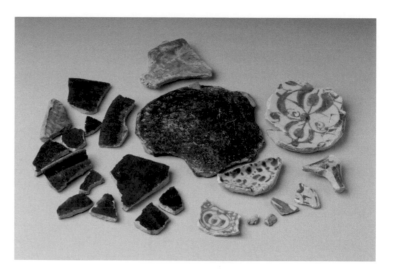

When stability or aesthetic concerns call for conservation treatments, works of art are approached individually, on a case-by-case basis. No single approach is appropriate for all categories of art or owners. The degree of restoration considered acceptable or desirable often differs among, for example, private collectors, art museums, and archaeologists.

The respect accorded the original work of art is also broadening to include historical restorations, and the restoration of art and cultural property has become a fertile subject for conservators and art historians to study. It was not so long ago that conservators and curators, in the name of "originality," were actively removing from ancient marble sculpture restorations added in the seventeenth and eighteenth centuries. The elimination of these restorations, which were sometimes executed with great skill and then-state-of-the-art techniques, often left a

Fig. 15
Collection of twenty-one alien sherds removed from the sweetmeat dish, cat. 35.

Fig. 16
Sweetmeat dish, cat. 35, detail of the interior from the bottom, showing individual wheel-thrown bowls joined together with fillets of clay added by hand.

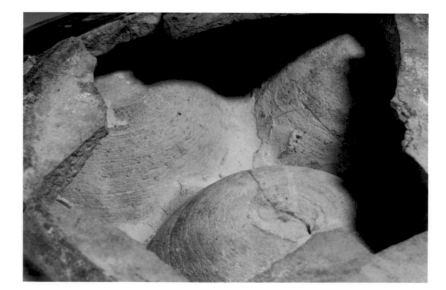

forlorn torso marked with dowel holes, and a heap of arms and legs discarded along with the cultural and social history they represented. In some instances, it has proved wiser to leave earlier restorations intact. When, as in the case of the sweetmeat dish, previous restorations are removed, the conservator endeavors to document and preserve evidence of the historical treatment. Yet we cannot know how our efforts and decisions will be judged in sixty years. Each era seems blind to its own faults, and we would do well to continually ask ourselves, "What evidence that future generations will wish to have might we inadvertently be removing or effacing?"

Notes

1 All quotes and information from Richard Frye came through personal communication with Mary McWilliams on February 26 and April 2, 2004. His visit to the Tehran factory occurred at the end of a trip that also included Cairo, Damascus, Beirut, and Baghdad. Concluding that "things were not so nice in the art world," Frye severed his professional ties to the market after 1955 but continued to reflect on his experiences: see, for instance, Frye 1974.

2 The manager revealed that he was a Zoroastrian but did not disclose his name.

3 Alien sherds were used in the reconstruction of six Calderwood ceramics: cats. 26, 35, 131, 132, 134, and 135.

4 Exceptions include excavated material from Rayy, now housed in the University of Pennsylvania Museum of Archaeology and Anthropology, Philadelphia, and from Nishapur, now in the Metropolitan Museum of Art, New York.

5 For additional examinations of similar restoration practices, see Kawami 1992, 228–29; Koob 1999; and Norman 2004.

6 See the American Institute for Conservation (AIC) Code of Ethics and Guidelines for Practice: *http://www.conservation-us.org*, and the Institute of Conservation (ICON) Professional Guidelines: *http://www.icon .org.uk*, promoted in part by the European Confederation of Conservator-Restorers' Organisations.

7 Other examples of this type can be found in the Khalili Collection: see Grube 1994, 224–25, cat. 247; and the Walters Art Museum, Baltimore, 48.1011. A third example, formerly in the Kevorkian Collection, illustrated in A. U. Pope 1938–39, vol. 5, pl. 644C, is now in the Nelson-Atkins Museum of Art, Kansas City: see n. 11 below.

8 By Asian ceramics collector and radiologist Dr. William Goldstein.

9 Acryloid B-72 is supplied as small beads. For use as an adhesive, consolidant, paint medium, or varnish, it must be prepared in the laboratory by being dissolved in specific concentrations of organic solvents.

10 The surface decoration of the sweetmeat dish was also analyzed. For an analysis of the blue exterior glaze of this and other Calderwood ceramics, see, in this catalogue, the essay by Jessica Chloros and Katherine Eremin, "Cobalt Fingerprints in Islamic Ceramics," 51–63, as well as an unpublished technical study of luster painting in Calderwood ceramics by Holly Salmon (Objects Conservation Intern 2002–3, Straus Center for Conservation and Technical Studies), available for reading in the library of the Straus Center for Conservation and Technical Studies.

11 32-110. Images and information were provided by Kate Garland, Senior Conservator, Objects, Nelson-Atkins Museum of Art, Kansas City (personal communication).

Cobalt Fingerprints in Islamic Ceramics

Jessica Chloros and
Katherine Eremin

Cobalt blue, derived from cobalt ores, is one of the most important colors in the vibrant palette of glazed Islamic ceramics. Due to its abundance and purity, Iranian cobalt was widely used across the Islamic lands and exported to other areas, such as China. There are, however, several other known sources—in the Middle East, China, and Europe. Cobalt is associated with other elements, which are normally retained during processing. Variations in the associated elements (the chemical fingerprint) of cobalt glazes may potentially reveal the provenance of the ores used to make them, and thus inform discussions about specific objects or groups of objects. Nevertheless, despite recent studies of cobalt glazes in European, Islamic, and Chinese ceramics, the links to distinct sources often remain unclear.

The Norma Jean Calderwood Collection of Islamic Art at the Harvard Art Museums contains many cobalt-glazed ceramics, providing an opportunity for a technical study of cobalt chemistry. Of the twenty-one objects selected for study, all except one, a Turkish tile, are attributed to Iran. None of the pieces studied bears a date, and all are hence dated primarily by art-historical criteria, confirmed in some instances by thermoluminescence (TL) analysis (see catalogue entries). The goals of this study were to identify the elements associated with the cobalt pigment used on each object and to compare the results of this analysis with the findings of relevant published studies, in order to assess correlations or inconsistencies in geographical or chronological attribution.

Cobalt Ores

Bowl with radial interlace design, cat. 28, detail.

There are over seventy different complex cobalt minerals, which fall into three main groups: the sulphides, such as cobaltite (CoAsS) and linnaeite (Co_3S_4); the arsenides, such as smaltite ($CoAs_3$); and oxidized forms such as asbolane or earthy cobalt.[1] Each group has a distinct association of elements, many of which are retained during processing and inherited by the cobalt glaze on the finished ceramic.[2] The sulphides tend to associate with arsenic, lead, zinc, and copper;

the arsenides with nickel, silver, and gold; and the oxidized compounds with manganese, copper, iron, bismuth, or silver. A number of important cobalt ore sources, such as those in the Erzegebirge (between Saxony and Bohemia),[3] in Iran (Kashan and central Iran),[4] and in the Caucasus, are arsenical cobalt ores (sulphides and arsenides), while Egyptian and Chinese cobalt sources tend to be manganiferous (asbolane, earthy cobalt, and alums).[5]

One of the most important sources of cobalt in the medieval Middle East appears to have been near Kashan, Iran, in the Kohrud Mountains.[6] Cobalt is discussed by Abu'l-Qasim, one of the prestigious Abu Tahir family of potters based in Kashan, who wrote a treatise on the manufacturing of tiles and other ceramic objects in 1301. This manuscript is one of the few primary sources that describe ceramic and glaze production. In discussing different ingredients, Abu'l-Qasim states the following about cobalt:

> The sixth is the stone *lājvard*, which the craftsmen call *Sulaimānī*. Its source is the village of Qamṣar in the mountains around Kāshān, and the people there claim that it was discovered by the prophet Sulaiman [Solomon]. It is like white silver shining in a sheath of hard black stone. From it comes *lājvard* colour, like that of *lājvard*-coloured glaze etc. Another type comes from Farangistān [Europe] and is ash-coloured and soft. And there is a red kind found in the mine which is a deposit on the outside of the stones and is like the red shells of pistachios. This kind is very strong but is a fatal deadly poison.[7]

In the Abu'l-Qasim text, *sang-i lājvard* is translated from Persian as "lapis lazuli," which was and still is mined in Badakhshan, Afghanistan.[8] Lapis lazuli is not stable if used as a glaze colorant, however, so in this context *sang-i lājvard* must mean cobalt.[9] Abu'l-Qasim's description of "white silver" suggests cobaltite (a cobalt arsenic sulphide which often contains significant iron and some nickel), while the "red kind" is probably erythrite (a hydrated cobalt arsenate that can have significant nickel substituting for the cobalt). The imported variety is thought to be asbolane (a hydrated oxide of cobalt, nickel, and manganese ore with variable chemistry); the passage above indicates that cobalt was imported from Europe as early as the beginning of the fourteenth century, despite the abundance of this ore in Iran.

Historical accounts from the nineteenth and twentieth centuries show that cobalt production was still occurring in the area around Kashan, and that this region remained a major supplier of cobalt for the Islamic lands. It is hence apparent that Kashan was an important source of cobalt for several centuries. By the time that Arthur Houtum-Schlinder writes about the Kashan mines in 1896, however, it appears that only earthy cobalt remains, and that it contains only about 5 percent metal.[10] Such a change in ore species from medieval to later times would probably result in a change in the associated elements, even though the cobalt ore still originates from Kashan. Writing in 1966, Hans Wulff describes the state of the mining industry around Kashan and Qum and details how the cobalt oxides were removed from small pockets in the rocks ("cobalt wads") and the impure cobalt oxide was formed into balls for sale.[11] Wulff's account describes more processing taking place in order to make the cobalt usable. It seems that although Kashan may have been

the major source of cobalt for Islamic craftsmen for hundreds of years, the mines became depleted over time and other sources were sought.

Cobalt was also mined in the Anarak district of central Iran[12] and in other parts of the Middle East, such as eastern Turkey and the Caucasus,[13] Yemen and Saudi Arabia,[14] and Europe, including the Black Forest in Germany,[15] the Erzegebirge,[16] and the Pyrenees.[17] The deposits in central Iran are complex, with nickel-cobalt arsenide ores, copper-iron sulphides, and uranium and bismuth ores, with multiple mineral species in each group and very low iron in the nickel-cobalt ores.[18]

Processing and Use of Cobalt

To color glass or decorate ceramics, cobalt was typically converted into a cobalt oxide or processed to make a blue glaze frit. Cobalt oxide was produced by heating the cobalt ore; it could be used alone, but, being a strong colorant, it tended to result in uneven distribution, with deep blackish-blue spots in the glaze.

To produce a glaze frit, the cobalt oxide was processed further by heating it with some combination of quartz, flint, potash, and soda, yielding a partially fused, glassy material. The frit mixture was then heated in a special frit kiln until it melted, after which it was ladled out and poured into cold water, which shattered it into small granules. The granules were ground into a powder and mixed with water and other additives to form a liquid glaze used to paint underglaze decoration. Coarsely ground frit produced a deep blue color; when finely ground it yielded a lighter blue.

Historically, potters in Islamic lands developed several methods for applying the cobalt glaze. One was to paint cobalt oxide directly onto a white-glazed ground before firing, to produce dark blue decoration sometimes termed "in-glaze." A second was to apply fritted cobalt glaze under a clear glaze, with the cobalt decoration hence referred to as "underglaze"; this is exemplified by the Calderwood dish with peonies (cat. 42 and fig. 5 in Walter B. Denny's essay "Inspiration and Innovation," 157–68). A third method consisted of applying the fritted cobalt glaze over an already fired white glaze; sometimes called "overglaze," this is the technique used in *mīnāʾī* wares (see, for instance, cats. 26–28, and Denny, fig. 1).[19] In addition, cobalt could be used as a glaze colorant to produce a monochrome dark blue glaze, as seen on an albarello (cat. 36) and a sweetmeat dish (cat. 35) in the collection.

Under magnification, the appearance of the cobalt pigment differs according to its method of application and may also depend on its preparation and initial composition. On the Calderwood *mīnāʾī* bowl with radial interlace design (fig. 1), the overglaze pigment looks patchy and speckled under magnification (fig. 2). In other ceramics in the study, such as a seventeenth-century spouted ewer (fig. 3), the underglaze pigment has dissolved much more completely into the glaze (fig. 4). The magnification of a late sixteenth-century Turkish wall tile (cat. 43 and Denny, fig. 4) shows the appearance of cobalt pigment under a thick and bubbly clear glaze

Fig. 1
Bowl with radial interlace design,
cat. 28.

Fig. 2
Photomicrograph (field of view 10 mm)
of bowl with radial interlace design,
cat. 28. Cobalt appears patchy and
speckled in *mīnāʾī* technique.

(fig. 5). Three ceramics with luster decoration were included in this study. In the fragmentary star tile depicting lovers (fig. 6), a magnified section shows that the cobalt looks patchy (fig. 7), similar to its appearance on the *mīnāʾī* bowl, since in both instances fritted cobalt glaze was applied over an already fired white glaze.

Methodology

Twenty-one ceramics with cobalt-blue glaze were selected for examination and analysis with visible/ultraviolet (UV) light and energy dispersive X-ray fluorescence (XRF). All but one of the objects are fritware; the exception is the nineteenth- or twentieth-century earthenware beehive cover (cat. 51). UV-light examination was the principal means used to distinguish restorations not obvious upon visual inspection. These restorations normally fluoresce in UV light and were avoided as analysis sites.

XRF provides a powerful tool for determining the elemental chemical fingerprint of the cobalt glaze. It is non-destructive, and because no sample removal or preparation is required it allows fairly quick analysis of multiple areas. Its efficiency was

Fig. 3
Spouted ewer with curving handle,
cat. 45.

Fig. 4
Photomicrograph (field of view 10 mm)
of spouted ewer with curving handle,
cat. 45. Cobalt underglaze has diffused
into the surrounding glaze.

Fig. 5
Photomicrograph (field of view 10 mm)
of wall tile with composite flowers and
saz leaves, cat. 43. The clear glaze over
the cobalt is thick and bubbly.

of particular benefit to this study, since the glazes were not homogeneous, and several areas from each piece required testing. XRF is also highly sensitive to the metallic elements of interest in glaze colors. The XRF system used was a Bruker ARTAX µXRF spectrometer with a molybdenum tube and a spot size of approximately 70 microns. Analyses were run at 600 µA current and 50KeV voltage for between 200s and 600s. Multiple analyses were undertaken on each ceramic, on both cobalt-blue and white or clear areas, with the exact area analyzed shown on a video camera. Since the XRF analysis penetrates several layers of glaze and ceramic, the spectra from the clear glaze over the blue cobalt layer or from the white glaze under the blue cobalt layer were subtracted from the spectra of the blue glaze to isolate the elements associated with the cobalt blue itself (fig. 8).

There are two limitations of XRF relevant to this study. The first is that the technique as applied here is qualitative or, at best, semi-quantitative, meaning that

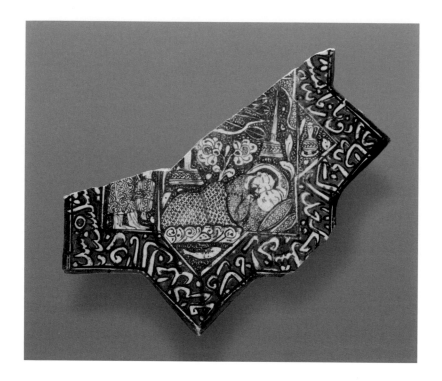

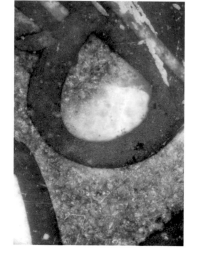

Fig. 6
Fragmentary star tile with lovers, cat. 37.

Fig. 7
Photomicrograph (field of view 10 mm) of the fragmentary star tile, cat. 37. Cobalt appears patchy, as on *mīnā'ī* ware.

Fig. 8
XRF analysis of the fragmentary star tile, cat. 37, comparing a spectrum from the blue cobalt glaze (blue) with one from a white glaze area (red). The peaks are labeled with the key elements detected. The blue glaze (blue spectrum) has high levels of iron (Fe), cobalt (Co), arsenic (As), and strontium (Sr). The white glaze (red spectrum) lacks these, but has more lead (Pb) and copper (Cu) than the blue glaze. Potassium, calcium, and tin are also present but occur at different energies from the elements shown in this detail.

XRF analysis can identify the elements present but cannot accurately quantify their amounts. The second limitation is that information from multiple layers of glaze is combined in a single analysis, as already mentioned.[20] In some instances, thick layers of clear overglaze prevented detection of elements in the underlying blue cobalt decoration, particularly where a lead-rich overglaze was present. In such cases, analysis of damaged areas with missing overglaze was required to reveal the cobalt signature.

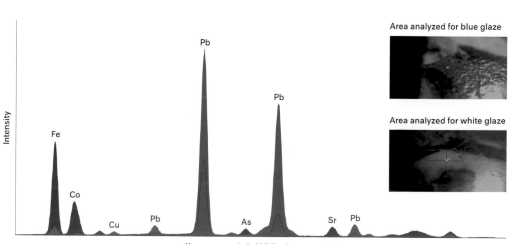

Geometry also caused some problems, since the XRF head has to be focused very close to the surface of the glaze. In the case of the flat-rimmed bowl with bird in foliage (cat. 41), the shape of the bowl prevented the XRF from focusing on the blue-glazed interior.

Results

The table below shows the results of the XRF analysis, listing elements present within the cobalt layer alone, as well as those present in any associated white or clear glaze: arsenic (As), calcium (Ca), cobalt (Co), copper (Cu), iron (Fe), lead (Pb), manganese (Mn), nickel (Ni), potassium (K), tin (Sn), and zinc (Zn). In the cobalt layer, arsenic, iron, nickel, zinc, copper, manganese, and calcium were found in various combinations. Similar associations have been noted in other studies.[21]

XRF Results for Calderwood Collection Ceramics Analyzed

Cat no. Accession no. Description	Date	Provenance	Cobalt Blue	White/Clear	Technique
Cat. 21 2002.50.95 *Cup with lobed rim and human faces*	12th century	Iran	(Ca), Fe, Co, (Cu), As	N/A	monochrome glaze
Cat. 26 2002.50.52 *Bowl with harpies*	12th–13th century	Iran	Fe, Co, As, Zn	K, Ca, Pb, Sn	over white glaze
Cat. 27 2002.50.53 *Bowl with enthroned ruler and courtiers*	12th–13th century	Iran	Fe, Co, As	K, Ca, Pb, Sn	over white glaze
Cat. 28 2002.50.114 *Bowl with radial interlace design*	12th–13th century	Iran	Fe, Co, As	K, Ca, Pb, Sn	over white glaze

Cat no. Accession no. Description	Date	Provenance	Cobalt Blue	White/Clear	Technique
Cat. 35 2002.50.59 *Sweetmeat dish*	c. 1200	Iran	Fe, Co, As	K, Ca, Pb, Sn	over white glaze
Cat. 36 2002.50.60 *Albarello*	c. 1200	Iran	Fe, Co, (Cu, Zn), As	K, Ca, Pb	over white glaze
Cat. 37 2002.50.125 *Fragmentary star tile with lovers*	13th–14th century	Iran	Fe, Co, As	K, Ca, Cu, Pb, Sn	over white glaze
Cat. 38 2002.50.80 *Star tile with lotus decoration*	14th century	Iran	Co, As	K, Ca, Pb, Sn, Fe	over white glaze
Cat. 39 2002.50.85 *Ten-sided bowl with high foot*	14th century	Iran	Fe, Co, As	K, Ca	under clear glaze
Cat. 40 2002.50.78 *Flat-rimmed bowl with radial design*	14th century	Iran	Fe, Co, As	K, Ca, (Pb)	under clear glaze
Cat. 41 2002.50.58 *Flat-rimmed bowl with bird in foliage*	14th century	Iran	geometry problem		under clear glaze
Cat. 42 2002.50.66 *Dish with peonies*	c. 1475	Iran	Co, As	K, Ca	under clear glaze
Cat. 44 2002.50.94 *Small dish with stylized rock dove*	c. 1675–1725	Iran	Co, As	K, Ca, Cu	under clear glaze

Cat no. Accession no. Description	Date	Provenance	Cobalt Blue	White/Clear	Technique
Cat. 45 2002.50.67 *Spouted ewer with curving handle*	17th century	Iran	Co, As	Ca, Pb	under clear glaze
Cat. 46 2002.50.116 *Small bowl of "Gombroon ware"*	18th century	Iran	Mn, Fe, Co, (Zn), As	K, Ca	under clear glaze
Cat. 51 2002.50.65 *Beehive cover*	19th–20th century	Iran	Ca, Mn, Fe, Co, Cu, Zn, As	K, Ca	under clear glaze
Cat. 139 2002.50.51 *Ewer with rooster-head spout*	19th–20th century	probably Iran	Fe, Co, As, (Zn)	K, Ca, tr Pb	under clear glaze
Cat. 142 2002.50.77 *Small vase with stripes*	19th–20th century	probably Iran	Co, As, Cu	K, Ca, Pb (low), Fe	under clear glaze
Cat. 140 2002.50.79 *Bowl with inscribed rim*	19th–20th century	probably Iran	(Fe), Co, As	K, Ca, tr Pb	under clear glaze
Cat. 141 2002.50.81 *Bowl with inscribed rim*	19th–20th century	probably Iran	Co, As	K, Ca, tr Pb, Fe	under clear glaze
Cat. 43 2002.50.108 *Tile with composite flowers and saz leaves*	c. 1585–95	Turkey	Co, Ni, As	Ca, Pb, Sn	under clear glaze

Discussion

Iran

Iranian ceramics make up the larger part of this study, with nineteen analyzed examples. They can be broadly divided into early (twelfth to thirteenth century), middle (fourteenth to seventeenth century), and late (eighteenth to twentieth century). The early group shows an association of cobalt with arsenic and iron, and frequently with zinc and/or copper, as seen for the *mīnāʾī* bowls (fig. 1 and cats. 26–28) and the luster pieces (fig. 6 and cats. 35–37), all of which probably came from Kashan. The middle group shows the emergence during the fourteenth century of ceramics with associated cobalt and arsenic but no iron, although some high-iron examples persist until the fifteenth century. The fifteenth-century dish with peonies (cat. 42) is an example of the shift to cobalt without iron during and after the fourteenth century, but the association of both iron and arsenic with cobalt endures in two fourteenth-century bowls (cats. 39 and 40), indicating simultaneous reliance on two cobalt sources.

The use of cobalt with arsenic but no iron continues in the ceramics dating to the seventeenth or early eighteenth century, after which the situation becomes more complex, with some of the later objects having added elements, including iron, manganese, arsenic, zinc, and copper. Four pieces originally believed to date from the twelfth to thirteenth century were shown by TL dating to be of modern origin (probably nineteenth to twentieth century): two bowls with inscribed rims (cats. 140 and 141), a small vase with stripes (cat. 142), and a ewer with a rooster-head spout (cat. 139). The cobalt fingerprints of the striped vase and one of the inscribed bowls (cat. 141) lack the high iron expected for the pre-fourteenth-century pieces, and therefore support a modern date. The cobalt signature on the other inscribed bowl (cat. 140) is different from that of the first, despite the close similarity of the two bowls in all other respects; given its higher iron levels in some areas, this bowl could potentially be interpreted as a genuine medieval artifact. Results from both bowls vary by area, however; some areas include high levels of titanium, suggesting modern manufacture. The data therefore demonstrate the need for caution, if not outright suspicion, regarding these pieces. In contrast, the cobalt fingerprint of the rooster-head ewer, with its high levels of iron and arsenic, does not by itself indicate that the vessel is not of medieval origin.

Turkey

XRF of the only Turkish ceramic in the Calderwood Collection, a wall tile with composite flowers and *saz* leaves (cat. 43), was unique in showing nickel as well as arsenic associated with the cobalt. Most Turkish ceramics from other studies also show nickel with cobalt, but without arsenic.[22] One study, however, found that arsenic occurred exclusively in cobalt glazes dating from 1530 to 1560.[23] Since some ceramics from this period showed the earlier cobalt-nickel association with no arsenic, two sources of cobalt must have been used during this time.[24] As discussed in the catalogue entry, the tile can be dated with reasonable confidence to 1585–95.

This analysis shows that the date range for the use of cobalt associated with both nickel and arsenic should be extended. It also reflects the limitations of the current database of analyses and the need to add analytical information from securely dated objects.

Possible Cobalt Sources

The data from these and other cobalt-decorated Islamic ceramics clearly show that a change in the cobalt fingerprint for Iranian ceramics occurs around the fourteenth century. Determining the reason for this change, however, is more complicated. Several of the twelfth- to fourteenth-century pieces with a cobalt-iron-arsenic signature are conventionally attributed to Kashan, and it would be reasonable to suggest that local cobalt was used for their production. That ores with cobalt, arsenic, and probably iron are believed to have been mined near Kashan further supports this supposition. Thus, we may tentatively ascribe the cobalt-arsenic-iron signature to the use of ores from the environs of Kashan. The presence of this signature on ceramics from other areas, such as Syria and elsewhere in Iran, is consistent with the known export from Kashan of cobalt pigments for use in ceramic glazes. The change to an iron-free cobalt-arsenic association may result from the use of different ore species in the same deposit or of ores from a completely different area; it may also be due to changes in processing technology. The ores from central Iran are known to be low in iron but are generally nickel-rich;[25] the expected result of their use should be a change to a cobalt-nickel-arsenic or cobalt-nickel signature rather than simply the disappearance of iron. Similarly, the cobalt in Abbasid-period ceramics, with sources thought to be in Yemen or Saudi Arabia, shows an association of cobalt, iron, and zinc without significant arsenic, which does not fit the pattern observed here.[26] While the early iron-arsenic-cobalt signature may be associated with local ores from Kashan, no obvious source can yet be suggested for the later iron-free ores.

In Turkish ceramics, cobalt and nickel are commonly associated, and the appearance of arsenic over a limited period indicates the use of more than one source of ore. It is tempting to suggest that Turkish ceramicists may have utilized central Iranian cobalt; nevertheless, the existence elsewhere of ores with similar associations means that this must at present remain an interesting possibility.

The late objects from Iran show a much greater variability in cobalt signature, which may result from the import of foreign cobalt, the mixing of different ores, or changes in processing. The continuous use of the same mines for many centuries explains why genuinely old ceramics may have cobalt signatures similar to those of other pieces shown to be modern by TL dating; such results indicate the need for caution in ascribing specific signatures to a particular period. Definitive identification of the cobalt used in these late Iranian ceramics will have to wait until we have more detailed information about the many known sources in Europe, the Middle East, and Asia; about the processing technology employed

over the years such sources were exploited; and about the likely trade patterns among these areas.

Conclusion

XRF provides a key tool for qualitative or semi-quantitative assessment of glaze chemistry and identification of chemical fingerprints. Changes in the suite of elements associated with the cobalt glaze indicate chronological and geographical variation in the cobalt sources used, in processing technology, or in both of these. Two distinct trends were observed with Iranian ceramics: first, that the cobalt glaze on twelfth- to fourteenth-century pieces was associated with both arsenic and iron; second, that a glaze with cobalt and arsenic but no iron emerges in the fourteenth century. Both fingerprints occur during the fourteenth century, but by the fifteenth and sixteenth centuries, iron-free cobalt has become dominant.

Based on the presence of nickel, the cobalt sources for Turkish ceramics appear to have been distinct from the others, with two sources used for a brief time during the sixteenth century. Analysis of a securely dated Turkish tile from the Calderwood Collection shows that the rare cobalt-nickel-arsenic fingerprint continues to appear at a date later than previously thought.

This analysis of Calderwood ceramics contributes significantly to a larger database compiled from previous studies of Islamic cobalt glazes. As data become available, institutions will be able to make more informed assessments of their objects. Other analytical techniques may be useful in gaining quantitative data to complement the patterns revealed through XRF. The ultimate goal of the database is to link cobalt signatures with distinct ore sites, but further work is required before this can become a reality.

Notes

We would like to thank the following scholars, scientists, and conservators for their contributions to this essay: Mary McWilliams, Richard Newman, Michele Derrick, Henry Lie, and Robert Mason.

1 Andrews 1962, 6–11.

2 Cowell and Fukang 2001, 601.

3 Middleton and Cowell 1993, 103.

4 Wulff 1966, 163.

5 Wen and Pollard 2009, 26; Shortland et al. 2006, 158; Wen et al. 2007, 109.

6 Raby 1989, 58.

7 Translated in Allan 1973, 112.

8 Ibid., 116 and n. 11.

9 Ibid., 116.

10 Houtum-Schindler 1896, 114.

11 Wulff 1966, 163.

12 Tarkiam ct al. 1983, 111.

13 Andrews 1962, 3, 133 35.

14 Hallett et al. 1988, 268.

15 Henderson 1989, 67.

16 Middleton and Cowell 1993, 103.

17 Pérez-Arantegui et al. 2009, 2504.

18 Tarkiam et al. 1983, 130–31.

19 The designation "overglaze," follows the terminology used by Koss et al. 2009, 39, but it should be noted that other studies distinguish between "in-glaze" and "overglaze" techniques in the decoration of some *mīnā'ī* pieces.

20 Due to the limitations of the XRF equipment, some of the ceramics were sampled for another analytical technique, scanning electron microscopy; those results are not within the scope of this discussion.

21 Cowell and Fukang 2001, 604; Mason et al. 2001, 198; Wood et al. 2007, 670, 680; and Wen 2012. Although a recent paper, Wen and Pollard 2009, does not discuss arsenic, which was a key element in the patterns found in our study, these authors also detected arsenic in many pieces, and this element is included in the full study, Wen 2012.

22 Cowell and Fukang 2001, 602, 604; Henderson 1989, 67; and Chloros 2008.

23 Henderson 1989, 67.

24 Ibid.

25 Tarkiam et al. 1983, 117.

26 Wood et al. 2007, 680.

The Qajar Lacquer Object

David J. Roxburgh

Pairing painting with varnish, the "lacquered" object is one of the best-known artistic forms made during the rule of the Qajar dynasty over Iran, between 1779 and 1924. Though paint combined with varnish was not a new medium, having been utilized for bookbindings since the late 1400s, its use during the Qajar period was expanded to other objects.[1] In addition to bookbindings, these included small storage boxes, caskets, mirror cases (fig. 1), and pen cases—all forms that had existed since earlier times—as well as more modern articles, among them playing cards, folding fans, handheld mirrors, and containers for such personal possessions as eyeglasses, letter seals, gaming boards, and chess sets (fig. 2).[2] On a larger scale, the medium was used in the production of decorative doors and window shutters. The ubiquity of Qajar painted lacquers—today public and private collections abound with specimens, although the majority of them are still unpublished—reflects their popularity as commodities for both local and foreign buyers.[3] Artists created lacquers, as direct commissions or on-speculation offerings, for various sectors of Qajar society and a growing foreign clientele who visited Iran for business or personal travel and sought souvenirs of their sojourns there.[4] Several travelers to Iran in the 1800s describe the vigorous trade in lacquers and the displays of these goods in the bazaars of the major cities, including Isfahan and Tehran. Because of the prominent artist families resident in Isfahan and Kashan, those centers in particular dominated the market.[5]

The Subject Matter of Lacquers

Of all Qajar lacquer objects, the pen case (qalamdān) stands out as the most representative and best-known form. Pen cases were made as two basic types: a box with a hinged lid and a container consisting of an outer case (ṭabla) and a retractable drawer (zabāna, literally, "tongue"). The pen case was used to safeguard and transport the tools of writing—chiefly pens, inkwell, scissors, and penknife. Its specialized function, however, is seldom reflected in its decoration. The range of subjects and themes depicted on pen cases is startling: one finds male and female portrait busts (Iranian, European, and Indian types) arranged singly or paired in vignettes;

Mirror case with birds and flowers, cat. 53, detail.

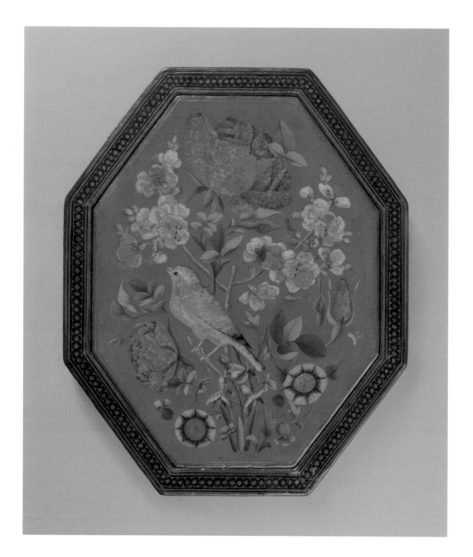

full-length portraits; amorous couples; landscapes and city views; pastoral scenes; depictions of the hunt that invoke epic Persian heroes or represent the hunting prowess of contemporary Qajar nobles; scenes of battle between the Qajars and their foes or historical contests such as that waged between the Safavids and Ottomans at Chaldiran in 1514; courtly scenes from the Safavid era of Shah Tahmasp and Shah 'Abbas I; portraits of Qajar princes and prominent members of the administration; flower-and-bird (*gul va bulbul*) compositions; Muslim saints and dervishes; the Prophet Muhammad accompanied by his daughter Fatima, son-in-law 'Ali ibn Abi Talib, and grandsons Hasan and Husayn; scenes of wedding preparations and rites; depictions of the Virgin and Child, the Holy Family, and Christian saints; and images referencing the great classics of Persian poetry, including tales from Firdawsi's *Shāhnāma* (Book of Kings), of circa 1010; Farid al-Din 'Attar's *Manṭiq al-ṭayr* (Conference of the Birds), of 1177; and Nizami's *Haft paykar* (Seven Portraits) of 1197, from his *Khamsa* (Quintet) (fig. 3). Other pen cases display aniconic decorations on their outer surfaces—including

diaper designs or scrollwork of interlacing palmettes, lotuses, and other flowers—generally executed in gold pigment over colored grounds.

Figural compositions of these manifold themes may be organized as continuous panoramas or divided into sequences of self-contained vignettes on the lids, sides, and ends of pen cases, with the surfaces of the retractable drawers and bases of the outer cases usually covered with non-figural designs. Though some thematic coherence is maintained in the choice of motifs combined on any single pen case—as in, for example, the juxtaposition of flower-and-bird and portrait vignettes (fig. 4), or subtle variations on a single flower-and-bird theme (fig. 5), there is surprising variation overall in the mixture of subjects, suggesting that the Qajar artist had a broad repertoire of themes at his disposal and deployed them in any number of combinations. While some combinations offered legible narratives and others possessed metaphorical or allegorical significance, they were largely unrelated to the function of the object that carried them. This sharp bifurcation between the specific functional use of the pen case and the visual meanings conveyed on its exterior points up the importance of the buyer, who selected from a wealth of possible subjects according to personal taste, choosing an object that might reflect something about his or her individual or collective identity and social standing.[6]

Fig. 2
Lacquered box with chess pieces.
Iran, Qajar period, 19th century.
Wood with painting under varnish,
7 × 30 × 9 cm (2¾ × 11¹³⁄₁₆ × 3⁹⁄₁₆ in.).
Harvard Art Museums/Arthur M. Sackler Museum, Gift of John Goelet, 1958.261.

The Technique, Design, and Visual Effect of Lacquers

In technical terms, little separates painting under lacquer from painting on paper in books.[7] At the outset, it is important to emphasize that Iranian lacquer works, from the late 1400s through the Qajar era, are wholly distinct from East Asian

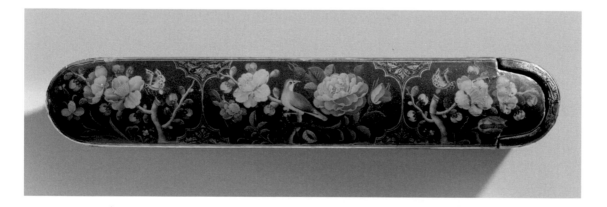

lacquers: in the East Asian lacquer technique, a wooden substrate supports successive layers of colored lacquer, usually in monochrome (red or black), built up to produce an opaque surface whose designs are frequently composed in striking relief.[8] In Iran, the components of lacquered objects were predominantly fashioned from paper—either layers of paper sheets glued together (resembling paste-

board) and pressed into a mold, or paper pulp (papier-mâché), also molded. The adhesive paste (*sirish*) used to attach the layers of paper to one another or to solidify the paper pulp was produced from the asphodel lily (*Asphodelus ramosus*).[9] When the three-dimensional paper forms had firmed up and dried, a thin layer of gesso (traditionally an animal glue with chalk) was applied to the surfaces to provide a smooth white ground for the pigment. Descriptions of this stage in the production process also list the contents of the applied paste as glue, verjuice, and lime water, and add that the pasted object was passed over a bed of lead acetate.[10] The artist would then outline his composition freehand or use a pounced drawing to transfer the design to the surface of the object before beginning to paint. When finished, the molded paper form was entirely covered with watercolors or gouache (watercolors mixed with gum arabic, procured from the Acacia tree, as a binder) and then coated with several thin applications of varnish. The varnish (*rawghan-i kamān*) was composed of the resin sandarac, derived from the tree *Tetraclinis articulata*, combined with sesame or walnut oil.[11]

The application of varnish served various purposes: it provided a protective coating for the pigment beneath, enhanced the refractive properties of the polychrome surface, giving the impression of deeper and more saturated colors, and unified the object by imparting a glossy sheen and a homogenized chromatic harmony (this was especially true in instances where tinted lacquers were used).[12] What was essentially a two-phase application of color and varnish is signified by the Persian term generally used to designate the "lacquer" technique, *rang va rawghan*, literally, "color and varnish." Qajar lacquered objects had mostly flat or gently curved surfaces; the painter drew upon pictorial figure-ground relationships and, more rarely, modeling to produce the impression of spatial depth. Some examples also employed raised geometric figures—generally medallions and finials—to create actual, physical relief that lent another form of complexity to the object surfaces. Strata of pigment and varnish—often several alternating layers of varnish and polychrome painting—similarly increased the apparent depth.[13] Still more complex surface effects—with added appeal for the eye—were created by suspending finely ground nacre (mother-of-pearl), metal particles, or gold flecks in the polychrome pigment or applying them over it. Such practices, described centuries before in calligraphers' recipes for fancy inks,[14] enhanced the reflective properties of the lacquerwork; when the object was handled, the tiny flecks of nacre or metal responded to the shifting angles of light and seemed to be simultaneously glistening on the surface and shining out from beneath the depths of pigment, like stars in a dusky sky.[15]

One of the primary appeals of lacquer surely lay in its capacity to bring the visually complex world of Persianate painting, once concealed inside the covers of books, to the outer surfaces of a variety of portable objects. By means of this "externalization," lacquer effected the transformation of the medium of painting. While this change had been initiated by artists working under the rule of the Safavid, Afsharid, and Zand dynasties between 1501 and the mid-1790s, it was expanded by Qajar artists, who were open as never before to extracting images from a broad variety of sources, in effect paralleling what was going on in the world around them.

Fig. 3
Pen box depicting scenes from the tale of Bahram Gur and the seven princesses. Iran, Qajar period, 1878–79. Pasteboard with painting under varnish, 4.1 × 4 × 24 cm (1⅝ × 1⁹⁄₁₆ × 9⁷⁄₁₆ in.). Harvard Art Museums/Arthur M. Sackler Museum, Gift of John Goelet, 1958.260.

Fig. 4
Pen box with flowers, birds, and portraits, cat. 56.

Fig. 5
Pen box with birds, flowers, and butterflies, cat. 55.

Lacquer and Its Relation to Old and New Media

Lacquers from as early as the Safavid period (1501–1722) show artists' process of adapting to their objects European imagery from printed media, chiefly engravings, and painted sources, such as oils on canvas. In fact, the term *farangī-sāz*, meaning "European style," had long been used in Persian: this referred not only to the adoption of European subjects and visual genres but also to the application of modeling and perspective.[16] Although new image-making technologies—lithography, chromolithography, and photography—came to influence artistic production under Qajar rule, artists of the period continued to draw upon earlier forms of print culture. A Qajar mirror case, for example, includes the image of a mother, a child, and an angel on the inner surface of the lid (fig. 6). While the polychrome stippling and wash often resemble ceramic glazing or enamel and not simply the techniques of painting in watercolor and gouache, the monochrome of the faces

and landscape details mimics the effect of an engraving. Other Qajar lacquers have yellow- or amber-hued grounds with designs executed in grisaille, which in their overall monochrome palette show an even stronger affinity with prints.[17]

Iranian artists, even before their exposure to lithography and photography, had habitually excerpted images from one medium and applied them to others.[18] Artists of the Qajar era looked back to Safavid arts for subject matter and styles to imitate,[19] but they also borrowed from recent or contemporary sources, including lithographed books and single sheets, newspapers, photographs, photolithographs, and ultimately chromolithographs, imported or domestic.[20] A host of new subjects, details, compositional ideas, and modes of expression thus became available to them, as did the emotional and psychological aspects of certain images, especially portraits of individuals. Some of these pictorial resources were translated—in the double sense of being transferred and being adapted—to the surfaces of lacquer objects, with or without visual traces of the original medium being preserved.[21]

It is difficult to convey the complex, intricate networks of image production as Qajar lacquer artists simultaneously responded to a deep historical tradition of Persianate book and object painting and to successive waves of new media. General observations of affinities of form and subject between media explain only in part the nature of the Qajar artist's creativity in a nineteenth-century world transformed by the escalating market for commodities and by various forms of mechanical reproduction. Qajar lacquer objects were not industrially manufactured, of course, but they nevertheless show the effects of the marketplace in their broad range of subject matter, endlessly recombined by artists and their workshop apprentices. Subtle changes in the design of objects of related theme, or new combinations of subjects, constantly reinvigorated the tradition by producing novel results that continued to make lacquer objects attractive to domestic and foreign buyers. Tangible evidence of this process and its effects can be found in the lacquer objects themselves and, more rarely, in collections of the technical materials made and used by their artists.

Two albums of Qajar artists' technical materials are presently known. The first, in Tehran,[22] is associated with Lutf 'Ali Khan Suratgar, a contemporary of the renowned artist Abu'l-Hasan Ghaffari, titled Sani' al-Mulk ("Craftsman of the Kingdom"), who was active between 1842 and 1866.[23] The twelve folios of this album preserve a collection of drawings, sketches, and pounces kept within Lutf 'Ali Khan's family, passed down to him through generations of his artist forebears. Reflecting styles associated with the Safavid, Zand, and early Qajar (that is, from the reign of Fath 'Ali Shah, 1797–1834) periods, these folios represent the broad range of historical materials that retained currency as possible artistic models.

Another Qajar album, at Harvard, contains a much larger collection of artists' materials, including single drawings or groups of drawings mounted in carefully balanced compositions on its folios.[24] There are several watercolor paintings in color or grisaille, as well as numerous compositional prototypes drawn in ink or watercolor. One folio includes three designs: a cusped medallion depicting a seated couple drinking, and two rectangular compositions of flower-and-bird

Fig. 7
Fol. 23r from an artist's album.
Iran, Qajar period, 19th century.
Ink and opaque watercolor on paper,
33.3 × 22.8 × 5 cm (13⅛ × 9 × 1¹⁵⁄₁₆ in.).
Harvard Art Museums/Arthur M. Sackler
Museum, Alpheus Hyatt Purchasing Fund,
1960.161.

Fig. 8
Fol. 30r from an artist's album.
Iran, Qajar period, 19th century.
Ink and opaque watercolor on paper,
33.3 × 22.8 × 5 cm (13⅛ × 9 × 1¹⁵⁄₁₆ in.).
Harvard Art Museums/Arthur M. Sackler
Museum, Alpheus Hyatt Purchasing Fund,
1960.161.

subjects suitable for the sides or lids of pen cases (fig. 7). On a second folio are arranged three artist's sketches. A central composition depicting a scene of feasting in an architectural interior is flanked by two rectangular compositions. In one of these, portrait busts alternate with perspectively constructed urban landscapes; in the other, different busts are surrounded by scenes of a courtly audience (fig. 8). Other folios in the album present numerous pounced drawings, used to transfer "blind" compositions—hollow outlines lacking internal details—to the shaped paper forms of what would become painted lacquers. In the most common technique of pouncing indicated by these Qajar models, a design on paper was pricked with a pin to form holes along its contours. The pricked sheet was placed on top of the pasteboard or papier-mâché object and charcoal or chalk applied to the upper surface of the paper sheet. Particles of the charcoal or chalk deposited on the surface of the object through the pinpricks served as a guide to the artist in drawing the outlines of the design, to which he then applied pigment.

Although this process might suggest highly repetitive results, the lacquer artist had the capacity to reconfigure prototypes in new arrangements, to shift the balance of his palette, and to vary the details within the basic outlines of a design, all of which he did. While this form of production was certainly not new—manuscript paintings since the early 1400s had been conceived and executed by a comparable method—Qajar artists of lacquer objects applied it to their great advantage by embracing a broad spectrum of sources, from images fashioned for the elite to those in mass circulation. Thus were mechanically reproduced images cycled back into hand-made ones that bore the direct trace of an artist's touch.

It was presumably this wide embrace, which cut across the forms of art available to and consumed by different social classes in Europe (and Iran), that prompted some nineteenth-century European travelers to criticize the Qajar lacquer artist, whose breadth of source materials and willingness to mix them in single objects raised questions about his taste and capacity for aesthetic discernment. The point was made most forcefully by M. Le Comte Julien de Rochechouart, who succeeded Joseph Arthur Comte de Gobineau at the French Legation in Tehran in 1863. Among the many observations de Rochechouart makes about Qajar art in his *Souvenirs d'un voyage en Perse* of 1867 is that artists "have as their models images of Lorraine that garnish the shop windows of our village wig makers or lithographs that decorate the rooms in taverns: Asia, Africa, Nina, 'Matilda's Smile,' 'A Fire in the New World'; and even worse, lewd engravings of the sort only sold in the back shops of certain neighborhoods."[25] For de Rochechouart, "the Persians are ornamentalists, nothing more," and "their painting is an utterly industrial art form ... entirely outside the aesthetic norms to which we are accustomed."[26] We may surmise that the Qajar artist's creative process was viewed as something akin to the découpage or bricolage of contemporary European Victorian scrapbook makers, who cut out and excerpted ready-made compositions and fashioned them into new configurations—a domestic practice at a distant remove from that of the professional artist. Nonetheless, the Qajar artist's practice was well suited to the demand for an efficiently produced and competitively priced industrial art. While to European eyes the maker of this art was both "seller" (*marchand*) and "worker" (*ouvrier*),[27] to the Iranians he practiced a wholly legitimate and culturally approved creative method.

Notes

1 On the history of lacquer from the Iranian world since its emergence at the late Timurid court of Sultan Husayn Mirza (r. 1470–1506), see Khalili et al. 1997, 1:16–18; Diba 1994.

2 B. W. Robinson 1989, 131.

3 Study of Qajar art has come relatively late to the field of Islamic art history, largely due to the privileging of the medieval through early modern periods and to the prejudice that Qajar art represents cultural corruption and aesthetic inferiority when compared to "classical" art as principally defined through the arts of the book. For a brief review of the reception of Qajar art, see Floor 1999, 125. A serious and comprehensive study of Qajar art was offered in the exhibition Royal Persian Paintings: The Qajar Epoch 1785–1925, on show between 1998 and 1999 at the Brooklyn Museum of Art, New York (see Diba 1998), and adapted for its 1999 London venue at the Brunei Gallery, School of Oriental and African Studies, University of London (see Raby 1999).

4 On Qajar-era painting as a "market-oriented" art, the open market, and what visitors found on sale in Iran, see Floor 1999, 131–32; also Szántó 2010, 52. Although lacquer objects are equivalent to handmade multiples, it is not possible to separate out examples made as direct commissions from those made routinely in speculative production.

5 Although no one has yet published a systematic study of artistic production, the relation of artists to apprentices, and the degrees of specialization and division of labor within workshops, some important preliminary observations are offered in Floor 1999.

6 Visual vocabularies may have been more restricted on specific kinds of objects by dint of what was deemed socially acceptable, as in the lacquer covers of Qur'ans or mirror cases. Qur'an covers and mirror cases have been identified as the most common gifts made to young married couples (Szántó 2010, 52–53, 55). Longstanding practices would have militated against figural compositions on Qur'an covers or their protective boxes, which explains the preponderance on these items of flower-and-bird or aniconic vegetal themes. The specific suitability of some subjects to mirrors given as part of the wedding dowry cannot be ascertained until these mirrors are distinguished from ones acquired at other times in a person's life.

7 Diba 1989, 148, describes lacquer as "an adaptation and extension of the art of traditional miniature painting."

8 The formal effects of East Asian lacquers were adapted by artists in Iran and Central Asia for other media, principally wood, stone, and leather, in the post-Mongol period: see Crowe 1996.

9 Descriptions of the technique are provided in McWilliams and Roxburgh 2007, 61–62, and in B. W. Robinson 1989, 131–33.

10 De Rochechouart 1867, 271. Lead acetate was often used by painters to enhance the drying properties of pigments; in lacquerwork production it seems to have been intended to speed up the drying of the gesso but possibly also to whiten the object. De Rochechouart adds that for objects to be painted with flowers, the step of applying lead acetate (acétate de plomb) is skipped. Khalili et al. 1997, 2:16, suggests that "a suspension of white lead, or lead carbonate in varnish," is meant by acétate de plomb, which he translates as "sugar of lead."

11 A Safavid-period description of varnish making is in Sadiqi Beg's Qānūn al-ṣuvar (Canons of Depiction), written sometime between 1576 and 1602: see Dickson and S. C. Welch 1981b, 269. It is remarkably similar to de Rochechouart's observation from the 1860s, as noted in Khalili et al. 1997, 2:16. Europeans who described the production of lacquer objects in Iran include Sir John Chardin (who was in Iran between 1673 and 1677) and M. Le Comte Julien de Rochechouart. See Chardin 1988, 274; de Rochechouart 1867, 271–72. Numerous other details about the lacquer technique can be found in Khalili et al. 1997, 2:13–18.

12 For colors in varnish, see Porter 1992, 98. While the present amber hue of many Qajar lacquers may be due to the degradation of the varnish over time, tinted varnishes were used in addition to clear ones. S. G. W. Benjamin, American ambassador to Persia, noted that the varnish "adds a deliciously mellow effect to the delicate designs over which he [the artist] devotes such patient and loving toil" (cited in Floor 1999, 127; for full source, see Benjamin 1887, 314–15). The appearance of varnish on lacquer is similar to that of oil painting on canvas, a medium also propagated in Iran by Qajar artists and their patrons. While the formal similarities between the two media are obvious, lacquer preceded oil painting in Iran by at least two centuries.

13 De Rochechouart 1867, 272, notes that in flower paintings, the background was painted first, a layer of varnish was added next, and then the flowers were painted. Final layers of varnish protected the completed image.

14 The preparation of "peacock ink," described by Simi Nishapuri in his circa 1435 treatise, *Jawhar-i Sīmī* (Simi's Jewel), included "pulverized pearl and coral," among other ingredients: see Thackston 1990, 225.

15 De Rochechouart 1867, 272, states that the lacquer objects with nacre or gilded grounds were the most highly esteemed, and describes the process of applying metal particles or small flakes of gold. Further deductions about the technique recounted by de Rochechouart are offered in Khalili et al. 1997, 2:17.

16 For the impact of European prints and paintings on Safavid art, see Canby 1996a and Sims 1983, 73–83.

17 Khalili et al. 1997, vol. 2, cats. 357–59.

18 Floor 1999, 123–34, and Vernoit 2006 discuss the histories in Iran of lithography, which arrived circa 1817, and photography, which came after 1840.

19 For the imitation of Safavid art in Qajar lacquers, some of which seem to have been made to deceive buyers, see Szántó 2010, 51, and B. W. Robinson 1989, 143. Representative examples of Qajar imitations of Safavid lacquers are published in Khalili et al. 1997, vol. 2, cats. 314–20. New tastes in lacquer objects were also mediated through imported Russian lacquers manufactured for a Qajar market throughout the 1800s: see Khalili et al. 1997, 2:219–33; B. W. Robinson 1989, 142.

20 For a study of Qajar-era lithographed books, see Marzolph 2001.

21 Some sense of the interactions between these media can be gauged through the Qajar works of art reproduced in Diba 1998, esp. 239–66, and Raby 1999, 56–95.

22 Diba 1989, 157–59. The album is currently in the Riza Abbasi Museum and Cultural Center, 1299–1309, 1311–1510.

23 Abu'l-Hasan Ghaffari is treated in nearly every study of Qajar painting. For a comprehensive overview of his biography, see Raby 1999, 56.

24 Harvard Art Museums/Arthur M. Sackler Museum, 1960.161. The album is presently being studied by the author for an exhibition and will be published as a monograph.

25 De Rochechouart 1867, 264.

26 Ibid, 262.

27 Ibid, 265.

کتاب شاه نامه

The Illustrated *Shāhnāma* in Sixteenth-Century Shiraz

Marianna Shreve Simpson

Of the many artistic centers active in Iran during medieval and early modern times, perhaps none had a longer or more continuous and productive history than the city of Shiraz. Founded after the Islamic conquest in the seventh century and later designated the capital of Fars Province in south-central Iran, Shiraz was held in high regard through the centuries as a place of piety, learning, and culture.

Little is known about the early history of the visual arts in Shiraz. By the first half of the fourteenth century, however, the making of deluxe manuscripts, including copies of both religious and literary texts, had developed into a major artistic enterprise. By the middle of the fifteenth century, the calligraphers, illuminators, painters, and bookbinders of Shiraz were creating an impressive number of volumes of various kinds, both on commission for private patrons and for commercial sale on the open market. This high rate of production continued throughout the next century, and today there are more fine sixteenth-century manuscripts surviving from Shiraz than from any of the other cities in Iran, including Tabriz, Mashhad, and Qazvin, where the arts of the book also flourished.

Throughout the extended tradition of bookmaking in Shiraz, one masterpiece of Persian literature—the *Shāhnāma*, or Book of Kings—was repeatedly copied and illustrated.[1] Composed by Abu'l-Qasim Firdawsi around 1010 CE, this epic poem of some fifty thousand verses recounts the myths, legends, and history of Iran from the dawn of time to the arrival of the Muslim Arabs in the seventh century. Firdawsi structured his magnum opus around three main temporal and dynastic eras—the mythical Pishdadian era, the legendary Kayanian, and the historical Sasanian—divided it into cycles that span the reigns of fifty monarchs, and enlivened it with countless rousing tales of Iran's ancient heroes and villains. The immense narrative scope of the *Shāhnāma* is anchored by recurring themes: the struggle of good against evil, of man against nature and the supernatural, of fathers against sons, of subjects against kings, and of Iran against the enemy kingdom of Turan. These in turn are united by a dual leitmotif: the immortality of noble action and the inevitability of death.

Illuminated titlepiece, from the 1562 manuscript of the *Shāhnāma*, cat. 75, detail.

77

Firdawsi's *Shāhnāma* inspired a rich and varied body of imagery over the centuries, particularly in the form of illustrated Persian manuscripts. Nowhere was this tradition of epic illustration developed more consistently than in Shiraz, culminating in the second half of the sixteenth century. The Calderwood Collection contains two sets of *Shāhnāma* illustrations from this period (as well as associated text and illuminated folios) that allow us to appreciate how Shiraz artists undertook the making of deluxe *Shāhnāma* manuscripts. While the centuries-long history of *Shāhnāma* manuscripts in Shiraz certainly merits attention, this essay concentrates on its climactic, sixteenth-century production, with particular attention to the material, decorative, pictorial, and iconographic characteristics of the works in the Calderwood Collection. The goal here is to situate these *Shāhnāma* illustrations in their contemporary context and to consider the extent to which, on the one hand, they adhere to established artistic conventions and, on the other, they introduce new ideas into the tradition of *Shāhnāma* illustration.

Manuscript Production in Sixteenth-Century Shiraz

Studies of the arts of Shiraz during the fourteenth and fifteenth centuries generally assume that deluxe manuscripts were produced either in private or personal ateliers sponsored by local princes or governors, or in commercial—and thus presumably public, or at least open—workshops.[2] The evidence for atelier production and elite patronage of that era comes primarily from dedicatory inscriptions in manuscripts themselves, while the case for commercial workshops rests on the absence of any such documentation. Fortunately for those studying sixteenth-century Shiraz, another, independent, source about manuscript production there is available in the form of first-hand testimony by the chronicler Budaq Qazvini, who evidently spent time in the city before 1576. At the time of his visit, Shiraz served as the principal seat of the Dhu'l-Qadrs, a Turkman tribe appointed to govern Fars Province on behalf of the Safavid dynasty, which ruled Iran from 1501 to 1722.[3] The city prospered under the Dhu'l-Qadrs from 1503 until 1590, when an unsuccessful revolt against the Safavids resulted in the permanent loss of the Turkman sinecure in Fars.[4] According to Budaq Qazvini's oft-cited commentary:

> There are many writers of *nastaʿlīq* [a cursive script] in Shiraz. They all imitate one another, and it is absolutely impossible to distinguish the writing of one from that of another. The women of Shiraz are copyists, and if they are not literate, they make pictures. This author went to Shiraz and investigated. It is a fact that in every household the wife is a scribe [*kātib*], the husband is a painter [*musavvir*], the daughter is an illuminator [*muzahhib*] and the son is a binder [*mujallid*]. However many books are desired, they can be produced in one house. If one should be inclined to order a thousand books, they could be produced exactly alike in one year in Shiraz, all in one style such that they could not be distinguished from one another in any way. It was a witticism of [the Safavid prince] Bahram Mirza, who said, "In Shiraz they grow books. For one thing, there are so many of them, and secondly because they all look alike."[5]

This vivid eyewitness account casts the making of manuscripts in sixteenth-century Shiraz as a family- or household-based operation, or what might be called a cottage industry, with a clear division of labor and a definite hierarchy of generations and genders. It also confirms what the many extant Shirazi manuscripts suggest: that the output of these workshops was prodigious, in both numbers and speed.[6] Furthermore, Budaq Qazvini's observation about the possibility of "ordering a thousand books" suggests that the family workshops of Shiraz took individual commissions (that is, worked on consignment) as well as producing books for sale on the open market.

At the same time, the chronicler gives a false impression on two points, belied by the manuscripts surviving today. First, Shiraz artists did not labor anonymously, as Budaq Qazvini's account might lead us to believe. Although he does not mention the names of any of the "writers of *nasta'līq*" or other artists whom he must have observed, the large number of extant manuscripts allows us to identify over a dozen illuminators and painters and several dozen calligraphers or scribes at work in sixteenth-century Shiraz.[7]

Second, while sixteenth-century Shiraz manuscripts share many formal characteristics that scholars now recognize as particular to this "school," they are not "all in one style such that they could not be distinguished one from each other in any way." As the following discussion of the two separate sets of *Shāhnāma* illustrations in the Calderwood Collection reveals, there was considerable variation and variety within Shiraz volumes, even within copies of Firdawsi's epic poem, with its centuries-old pictorial tradition. Furthermore—now giving Budaq Qazvini's inference an admittedly modern interpretation—the quality of sixteenth-century Shiraz manuscripts is often very high.[8] Thus, in terms of twenty-first-century reckoning, Shiraz works seem both distinctive and distinguished.

Many sixteenth-century Shiraz manuscripts contain the names of the artists responsible for their transcription, decoration, and illustration, some of whom, particularly the calligraphers, note specifically that they were working in Shiraz. By contrast, not a single one of the scores of extant Shiraz volumes, including the large number that may rightly be considered luxurious, identifies a specific patron. This documentary disparity—dozens of artists' names on the one hand, and not a single patron's name on the other—does not fit easily with the prevailing art-historical notion that high-quality production required, or at least responded to, high-level patronage. Since the finest Shiraz manuscripts date from the period when the city was the principal seat of the Dhu'l-Qadr governors, and since the quality of Shiraz production began to decline at precisely the moment when they lost power, scholars have inferred that the Turkman governors must have actively sponsored, or at least provided major financial support for, the book arts.[9] If dedications to specific Dhu'l-Qadr governors and other officials are lacking in Shiraz manuscripts, it is because, or so the argument goes, volumes were commissioned not to enhance personal libraries or collections, but rather to be given as gifts.

Recipients of such gifts could have included, for example, the courtiers who attended the Safavid prince Mirza Muhammad during his brief residence in Shiraz in the 1570s.[10] While this remains speculative, there exists clear evidence

that Shiraz manuscripts were avidly collected outside Iran, specifically among the sultans and courtiers at the court of Ottoman Turkey. The Topkapı Palace Museum Library (comprising the consolidated holdings of various Ottoman palace libraries) today houses some 100 Shiraz volumes, many of them inscribed with the names or stamped with the seals of their original Ottoman owners.[11] Many of the extant Shiraz manuscripts in Istanbul seem to have entered Ottoman collections during the last quarter of the sixteenth century, at just about the time that Budaq Qazvini was visiting Shiraz; the high output that he observed may have been in response to demand from Ottoman Turkey.[12] Thus, manuscript making in sixteenth-century Shiraz was at once a cottage industry and an export business.

In her seminal study of sixteenth-century Shiraz as a center of manuscript production and painting, Lâle Uluç charts stylistic development in the city through several phases: 1503–65, 1565–80, 1580–90, and 1590–1603.[13] Muhammad al-Qivam al-Katib al-Shirazi, the scribe who copied one group of folios in the Calderwood Collection (cats. 73–93), completed his work in Ramadan 969, corresponding to May–June 1562; this manuscript thus falls towards the end of Uluç's first phase. The other set of Calderwood leaves (cats. 94–101) comes with no such internal documentation but may be dated on stylistic grounds to circa 1575–90, as will be argued below, and thus spans the middle phases of Uluç's developmental scheme. To set the stage for more detailed discussion of these sets, the salient physical and visual characteristics of deluxe manuscripts made in Shiraz from the 1560s through the 1580s will be briefly reviewed here, with the two fragmentary *Shāhnāma*s in the Calderwood Collection providing pertinent benchmarks.[14]

The most noticeable feature of Shiraz manuscripts dating from the second half of the sixteenth century is their large format, as measured in folio height. Copies of the *Shāhnāma* seem to have initiated this trend, which was then followed by other texts.[15] Folios in epic volumes dating from the 1550s generally range between 30 and 35 cm high. Within a decade, this dimension had grown to 35–40 cm; the height of the folios in the Calderwood *Shāhnāma* of 1562, for instance, measures over 37 cm. The size of *Shāhnāma* manuscripts continued to increase from about 1565 through the 1570s and 80s, as evidenced by the second set of Calderwood folios, which are 42 to 43 cm in height.[16]

These large-scale folios typically consist of sheets of highly polished cream-colored paper; often, the vertical area reserved for the text has been dusted or sprinkled in gold, which gives an additional sheen to the written surface.[17] The poetic verses are written in *nasta'līq* script,[18] with two distichs, or verses, per line and twenty-five horizontal lines on the back and front sides of each text folio. Series of rulings (lines of various widths and colors) frame the written surface; pairs of thin lines in black, gold, and sometimes additional colors separate the columns of text, with the interstitial spaces filled with illuminated designs. The outer rulings, intercolumnar rulings, and illuminated column dividers are distinctive to and consistent within each manuscript.[19] To herald or summarize the action of Firdawsi's poem, illuminated rubrics or headings in rectangular panels occupy the width of the two middle text columns and the height of two lines. Unlike the rulings and intercolumnar dividers, the rubric illuminations vary a great deal from page to page in both Calderwood *Shāhnāma*s.

Fig. 1
Illuminated frontispiece,
from the circa 1575–90
manuscript of the *Shāhnāma*.
Sotheby's London, 5 April 2006, lot 39.

Although the Calderwood *Shāhnāma*s are no longer intact, the surviving leaves
confirm that both originally opened with a series of large-scale illuminations, as
was customary for deluxe Shiraz manuscripts. The "front matter" in such works
can include a double-page illuminated frontispiece, a double-page pictorial fron-
tispiece framed in an illuminated border, or both of these compositions. The circa
1575–90 manuscript originally included both: a double-page enthronement scene
of King Solomon and Bilqis, the Queen of Sheba (see below), and a double-page
illuminated frontispiece, of which only the right half survives (fig. 1). The 1562
set of leaves today retains only the left-hand page of what once would have been

Fig. 2
Illuminated frontispiece,
from the 1562 manuscript
of the *Shāhnāma*, cat. 73.

a double-page illuminated frontispiece (fig. 2), and there is no longer any way to know if the original illumination would have been preceded by a pictorial frontispiece. Nevertheless, the surviving halves of the two double-page illuminated frontispieces demonstrate the type of compositions found in Shiraz manuscripts from about the 1550s onward: a vertical rectangular field containing a central, ovoid medallion on axis with a pair of smaller pendants above and below it, surrounded by a thin frame. This composition is enclosed on three sides by a wide border with scalloped elements, punctuated in the middle of one or more sides by a large, rounded triangular medallion that sometimes projects into the outer margin.[20]

While the illuminated frontispieces in the two Calderwood *Shāhnāma*s share the same compositional arrangement and basic color scheme of predominantly gold and blue, their individual decorative motifs vary considerably, as does the relative size of their vertical fields and outer borders. The text inscribed within their central medallions is identical, however, comprising the opening lines of a preface that was added to the *Shāhnāma* in the fifteenth century.[21] The preface to the 1562 *Shāhnāma* originally filled a dozen or so folios, with its concluding lines written in a broad inverted triangle flanked by illuminated panels (recto of cat. 75: see Walter B. Denny's essay, "Inspiration and Innovation: Footprints from Afar in the Calderwood Collection," fig. 10).

The introductory section in the 1562 *Shāhnāma* is followed immediately by Firdawsi's epic text, signaled by an illuminated titlepiece (fig. 3). This decorative device consists of two registers, with design elements that echo those of the illuminated frontispiece.[22] The lower register consists of a horizontal rectangular panel

Fig. 3
Illuminated titlepiece,
from the 1562 manuscript of
the *Shāhnāma*, cat. 75, detail.

Fig. 4
Colophon page, from the 1562 manuscript of the *Shāhnāma*, cat. 93, detail.

with a gold central cartouche and pendants; the cartouche is inscribed *Kitāb-i Shāhnāma* (Book of the *Shāhnāma*). The upper register contains a large, projecting half-medallion.

The end of the 1562 manuscript is also richly illuminated, with a colophon in the form of an inverted triangle containing the signature of the scribe Muhammad al-Qivam al-Katib al-Shirazi and the date he finished copying the work (fig. 4). The colophon's basic layout and decoration are very similar to that of the last page of the preface.

The opening and closing folios of both Calderwood *Shāhnāma*s contain decorative elements characteristic of deluxe Shiraz manuscripts, including verses surrounded by gold contour or "cloud" panels sprinkled with small stems and colored blossoms; verses written on the diagonal, creating triangular spaces that are filled with sketchy floral sprays on colored grounds;[23] and outer margins decorated with large blossoms and leaves in gold.

Variations on these same types of illumination appear elsewhere throughout the two sets, most noticeably on the illustrated pages and the pages that face them. Instead of gold blossoms and leaves, the margins around the paintings include, for instance, an aviary of birds flying through racing clouds and a menagerie of real and mythical animals in landscape settings (figs. 5 and 6). The use of gold marginalia adds to the overall luxurious aesthetic, while the illuminated and sometimes diagonally written verses on pages preceding paintings direct attention to the illustrations and thus serve as signposts within the pictorial program of both manuscripts (see, for example, cats. 79, 82, 85, and 87).[24]

The layout and decoration of the Calderwood *Shāhnāma* folios are typical of Shiraz manuscripts from the second half of the sixteenth century, but many of the same features are found in manuscripts produced elsewhere in sixteenth-century Iran, including those made for members of the Safavid dynasty and its court. Indeed, the expanded size and lavish illumination of Shiraz manuscripts from the 1560s to the 1580s may have emulated models set by Safavid court production, including the now-dispersed *Shāhnāma* made for Shah Tahmasp, of which the Calderwood Collection possesses one folio (cat. 72, and see, in this volume, fig. 4 of the preface).[25] There also are certain similarities in painting styles and in the overall approach to "picture-making" as practiced at Safavid court ateliers during the 1520s through 1560s and within the cottage industry of manuscript production in Shiraz during the 1560s through 1580s. For instance, the illustrations tend to occupy full pages and to be framed by rulings in color and gold, similar to the lines around the written surfaces of text pages. In the Tahmasp *Shāhnāma* and other Safavid court manuscripts, however, full-page illustrations are frequently irregular in their configuration, and pictorial elements may break through their rulings and "spill out" into side and upper margins. By contrast, Shiraz compositions, while sometimes irregular in shape, are generally confined within their rulings, with only occasional projections into the margins (figs. 5 and 6).

As a rule, sixteenth-century Persian manuscript paintings incorporate panels of text into their picture planes. In Safavid court production such text panels vary greatly in number and placement and often appear barely noticeable within the painted compositions. In Shiraz manuscripts, the size and location of the text panels seems to have been regulated by a fixed formula, with one panel of two to seven lines of text in the upper part of the picture plane and another of one to four lines at the bottom.[26] In both Calderwood sets, these panels are always flush with the side rulings, and the lower panels are always flush with the bottom ruling.[27] In the 1562 *Shāhnāma*, the upper panel is placed immediately underneath the upper ruling, whereas in the circa 1575–90 *Shāhnāma* the upper panel is positioned, as if floating, about a quarter of the way down the picture plane, so that the composition extends or continues above it. Whatever the number of text lines they contain or their placement vis-a-vis the top rulings, the upper and lower text panels are always aligned with each other and always four columns wide—the same width as the written surface of the text folios. The paintings themselves, however, are always wider by about one and one-third text columns, so that the text panels occupy approximately three-quarters of the width of the painting.

Fig. 5
Guruy Executes Siyavush,
from the 1562 manuscript of
the *Shāhnāma*, cat. 82.

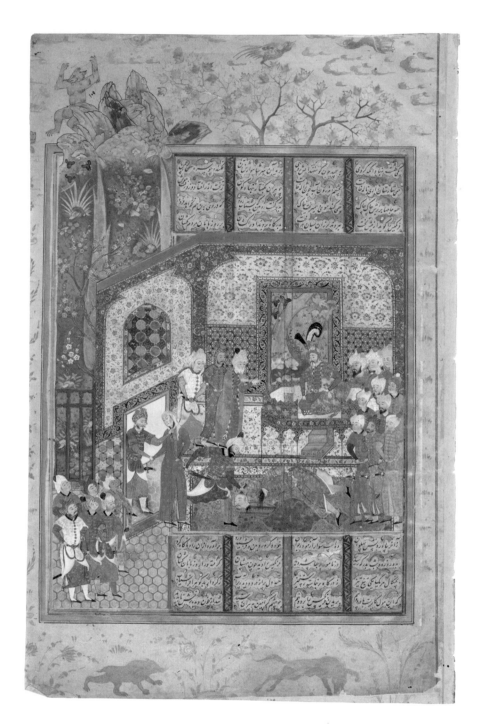

Early in the study of Persian painting it was proposed that the compositional struc-
ture of any Shiraz manuscript illustration was connected to the proportional rela-
tionship between its two text panels and its overall painted surface, which created
an inner space (that is, the area between the text panels) and an outer space (that is,
the one-quarter of the composition outside the text panels). Dubbed the "Shiraz
canon," this mathematically controlled system held that the principal action of
the illustration occurred within the inner space and, further, that the position of
the principal actors was coordinated with the vertical axes of the four columns
that divide the two text panels incorporated into the top and bottom of the picture

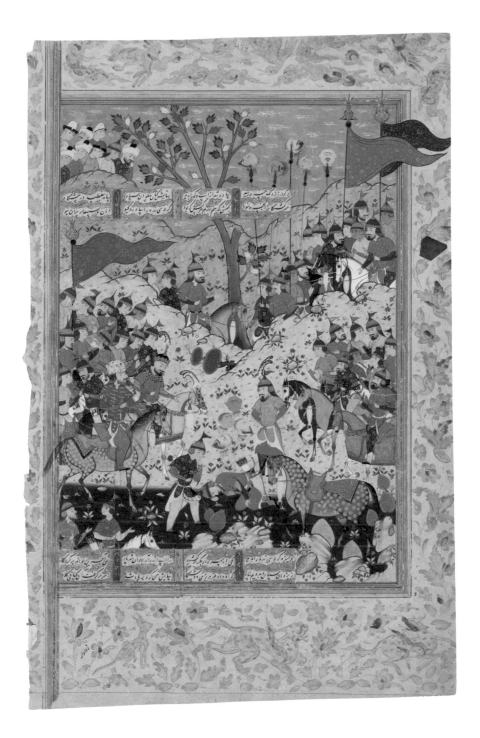

plane.[28] Although more recent scholarship has questioned the validity of such a system and its universal applicability to Shiraz manuscript illustration,[29] it is all but certain that Shiraz painters used the standardized layout of their picture planes as a matrix or grid in organizing their narrative compositions. In her technical study of Shiraz manuscript illustrations in this catalogue, Penley Knipe found that the vertical axes of the text columns lay beneath the paint surface (see "Technical Observations on a *Shāhnāma* Manuscript," 115–33). Even when working with the same basic matrix or illustrating the same epic scene, however, Shiraz painters achieved considerable compositional variety, as will be discussed below.

Fig. 6
Gudarz Pays Homage to Kay Khusraw and Shows Him the Enemy Corpses, from the circa 1575–90 manuscript of the *Shāhnāma*, cat. 98.

The Illustrated *Shāhnāma* in Shiraz, circa 1560–90

There is no easy way to estimate how many *Shāhnāma* manuscripts were illustrated in Shiraz during the 1560s through 1580s, but based on available listings of recorded volumes, as well as the registers of sixteenth-century Ottoman collections, we may assume that they numbered in the scores. The intact copies surviving from this period contain between 500 and 700 folios, and anywhere from a dozen to five dozen text illustrations, with thirty on average. It is a greater challenge to determine such information for those *Shāhnāma* volumes that, like the two Calderwood sets, now exist in only fragmentary form. A compilation of their known folios, however, does provide some clues (see appendices 1 and 2) and allows us to conclude that the 1562 manuscript originally had 577 folios, of which at least thirty-five folios, including sixteen now in the Calderwood Collection, were illustrated.[30] Fewer folios have survived from the circa 1575–90 manuscript; altogether twenty-seven are known today, including two of front matter and twenty-four with paintings. Of these folios, ten belong to the Calderwood set and the rest to various public and private collections.

Besides helping to determine the original order of the folios and the tally of their illustrations, the appended reconstructions permit further, albeit preliminary, observations about these two manuscripts. From the colophon (fig. 4), we know that the first Calderwood set, dated Ramadan 969 (May–June 1562) was the work of Muhammad al-Qivam al-Katib al-Shirazi, a scribe active from the early 1530s through about the mid-1570s and responsible for the transcription of some twenty or so texts of various kinds.[31] His known corpus includes at least one other *Shāhnāma*, dated 970 (1562–63),[32] indicating that he worked on two copies of Firdawsi's epic in succession.

Although it seems that Muhammad al-Qivam was the sole copyist of the Calderwood *Shāhnāma*, he was not the only artist involved in its production. The illustrations may have been the work of as many as four different painters, whose individual contributions may be distinguished by particular details.[33] For instance, the artist who painted *Rustam and the Iranians Hunt in Afrasiyab's Preserves* (cat. 80) rendered his hunters' turbans as *tāj-i Ḥaydarī*, that is, white cloth wrapped around caps with tall red or black batons, while the painter of *Kay Khusraw Reviews His Troops* (cat. 83) gave the shah's escorts turbans wrapped around conical red caps adorned with white plumes.

As for the second Calderwood set, the reconstruction of its surviving twenty-seven folios and the fuller visual analysis that such an assemblage permits leads to a proposed dating.[34] More significantly, the compilation reunites in virtual form the two paintings of the original double-page frontispiece, depicting King Solomon on the right, and Bilqis, the Queen of Sheba, on the left (fig. 7, a–b). This frontispiece serves as a convenient point of departure for considering the dating. As Serpil Bağcı has shown, the practice of representing Solomon and Bilqis on the opening pages of Shiraz manuscripts seems to have started in the 1480s, doubtless due as much to the symbolic significance long attached to Solomon in Shiraz as to specific historical circumstances.[35] The earliest examples of such frontispieces

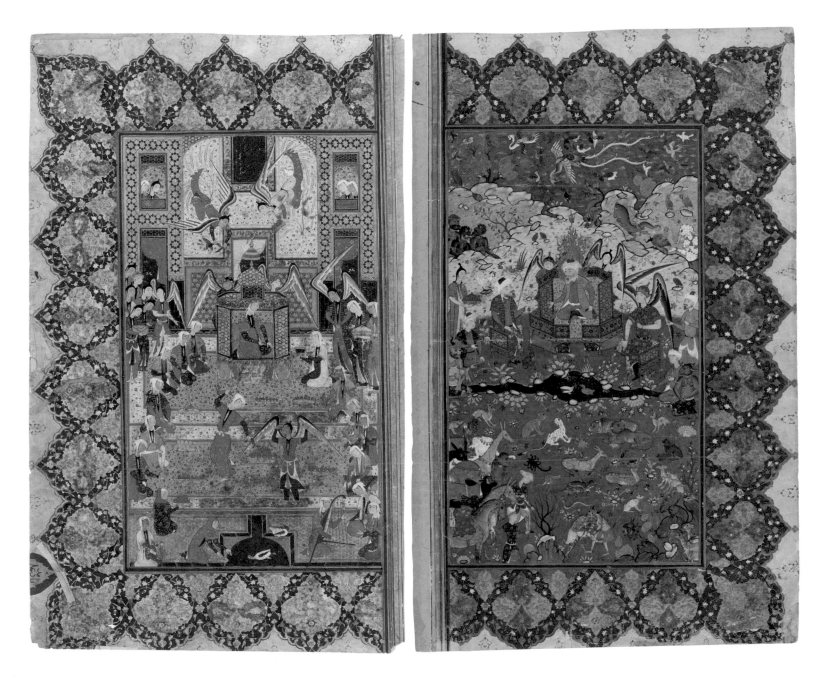

Fig. 7, a–b
Solomon and Bilqis Enthroned,
double-page frontispiece from
the circa 1575–90 manuscript of
the *Shāhnāma*, now separated.

a. Solomon, cat. 94.

b. Bilqis.

Sotheby's London, 5 April 2006, lot 39.

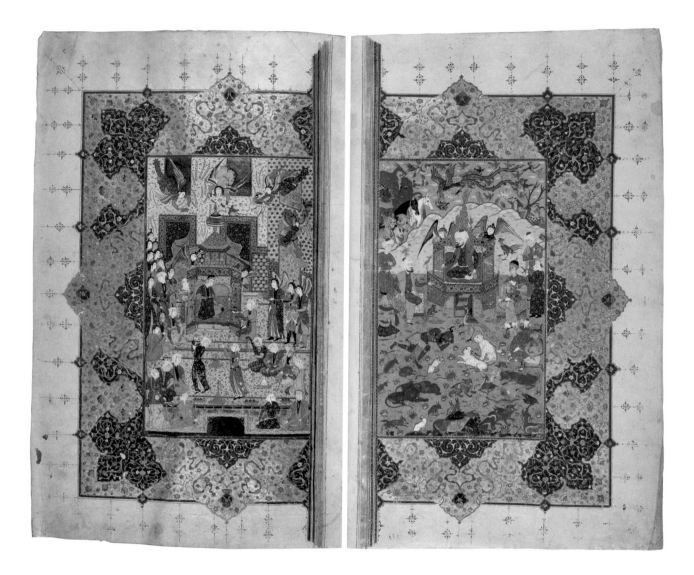

depict Solomon and Bilqis seated side by side on a wide throne in a landscape setting; they are accompanied by courtiers as well as a host of animals, birds, and supernatural creatures on the ground and in the sky. By the mid-sixteenth century, however, and as seen in the undated Calderwood *Shāhnāma*, Solomon and Bilqis occupy separate thrones, located on the two facing halves of double-page compositions. While Solomon remains seated en plein air, Bilqis has moved indoors into a richly appointed chamber. Very similar Solomon and Bilqis frontispieces open a number of manuscripts dated or datable to the late 1560s through the mid-1580s. These include a volume of Saʿdi's poetry transcribed by Muhammad Qivam al-Katib al-Shirazi in 974 (1566) and illustrated in 977 (1568–69), now in the British Library, and a *Shāhnāma* copied in Shiraz on 10 Muharram 982 (May 2, 1574), now in the Topkapı Palace Museum Library (fig. 8).[36] Particularly telling in the Bilqis portion of these three examples are the angels who swoop down over the queen's head; one carries a gold platter of red fruit, while another holds a duck in one hand and a knife in the other. Also of note here is Bilqis's elaborate throne, which rises to an umbrella-like dome topped with a golden finial in the form of a hoopoe, the bird who carried messages between the queen and Solomon.

The 1574 *Shāhnāma* offers additional points of comparison with the undated Calderwood *Shāhnāma*, including the same distinctive layout for a number of their illustrated folios. On these folios, as discussed above, the upper text panel is placed below, rather than directly against, the upper rulings of the picture plane, and the resulting space between text panel and ruling forms the upper area of the painting. Both manuscripts contain scenes set in palace interiors, in which the upper area of the picture plane is filled with a polygonal, walled rooftop terrace and a central canopy—an architectural element that was introduced into Shiraz painting around 1560 and quickly became a standard feature of luxury manuscripts produced in Shiraz for the rest of the century.[37] Usually these rooftop terraces are occupied by figures who look down upon the action taking place below; both the 1574 *Shāhnāma* (fol. 447a)[38] and the undated *Shāhnāma* to which the Calderwood set belongs include a very similar pair of women at the right side of their respective, and likewise similar, rooftops (fig. 9). Finally, both manuscripts depict a number

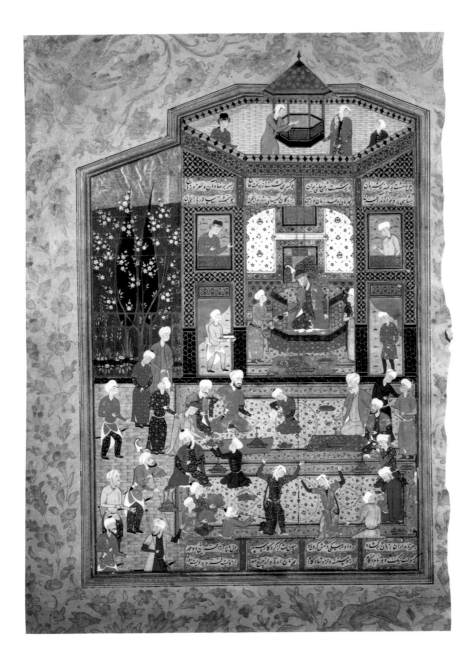

Fig. 9
Anushirvan Enthroned,
from the circa 1575–90
manuscript of the *Shāhnāma*.
Private collection, London.

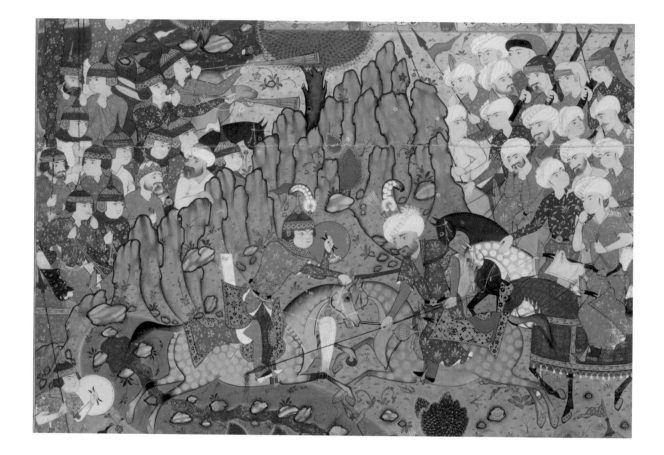

of the same *Shāhnāma* episodes and share both general and specific iconographic and compositional features that would seem to warrant fixing the terminus post quem for the undated Calderwood folios at around 1575.[39] Since many of the same features appear in intact *Shāhnāma*s dated or datable through the 1580s, the fragmentary Calderwood manuscript conceivably could have been illustrated at any time up to about 1590.

The circa 1575–90 *Shāhnāma*, like the 1562 copy, seems to have been illustrated by several painters, as evidenced by variations in figural style. The warriors in the battle scene *Bahram Chubina Slays Kut of Rum* (fig. 10), for instance, have larger bodies and "chunkier" faces than those in the illustration *Iskandar Mourns the Dying Dara* (cat. 99, and Knipe, "Technical Observations," fig. 1). Also of note in *Bahram Chubina Slays Kut of Rum* are four soldiers (three of them carrying guns) at the right, below the upper text panel: these four wear the distinctive headdresses of Ottoman janissaries. Such figures entered the Shiraz repertoire during the early sixteenth century, usually in illustrations of Iskandar and Dara.[40] Their presence in a different scene within the circa 1575–90 *Shāhnāma* indicates both an artistic familiarity with past practice and an ability to adapt established pictorial elements to a new narrative context.

In keeping with the general reputation of sixteenth-century Shiraz manuscripts as "provincial" and qualitatively inferior to Safavid court production, illustrated Shiraz *Shāhnāmas* from the second half of the century have frequently been dismissed as formulaic and lacking originality and imagination.[41] While it is true that certain passages of the epic were regularly selected for illustration in Shiraz (as well as in other centers of Persian manuscript production), it is equally the case that no two illustrated Shiraz *Shāhnāma* manuscripts are identical. Furthermore, illustrations of shared scenes often prove to be both compositionally varied and iconographically imaginative, as the comparison below reveals.[42]

Both the 1562 and the circa 1575–90 *Shāhnāmas* include a representation of the legendary hero Rustam slaying an enormous cave-dwelling demon called White Div (figs. 11 and 12).[43] Rustam's feat culminates the last of a series of seven trials, known as the *haft khān*, that he has faced during a mission to rescue the Iranian king Kay Kavus, who has been taken captive and blinded by White Div during an ill-fated invasion of the neighboring territory of Mazandaran. This was the most frequently illustrated episode in the entire *Shāhnāma*; over one hundred depictions of the scene, dating from the fourteenth to the seventeenth century, are known today.

Rustam's encounter with White Div is a fast-paced adventure, with several key narrative stages or moments. Rustam approaches the div's cave with a local warlord named Awlad, whom he has taken hostage during his fifth *khān*, and finds the cave guarded by a host of subordinate divs. Heeding Awlad's counsel (and binding him to a tree to prevent his escape), Rustam waits to attack the guardians until they have fallen asleep in the midday sun, and lops off their heads. He then enters the dark cave and rouses the sleeping White Div with a shout. The ensuing battle is fought in a quick succession of moments, with White Div first charging Rustam with a millstone. Rustam recovers, strikes his opponent in the midsection with a sword, and then hacks off an arm and a leg. Despite this mutilation, White Div grapples fiercely with Rustam. The Iranian hero gathers his strength and throws White Div down so hard that the demon expires. Finally Rustam draws his dagger, stabs White Div in the chest, and carves out his liver.

By the second half of the sixteenth-century, the general iconography of the seventh *khān* had been well established, as reflected in both the 1562 and circa 1575–90 illustrations. Rustam and White Div struggle together in the black interior of the rock-hewn cave, often along with several anthropomorphic divs who vary in size, color, and physiognomy. Additional, equally diverse demons ring the cave's perimeter or occupy the surrounding landscape, where Awlad is bound to a tree. Rustam is invariably bearded and wears his traditional animal-skin robe and snow-leopard helmet, while White Div is spotted, with red eyes, "flaming" eyebrows, and fangs, horns, or both; he sports a brightly colored skirt and gold jewelry. Several of the creature's severed limbs—usually legs, feet, or hands—lie on the cave floor. In short, the standard representation of the episode conflates various moments in the combat, combining earlier events outside the cave with actions now taking place within it.

Although the extraction of the liver is the literary culmination of the adventure, most illustrations show Rustam stabbing White Div in the chest or abdomen. This is the very moment depicted in the 1562 *Shāhnāma*, following the final verse (the so-called breakline) in the upper text panel of the painting. The comparable illustration in the circa 1575-90 *Shāhnāma*, however, depicts Rustam preparing to stab his adversary by raising his dagger—an action that Firdawsi does not actually describe, but that is a logical prelude to the coup de grâce.

On the whole, the 1562 illustration is at once more animated and considerably gorier than the later version. The host of guardian divs outside the cave includes

Fig. 11
Rustam Kills White Div, from the 1562 manuscript of the *Shāhnāma*, cat. 79 B.

a bright-pink creature clutching the tree trunk, a second, smaller demon clambering in the branches above him, and a third, even more diminutive, black-and-white spotted monster climbing a rocky scarp below. Rustam's horse, Rakhsh, whinnies from the horizon, as if to alert his master to the other divs in the vicinity, including one hoisting a boulder, and, beside him, a particularly malevolent brown creature skulking behind a rock. Just outside the cave, a large black div who has been sliced through the middle writhes in agony, and inside it four other maimed and bloody creatures lie prostrate, including a decapitated victim of Rustam's sword. Blood spurts from White Div's stomach as Rustam thrusts in the knife, and oozes from the stumps of his severed left arm and right leg.[44] Small wonder then that White Div props himself up and stares in desperation at his wounds.

By comparison, the circa 1575–90 illustration of this episode seems positively pacific. The many fewer divs who guard the cave and watch from behind the horizon appear more befuddled than threatening or alarmed, while those inside, including a brilliant blue, bird-headed creature at the lower right, seem to be commenting on the fight rather than suffering from it, even when wounded, as is the bright orange demon missing his left hand. White Div lies on his back, still clinging to Rustam but apparently already dead after having been slammed to the ground, as described in the verses in the upper text panel.[45] Although vanquished,

Fig. 12
Rustam Kills White Div,
from the circa 1575–90
manuscript of the *Shāhnāma*.
Museum Rietberg, Zurich.

White Div here is massive, in keeping with Firdawsi's previous text. Rustam, on the other hand, looks slight, even somewhat vulnerable, a perception enhanced by the large boulders surrounding the cave. The contrast in the physiques of the two protagonists has the effect of making Rustam's feat appear epic and momentous in its proportions. Rather than the exuberant piling-on of gory detail in the 1562 version, this painting uses a far subtler means—the formal manipulation of scale—to achieve the same end, the visual demonstration of Rustam's heroism.

Besides the double-page pictorial frontispiece and illuminated border on its opening folios (and a similarly conceived finispiece at the end),[46] a typical sixteenth-century Shiraz Shāhnāma frequently includes a double-page composition at the midpoint of both the manuscript and Firdawsi's epic narrative, illustrating the story of Luhrasp's accession to the Iranian throne.[47] Although it is far more unusual for a Shiraz Shāhnāma to contain other double-page illustrations, the circa 1575–90 Calderwood set contains two such pairs (cats. 95 A–B and 96 A–B).[48] One of these depicts the fire ordeal of Prince Siyavush, who has been falsely accused of rape by his stepmother, Sudaba, the wife of his father, the Iranian king Kay Kavus (fig. 13, a–b).[49] The typical sixteenth-century Shiraz single-page version of this scene is dominated by a conflagration through which Siyavush must ride to prove his innocence. At one side is usually a palace with an upper story from which Sudaba looks on, while other witnesses, including Kay Kavus (identifiable by his crown), gather below. Sometimes additional bystanders appear in the background.[50] The circa 1575–90 illustration expands this composition by dividing it into halves: the right half occupied by the palace façade, with Sudaba and attendants on the second-story balcony and spectators outside, and the left half filled with three groups of onlookers, including Kay Kavus mounted on a dappled horse, all watching Siyavush ride through the flames. Interestingly, the simultaneous division and doubling of the traditional composition and the multiplication of spectators has the effect of diminishing the sizes of both Siyavush and the flaming pile of logs, thus lessening the import of his test and vindication.

The other double-page illustration in the circa 1575–90 Shāhnāma is more novel, even idiosyncratic, in both its iconography and its composition (fig. 14, a–b). Whereas the two-part Siyavush scene represents a single narrative moment, this illustration combines two successive moments in an episode involving Rustam and his son, Sohrab. In this tragic tale of mistaken identity, it is only after the mighty warrior has mortally wounded his son that he recognizes Sohrab from an amulet on the boy's arm. The pathos of this filicide is heightened by Sohrab's long soliloquy as he lies dying. When death finally comes, Sohrab's body is placed in a coffin, and Rustam follows the funeral procession on foot, his clothes torn to shreds and "his heart pierced with grief."[51]

Certain key moments of this tragic tale were illustrated repeatedly in sixteenth-century Shāhnāmas, with perennial favorites being the scenes of Rustam stabbing Sohrab and of Rustam discovering Sohrab's identity and keening over his dying son. There are also a few paintings of Sohrab's funeral, which occurs towards the end of the episode. Most Shiraz manuscripts depict only one of these three scenes.[52] Far more unusual—indeed, seemingly without iconographic prototype or parallel—is the two-part depiction in the Calderwood Collection, with the right side repre-

senting Rustam discovering Sohrab's identity, and the left side showing him carrying Sohrab's casket. The treatment of the scene in which Rustam recognizes Sohrab is consistent with both earlier and contemporary examples: Sohrab lies on the ground with his upper body partially bared to expose his wound and the amulet bound to his upper arm, and Rustam kneels alongside and rends his tiger skin robe in grief. The facing illustration, of Rustam carrying Sohrab's crown-bedecked coffin is, however, totally novel; in fact, it diverges significantly from Firdawsi's narrative, in which Sohrab's coffin is taken from the battlefield while Rustam returns to his tent. In short, this double-page illustration depicts narrative progression rather than an integrated narrative whole, albeit with a sense of conceptual, formal, and literary unity provided by the common treatment of the landscape setting and figures in both halves, as well as the continuous text and the surrounding illuminated border.

Fig. 13, a–b
The Trial by Fire of Siyavush, double-page illustration from the circa 1575–90 manuscript of the *Shāhnāma*, cat. 96.

Given where the stories of Siyavush's trial and Rustam's fatal fight with Sohrab come in the sequence of Firdawsi's fifty narrative cycles, it is unlikely that either of these two double-page illuminated paintings was created as a mid-manuscript marker for the 1575–90 *Shāhnāma*. It is therefore tempting to speculate that, rather than a codicological function, they might have had special significance for whoever owned or ordered this manuscript. Both compositions illustrate episodes in the

Fig. 14, a–b
Rustam Mourns Sohrab and Carries His Coffin, double-page illustration from the circa 1575–90 manuscript of the *Shāhnāma*, cat. 95.

ongoing saga of father-and-son conflict, a central theme of Firdawsi's *Shāhnāma*. As Dick Davis has discussed, the conflicts between Rustam and Sohrab and between Kay Kavus and Siyavush are also intertwined with the interactions of a king (Kay Kavus in both cases) and his subjects, and the principal characters are variously victor and victim, king and subject, father and son.[53] Furthermore, these parallel conflicts and relationships also concern the inevitability of death, another

Shāhnāma leitmotif explicit in the tale of Rustam and Sohrab and implicit in that of Siyavush's trial. Although the fragmentary state of the circa 1575–90 *Shāhnāma* permits no more than a tentative hypothesis about its production or patronage, it is possible that personal circumstance, such as the sudden death of a beloved son, prompted the choice of these particular narrative episodes for illustration and determined their unusual treatment—particularly pronounced in the scenes of Rustam and Sohrab—as double-page compositions.

The Illustrated *Shāhnāma* in Sixteenth-Century Shiraz

Such speculation in an effort to provide a rationale for two unusual compositions in one fragmentary Shiraz *Shāhnāma* leads inevitably to the larger questions of why Firdawsi's epic poem was illustrated so consistently in Shiraz during medieval and early modern times, and why it was so popular in sixteenth-century Shiraz. Recent scholarship has proposed various, often persuasive, interpretations for particular *Shāhnāma* manuscripts, singly or in groups, illustrated in Shiraz during the fourteenth and fifteenth centuries—interpretations that generally have been informed by substantial evidence concerning these volumes' dynastic or individual patronage.[54] Safavid Shiraz, however, has been largely left out of these discussions, partly because of the absence of any secure documentation of patronage by the Dhu'l-Qadr governors of the city, and partly because of a prevailing attitude that has dismissed Shiraz manuscripts as visually undistinguished and indistinguishable. At most, it has been suggested that the *Shāhnāma* was regularly illustrated in sixteenth-century Shiraz because of the market for such deluxe volumes in Ottoman Turkey. Or, to put it another way, as a collective, the Shiraz workshops observed by Budaq Qazvini constituted an industry that produced a reliable "product," largely in response to distant demand.

As this discussion of the Calderwood folios has shown, Shiraz *Shāhnāma*s of the second half of the sixteenth century demonstrate significant variation and innovation, even while sharing many formal characteristics. The hint of personal or particular motivation offered by the circa 1575–90 *Shāhnāma* suggests that closer analysis of intact manuscripts, particularly of the details of their pictorial programs, may provide further clues that yield a fuller and clearer explanation of the steadfast attachment of Shiraz artists (and doubtless also patrons) to Firdawsi's epic during the second half of the sixteenth century. Firdawsi's poetry clearly provided a constant, powerful stimulus to artistic creativity in Shiraz, while the thematic depth and narrative breadth of the Book of Kings offered a deluxe volume the potential to be an innovative, and even customized, work of art.

Notes

1 I am indebted to Lâle Uluç, the doyenne of sixteenth-century Shiraz manuscript and painting studies, for her advice and assistance with this essay.

 There is a vast bibliography on the *Shāhnāma*, both as literature and as art. Recent overviews include B. W. Robinson 1983; B. W. Robinson 2002; M. S. Simpson 2004; Hillenbrand 2007, 95–103; M. S. Simpson 2009; and Brend and Melville 2010 (with very helpful discussions of the poem's contents and context). See also Clinton 2001.

2 For the art and patronage of Shiraz under the Injus (1325–57), see Wright 1997; M. S. Simpson 2000; Carboni 2002, 214–22; Sims 2006, 269–74; Wright 2006, 248–68. For the Muzaffarids (1353–93), see B. W. Robinson 1958, 11–12; Gray 1979b, 121–22; B. W. Robinson 1983, 282; O'Kane 2006. For the Timurids (1370–1506), see Gray 1979b; Gray 1986, 844; B. W. Robinson 1991, 11–20; Sims 1992, 45–58, 54–57; Bağcı 1995, 106–7; Wright 2004; Abdullaeva and Melville 2008. For the Aq-Qoyunlu Turkmans (1453–1502), see B. W. Robinson 1954; B. W. Robinson 1958, 26–29, 59–61; B. W. Robinson 1979; B. W. Robinson 1982, 35–36; B. W. Robinson 1983, 287–88; B. W. Robinson 1991, 21–43; Soudavar 1992, 136.

3 A detailed history of Shiraz in early modern times, and specifically during the Safavid period, remains to be written, although the essentials may be found in Uluç 2000b; Uluç 2006, 37–55; and (to a lesser extent) Shahbazi 2004.

4 Savory 1978, 2:609–12, 690–91; Quinn 1996, 14; Babayan 2002, 359–60; Babaie et al. 2004, 15, 28, 37, 95, 119; Newman 2009, 52–53, 68.

5 Būdāq Qazvīnī, *Javāhir al-akhbār*, National Library of Russia, St. Petersburg, Dorn 288, fols. 109a–b. I am most grateful to Olga Yastrebova for providing the original Persian text at the request of Adel Adamova, and to Wheeler Thackston for this translation, which substantially revises that of Akimushkin and Ivanov 1979, 50, which has been the basis for most citations. See also Çağman and Tanındı 2002, 46n1 (the only English translation to include Bahram Mirza's jocular remark). Budaq Qazvini's description of the household and familial context for manuscript-making in sixteenth-century Shiraz may be contrasted with what is known about the structure and practices of courtly libraries and ateliers in both the Timurid and Safavid periods: see

Thackston 1989, 323–27; M. S. Simpson 1993. See also n. 6 here.

6 B. W. Robinson 1983, 287–88, refers in a general way to "innumerable copies of the *Shāhnāma*" from this period, and more specifically to thirty-seven such volumes; Sims 1992, 68, lists only twenty or so. See also Bağcı 1995, 107.

7 The early seventeenth-century chronicler Qazi Ahmad lists and praises various Shiraz calligraphers, although none seems to have worked much past the early decades of the sixteenth century: see Minorsky 1959, 29 and 67. Modern-day scholars of Persian painting have long been attentive to the artists' names found in manuscript colophons, illuminations, and paintings and have compiled extensive listings, often based on specific manuscript collections. For a listing of sixteenth-century artists, see Stchoukine 1959, 211–14 (and 98–122 for descriptions of various Shiraz manuscripts and mention of their artists); for a specific roster of sixteenth-century Shirazi artists, see Guest 1949, 57–64, recently superseded by the extensive listings in Uluç 2000a, 325–52. We also now know of a group of manuscript artists at work, circa 1515–28, at the "threshold" (*āsitāna*) of a saint's tomb or shrine in Shiraz: see Uluç 2000a, 291–94; Çağman and Tanındı 2002; Uluç 2006, 98–99; Uluç 2007. This seems to represent a variation, and possibly a limited one, on the "typical" setting for manuscript production that Budaq Qazvini described later in the century.

8 This point is argued vigorously and persuasively in Uluç 2006.

9 See especially Uluç 2000b and Uluç 2006, chap. 8; also Babaie et al. 2004, 115; Newman 2009, 18 (following Canby 2000a, 35).

10 Uluç 2006, 478–79.

11 Book inventories and gift records in Ottoman chronicles and archives suggest that this number could have been much higher: Uluç 2006, 469–78; Uluç 2011.

12 Uluç 2000b, 89.

13 Uluç 2006, chaps. 3, 5–7. Her four chronological divisions are not necessarily clear cut, however, and there is considerable formal overlap among them.

14 In addition to Uluç 2006, see also B. W. Robinson 1982, 58–59; Titley 1983, 92–102.

Neither set of Calderwood folios constitutes a complete codex, and neither has its original binding.

15 Uluç 2006, 225–26.

16 Both sets of Calderwood Collection leaves seem to have been trimmed, so their original dimensions would have been even larger.

17 The gold dust in the 1562 *Shāhnāma* appears to have been "refreshed" at some point in the past.

18 Interestingly enough, *nastaʿlīq* script appears to have originated in Shiraz. See Blair 2006, 274–81 (following Wright 1997 and 2003) and 418.

19 Most of the folios in the Calderwood 1562 set (cats. 73–93) feature illuminated intercolumnar dividers with a gold leaf-and-stem motif in a zigzag pattern. On the opening and closing folios, as well as on some text pages that face illustrated pages, however, these dividers are more colorful and consist of the same gold leaf-and-stem motif, the right and left dividers on a background of light blue and the central divider on orange: see, for instance, 2002.50.123v (cat. 75); 2002.50.151r–v (cat. 76 A). The color scheme and designs are more varied still throughout the undated Calderwood set (cats. 94–101), where dividers are ruled with gold and light green lines and decorated with sketchy, three-petaled floral forms on thin curved stems in black on a gold ground, or alternatively ruled with gold and orange lines and decorated with the same flowers and stems in gold on a bright blue ground.

20 Stanley 2004, fig. 7.1; Uluç 2006, 93, 320, and figs. 121, 122, 179, 264, 271–72.

21 Roemer 1989; Khaleghi-Motlagh 1989a; Riyāḥī 1993, 364–418.

22 See also Stanley 2004, fig. 7.2; Uluç 2006, fig. 115.

23 Each Calderwood set has its own decoration for these triangular cornerpieces. See also Stanley 2004, fig. 7.4; Uluç 2006, fig. 172.

24 A similar purpose may be inferred for the oblique, illuminated verses that precede the end of the *Shāhnāma* text and Muhammad al-Qivam's colophon in the 1562 manuscript. For a discussion of the function of oblique verses in an earlier Shiraz *Shāhnāma*, see Wright 2004, 70–72; see also Stanley 2004, 85.

25 B. W. Robinson 1982, 58; Titley 1983, 94; Uluç 2006, 139–40, 225–29, 265–68, 290–91.

26 An exception is found in the first illustration in the 1562 *Shāhnāma*, which has an extra large upper text panel and no lower text panel: 2002.50.150r (cat. 76 B).

27 The text panels are flush with the rulings on the right side in illustrations painted on the recto of a folio, and flush with the rulings on the left side in illustrations painted on the verso of a folio.

28 Guest 1949, 25–30.

29 Stanley 2004, 92–95.

30 The folios were numbered at a later date and so do not reliably reflect the original foliation of the 1562 manuscript. The identification of the nineteen other illustrations from the volume (current whereabouts unknown) is based on the catalogue information given in Christie's 1995, lot 79, which includes mention of six miniatures already missing from the manuscript. The catalogue entry omits, however, one of the illustrated folios later acquired for the Calderwood Collection: 2002.50.41 (cat. 87).

31 Bayānī 1966–69, 3:814–16; Uluç 2000a, 335–37, also lists various of these manuscripts (although not a *Kulliyāt* of Saʿdi belonging to the Freer Gallery of Art, F1971.5), but elsewhere cautions that past scholars have often confused Muhammad al-Qivam al-Katib al-Shirazi with other Shiraz scribes bearing similar names (Uluç 2006, 184n13). The colophon in at least one of the manuscripts in Uluç's 2000a listing, a *Shāhnāma* dated 956 (1549), specifies it was completed *dar al-mulk Shīrāz* (in the dominion of Shiraz). Here, however, the scribe signed himself simply *Muḥammad kātib*, and so may not be the same person as Muhammad al-Qivam al-Katib al-Shirazi.

32 Uluç 1994.

33 Christie's 1995, lot 79.

34 Given as circa 1560–70 (but without explanation) in previous publications: Sotheby's 2006a, lots 39–40; Sotheby's 2008, lot 40; Komaroff 2011, cats. 149–50.

35 Bağcı 1995; Uluç 2006, 291–301.

36 British Library, London, Add. 24944, fols. 2b–3a; Topkapı Palace Museum Library,

Istanbul, H. 1497, fols. 1b–2a. Uluç 2000a, 421–24, 435–36, provides full details of these two manuscripts. See also Titley 1983, 96 and pl. 14; Baˇgcı 1995, figs. 3a–b, 4a–b, 5a–b. For other comparable frontispieces, see Uluç 2006, figs. 136, 137, 229, and 240 (where, however, Bilqis is enthroned on an outdoor terrace); A. Welch 1972, vol. 1, cat. Ir.M.21.

37 Uluç 2006, 180.

38 Uluç 2006, fig. 208.

39 Shared scenes in the 1574 *Shāhnāma*, Topkapı Palace Museum Library H. 1497 (designated TPML), and the circa 1575–90 *Shāhnāma*, dispersed (designated D):
 1TPML. fol. 17a (Uluç 2006, fig. 190)
 1D. David Collection, Copenhagen, 56/2007 (Appendix 2, #3a)
 2TPML. fol. 182a
 2D. Calderwood 2002.50.35r (Appendix 2, #13a)
 3TPML. fol. 284a
 3D. British Museum, London, 206,0420,0.1 (Appendix 2, #16a)
 4TPML. fol. 295b
 4D. Los Angeles County Museum of Art, M.2009.44.4r (Appendix 2, #17a; Komaroff 2011, fig. 131)
 5TPML. fol. 333a (Uluç 2006, fig. 184)
 5D. Calderwood 2002.50.34v (Appendix 2, #18b)
 6TPML. fol. 458a
 6D. Los Angeles County Museum of Art M.2009.44.1 (Appendix 2, #25a; Komaroff 2011, fig. 130).

40 Uluç 2006, 160–62 and figs. 67–68, 110–11.

41 Uluç 2006, 320.

42 Altogether the fragmentary *Shāhnāma*s of 1562 and circa 1575–90 share four scenes: *The Court of Gayumars* (cat. 76 B and Appendix 2, #3r); *Rustam Kills White Div* (cat. 79 B and Appendix 2, #6v); *The Execution of Afrasiyab* (cat. 86 B and Appendix 2, #15v); *and Rustam Kicks Aside the Rock Thrown by Bahman* (cat. 88 B and Appendix 2, #16r).

43 The following discussion draws on Clinton and M. S. Simpson 2006b; see 183 for an explanation of White Div's name.

44 See Titley 1983, pl. 42, and Uluç 2000a, ms. no. 61, for another similar and roughly contemporary version of this scene, in a Shiraz *Shāhnāma* now in Topkapı Palace Museum Library, Istanbul (H. 1475, fol. 80a). This painting includes a div prancing above the upper ruling in a fashion comparable to that of a div in another illustration in the 1562 Calderwood *Shāhnāma* (2002.50.153r, cat. 82 B).

45 Khaleghi-Motlagh 1987–2008, 2:43, verse 580; the critical verse is the first in the fifth line in the upper text panel of the illustration.

46 Uluç 2006, figs. 105, 224–26, 241, 244, 320–21.

47 Judging from the various double-page illustrations of the scene reproduced in the Shahnama Project database, this practice was well entrenched by the 1560s, and perhaps even earlier. See also Stanley 2004, 95–96 and fig. 7.3; Clinton and M. S. Simpson 2006a, 225–28 and figs. 1–2; Uluç 2006, 226 and fig. 183.

48 Although the two double-page compositions in the Calderwood Collection depict distinctive scenes, they share the same layout, with two lines of illuminated text at the top and bottom of each facing side and an illuminated border enframing the whole. In both cases the text is continuous. An intact *Shāhnāma* attributed to circa 1590–95, and thus later than the presumed date of the circa 1575–90 Calderwood *Shāhnāma*, contains five double-page compositions, including the familiar scene of Luhrasp enthroned: see Uluç 2000a, 512–13, ms. no. 72. It is tempting to imagine that the Calderwood manuscript originally had additional double-page illustrations.

49 Davis 1992, xxvii and 108–29.

50 Uluç 2006, figs. 74–75, 93, 124.

51 Clinton 1984; Clinton 1987; Davis 1992, 103–8; Clinton 2001, 68–69.

52 A very few sixteenth- and seventeenth-century volumes, albeit none from Shiraz, illustrate two of the three scenes on successive folios. These include the Tahmasp *Shāhnāma*, 1520s–30s, dispersed folios 155a and 156b: see Canby 2011, pls. 123–24. They also include a *Shāhnāma* dated 1014–16 (1605–8), in the Metropolitan Museum of Art, New York, 13.228.16, fols. 104a and 105a: see Jackson and Yohannan 1914, 20–27. These two 1605–8 folios are reproduced in the Shahnama Project database, where the date of the manuscript is given as 1607. See also Clinton 2001, pl. 2; Uluç 2006, figs. 116, 119.

53 Davis 1992, 108–11.

54 In addition to the references in n. 6 above, see Hillenbrand 2002, 154–55; Soucek 2000.

Appendix 1

Shāhnāma copied by Muhammad al-Qivam al-Katib al-Shirazi, dated Ramadan 969 (May–June 1562), Shiraz.

37 folios (19 text, 16 illustrated), Calderwood Collection, 2002.50 . . . ; listed here by final digits of accession numbers, followed by catalogue numbers in this volume.

19 folios (13 illustrated and catalogued, 6 illustrated and listed as removed from ms.), Christie's, 17 October 1995, lot 79; listed here in brackets.

Folio numbers are later additions and may not correspond to the original foliation of the manuscript.

Folio	Acc. and cat. nos.	Khaleghi-Motlagh edition (except prose preface refs.)	Cycle	Content
3a	.27r, cat. 73	364, lines 5–9		illuminated frontispiece with prose preface[1]
3b	.27v	364, line 10–367, line 7		prose preface
11a	.137r, cat. 74	402, line 7–405, line 20		prose preface
11b	.137v	402, line 21–408, line 10		prose preface
13a	.123r	416, line 11–418, line 4 + addnl. text		prose preface with illuminated conclusion
13b	.123v, cat. 75	I:3–5, vv. 1–34	Preface	illuminated titlepiece with opening SN verses
16a	.151r	I:12–15, vv. 108–55 + 1 v.	Preface	text
16b	.151v, cat. 76 A	I:15–18, vv. 156–205	Preface	illuminated text
17a	.150r, cat. 76 B	I:18, v. 206–21, v. 7	Preface/Gayumars	illustration: *Court of Gayumars*
17b	.150v	I:22–24, vv. 8–55 + 1 v.	Gayumars	text
27a	.166r	I:114–17, vv. 394–447	Faridun	text
27b	.166v, cat. 77 A	I:117–20, vv. 448–93	Faridun	illuminated text
28a	.165r. cat. 77 B	I:120–21, vv. 494–512	Faridun	illustration: *Murder of Iraj*
28b	.165v	I:121–24, vv. 513–42	Faridun	text

Folio	Acc. no.	Khaleghi-Motlagh edition	Cycle	Content
49a	.129r	I:254–56, vv. 1300–1355	Manuchihr	text
49b	.129v, cat. 78 A	I:258–62, vv. 1356–1409	Manuchihr	illuminated text
50a	.28r, cat. 78 B	I:262–63, vv. 1410–21	Manuchihr	illustration: *Marriage of Zal and Rudaba*
50b	.28v	I:264–67, vv. 1425–70	Manuchihr	text
66a	.134r	II:36–40, vv. 487–535	Kay Kavus	text
66b	.134v, cat. 79 A	II:40–43, vv. 537–77	Kay Kavus	illuminated, diagonal text
67a	.42r, cat. 79 B	II:43, vv. 578–89	Kay Kavus	illustration: *Rustam Kills White Div*
67b	.42v	II:43–47, vv. 590–638	Kay Kavus	text
75a	.156r	II:96–99, vv. 376–421	Kay Kavus	text
75b	.156v, cat. 80 A	II:99–101, vv. 422–42; 103–5, vv. 1–33	Kay Kavus	illuminated text
76a	.155r, cat. 80 B	II:105–7, vv. 34–49	Kay Kavus	illustration: *Rustam and Iranians Hunt in Afrasiyab's Preserves*
76b	.155v	II:107–10, vv. 50–100	Kay Kavus	text
[83a	79.6]	II:185ff.	Sohrab	[illustration: *Rustam Mourns (?) Sohrab*]
100a	.128r	II:296–99, addnl. vv. after n. 19–v. 1479	Siyavush	text
100b	.128v, cat. 81 A	II:299–303, vv. 1480–532	Siyavush	illuminated text
101a	.25r, cat. 81 B	II:303–5, vv. 1533–48	Siyavush	illustration: *Marriage of Siyavush and Farangis*
101b	.25v	II:305–8, vv. 1549–98	Siyavush	text
108a	.154r	II:353–58, vv. 2235–86	Siyavush	text
108b	.154v, cat. 82 A	II:358–61, vv. 2286–319	Siyavush	illuminated, diagonal text

Folio	Acc. no.	Khaleghi-Motlagh edition	Cycle	Content
109a	.153r, cat. 82 B	II:361–62, vv. 2320–38	Siyavush	illustration: *Guruy Executes Siyavush*
109b	.153v	II:362–66, vv. 2339–91	Siyavush	text
124a	.148r	III:16–19, vv. 228–76	Kay Khusraw	text
124b	.148v, cat. 83 A	III:19–20, vv. 277–91	Kay Khusraw	illustration: *Kay Khusraw Reviews His Troops*
125a	.149r, cat. 83 B	III:20–23, vv. 293–344	Kay Khusraw	illuminated text
125b	.149v	III:23–24, vv. 345–65; III:27–28, vv. 1–25	Kay Khusraw	text
133a	.159r	III:71–73, vv. 708–53	Kay Khusraw	text
133b	.159v, cat. 84 A	III:73–74, vv. 754–69	Kay Khusraw	illustration: *Piran Attacks the Iranians at Night*
134a	.160r, cat. 84 B	III:74–77, vv. 770–818	Kay Khusraw	illuminated text
134b	.160v	III:77–80, vv. 819–65	Kay Khusraw	text
[150a	79.11]		Kamus-i Kashani	[illustration: *Rustam Slays Ashkabus and His Horse*]
[159b	79.12]		Rustam and Khaqan-i Chin	[illustration: *Rustam Lassoes the Khaqan of Chin*]
[168b	79.13]		Rustam and the Div Akhvan	[illustration: *Rustam Thrown into the Sea by the Div Akhvan*]
[182a	79.14]		Bizhan and Manizha	[illustration: *Rustam Rescues Bizhan from the Pit*]
[193a	79.15]		Twelve Rukhs	[illustration: *Bizhan Kills Human*]
231a	.168r	IV:270–74, vv. 1563–610	Great War	text
231b	.168v, cat. 85 A	IV:274–76, vv. 1610–45	Great War	illuminated, diagonal text
232a	.167r, cat. 85 B	IV:276–77, vv. 1646–57	Great War	illustration: *Iranians Repel Afrasiyab's Night Attack*
232b	.167v	IV:277–80, vv. 1658–709	Great War	text

Folio	Acc. no.	Khaleghi-Motlagh edition	Cycle	Content
239a	.162r	IV:316–19, vv. 2269–316	Great War	text
239b	.162v, cat. 86 A	IV:319–22, vv. 2317–58	Great War	illuminated text
240a	.161r, cat. 86 B	IV:322–23, vv. 2359–74	Great War	illustration: *Execution of Afrasiyab*
240b	.161v	IV:323–26, vv. 2375–423	Great War	text
[257–58]				[illustration removed]
[263a	79.18]		Gushtasp	[illustration: *Arjasp's Troops Fight the Turanians*]
269a	133r	V:171–77, vv. 1004–56	Gushtasp	text
269b	133v, cat. 87 A	V:177–81, vv. 1057–98	Gushtasp	illuminated, diagonal text
270a	.41r, cat. 87 B	V:181–82, vv. 1099–108	Gushtasp	illustration: *Death of Luhrasp in Battle against the Forces of Arjasp*
270b	.41v	V:182–85, vv. 1109–55	Gushtasp	text
292a	.164r	V:16 lines + 314–17, vv. 288–303	Rustam and Isfandiyar	text
292b	.164v, cat. 88 A	V:317–19, vv. 304–335 + 1 v.	Rustam and Isfandiyar	illuminated text
293a	.163r, cat. 88 B	V:320, vv. 336–44	Rustam and Isfandiyar	illustration: *Rustam Kicks Aside the Rock Thrown by Bahman*
293b	.163v	V:320–23, vv. 345–80	Rustam and Isfandiyar	text
[300a	79.20]		Rustam and Isfandiyar	[illustration: *Rustam Fights Isfandiyar*]
[313b	79.21]		Rustam and Isfandiyar	[illustration: *Rustam, Dying, Kills Shaghad*]
[344a	79.22]		Iskandar	[illustration: *Iskandar Comforts the Dying Dara*]
[360–61]				[illustration removed]
[371–72]				[illustration removed]

Folio	Acc. no.	Khaleghi-Motlagh edition	Cycle	Content
401a	.157r	VI:372–76, vv. 149–92	Yazdigird	illuminated, diagonal text
401b	.157v, cat. 89 A	VI:376, vv. 193–99	Yazdigird	illustration: *Bahram Gur Hunts with Azada*
402a	.158r, cat. 89 B	VI:376–80, vv. 200–248	Yazdigird	illuminated text
402b	.158v	VI:380–84, vv. 249–97	Yazdigird	text
[419–20]				illustration removed
[440a	79.24]		Anushirvan	[illustration: *Anushirvan's Army Besieges the Roman Fort of Arayish*]
[488b	79.25]		Hurmuzd	[illustration: *Bahram Chubina Kills Sava*]
[497–98]				illustration removed
506a	.132r	VII:616–21, vv. 1788–840	Hurmuzd	text
506b	.132v. cat. 90 A	VII: 621–25, vv. 1842–91	Hurmuzd	illuminated text
507a	.40r, cat. 90 B	VII:625–26, 1 v. + vv. 1893–901	Hurmuzd	illustration: *Gushtaham and Banduy Blind Hurmuzd*
507b	.40v	VII: 626–29, vv. 1899–926; VIII:4, vv. 1–15	Hurmuzd; Khusraw Parviz	text
[519a	79.27]		Khusraw Parviz	[illustration: *Khusraw's Son Shirvi Sent to School*]
[522–23]				[illustration removed]
572a	.122r	VIII:670–72, vv. 698–723	Yazdigird	illuminated, diagonal text
572b	.122v, cat. 91 A	VIII:672–73, vv. 724–37 + 1 v.	Yazdigird	illustration: *Burial of Yazdigird*

Folio	Acc. no.	Khaleghi-Motlagh edition	Cycle	Content
573a	.136r, cat. 91 B	VIII:673–75, vv. 738–65	Yazdigird	illuminated text
573b	.136v	VIII:675–78, vv. 766–95 + 1 v.	Yazdigird	text
576a	.124r	VIII:686–87, vv. 677 (5th line)– 892 (20th line) + 5 lines	Yazdigird	text
576b	.124v, cat. 92	not in Khaleghi-Motlagh		illuminated, diagonal text
577a	.138r, cat. 93	not in Khaleghi-Motlagh		illuminated text and colophon

1 The prose preface references come from Riyāḥī 1993.

Appendix 2

Shāhnāma, circa 1575–90, Shiraz.

10 illustrated folios, Calderwood Collection, 2002.50 . . . ; listed here as CC and by final digits of accession numbers, followed by catalogue numbers in this volume.

12 illustrated folios in the following collections and auctions: Asian Civilizations Museum, Singapore (ACM); British Museum, London (BM); David Collection, Copenhagen (DC); Los Angeles County Museum of Art (LACMA); Museum Rietberg, Zurich (MR); Sotheby's, London, 5 April 2006 (SOTH 2006).

5 illustrated folios in private collections, London (#11, #21, and #22 courtesy of Simon Ray).

This manuscript does not seem to have been foliated, although page numbers have been added in graphite and are given here in brackets.

Order	Collection	Khaleghi-Motlagh edition (except prose preface refs.)	Cycle	Content
#1a	CC .37r			seals
#1b	CC .37v. cat. 94			illustrated frontispiece: *Solomon Enthroned*
#2a	SOTH 2006, lot 39r			illustrated frontispiece: *Bilqis Enthroned*
#2b [4]	SOTH 2006, lot 39v	364, lines 1–4		illuminated frontispiece with prose preface[1]
#3a	DC No. 56/2007r	I:18–22, vv. 207–11	Gayumars	illustration: *Court of Gayumars*
#3b [30]	DC No. 56/2007v	I:22–24, vv. 19–59	Gayumars	text
#4a(?)	SOTH 2008, lot 40	I:151, vv. 994–99	Faridun	illustration: *Manuchihr Kills Salm*
#5a [151]	ACM 2009-01606r	I:347–48, vv. 36–43	Kay Kubad	illustration: *Rustam Lifts Afrasiyab from the Saddle by His Belt*
#5b	ACM 2009-01606v	I:348–51, vv. 44–96	Kay Kubad	text
#6a	MR	II:39–42, vv. 531–71	Kay Kavus	illuminated, diagonal text
#6b	MR	II:42–43, vv. 572–83	Kay Kavus	illustration: *Rustam Kills White Div*

Order	Collection	Khaleghi-Motlagh edition	Cycle	Content
#7a [203]	CC .32r	II:185–87, 2 vv. in n. 24–v. 874	Sohrab	illuminated, diagonal text
#7b [204]	CC .32v, cat. 95 A	II:187, vv. 875–82	Sohrab	illustration: *Rustam Mourns Sohrab*
#8a [205]	CC .131r, cat. 95 B	II:187–88, vv. 883–91	Sohrab	illustration: *Rustam Carries Sohrab's Coffin*
#8b [206]	CC .131v	II:188–91, vv. 892–935	Sohrab	text
#9a [217]	CC .142r	II:233–34, vv. 470–96	Siyavush	illuminated, diagonal text
#9b [218]	CC .142v, cat. 96 A	II:234, vv. 497–504	Siyavush	illustration: *Trial by Fire of Siyavush* (right side)
#10a [219]	CC .143r, cat. 96 B	II:234–37, vv. 505–18	Siyavush	illustration: *Trial by Fire of Siyavush* (left side)
#10b [220]	CC .143v	II:237–40, vv. 519–70	Siyavush	text
#11a	private collection	II:403, vv. 309–16	Kay Kavus	illustration: *Human Rescues Afrasiyab from Rustam*
#11b	private collection	II:403–8, vv. 317–67	Kay Kavus	text
#12b [351]	SOTH 2006, lot 42	III:184–85, vv. 1305 n. 18–1309	Kamus-i Kashani	illustration: *Rustam Slays Ashkabus and His Horse*
#13a [425]	CC .35r, cat. 97	III:381, 1 v. + vv. 1052–58	Bizhan and Manizha	illustration: *Rustam Rescues Bizhan from the Pit*
#13b [426]	CC .35v	III:381–84, vv. 1059–96	Bizhan and Manizha	text
#14a [473]	CC .38r	IV:154–55, vv. 2357–79	Twelve Rukhs	illuminated, diagonal text
#14b [474]	CC .38v, cat. 98	IV:155–56, vv. 2380–86	Twelve Rukhs	illustration: *Gudarz Pays Homage to Kay Khusraw and Shows Him the Enemy Corpses*
#15b [534?]	SOTH 2006, lot 41	IV:322–23, vv. 2364–82	Great War	illustration: *Execution of Afrasiyab*
#16a [627]	BM 2006,0420,0.1	V:319–20, vv. 335–41	Rustam and Isfandiyar	illustration: *Rustam Kicks Aside the Rock Thrown by Bahman*
#16b [628]	BM 2006,0420,0.1	V:320–23, vv. 342–78 + 1 v.	Rustam and Isfandiyar	text

Order	Collection	Khaleghi-Motlagh edition	Cycle	Content
#17a	LACMA M.2009.44.4(r)	V:412, vv. 1380–87	Rustam and Isfandiyar	illustration: *Rustam Shoots Isfandiyar with a Double-Pointed Arrow*
#17b	LACMA M.2009.44.4(v)	V:412–17, vv. 1388–439	Rustam and Isfandiyar	text
#18a [691]	CC .34r	V:552–55, vv. 298–328	Dara	illuminated, diagonal text
#18b [692]	CC .34v, cat. 99	V:555, vv. 329–36	Dara	illustration: *Iskandar Mourns the Dying Dara*
#19a [725?]	CC .36r, cat. 100	VI:95, vv. 1396–403	Iskandar	illustration: *Iskandar Meets the Angel Israfil and Khizr Finds the Water of Life*
#19b [726]	CC .36v	VI:95–99, vv. 1303–452	Iskandar	text
#20a	private collection	VI:202–3, vv. 128–35	Ardashir Babakan	illustration: *Ardashir Recognizes His Son Shapur during a Polo Game*
#20b	private collection	VI:203–6, vv. 136–86	Ardashir Babakan	text
#21a [833]	private collection	VI:514–17, vv. 1314–61	Bahram Gur	text
#21b [834]	private collection	VI:517–18, vv. 1362–79	Bahram Gur	illustration: *Bahram Gur Hunts Onagers*
#22a [877?]	private collection	VII:88–89, vv. 14–19	Anushirvan	illustration: *Anushirvan Enthroned*
#22b	private collection	VII:89–92, vv. 21–68	Anushirvan	text
#23a [895]	LACMA M.2009.44.29(r)	VII:154–59, vv. 852–900	Anushirvan	text
#23b	LACMA M.2009.44.29(v)	VII:158–59, vv. 897–900	Anushirvan	illustration: *Piruz Advises Nushzad not to Rebel against Anushirvan*

Order	Collection	Khaleghi-Motlagh edition	Cycle	Content
#24a [919]	private collection	VII:253, vv. 1982–95	Anushirvan	illustration: *Nushirvan's Armies Stage a Mock Battle*
#24b [920]	private collection	VII:254–57, vv. 1996–2043	Anushirvan	text
#25a	LACMA M.2009.44.1(r)	VII:539–40, vv. 893–900	Hurmuzd	illustration: *Bahram Chubina Kills Sava*
#25b	LACMA M.2009.44.1(v)	VII:540–44, vv. 901–50	Hurmuzd	text
#26a [1021?]	LACMA M.2009.44.3(r)	VIII:46, vv. 584–91	Khusraw Parviz	illustration: *Khusraw Parviz Fires an Arrow at Bahram Chubina*
#26b [1022]	LACMA M.2009.44.3(v)	VIII:47–50, vv. 592–640	Khusraw Parviz	text
#27a [1041?]	CC .14r, cat. 101	VIII:132–33, vv. 1736–45	Khusraw Parviz	illustration: *Bahram Chubina Slays Kut of Rum*
#27b [1042]	CC .14v	VIII:133–36, vv. 1746–93	Khusraw Parviz	text

1 The prose preface references come from
Riyāḥī 1993.

Technical Observations on a *Shāhnāma* Manuscript

Penley Knipe, with
material analysis by
Katherine Eremin

Of the ninety-two works on paper in the Calderwood Collection, seventy-seven are folios that have been disbound from manuscripts. The majority of these may be grouped into two sets, both from illustrated manuscripts of the great epic poem the *Shāhnāma* (Book of Kings) by the Persian poet Abu'l-Qasim Firdawsi. The larger set, with thirty-seven folios, preserves a colophon stating that it was copied in Shiraz in 1562 by the calligrapher Muhammad al-Qivam al-Katib al-Shirazi.[1] The second set, comprising ten folios,[2] contains no information regarding its place or date of creation, but on art-historical grounds Marianna Shreve Simpson has assigned it to Shiraz, circa 1575–90. In her essay in this catalogue, Simpson places these two manuscript fragments in their historical, art-historical, and codicological contexts (see 77–113).

To understand the fragmentary manuscripts more fully, technical examinations were undertaken at the Straus Center for Conservation and Technical Studies. In particular, these examinations focused on the ten folios from the circa 1575–90 *Shāhnāma*, in the hope that analysis of the materials and techniques would shed light on whether these leaves did indeed come from a single manuscript. Furthermore, on several of the paintings from this group a layer of blue paint had been somewhat crudely applied; would analysis reveal it to be the work of a later hand, retouching damaged sections? Because of the secure attribution and date for the 1562 *Shāhnāma*, its folios were also studied as a standard: would they prove similar to those from a manuscript produced more than a decade later? Aiming to illuminate artistic practice in sixteenth-century Shiraz, this essay focuses on four paintings, three from the circa 1575–90 set and one from the 1562 set, and devotes special attention to divergent findings and to subjects less well understood, such as underdrawing and binding media.

Rustam Rescues Bizhan from the Pit, from the circa 1575–90 manuscript of the *Shāhnāma*, cat. 97, detail.

115

Examination, Analytical Tools, and Comparative Analysis

When looking at layered and complex works, it is helpful to understand how they were created and what kind of paper and tools were used. Two contemporary treatises on the craft of Persian painting offer valuable insight into process: *Qānūn al-ṣuvar* (The Canons of Painting) by Sadiqi Beg,[3] dating to the fourth quarter of the sixteenth century, and *Gulistān-i hunar* (The Rose Garden of Art) by Qazi Ahmad,[4] from circa 1596. Reference to these writings is included in relevant parts of this essay.

In the laboratory, magnification and a variety of light sources provided valuable physical evidence of how the paintings were created and possibly altered. The pages were examined with a binocular microscope and with ultraviolet light and infrared illumination. Ultraviolet examination may highlight restorations, as these changes often fluoresce differently from adjacent original material. Examination by infrared reflectography (IRR) renders many pigments transparent and can reveal underdrawing done in infrared-absorbent materials, such as carbon.[5] For example, an underdrawing executed in charcoal, though hidden by pigment in normal light, will be visible on the reflective white paper substrate. Transmitted light (light shining through the paper from below) was used to study paper structure and to scan the borders to determine if the edges of the manuscript pages were original.

Material analysis provided a complementary means of characterizing these paintings.[6] The colorants, that is, the pigments used to make the opaque watercolors, were analyzed with X-ray fluorescence spectroscopy (XRF), micro-raman spectroscopy (Raman), Fourier-transform infrared spectroscopy (FTIR), scanning electron microscopy with energy dispersive microanalysis (SEM-EDS), and polarized light microscopy. Paper fibers were analyzed via polarized light microscopy.[7] XRF is a non-destructive method of testing that provides information for those elements with atomic weights above potassium. Raman provides in situ non-invasive molecular analysis for inorganic and some organic compounds. Additional organic compounds, including pigment binders (the sticky material that causes the pigment to adhere to the paper), can be identified by FTIR, which requires a microscopic sample.[8] SEM-EDS yields information about structure, topography, and elemental composition but like FTIR requires a small sample.

This essay also draws upon earlier analytical studies of Islamic painting. Nancy Purinton and Mark Watters's 1991 study of nineteen fifteenth- to seventeenth-century Persian paintings in the Los Angeles County Museum of Art includes an excellent review of the historical literature and earlier analytical work and provides a summary of how pigments were made and how the artists worked.[9] More recent research has supplemented knowledge of the palette of sixteenth-century Persian painters via the use of Raman spectroscopy. The picture that has emerged from previous studies, combined with our analysis of the Calderwood folios, suggests

the use of a reasonably consistent palette that is discussed below and summarized in the accompanying table.[10]

The circa 1575–90 *Shāhnāma*

The folios of the circa 1575–90 *Shāhnāma* (for example, fig. 1) were painted in opaque watercolor, shell gold, and black ink onto paper framed with ruling lines and wide margins decorated with gold and silver designs. The paper substrates are continuous sheets. Although the truncation of the margin designs indicates that the folios have been trimmed along the non-bound edges, new edges have not been added.

Paper

Paper samples were taken from one folio of the 1575–90 set, as well as from one of the 1562 folios.[11] Both folios proved to be made of bast fibers, as is typical for Persian papers from this period. There was nothing to distinguish the papers from each other. Both were light tan in color and finely made, with a relatively even distribution of fibers. In traditional practice, paper was burnished before receiving ink or paint, and reburnished throughout the process of painting to lock the painted layers together.[12] In both sets of Calderwood folios, the paper surface exhibits the characteristic sheen indicative of burnishing; in raking light, striations in various directions are visible, the result of burnishing in one direction and then another.

Artistic Practice and Process

In Persian paintings of this period, underdrawing was done with a brush or with a charred stick that produced a dry, black carbonaceous line. To judge from the fluid nature of the red lines visible in areas of paint loss, the underdrawing on the circa 1575–90 *Shāhnāma* was applied with a brush (fig. 2). The composition of the red ink is not known, but it strongly resembles a dilute form of the red ink used for the final outlines around faces and hands (fig. 3). Microscopic examination also showed a less common presence of lines in black ink alongside the red. The 1562 *Shāhnāma* folio had two types of underdrawing: the brush-applied red ink, and charcoal. Purinton and Watters found twelve examples of underdrawing where the range of colors suggested they may have been a mix of leftover pigments from the painter's palette.[13] The fact that the red lines observed in the current study appeared similar to the final red outline supports the hypothesis that the choice of underdrawing material was determined in part by what was readily available in the workshop.

IRR examination of both manuscripts revealed occasional minor adjustments to the composition. The rock outlines in *Iskandar Mourns the Dying Dara* (fig. 1), for

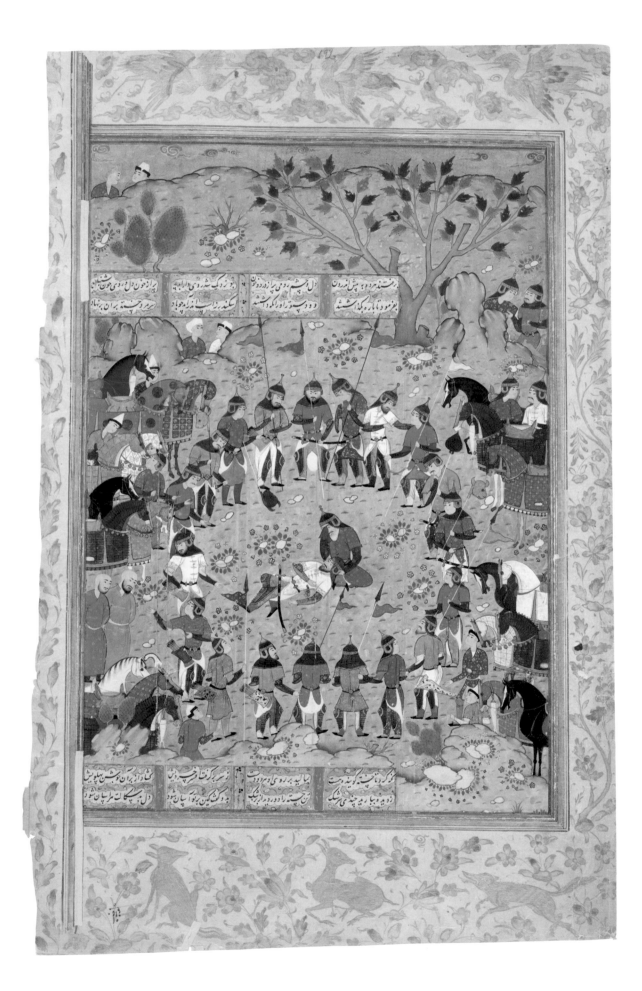

118

example, were shifted slightly, and leaves were turned into grassy tufts (figs. 4 and 5). In another area to the left of the center of this painting, a bulky robe was redrawn as a trim pair of pants. Generally, however, the underdrawing was used simply to place elements prior to the application of opaque watercolor. Overall, IRR examination of each painting revealed a sure hand that did not experiment and made few changes to the composition.

The highly consistent rendering of tiny details in flowers, horses, and rock surfaces suggests that all ten paintings from the circa 1575–90 Shāhnāma were indeed produced at the same workshop. The color gradation in the blue and purple background landscape and the pale orange foreground rocks was achieved with many strokes of a small brush. Fine parallel hatching produced the subtly rendered effects of volume and depth (fig. 4). In some paintings, hatched lines in multiple pigments were used systematically to create shadows of unusual color. In all ten folios, the rulings are nearly identical, including green lines that in some cases have mostly flaked away.

Careful study of *Iskandar Mourns the Dying Dara* (fig. 1) revealed some particulars about the artistic process and the sequence in which the painting was completed. The white details, as seen in the banner poles, were among the last executed. The full articulation of the rocks also came late in the process, as some remain unfinished.[14] In most paintings, however, the rocks were completed with heavy outlines in purple-red and black and the previously mentioned fine lines of colored shading. *Iskandar Mourns the Dying Dara* has outlines in red ink around faces and hands, a finishing step that lies on top of the rest of the design (fig. 3).

In the intercolumnar rulings, a thick and rather sloppily applied blue sometimes covers adjacent elements in the painting and text. Hints of a blue layer beneath it suggest that the thick blue may be later overpainting. Gold details were painted

Fig. 1
Iskandar Mourns the Dying Dara,
from the circa 1575–90 manuscript
of the *Shāhnāma*, cat. 99.

Fig. 2
Photomicrograph (field of view 6 mm)
showing red underdrawing in detail of
Rustam Rescues Bizhan from the Pit,
from the circa 1575–90 manuscript
of the *Shāhnāma*, cat. 97.

Fig. 3
Photomicrograph (field of view
9 mm) of face outlining in detail of
Iskandar Mourns the Dying Dara,
cat. 99.

Fig. 4
Video Spectral Comparator
image (field of view 33 mm),
detail of upper right of *Iskandar
Mourns the Dying Dara*, cat. 99.

Fig. 5
Video Spectral Comparator
IRR image (field of view 33 mm),
detail of upper right of *Iskandar
Mourns the Dying Dara*, cat. 99.

Fig. 6
Photomicrograph (field of view
10 mm) of background paint
going over script in detail of
Iskandar Mourns the Dying Dara,
cat. 99.

with shell gold (finely powdered gold mixed with a binder). The use of powdered gold rather than leaf was traditional for Persian painting of this period; it is visually confirmed by the appearance of the gold as flecks with small surrounding lacunae.

Consistent with previous studies, the black ink used for the text and the black watercolor pigment in the painting were both found with Raman spectroscopy and IRR examination to be carbon based (see table). Traditionally, ink, which was applied with reed pens, was soot-based (carbon), with additional ingredients adjusted to achieve the desired working properties.[15] The writing was often done before the pages were painted and illuminated, as evidenced by the script underneath paint in a detail of the upper-right corner of the lower text panel in *Iskandar Mourns the Dying Dara* (fig. 6). This physical evidence supports the Shiraz workshop system described in the late sixteenth century by Budaq Qazvini, who mentions folios passing from scribe to painter to illuminator (see Simpson, 78).

Palette

The colorants used in *Iskandar Mourns the Dying Dara* (fig. 1) proved to be consistent with the palette described in previous studies and artists' treatises. The yellows were from orpiment, the soft yellow sulfide of arsenic. The green in Dara's costume and in the plant and tree leaves, whether dark or light, was prepared with orpiment mixed with indigo, a dark blue dye from the *Indigofera* plant genus. White lead was mixed in to make lighter shades of green.[16] The intense blue of Iskandar's handkerchief was ultramarine, while the blue of the background landscape was a combination of lead white and indigo, giving a much softer and less saturated color. Other swatches of deep blue were also painted with ultramarine. Compared to other pigments, the ultramarine was generally very coarsely ground. The nearly black helmets were colored with silver, now tarnished and dark. The purple upper background contained lead white, ultramarine, and an unidentified pink colorant. The gray horse at the lower left and the gray costume at the lower center were both

executed in ultramarine and lead white mixed with at least one other color. Under magnification, the brown branches were inhomogeneous, and FTIR analysis showed that lead white, hematite, orpiment, and bone black[17] were present.

Reds in the painting were achieved in two ways: vermilion for deeper reds, and red lead for an oranger hue. This is true of reds used in larger areas, such as costumes, and in the minutest details of the flowers (fig. 7). Such a level of particularity suggests that even non-court workshops had a highly tuned sensibility. Many whites were achieved with lead white alone, while others had a little blue mixed in to soften them; the white pigment of the horse at the lower left of *Iskandar Mourns the Dying Dara*, for example, shows ultramarine scattered throughout. Skin tones were achieved by mixing white lead and red lead.

Some colors—ultramarine and vermilion, for instance—were applied in unadulterated form. Others, such as a green made from orpiment and indigo, were achieved through mixing pigments. Purple was made by mixing ultramarine and lead white with an unidentified component, probably an organic red. The supine figure of Dara was singled out not only by his position in the center of the composition but also by the color of his robe: a yellow made more brilliant than other yellows in the painting by mixing vermilion with orpiment. Mixed pigments also were used to produce more muted colors: the paler brown of the tree branches was achieved by the previously mentioned hematite mixture, whereas the deep red-brown of the horse at the right was hematite alone.

Study of *Iskandar Meets the Angel Israfil and Khizr Finds the Water of Life* (fig. 8) presented a mystery. The blue of the night sky at the top looked flat and heavy-handed, visually out of step with the rest of the painting. Under magnification, it appeared thick and bore an awkward relationship to its neighbors, as in the clumsy way in which it surrounded Israfil's profile. In places it covered red outlines that should have been finishing touches (fig. 9); in other areas, losses revealed that there may have been an earlier layer of blue paint beneath it (fig. 10.) Together, these observations suggest that the sky was repainted. If so, the retouching artist used

Fig. 7
Photomicrograph (field of view 12 mm) of vermilion and red lead flowers in detail of *Iskandar Mourns the Dying Dara*, cat. 99.

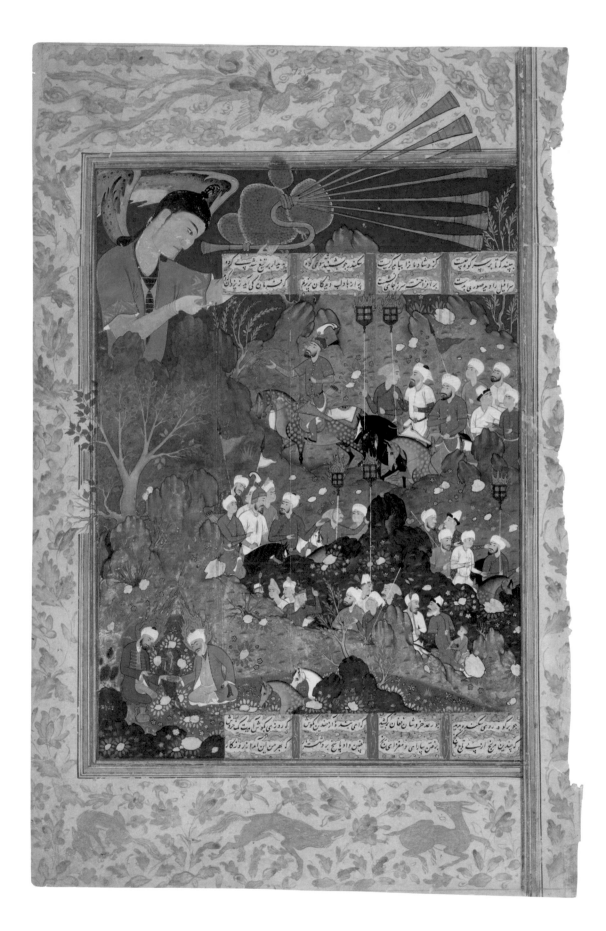

traditional pigments—natural, coarsely ground ultramarine for the blue and silver for the stars—and the reworking may be quite old.[18] Elsewhere in the painting, ultramarine passages were also coarsely ground, although applied somewhat more thinly and not covering finishing details. If the blue of the sky is original, its poor execution reveals uneven quality within a workshop.

The rest of *Iskandar Meets the Angel Israfil* was more in keeping with the other nine folios in terms of pigments and technique. Fine details, including the horses' spots, petals of flowers, and unfinished rocks, were consistent. The whites, such as the torch staffs, were again applied as a final step. Of note in this painting were the grid lines for text, visible in a detail of an unpainted rock at the upper right (fig. 11) and running down the vertical length of the painting.[19] Prior to the application of paint, the paper was prepared as a four-column text page. Its use for illustration reinforces the concept of the workshop functioning as an assembly line where paper was treated uniformly regardless of its ultimate use.[20] The palette of this painting was unremarkable except for the more liberal mixing of orpiment in many of the colors, producing a darker, more muted tonality than that of *Iskandar Mourns the Dying Dara*.

The pigments found in a third painting from the circa 1575–90 manuscript, *Rustam Rescues Bizhan from the Pit* (fig. 12), were consistent with those of the other two illustrations, and Raman analysis was more informative in determining the mixtures. FTIR found that the purple background contained lead white, ultramarine, vermilion, orpiment, and possibly an organic red colorant. The brown branch was found to be a mix of orpiment, red lead, vermilion, hematite, and carbon black— more pigments than were used for the branches in *Iskandar Mourns the Dying Dara*. Each of the wonderfully multicolored leaves was painted with either red lead, orpiment, vermilion, or combined orpiment and indigo; transparent glazes were added over the leaf tips. Raman analysis identified the glaze in some areas as red lead and in others as red lead mixed with an unidentified colorant. FTIR

Fig. 8
Iskandar Meets the Angel Isfrafil and Khizr Finds the Water of Life, from the circa 1575–90 manuscript of the *Shāhnāma*, cat. 100.

Fig. 9
Photomicrograph (field of view 11 mm) showing blue paint over red outline in detail of *Iskandar Meets the Angel Israfil and Khizr Finds the Water of Life*, cat. 100.

Fig. 10
Photomicrograph (field of view 6 mm) showing two possible layers of blue in detail of *Iskandar Meets the Angel Israfil and Khizr Finds the Water of Life*, cat. 100.

Fig. 11
Photomicrograph (field of view 14 mm) of grid lines in detail of *Iskandar Meets the Angel Israfil and Khizr Finds the Water of Life*, cat. 100.

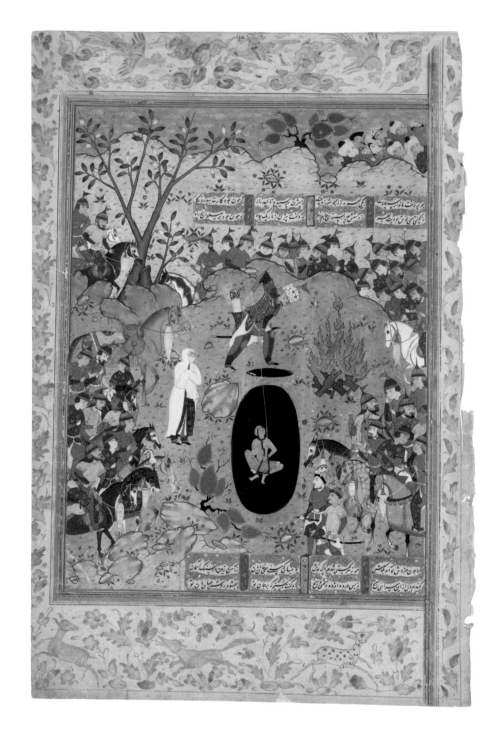

Fig. 12
Rustam Rescues Bizhan from the Pit,
from the circa 1575–90 manuscript
of the *Shāhnāma*, cat. 97.

confirmed red lead, but the glaze colorant remained unidentified. Water extraction on the glaze sample indicated the presence of a carbohydrate binder, such as a gum.

One of the most enigmatic elements in the painting is the pit, which is depicted as two highly burnished, undifferentiated black ovals so flat and prominent that they might appear to be poorly executed alterations. There are areas of paint loss in the horizontal oval that indicates the mouth of the pit (fig. 2), but the use of IRR and transmitted light provided little evidence to suggest that either area—the mouth or the cavern—had been retouched. A ground layer of lead white was

identified by XRF and FTIR and confirmed microscopically. Optical and FTIR analyses of a sample of the black paint layer from the mouth of the pit revealed that it was carbon-based, and that the binder was a carbohydrate, probably a gum. Examined in cross section and with SEM-EDS, the sample disclosed the surprising presence of scraps of gold and silver leaf (fig. 13). Could the metals have been leftovers from the workshop, thrown into the carbon-black colorant? If so, why was this done? Optical microscopy detected gold particles on the surface of the pit's cavern, perhaps transferred from an adjacent folio. Extensive XRF analysis did not find gold and silver in the cavern section itself, probably because they occur in isolated patches, easily missed with instrumentation. For now, at least, the pit keeps its secrets.

The 1562 *Shāhnāma*

One painting from the 1562 manuscript, *The Marriage of Zal and Rudaba* (fig. 14), was analyzed as a comparison to the three from the circa 1575–90 *Shāhnāma*. More finely executed than the later paintings, it features greater detail and delicacy of shapes, colors, and surface patterns, but its palette is mostly similar. The smooth and well-ground orange of the robe worn by the youth just to the left of the lower text block was painted with red lead, while the deep red of the skirt of a bearded man in the doorway was vermilion. A yellow costume of another youth, at the right within the doorway, was painted in orpiment with some vermilion added, as was Dara's robe in *Iskandar Mourns the Dying Dara*. All whites were identified as lead white. FTIR confirmed that the purple robe of another figure in the doorway contained lead white, gypsum, and vermilion, but found nothing to account for its blue cast; a water extraction micro-test indicated the presence of a carbohydrate binder, such as a gum, in this robe. The light green of the floor of the balcony at the upper left contained lead white and verdigris (a copper green), with a water-soluble protein binder, such as an animal glue. The dark green of Rudaba's robe also contained lead white, verdigris, and ultramarine.

Compared to the paintings from the later *Shāhnāma*, those in the 1562 manuscript appear less compelling. This is due in part to their smaller size, but also to condition problems, particularly damage and losses in the paint surface. The 1562 paintings have also suffered from the use of copper greens, which often embrittled and

Fig. 13
Cross-section photomicrograph (field of view 35 microns) taken in a scanning electron microscope. Back-scattered electron image showing metal foils in the pit opening in *Rustam Rescues Bizhan from the Pit*, cat. 97.

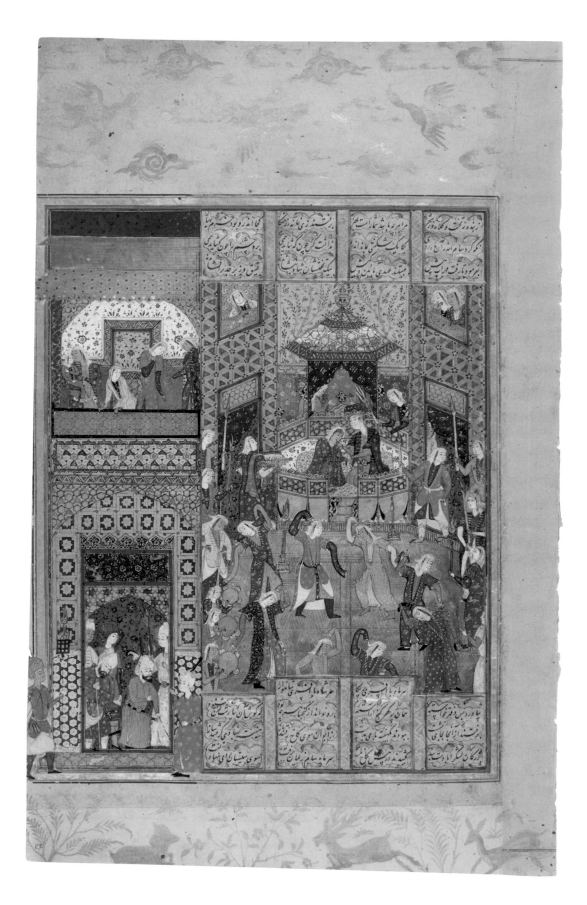

flaked off, and which darkened the paper beneath; paintings with these greens show evidence of retouching to compensate for the losses. Some of the red outlines were painted over areas of missing pigment, meaning that parts of the outline that at first glance appear original are, in fact, also later enhancements. Pigment analysis on the green robe of the red-skirted figure in the doorway also found evidence of modern overpainting with Prussian blue, developed in 1704, and titanium white, developed in 1870.[21] The edges of this folio have been repaired: a new gutter edge was added, probably for rebinding the folio in the manuscript; along the bottom, a replacement edge with gold stenciling mimics the original margin design. Such small discoveries offer a partial timeline in the lives of centuries-old manuscripts.

Discussion

The full palette of the paintings in the circa 1575–90 *Shāhnāma* appears somewhat limited relative to that of the 1562 manuscript, and to the range of results reported in the various analytical studies. This is especially apparent with respect to the greens. Within its limitations, however, this *Shāhnāma* conforms to the relatively consistent palette summarized in the table below, allowing us to conclude that it was both a typical and a traditional example of sixteenth-century manuscript production in Shiraz. The constant palette also suggests a certain satisfaction with the materials available and a reliability of supply, even over time.[22] For example, white was consistently made only from lead white, and ultramarine was found on forty one of the forty-four works analyzed. The subtle variations in color and tones in the 1575–90 paintings show evidence of complexity and careful consideration; this is even truer of the expanded palette of the 1562 folios. Well-supplied workshops appear to have been able to create a wide range of colors with materials at hand, and when other shades were needed, the artisans skillfully mixed them.

What about the greens? In the circa 1575–90 *Shāhnāma* manuscript there were no pure green pigments. Though varied in hue, the greens were achieved through mixing yellow orpiment with the blue of indigo. Clark and Mirabaud, when looking specifically at a Persian *Shāhnāma* manuscript from 1541, also found this mixture and no evidence of green pigments.[23] Other studies found a range of copper greens, with verdigris as the most abundant; copper greens were found at a ratio of 3:2 when compared to indigo-and-orpiment green. What does this material difference reveal about preciousness and relative value? Or could the deleterious effects of copper greens have been a factor that led some workshops to avoid their heavy use? The issue of natural greens versus mixtures deserves further investigation.

A related question concerns the color blue. While ultramarine was present, the circa 1575–90 paintings also used indigo, both with orpiment to make green and alone as a blue colorant.[24] Qazi Ahmad mentions indigo and white mixtures in passing, but specifies that lapis lazuli (ultramarine) is better.[25] In the 1562 painting *The Marriage of Zal and Rudaba*, only ultramarine was present; indigo was never found, despite repeated analyses.[26] Both uses of indigo—alone and combined

Fig. 14
The Marriage of Zal and Rudaba, from the 1562 manuscript of the *Shāhnāma*, cat. 78 B.

to make green—were seen in other studies, but in that of Purinton and Watters[27] ultramarine was one of the most common pigments found. Natural ultramarine was made by grinding the semiprecious gemstone lapis lazuli, an arduous process with sometimes inconsistent final results. The finest grade of lapis lazuli cost the artist dearly.[28] Indigo was known to fade but was still used for its high tinting strength, and doubtless in part because of the prohibitive cost of ultramarine. Its predominant use, alone and with orpiment to produce green, argues that the circa 1575–90 folios were made less expensively than works such as the 1562 paintings, which use copper greens and larger amounts of ultramarine.

The matter of binding medium remains difficult to penetrate. The treatise of Qazi Ahmad specifies that it was gum arabic, with egg yolk added when necessary.[29] In their translation of Sadiqi Beg's treatise, Martin B. Dickson and Stuart Cary Welch comment extensively about binders; they suggest that Sadiqi Beg was referring to an animal glue—a protein—in his writings, and that glue or albumen (egg white) may have been the traditional binder.[30] They propose that gum arabic, a traditional Western binding medium, began to be used in the 1590s and had become the dominant binding medium by 1650. Our preliminary findings suggest that a carbohydrate binder, such as a gum, was used for the pigments in the circa 1575–90 *Shāhnāma,* while both a carbohydrate and a protein binder were found on the 1562 painting, a work from at least a decade earlier, and as much as three decades prior to the date of transition to gums hypothesized by Dickson and Welch. Straus Center staff continue to study this aspect of Persian painting.[31]

Conclusion

Careful examination of the circa 1575–90 *Shāhnāma* folios revealed them to be representative examples of sixteenth-century Shiraz work and the consistent production of one workshop. These ten folios share important similarities with the 1562 *Shāhnāma.* The paper is comparable, and the pigments are both traditional and similar. Workshop techniques, such as underdrawing and final outlining, also link both manuscripts to the tradition of sixteenth-century Persian painting. Both manuscripts also show signs of later alterations, but only the repairs to the 1562 painting can be placed in a historical chronology based on pigment development dates. Nevertheless, there are important differences between the two manuscripts in both quality and condition. Despite its more compelling appearance and larger size, the circa 1575–90 *Shāhnāma* was more economically produced. The paintings in the 1562 *Shāhnāma* exhibit a more refined hand and utilize more precious pigments, including large quantities of ultramarine. Superior craftsmanship notwithstanding, the condition of the earlier manuscript, including many damages to the embrittled verdigris, diminishes its appearance.

Knowledge of how these manuscripts were painstakingly crafted—using underdrawing, fine brushes, reed pens, burnishing stones, and precious pigments—and of how they have changed through time deepens our experience and understanding of the works on paper in the Calderwood Collection.

Comparison of Relevant Analytical Work

COLOR	Harvard cats. 97, 99, 100. Shiraz, c. 1575–90	Harvard cat. 78 B. Muhammad al-Qivam, Shiraz, 1562	Clark and Mirabaud 2006. Persian, 1541	Fitzhugh 1988 (pigments): 19 objects. Snyder 1988 (paper): 21 objects. Persian, c. 1335–1600	Purinton and Watters 1991: 19 objects. Persian, 1425–1691	Jurado-López et al. 2004. Turkish, 16th century
GOLD	gold	gold	gold	gold, powders usually	gold, ground (14)	gold
YELLOW	orpiment, sometimes mixed with other colors	orpiment	orpiment	orpiment (17)	orpiment (16), yellow ochre (3)	pararealgar, realgar
BLUE	ultramarine, indigo	ultramarine	ultramarine	ultramarine (17), indigo (14), azurite (2)	ultramarine (18), azurite (6), organic blue (1-2)	ultramarine, indigo, ultramarine and indigo, indigo with small amounts of ultramarine and lead white
GREEN	orpiment and indigo	light green: verdigris, lead white, possible protein binder dark green: verdigris, lead white, Prussian blue, ultramarine, gold, titanium	orpiment and indigo	orpiment with indigo most common, copper greens (10), malachite (2)	verdigris (9), malachite (1?), brochantite (1), atacamite/ paratacamite (4), orpiment and indigo (2)	malachite and azurite, indigo and orpiment for darks, indigo (dark green), ultramarine and lead white also found
RED	red lead, vermilion, unidentified organic red	red lead, vermilion	red lead, vermilion	red lead (17), vermilion (13), organic (15)	vermilion (13), red oxide (13), red lead (5), red lake (1)	vermilion (dark pink), red lead and vermilion, red lead framing line, realgar

COLOR	Harvard cats. 97, 99, 100. Shiraz, c. 1575–90	Harvard cat. 78 B. Muhammad al-Qivam, Shiraz, 1562	Clark and Mirabaud 2006. Persian, 1541	Fitzhugh 1988 (pigments): 19 objects. Snyder 1988 (paper): 21 objects. Persian, c. 1335–1600	Purinton and Watters 1991: 19 objects. Persian, 1425–1691	Jurado-López et al. 2004. Turkish, 16th century
BLACK	carbon pit (cat. 97): lead white, carbon, gold, silver, possible carbohydrate binder		carbon	carbon (11)	charcoal (8)	carbon
WHITE	lead white	lead white	unid.	lead white (18)	lead white (17)	lead white
BROWN	brown horse: hematite branch: lead white, hematite, orpiment, bone black (cat. 99) branch: orpiment, red lead, vermilion, hematite, carbon (cat. 97)		hematite	hematite (6)		vermilion and orpiment, realgar, red lead and vermilion, vermilion and realgar, vermilion, other mixtures
OTHER	silver flesh: red lead, white lead purple (cat. 99): lead white, ultramarine, possible organic red, possible carbohydrate binder purple (cat. 97): lead white, ultramarine, vermilion, orpiment, possible organic red	purple: lead white, gypsum, and vermilion, possible carbohydrate binder	flesh: lead white, vermilion, and red lead violet: unid. organic gray: ultramarine and lead white	silver (11) mica, mother of pearl (1)	silver (3) lampblack ink (1)	

COLOR	Harvard cats. 97, 99, 100. Shiraz, c. 1575–90	Harvard cat. 78 B. Muhammad al-Qivam, Shiraz, 1562	Clark and Mirabaud 2006. Persian, 1541	Fitzhugh 1988 (pigments): 19 objects. Snyder 1988 (paper): 21 objects. Persian, c. 1335–1600	Purinton and Watters 1991: 19 objects. Persian, 1425–1691	Jurado-López et al. 2004. Turkish, 16th century
UNDER-DRAWING	red ink, some black ink	red ink and dry black carbonaceous material unid.			13: red and black (2) black (6) brown (2) purple-red (1) pink (1) brown and black (1)	
PAPER	well beaten bast fibers	well beaten bast fibers		21: linen (9) linen/hemp (5) unid. (2) linen/unid. (1) grass (1) cotton/linen/hemp (2) linen/hemp/unid. (1)		

Out of _____ objects in particular study, pigments etc. found () times.

unid. = unidentified

"Ultramarine" substituted for "lazurite" for consistency.

Any errors in the above chart, which is for comparative purposes only, are those of the essay author. For definitive information, please consult the original publications.

Notes

1 Cats. 73–93. The colophon is cat. 93.

2 Cats. 94–101.

3 Dickson and S. C. Welch 1981b.

4 Minorsky 1959.

5 Conversely, some pigments, such as lead white or azurite, are opaque to infrared light, so that it is not possible to look beneath them.

6 Katherine Eremin, Patricia Cornwell Conservation Scientist, did the vast majority of the analysis, supplied most of the comparative references, and assisted with the manuscript. Narayan Khandekar, Senior Conservation Scientist, took the samples and mounted and analyzed the cross section. Jens Stenger, Associate Conservation Scientist, conducted follow-up Raman and FTIR on the pit opening (cat. 97). Daniel P. Kirby, Andrew Mellon Associate in Conservation Science, worked on the binders using MALDI-TOF-MS (matrix-assisted laser desorption ionization time-of-flight mass spectometry). Michele Derrick, Associate Research Scientist, and Richard Newman, Head of Scientific Research at the Museum of Fine Arts, Boston, did the FTIR, SEM, and some microscopy. Many thanks to them all.

7 Thank you to Debora Mayer, Helen Glaser Conservator of Works of Art on Paper, Weissman Preservation Center, Harvard University, for the fiber identification.

8 Attenuated Total Reflectance FTIR does not require a sample, but it can cause a very small indent that could damage a paint surface.

9 Purinton and Watters 1991.

10 Studies were included in the table because of their relevance—in terms of contemporary dates, regional proximity, or visual similarities—to the Calderwood works analyzed, in the hope of gaining greater overall insight into patterns and anomalies.

11 Cats. 78 B and 99.

12 The exception to burnishing between layers is found with ultramarine. Sadiqi Beg cautions against burnishing this pigment and recommends instead that the color be laid directly with the medium (binder) and smoothed with one's hand: Dickson and S. C. Welch 1981b, 266. Since the quality of ultramarine decreases with continued grinding

during production, burnishing could presumably result in overpulverizing.

13 Dickson and S. C. Welch 1981b, 266.

14 Cat. 99 (fig. 1). Another folio in this set, cat. 100 (fig. 8), also has unfinished rocks.

15 Minorsky 1959, 199–200.

16 Lead was found with XRF, but Raman did not pick up lead white, even though more than one area was examined.

17 "An impure black carbon pigment prepared from charring animal bones. Bone black is composed of about 10 percent carbon and 84 percent calcium hydroxyapatite along with smaller amounts of magnesium phosphate and calcium carbonate. The stable blue-black pigment is denser than carbon black and has a good working quality for oil paints and watercolors": see CAMEO, under "bone black." This result was very specific about which type of carbon black was found. Other results were more general and did not pinpoint the source of carbon black.

18 Synthetic ultramarine was commercially available after 1828.

19 Grid lines are also visible on cat. 99.

20 Many thanks to Marianna Shreve Simpson for noting this when we looked together at the folios.

21 See CAMEO, under "Prussian blue" and "titanium white."

22 The dates of the manuscripts included in the table range from 1335 to 1691. Slightly more than half are from the sixteenth century.

23 Clark and Mirabaud 2006, 238.

24 No indigo was found in the blue areas of cat. 97, but since the blues were not extensively investigated on this folio, it may well be present.

25 Minorsky 1959, 198.

26 For example, the dark blue under-robe on a youth in the doorway at the lower left was ultramarine and lead white. The light blue leggings on the same figure were ultramarine alone. The darker blue of the curtain at center was ultramarine mixed with carbon to darken it. Even the dark gray in the horizontal panel under the door frame was ultra-

marine, no doubt combined with something
else; pigment analysis could not identify
the additional substance.

27 Purinton and Watters 1991, 129–30.

28 Harley referred to ultramarine as the
most costly of all pigments, in part because
"the demand for natural ultramarine
greatly exceeded supply": Harley 1982, 45.

29 Minorsky 1959, 198.

30 Dickson and S. C. Welch 1981b, 265–67.

31 Daniel Kirby (see n. 6 above) is continuing
to work on binder identification.

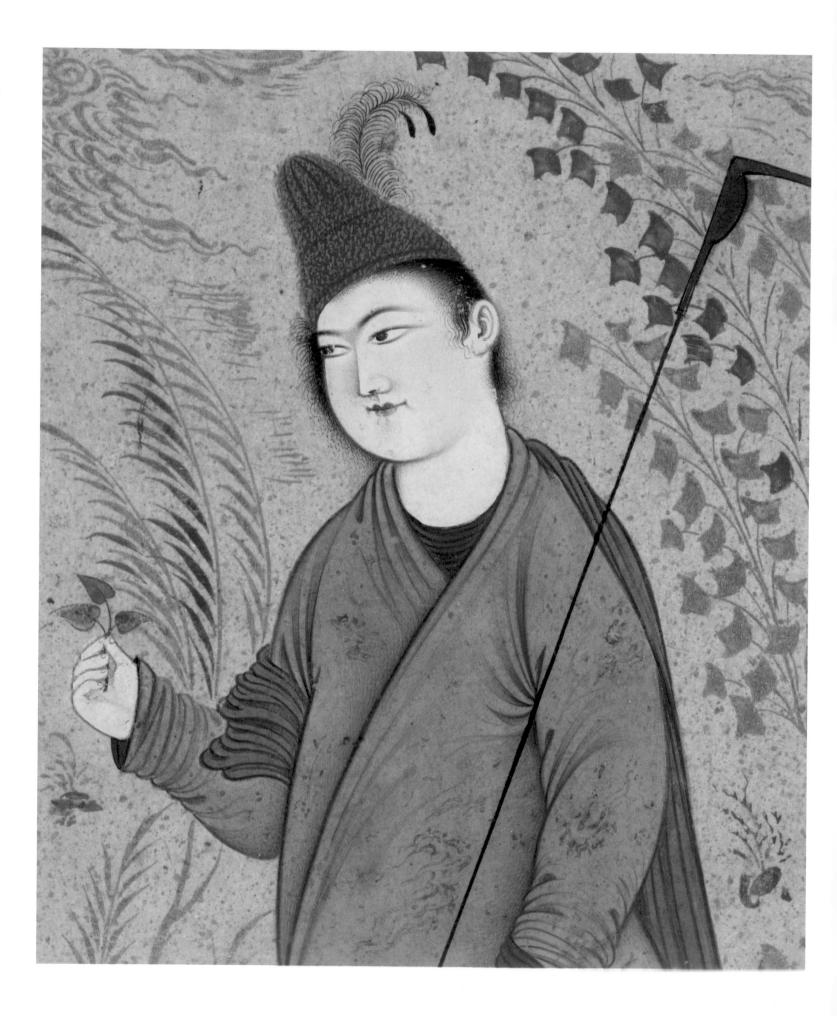

Beyond Books: The Art and Practice of the Single-Page Drawing in Safavid Iran

David J. Roxburgh

In the Islamic lands, drawing as an autonomous practice of image making, intended as an end in itself, arose in the late 1300s and took hold in the work of artists sponsored by the Timurid dynasty (1370–1507), which ruled over Iran and Central Asia. A vast store of drawings is extant in albums compiled during the 1400s at the Timurid court in Herat and the later Turkman courts of northwestern Iran, principally in Tabriz.[1] Many of these drawings manifest visual self-sufficiency inexplicable if they functioned only as disposable intermediaries in a design process that culminated in a different work, whether a painted manuscript illustration or an object crafted from metal, wood, textile, or ceramic.[2]

In addition to finished drawings, album collections often include others that appear initially to have served in developing a design or composition. Fully worked-up drawings used to transfer designs to objects in other media are also preserved.[3] Monochrome images based on such line drawings appear in Timurid manuscripts, a realm previously dominated by polychrome paintings of a principally narrative function.[4]

The graphic repertoire of Timurid drawings includes lines of constant width, sinuous lines that thin and thicken; short, staccato strokes; and stippling executed in different colors of ink (black, brown, blue, or red); sometimes these are enhanced by the addition of pale washes.[5] Such drawing techniques consistently emphasized the artist's skill, because mistakes in execution could not be concealed.[6]

Young Dervish, cat. 122, detail.

By the early 1500s, drawing had attained a secure place in artistic practice. Single-page works were collected and mounted in a new sort of album, the primary function of which was no longer simple preservation but rather the embodiment of a history of art and artists and a reflection of its owner's character and interests. The historian Haydar Mirza (1499–1551), who lists and notes the skills of artists whose careers spanned the period of transition from Timurid to Safavid dynastic rule

(that is, from the 1480s through the 1520s)—the likes of Shah Muzaffar, Mirak Naqqash, and Bihzad—highlights their relative competencies in art but consistently singles out their skills in draftsmanship as distinct from painting. Of Shah Muzaffar, Haydar Mirza writes, "His pen-and-ink drawings are to be found in the possession of some people. The masters of this art consider them very dear."[7] As this comment suggests, emphasis on authorship and on the link between the work of art and its maker had become more pronounced by the late 1400s and further increased in the early Safavid period.

Safavid Drawing: Subjects, Patrons, and Artists

Fig. 1
Recumbent Lioness,
cat. 118.

Artists sponsored by Safavid rulers Shah Isma'il (r. 1501–24) and Shah Tahmasp (r. 1524–76) routinely made drawings with a subject repertoire dominated by courtly themes—characters from the court, the ruler and his activities, the long-standing "princely cycle" (hunting, feasting, war, polo), and animals (fig. 1). Human portrayals included single, mostly idealized figures, pairs, and ensembles (*majālis*) set in detailed landscapes (fig. 2).[8] Some of these artworks went beyond preexisting narrative or visual conventions to suggest unique subjects or record actual, historical events. *Courtiers with a Horse and Attendant* (fig. 3) and the closely related *Incident at the Court* (fig. 4)—the first a pastoral image of a mountain fishing expedition, the second a scene believed to represent the young Tahmasp encouraged to descend from the branches of a tree—exemplify unique subjects.

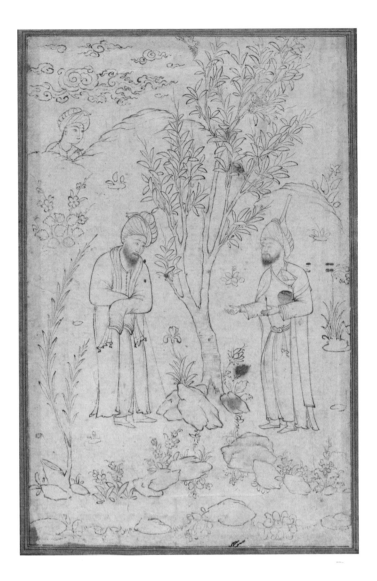

Safavid-period drawings conveyed meaning in various ways. Some depicted
known narratives from Persian literature; others inspired narrative readings
by configuring subjects in a manner that suggested stories.[9] When they included
images typological in nature—courtiers, princes, dervishes, scholars, etc.—these
could function as portraits or embody socio-cultural ideas and ideals, hence con-
veying such values as erudition, spiritual love, fidelity, or devotion.

Single-page drawings and paintings became a mainstay of artistic production
in the successive Safavid capitals, Tabriz, Qazvin, and Isfahan. Their increasing
ubiquity is generally understood to show an inverse relation to the strength of
the royal library-cum-workshop (*kitābkhāna*), an institution supported by shahs
and princes.[10] Royal patronage began to falter in the second half of Shah Tahmasp's
rule, when his growing disaffection with the visual arts and artists culminated
in his ultimate withdrawal of support for them. This permitted other patrons, the
Safavid prince Ibrahim Mirza (1540–1577) chief among them, to capitalize on
available artistic talent.[11] The vacuum of central support stimulated the dispersal
of artists—who the court historian Iskandar Beg Munshi (c. 1560–c. 1632) notes

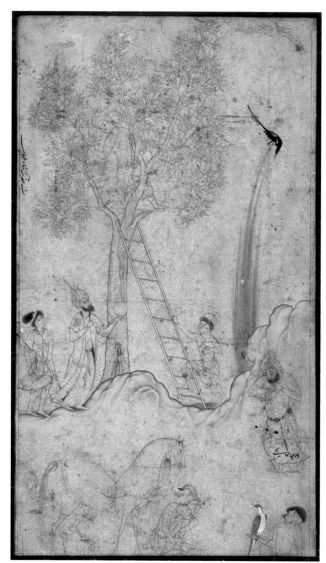

"were released [from the royal library] so that they could work on their own"—to other courts.[12] The paucity of royal patronage after the death of Shah Tahmasp was deepened by Tahmasp's son Shah Isma'il II (r. 1576–78), who ordered the execution of his cousin Ibrahim Mirza and all but one of his own brothers. The remaining brother, Shah Muhammad (r. 1578–87), was blind when he ascended the throne and faced internal turmoil throughout his reign.[13] Although Isma'il and Muhammad each supported a *kitābkhāna* and appointed to it a "director" (*kitābdār*), it remained for Shah 'Abbas I (r. 1587–1629) to reestablish royal patronage and, from 1598 onward, to embark on a more constant program of art commissions in his new capital, Isfahan. By then, however, the circumstances and rhythms of artistic production had already changed. In the aftermath of Shah 'Abbas I's social and economic reforms, which secured an expanded base of

patronage both at the court and among the military, professional, and merchant classes,[14] artists appear to have no longer depended on direct commissions from patrons or been constrained by their appointment to *kitābkhānas*. Instead, they made artworks to sell on a speculative basis,[15] working now in a manner long practiced by calligraphers, who wrote out individual specimens of calligraphy in the form of *qiṭ'as* (literally "fragments"). *Qiṭ'as* consisted of short poems of a few couplets written in *nasta'līq* script on various colors of paper and invariably signed by the calligrapher; they were bestowed as favors upon friends or sold to collectors. Albums of the 1500s and later are dominated by these calligraphic specimens.

Safavid Drawing and the Artist's Hand

The pronounced expressive and individualized style of Safavid drawings—the index of the artist's hand—makes them distinct from earlier examples, where such features are not so evident and may even have been suppressed. Two artists associated with stylistic developments in the production of single-page works were Sadiqi Beg (1533–c. 1612) and Riza 'Abbasi (c. 1560s–1635). Both of these artists continued trends already fostered by an older generation, such as Shaykh Muhammad and Muhammadi, but to heightened effect.[16] Over the course of their careers, Sadiqi Beg and Riza 'Abbasi expanded existing typologies with new subjects (such as portraits of Europeans and female nudes); added to their works a pronounced calligraphic quality with the aspects of an autograph, akin to handwriting; and made greater use of signatures.[17]

Such changes may well have been the effects of an expanded market that commodified art as a set of immediately identifiable subjects—genres within a circumscribed repertoire—executed according to established graphic criteria and linked to an individual artist by pronounced stylistic features, confirmed by a signature. Thus, Riza 'Abbasi's oeuvre, whether drawn or painted, can be subdivided into distinct categories—pilgrims, courtiers, dandies, shaykhs, dervishes (fig. 5), and lovers—that share distinct and repetitive formal techniques.[18] These comprise weighted lines tracing the outline of figures; short, broken lines with thick ends tailing off into thin strokes for turbans, wrapped sashes, and handkerchiefs; delicate, wispy lines for hair; and gold lines and washes for rendering landscape details, against which the figures—whether painted or drawn—are contrasted. These mannerisms are so commonplace that anyone acquiring artworks by Riza probably expected them.

The changes fashioned by Sadiqi Beg and Riza 'Abbasi were continued in the 1600s by the likes of Habib Allah Savaji, Muhammad 'Ali, Muhammad Qasim, Muhammad Yusuf, Mu'in Musavvir, and Shafi' 'Abbasi. One example attributed to Habib Allah Savaji shows the extent to which Safavid artists developed distinctive and differentiated graphic traits. The drawing *Young Woman Offering a Cup* (fig. 6) presents a formal language of lines—long and tapered, curved and wispy, dark and light, staccato—that demonstrate consummate skill and technical fluency while at the same time signaling the artist's hand and individual agency.

Safavid Drawing and Its Relation to Calligraphy

The growth of drawing and its general artistic value cannot be contested, but what other factors might have secured its prestige? As collecting albums grew more popular in the 1500s, so did the practice of including in them introductions or prefaces (*dībācha*) comprising histories of art, organized chronologically through lists of practitioners famous in calligraphy, the pictorial arts, and other aspects of the book.

Contemporary Safavid writers on art and its history tended to conflate drawing and painting, referring to both of these by the single term "depiction" (*taṣvīr*) and only occasionally noting distinctions between them. Two propositions, first advanced by 'Abdi Beg Shirazi and Qutb al-Din Muhammad "Qissa Khvan" (the Storyteller), drew a direct parallel between depiction (drawing and painting) and writing (calligraphy), and accorded depiction the high esteem granted to calligraphy.

In the *A'īn-i Iskandarī* (Rules of Alexander) of circa 1543, 'Abdi Beg Shirazi offered the principle of the two "pens" (*qalam*s)—the "reed pen" used by calligraphers and the "animal/hair pen," or brush, used by artists.[19] In his 1556–57 preface for an album to be made for Shah Tahmasp, Qutb al-Din Muhammad likened the "seven principles" (*haft aṣl*) of depiction, a repertoire of decorative manners and subject matters, to the "six principles" of calligraphy, that is, the "six cursive scripts" (*aqlām al-sitta*), codified by Ibn Muqla (d. 940) and enhanced by later generations of calligraphers.[20]

The propositions of 'Abdi Beg Shirazi and Qutb al-Din Muhammad were eagerly adopted—and often quoted without attribution—by contemporary and later writers on the history of art.[21] Of them, Dust Muhammad (c. 1494–1567) most explicitly capitalized on the productive symmetry between calligraphy, an unquestionably sanctioned art in Islam, and depiction, as both a practice and an art form, whose legality was endemically questioned.[22] His preface to an album made in 1544–45 for Shah Tahmasp's brother Bahram Mirza traced the ancestry of depiction to the Qur'anic illuminations of 'Ali ibn Abi Talib, and then contrasted the licitness of Persianate depiction with the illicitness of other world art traditions, chiefly that of Europe, through historical anecdotes about picture making.[23] Dust Muhammad's intention was to argue that, in the Persianate tradition, depiction was beyond reproach, since it did not cause the viewer to confuse the representation itself with anything it might reference in the real world.

The symmetry fashioned between "depiction" and "writing" through common historical origin and ensuing parallel histories was an ingenious construction of Safavid art historiography. But there were other ways to link the two artistic practices. An obvious one was to compare the practices of making single-sheet calligraphic specimens and single-sheet drawings. Both implied an individual author—as distinct from the multiple authorship entailed in the production of a manuscript—and were presumably acquired with that implication in mind. Moreover, the formal and stylistic features of these single-sheet works emphasized

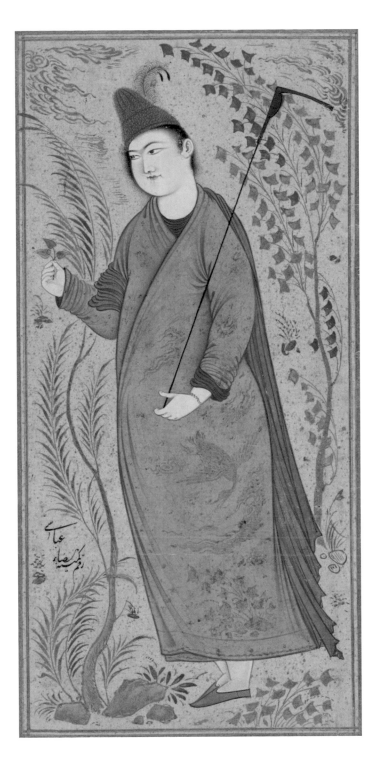

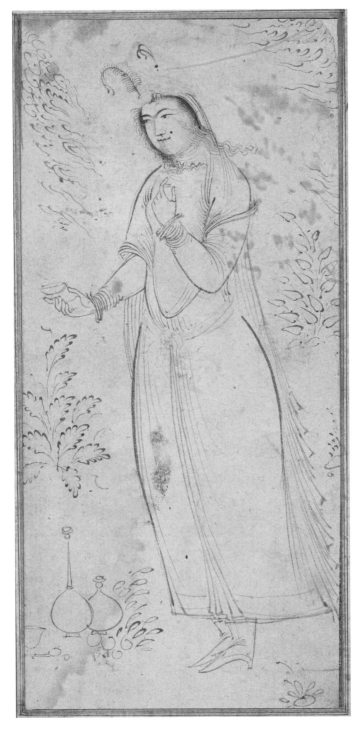

Fig. 5
Aqa Riza (Riza 'Abbasi),
Young Dervish, cat. 122, detail.

Fig. 6
Young Woman Offering a Cup,
cat. 123, detail.

the individual artist's or calligrapher's hand by a form of indexicality—the specific trace of the maker embodied in the work—balanced against artistic convention.[24]

One aspect of the parallel between writing and depiction that has drawn little attention concerns the relation between the body of the artist—corporeal and moral—and the practice of image making itself. On this topic, the artist Sadiqi Beg is quite explicit. His *Qānūn al-ṣuvar* (Canons of Depiction), written between 1576 and 1602, is the earliest extant text dedicated exclusively to the art of depiction. It gives both philosophical and pragmatic advice, closely paralleling in scope Sultan 'Ali Mashhadi's 1514 treatise, *Ṣirāṭ al-suṭūr* (Way of Lines of Writing).[25] Guiding the artist in technique, Sadiqi Beg writes:

> But remember in handling the brush [*qalamgīrī*] not to use a clenched fist.
> The main hold for the brush [*qalam*] is with your two fingers;
> the other three must provide the support
> if your brushstrokes [*taḥrīr-i qalam*] are to swerve freely about.
> For your work wants a certain dash,
> and the brush [*qalam*] is to be taken easily in hand.[26]

Using the noun for pen (*qalam*) as a synonym for brush, Sadiqi Beg is obviously concerned that the artist's hold on his instrument does not constrain movement and compromise the delicacy and fluidity of his lines.[27] He reiterates counsel given to calligraphers in a much earlier treatise by Abu Hayyan al-Tawhidi (d. after 1009–10), which combines advice on the practice of calligraphy with a host of anecdotes. One of al-Tawhidi's anecdotes, attributed to 'Ali ibn Ja'far, a secretary to the Abbasid caliph al-Ta'i' (r. 974–91), reads:

> There is nothing more useful for a calligrapher than to avoid using his hand for lifting up or putting down a thing, especially if it is heavy. If the movements assimilate themselves to the letters and the letters get buried in the movements, the essential traits of the forms of the handwriting and of the shape of the letters will be safeguarded only inasmuch as they have become filled with them, and their bodies will be protected only inasmuch as they have been put in relation to them. He said: Recently, I lifted a whip with my hand several times and cracked it over the head of my mount. As a result my handwriting was changed for a while.[28]

The potential of physical activity to adversely affect and alter the movements of the calligrapher's or artist's hand—movements imprinted in the body through practice and performance—is reflected closer to Sadiqi Beg's lifetime in an assessment offered by Haydar Mirza in 1546. His entry on Mirak Naqqash, adoptive father of the artist Bihzad and like him active at the Timurid court in Herat, reads:

> Mawlana Mirak Naqqash is one of the wonders of the age. He was Bihzad's master. His sketching is more masterly than Bihzad's. Although his execution is not up to Bihzad's, still all his works were done outside in the open air, whether he was traveling, in attendance on the prince or at home; and he was never tied to a studio or portfolio. This is strange enough, but further yet he practiced all kinds of sports, and this is absolutely at odds with being a painter . . . he often practiced body-

building exercises and gained a reputation for that. It is quite strange to couple painting with such things.[29]

Haydar Mirza is frankly astonished that Mirak Naqqash's peripatetic artistic production and cultivation of the body—two forms of physical movement—did not in the end compromise his artistry. His view should be compared with Sultan 'Ali Mashhadi's advice to calligraphers that they retreat to their homes to gaze upon choice specimens of calligraphy and practice their own writing only while sedentary.[30]

These concerns and admonitions further illuminate critical assessments of Riza 'Abbasi, Sadiqi Beg's contemporary. In his revision to the *Gulistān-i hunar*, Qazi Ahmad writes of Riza:[31]

> But vicissitudes (of fate) have totally altered Aqā Riḍā's nature. The company of hapless people (*nā-murād*) and libertines (*lavand*) is spoiling his disposition. He is addicted to watching wrestling and to acquiring competence (*vuqūf*) and instruction (*ta'līmāt*) in this profession.[32]

Some years later, Iskandar Beg Munshi reiterates this view of Riza 'Abbasi:

> His son, Aqa Reżā, was a skilled portrait painter, but it is well known that, in recent times, he stupidly abandoned this art in which he had so much skill and took up wrestling, forsaking his talented artist friends. Fortunately, he has now given up this nonsense, but he does not do much painting. Like Ṣādeqī Beg, he has a foul temper, is impatient and disagreeable, and has a very independent character. He was greatly favored by Shah 'Abbas I, but because of his temperament, he has never been fully trusted, and so he has remained poor.[33]

Qazi Ahmad and Iskandar Beg Munshi share the concern that wrestling and consorting with wrestlers negatively affect Riza 'Abbasi's work, not only because of the physicality of the sport but because wrestlers were at the time viewed with disdain and seen as morally corrupt.[34] Interpretations of these commentaries have tended to play up their expressions of a social decorum, and have given less emphasis to the tangible impact that sports might have had on the making of art. Qazi Ahmad and Iskandar Beg Munshi seem to be concerned with both. Implicitly, their worries trade in a concept long associated with calligraphy, and apparently now applied to depiction: that the artwork embodies as a physical trace the morality of its maker. At a time when Riza 'Abbasi routinely signs his works in the language used by calligraphers, what is to become of depiction if the extracurricular activities of the depicter risk leaving a permanent imprint on his art?[35]

Notes

1 Broad introductions to the history of Persian drawing were offered in Atil 1978 and Swietochowski and Babaie 1989. The Timurid and Turkman albums are in the Topkapı Palace Museum Library, Istanbul, H. 2152, H. 2153, and H. 2160. Many other drawings, mostly single sheets, are owned in collections worldwide.

2 Creative freedom and autonomy are expressed most directly in a corpus of drawings signed by Muhammad ibn Mahmudshah al-Khayyam, who was active at the Timurid court and a member of Prince Baysunghur's retinue: see Roxburgh 2002b, 59–61.

3 These forms of drawing are all preserved in the "Timurid workshop album" (Istanbul, Topkapı Palace Museum Library, H. 2152) assembled at the Herat court workshop during the reign of Shahrukh (r. 1409–47). For the album and its drawings, see Roxburgh 2005, chap. 3; Roxburgh 2002b. The well-known 'arẓadāsht (lit. "petition"), a progress report of artworks in preparation in the Timurid kitābkhāna of Herat, circa 1430, mentions the design for a saddle by Amir Dawlatyar copied by Khvaja Mir Hasan and then executed in mother-of-pearl by two artists: see Thackston 2001, 44.

4 As in the marginal drawings of Sultan Ahmad's dīvān of poetry, circa 1400 (see Atil 1978, 14–27), and in the anthologies fashioned in Shiraz for the Timurid prince Iskandar Sultan (1384–1415): see Roxburgh 2001a.

5 The graphic repertoire is discussed in Roxburgh 2002b, 50–55.

6 This performative dimension of drawing is noted in Soudavar 2000, 55.

7 Thackston 1996, 130. Haydar Mirza completed the history in 1546. Works by all three artists are mounted in the 1544–45 album made for Bahram Mirza, brother of Shah Tahmasp, including rare examples attributed to Shah Muzaffar: see Roxburgh 2005, 271 and 286–87.

8 A good example of the idealized courtly type is a drawing of a seated courtier attributed to Mir Sayyid 'Ali, circa 1540. See Lowry and Beach 1988, cat. 350.

9 The inferential narrative capacity of single-page drawings is discussed in Farhad 1987 and developed in Babaie 2001.

10 Current understandings of the kitābkhāna in this period closely relate the institution to a single patron, who supported its activities under a "director" (kitābdār). The precise mechanisms of artistic production, and how one kitābkhāna may have differed from another, have yet to be characterized in detail. For a review of current ideas and debates, see M. S. Simpson 1997, 318–22.

11 A review of the chronology and the factors adduced to account for Shah Tahmasp's actions—presented by authors Anthony Welch, Stuart Cary Welch and Martin Dickson, Layla Diba, and Abolala Soudavar—are presented in Roxburgh 2005, 243 and n. 99.

12 Iskandar Beg Munshi is careful to mention that the kitābkhāna was not completely dissolved because Shah Tahmasp appointed as librarian Mawlana Yusuf, a ghulām-i khāṣṣa (personal slave of the shah), and "committed to his charge the books contained in the royal library": Savory 1978, 1:271.

13 The effects of the rule of Shah Isma'il II and Shah Muhammad, changes propelled by the artist Muhammadi, and non-royal patronage are discussed in Soudavar 2000, esp. 53 and 61–69.

14 See A. Welch 1976 and A. Welch 1995. A recent expansion of Welch's work on patronage, focused on the results of the broad-based reforms of Shah 'Abbas I, is presented in Babaie et al. 2004.

15 Citing an anecdote about Sadiqi Beg preserved in a 1702–3 biography by the Safavid poet Mulla Ghururi, Anthony Welch proposes that single-page drawings and paintings were traded in bazaars "by merchant 'art dealers' specializing in them." See A. Welch 1976, 186–87 and n. 57.

16 A thorough overview of the careers of these artists can be found in A. Welch 1974.

17 Richard Ettinghausen described new characteristics of art from Shah 'Abbas I's reign as including a greater licentious quality, an interest in the life of the lower social classes, and caricature: see Ettinghausen 1974. The first scholar to observe formal correspondences between calligraphy and drawing seems to have been Armenag Sakisian: see Sakisian 1936, 59–69. Abolala Soudavar explicitly compares Riza 'Abbasi's drawing to nasta'līq script, observing that "in both cases a reed pen is used, whereby

continuously changing pressure brings varying thickness to a line" (Soudavar 1992, 265). Artists continued to introduce new and unique subjects into their work during the 1600s, while also retaining established figural types and subjects. A powerful example of the unique subject is Muʿin Musavvir's *Tiger Attacking a Youth*, a visual record of an event in Isfahan reported to the artist. The drawing, completed on Feb. 8, 1672, includes a lengthy inscription about the event and conditions in the city that winter: see Farhad 1992.

18 Canby 1996b, a monographic treatment of the artist, is organized by these and other categories. Canby's study is the most comprehensive and compelling account of the artist's oeuvre interpreted through his biography.

19 See Porter 2000. The terminology used by these and other authors in reference to pen and brush is presented in Roxburgh 2002a, 55.

20 For further information about Qutb al-Din Muhammad "Qissa Khvan" and scholarship on his preface, see Roxburgh 2001b, esp. 29–30. Porter suggests that the "seven principles" could also have been ʿAbdi Beg Shirazi's invention (Porter 2000, 113).

21 See Roxburgh 2002a, 55.

22 Concerns arose about depiction because it appeared to risk idolatry and associating the creative prerogatives of God with the capacities of man. For the identification of Dust Muhammad as Dust Muhammad ibn Sulayman Haravi, and details about his career, see Adle 1993, 226–30.

23 The preface is discussed at length in Roxburgh 2001b, esp. chap. 6.

24 For the complex relation between convention and originality in calligraphy, see Roxburgh 2008, esp. 289–95.

25 This treatise is included in full in Qazi Ahmad's art biography and history, *Gulistān-i hunar* (Rose Garden of Art), of circa 1606. See Minorsky 1959, 106–25.

26 Dickson and S. C. Welch 1981b, 262. For a Persian edition and commentary, see Dānishpazhūh 1970.

27 The distinction may have been moot. *Qalam* may have been preferred for the sake of meter and because artists used both reed pens and brushes to make drawings. See Soudavar 1992, 265, and Canby 2000b.

28 The treatise is translated and discussed in Rosenthal 1971, 29–30. In the following anecdote, a friend of Abu Hayyan al-Tawhidi likens the effect to music, pointing out that "the finest degree of sensitivity possible in sensory perception" is connected to the "fine soul" (ibid., 30).

29 Thackston 1996, 131.

30 See Minorsky 1959, esp. 117–18, 121–22.

31 Recensions of Qazi Ahmad's treatise are described in Porter 1988.

32 Minorsky 1959, 192–93. Minorsky notes that this criticism is absent from the earlier redaction of the treatise.

33 Savory 1978, 1:273.

34 Soudavar 1992, 272, comments on Riza's pursuit of wrestling in distinction to "developing his spiritual qualities," while Canby 2009, 36, notes that wrestlers were "considered by the upper class to be contemptible." The comments of Qazi Ahmad and Iskandar Beg Munshi are frequently invoked to explain a moment in Riza ʿAbbasi's career when he left court; when he returned to practice art, his approach and subject matter changed considerably. See Canby 1996b, 20–21 and 77–94.

35 Porter 2000, 112, notes the crossover in the use of verbs and nouns referring to depiction and calligraphy. For Riza ʿAbbasi's signatures, see the catalogue in Canby 1996b, 179–200. Also see cat. 122 of this publication. On the moral dimension of calligraphy, see Roxburgh 2008, 280–81.

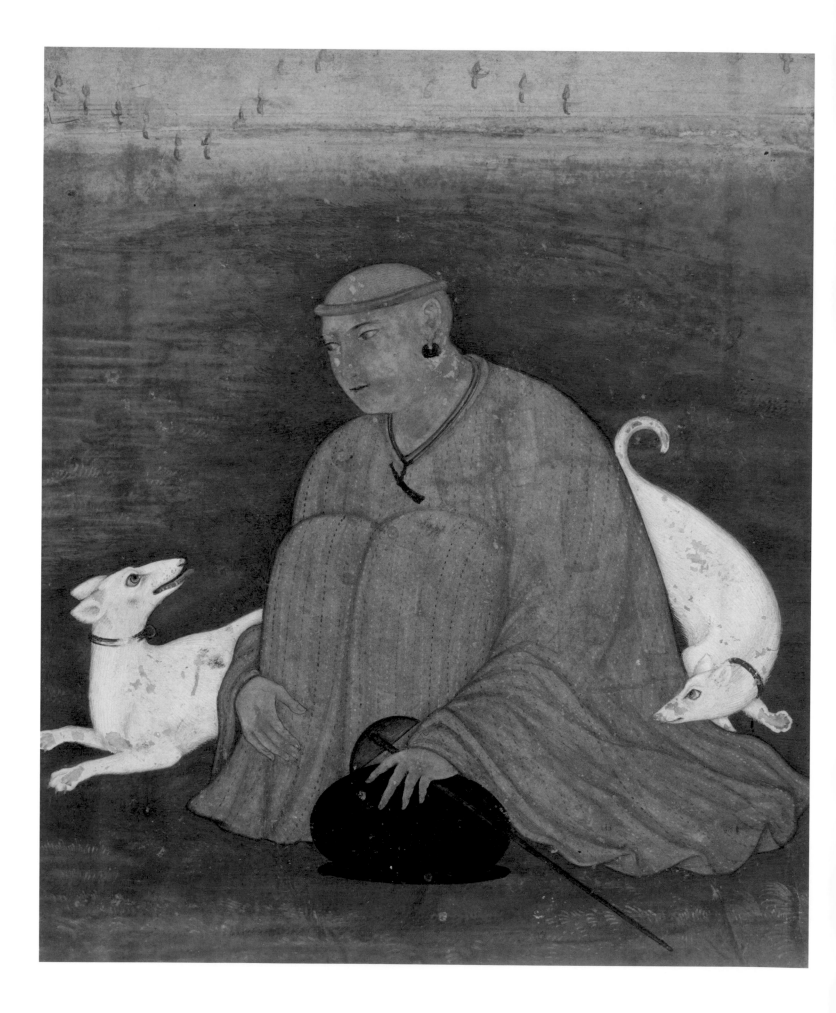

The Sati and the Yogi: Safavid and Mughal Imperial Self-Representation in Two Album Pages

Sunil Sharma

Two great Persianate dynasties, the Safavids of Iran (1501–1722) and the Mughals of India (1526–1858), both heirs to the splendid artistic and literary legacy of Timurid Herat, witnessed their political and cultural apex in the sixteenth and seventeenth centuries. A busy traffic of artists, poets, manuscripts, and albums between the two courts resulted in new and hybrid forms in poetry and painting. Rivals and friends at the same time, the Safavid and Mughal rulers sought to project their imperial self-image in various media for the benefit of their own subjects, for each other, and for the larger Persianate world. Although the Safavids and Mughals shared similar aesthetic and poetic sensibilities that resulted in the copying and illustration of older Persian classics, such as Firdawsi's *Shāhnāma*, Nizami's *Khamsa*, and Sa'di's *Gulistān*, the empires they ruled were very different in their ethnic and social fabric, as well as in their religious and linguistic groups. Thus, the ways in which they constructed images of their own power and place in the world had different emphases. Two paintings in the Calderwood Collection, one of a sati (fig. 1) and the other of a yogi (fig. 4), serve as examples of how art was tied into a complex system of imperial propaganda. This essay will provide the literary and historical context for these paintings, which were produced not as part of larger manuscript projects but as individual works of art.

The movement of people between the Safavid and Mughal realms was largely one-way, from west to east, while material objects as well as artistic and literary fashions traveled in both directions.[1] The historical sojourn of the Mughal emperor Humayun (r. 1530–40; 1555–56) at the court in Qazvin of Shah Tahmasp (r. 1525–76) initiated two centuries of complex cultural interface between the two empires, which began with Humayun's return from Qazvin with two Persian artists, Mir Sayyid 'Ali and Khvaja 'Abd al-Samad.[2] Similarly, in the field of literature, especially during the reigns of the emperors Akbar (r. 1556–1605), Jahangir (r. 1605–28), and Shah Jahan (r. 1628–58), scores of literati and scholars moved from Iran and Central Asia to India, whether for better prospects of patronage or in search of

Nath Yogi with Two White Dogs, cat. 128, detail.

a more tolerant social and religious atmosphere for those among them who were
Sunni Muslims or belonged to esoteric religious groups.

An example of a new kind of literary masterpiece that emerged in this period is
a verse romance, *Sūz u gudāz* (Burning and Melting), composed around 1604 for
Akbar's son Prince Daniyal by Muhammad Riza Naw'i Khabushani (d. 1609), an
Iranian émigré poet at the Mughal court.[3] Written in *masnavī* (rhymed-couplet)
form, it is a love story at whose center is an episode, related in a realistic and almost
ethnographic manner, of a sati (suttee), a Hindu widow who burns herself along
with the corpse of her husband.[4]

In the prefatory section of *Sūz u gudāz*, Naw'i declares that the classical love stories
of Farhad and Shirin and the images of moth and nightingale have become clichéd,
and calls for a new literary ethos for the age. The earlier Persian poetry of Nizami
(d. 1202) and Amir Khusraw (d. 1325) provided the usual models for romances;
Naw'i follows these authors' choices of poetic form and meter but departs from
them in subject matter. In the Indo-Persian context, Amir Khusraw had previously

composed narrative poems on contemporary events, such as a romance, titled *'Ishqīya* or *'Āshīqa*, based on the love of the prince Khizr Khan for the Hindu princess Deval Rani. Amir Khusraw's contemporary Hasan Dihlavi (d. 1338) also produced a poem, *'Ishqnāma*, on the love of a young Hindu couple, in which the surviving male protagonist joins his beloved on her funeral pyre. The interest in Indian tales as a source for romances resurfaced at the Mughal court, and Fayzi (d. 1595), the poet laureate under Akbar, began working on his own *Khamsa*, deriving one of its romances, the story of Nala and Damayanti, from the Sanskrit epic *Mahābhārata*. Thus, there had been prior efforts by Indian-born Persian poets to expand the repertoire of the romantic *masnavī* by adding local topics to those from the Iranian or Arabic past. But the fact that Naw'i, an Iranian-born poet, was departing from tradition and writing about an Indian love story signified something greater. The Mughals made a concentrated effort to express their distinct character in the arts while remaining part of the larger world of Persianate culture. The court literature of this period catered to the tastes of patrons but was also linked with politics, and a brief examination of Naw'i's *Sūz u gudāz* shows the political rationale for its production and copying.

The *Sūz u gudāz* is not a long work;[5] it comprises 492 *bayt*s (couplets), and its plot is relatively simple compared to those of the older romances. It tells the story of two unnamed lovers, a Hindu boy and girl, who are betrothed as children. When they are of marriageable age, the man is impatient to be united with his beloved and urges his father to arrange their wedding. On the auspicious day, the prospective bridegroom is killed when the wedding party passes by an old building that falls on him. His grief-stricken bride-to-be insists on becoming a sati—although technically the wedding has not happened yet—and her family attempts to dissuade her. When the emperor Akbar hears about this incident he, too, tries to persuade her to not give up her life. She remains firm, unmoved by the offer of riches. Finally, Akbar is convinced of the strength and independence of her resolve and sanctions her self-immolation, which takes place under the supervision of Prince Daniyal, who also attempts in vain to stop her.

Depicting the emperor Akbar in this manner serves to emphasize the idea of his reign as a golden age, and while such a depiction is part of a more complex set of circumstances in which this work was composed, it is also part of the Mughal propaganda machinery. An early Islamic mirror for princes, Nasir al-Din Tusi's *Akhlāq-i Nāṣirī*, written in the thirteenth century and popular at the Mughal court, advises the model king to be readily available to all his subjects. Thus, a common Hindu woman could have access to the Mughal emperor. Muslim sources had long been intrigued by sati as seen in the works of al-Biruni and Ibn Battuta[6] and had linked this practice with the politics of Muslim rule in India, but Naw'i avoids passing judgment on it by stereotyping the characters—depicting them as generic, unnamed individuals—and by working within a circumscribed poetic tradition.

At another level, the mystical meaning embedded in the act of annihilation by fire, a frequent theme in classical Persian poetry, associated with images of moth and candle,[7] would have been obvious to readers of Naw'i's text or viewers of its illustrations. The Hindu woman was analogous to the moth, which burns itself up in its ardent love, and as such, she enjoyed popularity among Mughal and Safavid

poets alike. For example, the Iranian poet Sa'ib (d. 1670), who visited Mughal India, combines both images in this verse: "No one is as manly in love as a Hindu woman / to burn in a flame is not for every moth."

The miniatures from the only Mughal manuscript of this text (British Library Or. 2839), probably the one made in the atelier of Prince Daniyal for presentation to his father, are the oldest visual representations of the practice of sati. Ananda K. Coomaraswamy, who first described them, takes as their inspiration the ideal of the golden age of tolerance and cultural exchange between Muslims and Hindus during Akbar's reign, although he does not properly contextualize Naw'i's poem in the milieu in which it was produced. Ironically, it is the very image that Naw'i mocks as being trite—the traditional, mystical one of moth and candle—that he repeatedly exploits. Focusing on the originality of the artist rather than on the poet, Coomaraswamy's analysis of the text favors reading it as a social document, and pinpoints features of Mughal painting mirrored in it:

> an interest in the present moment, in what is going on, in individual character and romance. Weary of the rather insipid, or at least, hackneyed types of Persian art, the Mughal painters developed an already great tradition of portraiture, in the direction of increased actuality. . . . The Mughals were realists, in a very modern sense.[8]

Applying this feature of painting to the literature of the Mughal court works only to a limited extent, yet Coomaraswamy's basic idea is valid. While the Mughals made use of this text to create a new, more inclusive canon of Persian literature that drew subject matter from the local landscape, the Safavids had another use for it.

Although Mughal literature was highly regarded by the Safavids and the wider Persianate world generally, it is nonetheless surprising to learn from Massumeh Farhad that, "except for the *Shāhnāma*, no other text enjoyed the same popularity as the *Suz u Gawdaz* in later Safavid Iran."[9] Portrayals of Indian women, whether they were shown as satis in copies of the *Sūz u gudāz*, or as courtesans on album pages, were extremely popular in this period. Sussan Babaie has convincingly suggested that the mural painting of the sati scene from Naw'i's work found in the Chihil Sutun Palace in Isfahan (fig. 2) indirectly commemorates the Safavid

Fig. 2
Woman Committing Sati, wall painting in the Chihil Sutun Palace. Iran, Isfahan, mid-17th century.

capture of the Mughal fort of Qandahar in 1649. As Babaie writes, "Whereas
the larger historical paintings in the audience hall [of the Chihil Sutun] proclaimed
the Safavid court as a sanctuary for the deposed monarchs, the *Sūz u Gudāz* story
symbolized the actual victory over a prized territory."[10] In this case, the mural
depiction of the woman's immolation may have connoted the annihilation of
Indian power, whereas the same scene in the manuscripts had more spiritual asso-
ciations. Both the production of the *Sūz u gudāz* and its subsequent copies made
in Safavid Iran demonstrate the intricate relationship between poetry and politics
in this period.

The Calderwood painting of the Hindu woman about to immolate herself appears
to be an album page rather than an illustration from a complete manuscript.
Dating from the same period as, or slightly later than, the other Safavid copies of
this work, which are assigned to the late 1640s and '50s, this painting is possibly
from the circle of the artist Muhammad Qasim. Other paintings of the scene depict
the woman about to enter the fire[11] or burning in her lover's embrace (fig. 3).[12]

Various figures in the Calderwood painting—the man wearing a European hat, the bare-chested woman, and the two grieving men on either side of the funeral pyre—are stock characters in Safavid painting of the seventeenth century. As if to convey the words of the sati herself, a single inscription at the bottom left of the painting reads, "I will seize the kingdoms of the West and East" (*mulk-i 'Arab u 'Ajam mīsitānam*). This utterance, a hemistich not from Naw'ī's tale but from a *ghazal* by the poet Sa'dī (d. 1291), takes on particular political significance in the context of the single album painting, where it is in some ways equivalent to the bold statement of the Chihil Sutun mural regarding the power of the Safavids, especially in their recent victory over the Mughals in Qandahar.

The *Sūz u gudāz* was one way that the Muslim Mughals, ruling over a majority Hindu population, made a conscious effort to incorporate this community into their political, as well as their artistic and literary, imagination. Another way to achieve this was through the representation of religious groups,[13] as exemplified by a Calderwood painting that shows a Hindu ascetic (*jūkī, jogi,* or *yogi*), dressed in a Hindu sadhu's saffron garb and accompanied by two dogs, in a barren landscape (fig. 4). The following inscription surrounds the image, one line above and one below:

> *dar firāq-i yār jūkī gashta am / bahr-i ān dildār jūkī gashta am*
> *mayl dārad shāh-i man bā jūkīyān / zān sabab nāchār jūkī gashta am*

> Separation from my beloved has made me a mendicant.
> I have become a mendicant for the sake of my beloved.
> My prince is inclined to [keep company with] mendicants;
> For that reason I was forced to become a mendicant.

The type of ascetic or mendicant shown here can be identified through his earrings as a *kānphatā*. Kanphata yogis, also known as Gorakhnathis or Nathpanthis, were followers of an order of ascetics founded by the tenth- or eleventh-century yogi Gorakhnath; they are usually shown wearing large earrings, whence the term *kān-phatā* (split-ear).[14] Their other distinguishing accoutrements include begging bowls and dogs. In the verses accompanying the image, the poet-lover, in an act of complete devotion, is ready to debase himself by becoming an ascetic.

The Calderwood yogi seems to have been part of the so-called Salim Album, compiled for Prince Salim (later Emperor Jahangir) between 1600 and 1604, when Salim had rebelled against his father and had his own atelier in Allahabad. A similar yogi figure (fig. 5) is found on one of the loose folios that constitute the Salim Album; it is now in the Chester Beatty Library, Dublin.[15] The almost identical border designs of the two paintings suggest that they may have been facing pages, representing two different kinds of Kanphata yogis: the Dublin yogi is dressed in a black robe and hat and is shown with a single white dog. From their iconography and styles, both paintings appear to have been produced at the Mughal court. In particular, the Mughal artist Govardhan, who was perhaps connected to the eclectic circle of Emperor Shah Jahan's son Dara Shikoh, specialized in these subjects and "apparently felt curiosity and sympathy for religious figures and eccentric

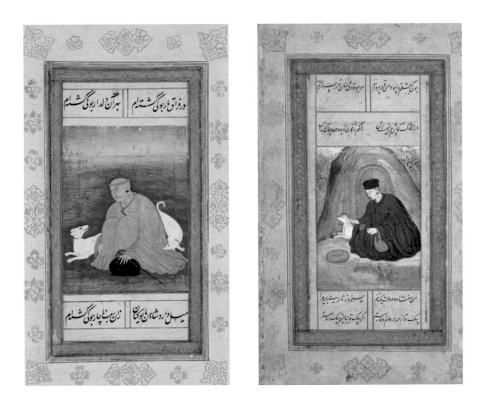

characters."[16] The inscription is longer in this painting than in the Calderwood one. The lines above the figure read:

jūkī-yi ʿishqam u sawda-yi tu dar sar daram /
mū bi-mū zawq-i tamannā-yi tu dar sar dāram
mārā zi khāk-i kūyash pīrāhanast bar tan /
ān ham zi khūn-i dīda sad chāk tā bi-dāman

I am the ascetic of love who is infatuated with you.
I desire you with every hair of my head.
My shirt is made with the dust of his lane
And that too is ripped to its hem and has blood from my eyes.

Below the image are the following lines:

man bi-haftād u du millat yak tanam / subhat u zunnār mībāyad marā
sag-i tu az hama dar ʿālam-i vafā bihtar / agar sag-i tu nabāsham sag zi mā bihtar

I am one with the seventy-two nations—
I should have a rosary and an infidel's girdle.
Your dog is better than the entire world of fidelity.
If I am not your dog, the dog is better than me.

The upper verses describe the degradation of the obsessive poet-lover in the same vein as those on the Calderwood page. The lower ones impart a message of religious

Fig. 4
Nath Yogi with Two White Dogs, cat. 128.

Fig. 5
Kanphata Yogi, folio from the so-called Salim Album. India, circa 1600–1605. Ink, colors, and gold on paper, 23.3 × 14.9 cm (9¹³⁄₁₆ × 5⅞ in.). Chester Beatty Library, In 44.3.

harmony with the "seventy-two nations"—a common reference in Persian poetry to the entirety of humanity.

Mughal artists produced innumerable paintings of ascetics and holy men, alone or in company with princes. Indo-Persian historical and poetic texts of this period also reflect this fascination. As explained by Walter Smith, Hindu holy men can be found in two kinds of texts from Akbar's period: "in illustrations to historical works, such as the *Babur Nama* and *Akbar Nama*, where they are shown in contemporary idealized settings, and in illustrations to Persian translations of Sanskrit texts, which depict sadhus and sanyasis as counseling sages and yogic adepts."[17] A whole range of realistic images, possibly actual portraits, of Jain monks, dervishes, Sufis, and members of other religious groups are found in the archive of Mughal painting. Yogis in particular were an important part of Mughal society; according to David Gordon White, "By and large, Mughal policy toward the yogis was pragmatic: they rarely interfered in their ways but made use of them when such was politically expedient."[18]

Mughal paintings of holy men can often be viewed in the context of a larger imperial program to document and celebrate the religious diversity of Indian society[19] and, additionally, to represent visually the Hindu-Muslim interface in India. The vast body of Mughal court literature and art was used to promote the vision of an empire that was home to diverse types and multiethnic peoples. An emphasis on and propagation of this image of India was integral to the success of the ruling polity. The association of Mughals such as Akbar and Dara Shikoh with holy men of different faiths was connected to a larger spiritual quest and interest in interreligious dialogue. Mughal portraits of Hindu holy men combine the ethnographic and the poetic, even in the absence of accompanying verses. In the *Āʾīn-i Akbarī* (Institutes of Akbar), Akbar's court historian Abu'l-Fazl describes the emperor's fascination with holy men as part of a deeper philosophical search that had both personal and political motives. The interest in holy men, like that in the practice of sati, promoted the idea within and outside the empire of a tolerant and benevolent rule.

Safavid and Mughal artists and poets thus drew inspiration from a variety of sources to fashion a carefully crafted image of the politics of their patrons, resulting in novel modes of representation. More specifically, two themes in painting and poetry became prominent in the seventeenth century: in the Safavid imagination, the land of India as a source of exotic wonders but also as a political and cultural rival; and, in the Mughal imperial program, the celebration of India's multicultural society. Surveys of the artistic or literary productions of this period— few studies combine the two disciplines—often overlook details that specific objects can provide. The paintings of the sati and the yogi from the Calderwood Collection may at first glance appear to be unrelated, but placing them in their proper cultural and artistic context brings out their interrelationships and embedded complexities. Although to some extent both figures were romanticized constructs despite their claim to be ethnographic and realistic, the fact of their representation and inclusion in albums has symbolic import and illuminates fascinating aspects of the Safavid-Mughal cultural and political encounter.

Notes

1 For surveys of the poetic culture of this period, see Yarshater 1988 and Alam 1999; for painting, see Schmitz 2004a and 2004b.

2 Soucek 1987.

3 Sharma 2007.

4 The term "sati" also refers to the cremation of a woman with her dead husband's body.

5 For the text, which was critically edited by Amir Hasan Abidi, see Naw'ī 1969. It is also included in the poet's *dīvān* (collected works): Naw'ī 1995. Major portions of it were translated by Mirza Y. Dawud and Ananda K. Coomaraswamy in a Victorian but largely accurate and readable style: see Dawud and Coomaraswamy 1912.

6 Rashid 1969, 144–45.

7 Schimmel 1992, 198–99.

8 Dawud and Coomaraswamy 1912, 5–6.

9 Quoted from Farhad 2001, 126. This is an illuminating study of an illustrated manuscript of the *Sūz u gudāz* in the Walters Art Museum, Baltimore.

10 Babaie 1994, 137.

11 Chester Beatty Library 268, fol. 31v, and 269, fol. 26.

12 Also Walters Art Museum, Baltimore, W.649, fol. 19v. I have not seen the other two known copies: Israel Museum, Jerusalem, Yahuda 1067; and Bibliothèque nationale, Paris, suppl. pers. 769.

13 This topic is studied in more detail in Sharma 2012. The Calderwood yogi is apparently the same one as described in Appendix 1.II of Wright 2008, 456. It was first published in Sotheby's 1967, lot 1211.

14 Briggs 1973.

15 CBL In 44.3. See Wright 2008, cat. 29, 270–71.

16 Okada 1992, 197.

17 Smith 1981, 67.

18 White 2009, 200.

19 For imperial propaganda in Shah Jahan's reign, see Koch 2001, xxvii; also Sharma 2011. See Kessler 2002 for a study of paintings of Mughal rulers visiting holy men.

Inspiration and Innovation: Footprints from Afar in the Calderwood Collection

Walter B. Denny

The pace, sources, and meaning of innovation vary widely among world artistic traditions. Stylistic change in the art of dynastic Egypt, for example, proceeded at a glacial pace in certain eras, only to move with radical speed in times of political upheaval. The interplay between respect for tradition and the excitement of innovation is present to some degree in every artistic tradition, but a culture's openness to the outside is a significant factor in the evolution of its art; dogmas of cultural superiority found in ancient Greece or China, for instance, or the cultural and physical isolation of Japan, may at times have deprived those cultures of externally inspired artistic change. This essay demonstrates that the position of the Middle East, located geographically and culturally between South and East Asia and the Mediterranean Basin, has brought about frequent and dynamic artistic change and has contributed over many centuries to major innovations in Islamic art.

This essay examines several works in the Calderwood Collection and the ways in which they have been influenced by artistic traditions from outside the Islamic Middle East. Three sources of inspiration considered here are the art of the Oghuz Turkic peoples who migrated westward to the Middle East after the tenth century CE, in particular the Seljuks and their successors, who ruled from the mid-eleventh century onward; Chinese luxury goods, especially in the aftermath of the Mongol conquests of the later thirteenth century; and Chinese pictorial imagery, with religion and cosmology deeply embedded in its complex iconography.

Tile with composite flowers and saz leaves, cat. 43, detail.

The Turkic Past and Iran

Looking at the roots of artistic traditions can be a perilous enterprise in an age when nationalism still colors the view of art history in many societies. The problem becomes acute when it involves the issue of Turkic influence in the art of Islam, especially if that art was created in places that, as modern states,

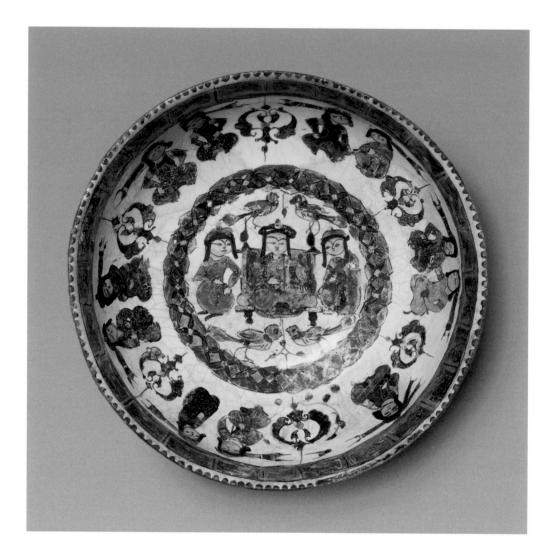

Fig. 1
*Bowl with enthroned ruler
and courtiers*, cat. 27.

do not now identify themselves with a Turkic heritage, but emphasize their Iranian, Arab, Indian, or Balkan national traditions.

A small white-ground ceramic dish in the Calderwood Collection (fig. 1), decorated in overglaze colors in the so-called *mīnā'ī* or *haft rangī* technique, was created in Iran in the first half of the thirteenth century, after the demise of the Great Seljuk state (1037–1194), but at a time when the patron class in Iran was still largely of Turkic ancestry, with language, culture, military organization, governance practices, and even religious traditions strongly linked to a Turkic past before the adoption of Sunni Islam.[1] If we can avoid the backward projection of modern nationalism onto the history of Persian art, we see that the greatness of that art over many centuries in fact depends on two complementary phenomena. The first is the tendency of artistic production to preserve Persian visual culture—style, subject matter, and media—under constantly changing political rule that included dominance by non-Persian minorities. The second is the remarkable ability of

Persian art to assimilate new ideas, be they Turkic concepts of rulership in the eleventh through the thirteenth century, Chinese motifs and styles in the period of Mongol and post-Mongol rule in the fourteenth century, or the introduction of European modeling and perspective through the import of paintings and prints in the seventeenth and eighteenth centuries.

The seated ruler with attendants represented on the Calderwood bowl is a common theme in Seljuk Iran; the confronted birds above and below the throne, long a feature of Turkic art, may have roots in the distant Buddhist past of these Turkic peoples in Central Asia.[2] The thirteenth-century costumes depicted here have elements that can be directly related to pre-Islamic Turkic tradition, and the round faces with their Asiatic eyes also are thought to reflect the Central Asian heritage of the Turkic rulers of Iran.[3] The coming of Seljuk rule in Iran seems to have resulted in a virtual explosion of figural images in Iranian art in a variety of media, among them stone and stucco sculpture, ceramics of human and animal form, narrative painting, and especially decoration on ceramic wares. Emel Esin has documented how various pre-Islamic Turkic ceremonial practices, among them cup rites and ceremonial libations, left a lasting impact on the institution of kingship in Iran and were reflected in works of figural art, where rulers are often depicted holding chalices as symbols of authority. Asiatic facial features and facial shape, certain elements of costume and hair style, the depiction of soldiers—as opposed to rulers—on horseback, and other elements of Seljuk representation surviving in both *mīnā'ī* and luster-painted ceramic wares (fig. 2), all show the stylistic influence of Turkic rule and institutions on Iranian art.[4] But by the thirteenth century these foreign elements, like so many others before them, had

Fig. 2
High-footed dish with two horsemen, cat. 30.

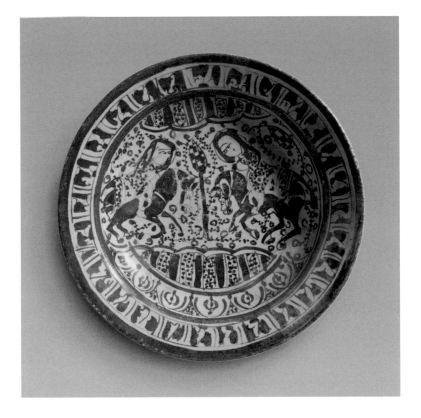

become completely assimilated into Iranian culture; in a pattern repeated since the time of Alexander the Great, the culture of Persia, especially its narrative and lyric poetry, dress, and institutions of rulership, had almost engulfed that of the conquering outsiders. In his classic 1963 history, *The Heritage of Persia*, Richard Frye ended his discussion of pre-Islamic Persian history with a chapter entitled "The Persian Conquest of Islam," in which he makes precisely this argument.[5] With all of its outside elements, the Calderwood bowl is ultimately part and parcel of the history of Persian art.

The Impact of China in Iran after the Mongol Invasions

Much has been written about the artistic impact of the motifs, imagery, and styles of China in the aftermath of the Mongol invasions of the thirteenth century and the establishment of Ilkhanid Mongol rule (1256–1335) in Iran.[6] In fact, there was a constant cultural interplay between Islam and China over many centuries, with notable artistic interchange during the Tang dynasty (c. 618–907),[7] and after 1300, in the Yuan and Ming periods. Jessica Rawson's influential study *Chinese Ornament: The Lotus and the Dragon*[8] is especially useful in demonstrating the broad impact of Chinese artistic motifs and styles on Islamic arts of the post-Mongol period. During the fourteenth century, not only in Ilkhanid Iran, with its thriving Silk Road ties to China within the broader Mongol Empire, but also in Syria and Egypt—lands never conquered by the Mongols—the archetypal Chinese artistic motif of the lotus blossom began to make its presence felt in artistic media of all kinds. An eight-pointed relief-molded star tile in the Calderwood Collection (fig. 3), painted in metallic luster with lotus blossoms on the north and east points, was probably created for a palace of a prince or governor affiliated with the ruling Ilkhanid dynasty in the fourteenth century.[9] The appearance of Chinese visual ideas in Iran would continue in an unbroken sequence throughout the Timurid period of the fifteenth century and that of Safavid rule (1502–1736).

The supplanting in China of the Mongol (Yuan) dynasty (1279–1368) by the native Ming dynasty (1368–1644) in the middle of the fourteenth century led to a new wave of Chinese luxury goods arriving in the Middle East. Fascination with the blue-and-white palette of early Yuan porcelain is plainly documented, and important examples are still to be found in the imperial Ottoman Turkish collections in Istanbul.[10] It was in the Ming period, however, that blue-and-white porcelain, much of it manufactured especially for export to the Muslim world, had a two-fold impact there; the fashion for these imported wares is recorded in Islamic miniature painting and also reflected in the ceramic arts of Iran, Syria, and the Ottoman Empire, where native potters began to make their own blue-and-white vessels.[11]

What a perusal of the Chinese-influenced works in the Calderwood Collection underlines, however, is a phenomenon not so much of influence as of internalization. Just as pizza became a staple of American cuisine in the later twentieth

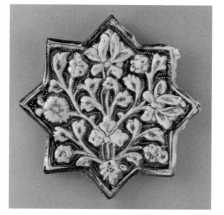

Fig. 3
Star tile with lotus decoration, cat. 38.

160

century, so in the sixteenth-century Middle East certain Chinese artistic motifs
and modes came to be so internalized in the arts of the Ottoman and Safavid
empires that they appear second nature to Islamic artists, their former exotic and
alien connotations having virtually evaporated. For example, an Ottoman tile from
circa 1585–95 (fig. 4), evidently used for refurbishing the Has Oda, or inner royal
chamber of the harem of Topkapı Palace, shows a central palmette and curved
serrated leaves, part of a familiar–indeed iconic–Ottoman court style convention-
ally called *hatayi* ("from Cathay," that is, China) in Turkish.[12] From about a century
earlier, a magnificent blue-and-white dish (fig. 5), possibly from a court manufac-
tory serving the Turkman dynasties who ruled northwestern Iran,[13] represents a
clear attempt to imitate a Chinese Ming original decorated with three peony blos-
soms. Its wave-and-crest rim decoration is another familiar Ming trope, with ante-
cedents in the Yuan period. As so frequently seen in the history of art, imitation
begets originality; imitation of Chinese blue-and-white ceramics in the Islamic
world begins as the sincerest form of flattery, and then develops into an original
Islamic tradition of powerful artistry.

Blue-and-white tablewares in both Chinese and Iranian versions were such a
common part of court banquets and entertainments that Persian miniature

Fig. 4
*Tile with composite flowers
and* saz *leaves*, cat. 43.

Fig. 5
Dish with peonies,
cat. 42.

painters during the fifteenth, sixteenth, and seventeenth centuries frequently depicted them as accoutrements of royal feasting. In a famous miniature painting of a nomadic encampment by Mir Sayyid 'Ali (fig. 6), one of these wares even conveys a subtle visual joke: in the upper part of the composition a young woman is shown wringing out laundry and placing it in a large blue-and-white Ming dish—a comment on the wealth as well as the manners of some nomadic clans. Finally, royal inventories attest to the popularity of Ming porcelain in many different Islamic courts, and collections surviving from Ottoman and Safavid times are among the richest in the world.[14]

From Iconography to Ornament: Chinese Fauna in Islamic Art

Perhaps the most extraordinary impact of Chinese imagery in Islamic art can be seen in the art of the margin painters of Iran. Magnificently illustrated books are of course one of the most important manifestations of Iranian creativity during the Safavid period. So popular did illustrated manuscripts become that

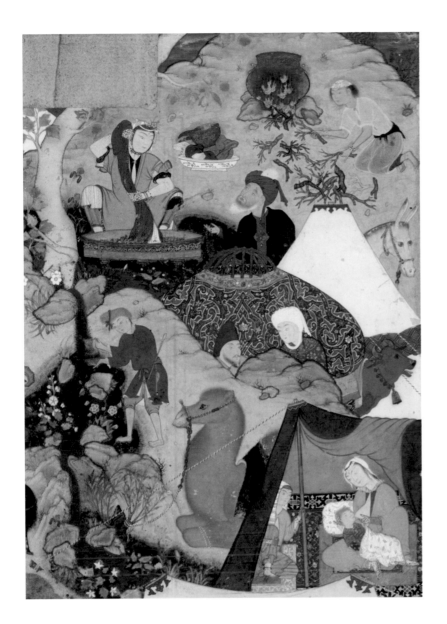

Fig. 6
Nomadic Encampment, detail.
Iran, Tabriz, Safavid period, circa 1540.
Opaque watercolor, gold, and silver
on paper, 28.4 × 20 cm (11⅛ × 7⅞ in.).

Harvard Art Museums/Arthur M.
Sackler Museum, Gift of John Goelet,
formerly in the collection of Louis J.
Cartier, 1958.75.

a flourishing commercial production of miniature painting illustrating beloved
Persian poetical texts arose in the south-central Iranian city of Shiraz, where
large numbers of manuscripts were illustrated by resident artists who closely
followed the stylistic developments of Safavid royal court painters in Tabriz and
Qazvin to the north.[15] The Calderwood Collection contains numerous illustrated
folios from these Shirazi manuscripts, including pages from the *Khamsa*, a quintet
of narrative poems by the poet Nizami (c. 1141–1209), and the *Shāhnāma*, or
Book of Kings, in effect the national epic of Persia, written by the poet Firdawsi
(c. 940–1020). Remarkably, while the paintings themselves illustrate well-known
stories and follow long-established traditions of iconography and composition,
the borders, executed in gold ink, present imagery of a different nature—that
of Chinese decoration of the times. The simurgh, a bird of Persian myth whose
form is taken from Chinese art, is often depicted in the topmost margin, with its

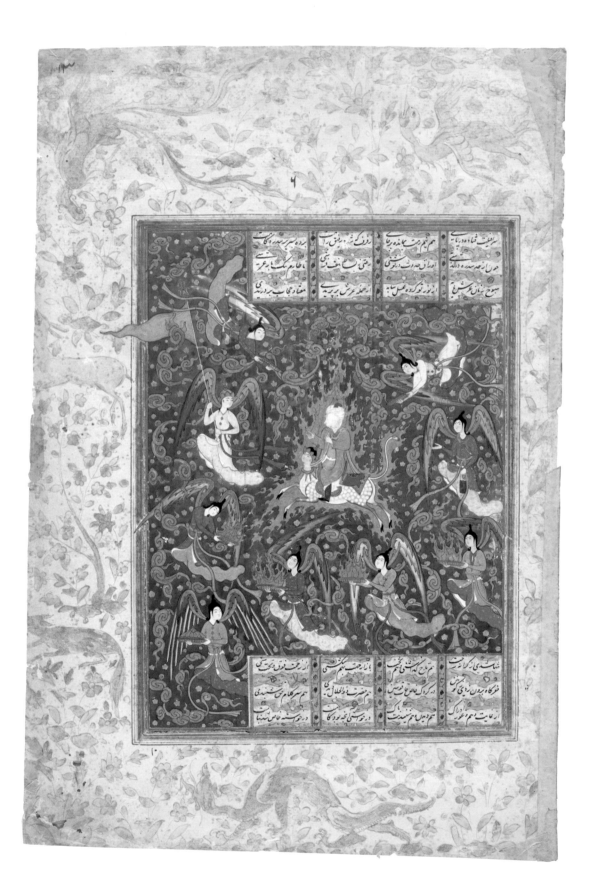

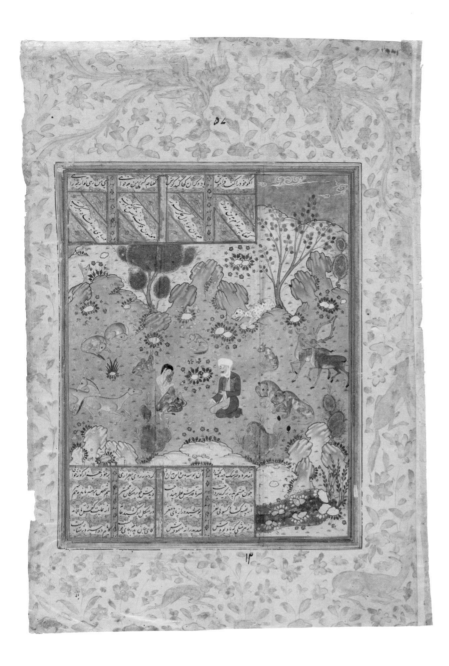

Fig. 7
The Prophet's Ascent,
cat. 107.

Fig. 8
Majnun in the Wilderness,
cat. 108.

long tail feathers creating beautiful and sinuous patterns (figs. 7 and 8); it is frequently accompanied by tightly curled Chinese cloud forms called *qi* (see, for example, the margins in cats. 97–100). A miniature painting from Nizami's *Khamsa* depicting the *mi'rāj*, or mystical night journey of the Prophet Muhammad (fig. 7), includes in its border not just a simurgh but also the element in Persian art most characteristically associated with a Chinese origin, the dragon. Symbolizing the cosmos in its original context, this creature appropriately accompanies the Iranian painter's celestial scene.

In many illustrated pages in the Calderwood Collection, animals well known from the literary and pictorial imagery of the Persian hunt—lions, hares, foxes, jackals, antelopes, and the like—share margin space with Chinese-derived elements. Close examination shows that these seemingly native animals are frequently depicted

وروح را بازو پس علی رسانیده چنته آن یک عیت که گفتام این مقام ابن واو واذبت

وفریدالدین عطار این حکایت نظم اورده است

بی آزا المنذ می پا پستی نوبی

ذنام نویم مرحم پستی نویی

نکر وی تو نماز از بی نیاز نیست

گوای جان تو بار و درنه

کی می تنگ آمذت زین بی نماز

نظم واو ذبه برقرن و پس نیای علی

کفرورد زه عزو پس تبا آنی

خدای تو نذا ای زلو کشته

فرستا وانت لطف کار نما

حمذ از لطف روحانی کشته

کة تا کرمذ رتمای کم نما بک

چون بشیخ از نخواب پیدا پذ بای راعنه کران برمقذ عزو سی نشتافت و برترقبر عزو سی نما

کار و و جنذ روز بر سر قبر مشکث شد و تا درحیات بو د و م روز بزیارت او رفتی که پدیدار اسلان عابرب برمقذ عزو سی

قبسه سا خت نمار نای ای تشکر قان کر راه گذر راه جکمت خراسان فرستا و او درطوس مقام کرفت آن قیذ قلع

بو د و مروی کی از اطراف چنته عارت قلعه آمذه بو د و نذ آزا و یران کرذ و نذ و ا تعمار ربو نذ بعذ از این درزمان نما

غازان امیر استیلغ که اموال بوس پس سور غال او بو د بیا بر ترتیب عزو سی اشارت فرمود کفت تاا ولی

خانتا می تقبیل مرقذ او نماک د و نماز نوز خانقا ، تمام شذ کا تضلیغ وفات یافت و آن عارت در توقف اثما

فی العلم عزو سی را بیکبار رفت و و سوست و شا همنا ره راکذا شت و یکتست که از زمان فارسی متذا ول سوا بو بو

این کتاب معجز و معترک می شو د و خواص این شا عنا ره است که در این طور سخن نبسی کرد ملوک و سلاطین وحکایت

عساف و معرک و رایت ملک وحمکگری وجذا نذاری با نوشت شده و مرچنذ شعرا لعب ازو سی نمو د ه نذ و کوشش

ار و د نذ و رر رصاحت ولطاف کشید نذ بآن پسپا قی جو علت بر مذارح فضا جت و بلاغت است و واکر بین

نبوی کتب د یکر که بعذ از این نظم کرد ه ازمعتوی شذی چون کر شاسپ و بهمن نامه و د ارا ب نامه و اسکندذ

و سلجوق نامه و شا مناه و غیرذ ذلک ولیک عذرت که شهر شاهنامه و شام و روم و ترکستان

کتاب شا عنا پسپا ر می پا آن یا مافت و در خراسان و فارس عراقین و هنذ بستان خو د می جنه قصه نمایذ

کآنجا جنب نب شناخته و نشذه نباشذ و این زمان جها صذ سال از آن تاریخ کذنشته است منوز می نوبنذ

ولیکن اکر در مر منجی کرآمذ اپات خو د می با شا منا و و در آنجا معنی نتوان یافت و آنجا علی بن ابی عا

نیام سلطان ملکث که پا شذا ت و آزما بنوی یک و موسب کرد و و مر با پسی از آن اپات شما نما

گرد و ... آزا علی جعه ء کتاب بی پا نته که مر مطوب و مطلوب نما لا پات

عزو سی را نفیر از شا منا شاهنا د اشثا ر پسپا ر پت

اما شرت ناره و والله اعلم

بت

with flames shooting from their shoulders (fig. 10), a clear indication that they represent Chinese versions of such fauna. Other borders (for example, fig. 9) depict Chinese-derived lotus palmettes similar to those that made their way onto the Iznik tiles of Ottoman Turkey (see fig. 4 above). The same orientalizing tradition of border decoration continues in Iran well into the seventeenth century, when wealthy patrons collected individual drawings, paintings, and calligraphic specimens, which were often framed with the work of contemporary margin painters (for example, cat. 123) and pasted into beautifully constructed albums.

The appearance of Chinese motifs and images in Persian art of the sixteenth century has long been studied and explained. Chinese porcelains, textiles, and even works on paper served as the vectors whereby these motifs traveled westward into West Asia, over the Silk Road. Such imagery pervaded Persian art of many media over hundreds of years. In this it differs dramatically from the chinoiserie that appeared in the art of Europe during the first half of the eighteenth century. The chinoiserie vogue was based on the foreignness of Chinese art—that is, Chinese motifs were used precisely because they were strange, exotic, and provocative. By contrast, Chinese elements used in Persian art were almost totally assimilated into everyday Persian style. A dragon in a margin of a book detailing an episode from the life of Muhammad is no more out of place than a sky filled with Chinese cloudbands in the depiction of a Persian romance, or Chinese-inspired lotus blossoms decorating a Persian textile. By the sixteenth century these motifs were integral to the Persian style, dramatic evidence of the ability of Persian art to assimilate new ideas and expand its horizons.

To what extent were the original symbolic meanings of these forms retained as they migrated westward? Despite the efforts of some scholars to maintain that the Chinese symbolism of fauna and flora was somehow transmitted along with the motifs themselves,[16] there is very little evidence to indicate that either the artists who adopted these motifs or the patrons of these artists' works were aware of such symbolism. Indeed, the juxtapositions of many Chinese-inspired margin elements with the painting subjects they surround argue against the idea that their original meanings were either retained or widely understood.

Fig. 9
Text folio, from the 1562 manuscript of the *Shāhnāma*, recto of cat. 75.

Fig. 10
Lower margin of *Gudarz Pays Homage to Kay Khusraw and Shows Him the Enemy Corpses*, from the circa 1575–90 manuscript of the *Shāhnāma*, cat. 98, detail.

A Lesson from the Calderwood Collection

If there is one lesson to be learned from this examination of a few objects in the Calderwood Collection, it is the truth of the dictum that, in art, "everything comes from somewhere else." If such fundamental cultural icons as nesting Matryoshka dolls in Russia (introduced from Japan about a century ago), tea drinking in the bazaars of Istanbul (introduced from Russia a little over a century ago), coffee drinking in Vienna (introduced from Turkey in the seventeenth century), or *pommes frites* in Belgium (potatoes introduced into Europe from North America) have emigrated from afar, then we should be even less surprised to see this migration occurring in visual art. Rather than the stereotype of a conservative phenomenon hemmed in by religion, Islamic art is a dynamic tradition, and from this inherent dynamism over the centuries it derives its beauty, diversity, and fascination.

Notes

1. The links between Islamic art of Iran in the twelfth and thirteenth centuries and the pre-Islamic Turkic past were explored in detail by Emel Esin over a long career; for her collected essays, see Esin 2004.

2. On confronted birds, see Lamm 1965.

3. See Grube 1968, 11–27, for a discussion of what the author called the Miran, or Central Asian, style and its impact on Islamic art.

4. On horses and horsemanship, see Esin 1965.

5. Frye 1966, 263–85.

6. On the Mongol legacy, see Komaroff and Carboni 2002.

7. On Tang-period interchange, see Schafer 1963.

8. Rawson 1984.

9. See Masuya 2002.

10. See Krahl 1986.

11. This artistic indebtedness continued during the later Qing dynasty (1644–1912). On the impact of Chinese blue-and-white wares, see Carswell 2000; also Finlay 2010, esp. 139–213.

12. On the *hatayi* style, see Atıl 1987, 97–104; also Denny 1983.

13. Recent research, however, suggests that this dish may have been made in Khurasan, to the east: see cat. 42.

14. Denny 1974, 76–99.

15. See, in this catalogue, Marianna Shreve Simpson's essay, "The Illustrated *Shāhnāma* in Sixteenth-Century Shiraz," 77–113.

16. See Cammann 1972.

Catalogue of the Collection

Susanne Ebbinghaus

Mary McWilliams

Robert D. Mowry

Mika M. Natif

David J. Roxburgh

Ayşin Yoltar-Yıldırım

Objects

Ceramics
(cats. 1–52)

Lacquer
(cats. 53–58)

Stone and metal
(cats. 59–61)

Works on Paper

Manuscript folios
(cats. 62–117)

Single-page drawings
and paintings
(cats. 118–30)

Study Collection

(cats. 131–52)

Objects

1, 2

Rectangular jar with lid
Northwest Iran, 9th–7th century BCE
Faience with turquoise (copper), yellow
(lead antimonate), purplish black
(manganese), and colorless alkali glazes
12.4 × 9.6 × 9.3 cm (4⅞ × 3¾ × 3¹¹/₁₆ in.)
2002.50.96

Cylindrical jar with lid
Northwest Iran, 9th–7th century BCE
Faience with turquoise (copper), yellow
(lead antimonate), and colorless alkali glazes
9.7 × 8 cm (3¹³/₁₆ × 3⅛ in.)
2002.50.97

In ancient as in later Iran, colorful glazes
embellished ceramic vessels and wall deco-
ration. The glaze colors (including tur-
quoise, yellow, white, and black) as well as
the animal and plant motifs depicted on
these objects largely followed Mesopota-
mian models. From the destruction level at
Hasanlu, in northwest Iran, dated to circa
800 BCE, come glazed tiles and vessels,
among these a beaker painted with an un-
usually loose, abstract pattern consisting of
triangles and dots.[1] The two jars discussed
here bear patterns similar to those of the
Hasanlu beaker and several other vessels
reportedly from the site or surroundings of
Ziwiye, an Iron Age citadel southeast of
Hasanlu.[2]

The 1947 find at Ziwiye of a rich assemblage
of artifacts, the so-called Ziwiye Treasure,
led to further clandestine excavations and
established the site as an antiquities-market
label, which also attracted forgeries.[3]
Although documented excavations in the
area appear not to have provided exact par-
allels for the lidded "Ziwiye-type" contain-
ers, they have revealed glazed vessels and
tiles.[4] Decorated with floral patterns as well
as ibexes, sphinxes, and other mythological
creatures, these finds attest that Mannea, as
the region was called in the ninth to seventh
centuries BCE, produced, or at least had
access to, skillfully made glazed artifacts.

The two Calderwood jars were perhaps
intended for cosmetics. The rectangular
example (cat. 1) has two pierced lug handles
and four stumpy feet; the appearance and ill
fit of its slightly domed lid suggest that it
may not belong to the jar. Turquoise glaze
lines frame the edges and divide the top of
the lid into four triangles, which are filled
with dots in the same color. The four sides
of the vessel are decorated in a turquoise
zigzag pattern. The standing triangle at the
center of each side is white with black dots;
the hanging triangle extending over each
corner is yellow with turquoise dots. Rim
and handles are covered in turquoise glaze,
which also extends partway down on the
interior. The jar is composed of numerous
fragments, with some fills and inpainting.

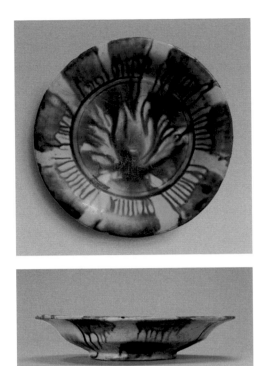

The cylindrical jar (cat. 2) has pierced lug handles and a dome-shaped lid that is pierced at the center. The vessel bears a battlement pattern outlined in turquoise and filled with yellow glaze. Spikes project above and below, and dots punctuate both the pattern itself and the spaces between the spikes. The lid features a cross-shaped motif outlined in turquoise and filled with yellow in two of the quadrants. There are turquoise dots in each of the segments. Much of the glaze is worn off and partly restored in modern paint.

Thermoluminesence analysis has confirmed the authenticity of the two Calderwood jars.[5] They are made not of clay but of faience, a quartz-based material. Scientific examination has shown that the glaze is a soda-lime glass derived from plant ash, as is common for this period. The glazes are colored by lead antimonate with various quantities of iron oxide for the yellow (Naples yellow), by copper for the turquoise, and by manganese for the purplish black.[6] The same colorants were used for glazed bricks from Achaemenid Persian Susa.[7]

SE

1 Dyson 1968, 90, 101, fig. xxxix; Dyson 1989, 9, fig. 10b; Fukai 1981, 8–9, figs. 9–10.

2 Fukai 1981, 8–21, compare especially pls. 15, 20, 25–27, 33–37, 44.

3 Godard 1950; Muscarella 1977; Muscarella 2000, 76–81.

4 See V. Curtis and St. J. Simpson 1998, 193–94, fig. 8: 4–6; Hassanzadeh 2006; Rezvani and Rustaei 2007, 146–47, 150, pls. 12–13, and pl. 26, figs. 12–13; Hassanzadeh and Mollasalehi 2011. Somewhat smaller, once-lidded containers were found at Hasanlu: see Dyson 1968, ill. on 90; Metropolitan Museum of Art (63.109.16 and 65.163.68).

5 Thermoluminescence analysis carried out by Oxford Authentication Ltd. in 2011 indicated that one jar (2000.50.96) was last fired between 1800 and 2800 years ago and the other (2000.50.97) between 1600 and 2800 years ago. Samples were taken from the bases of the jars, so the authenticity of the lids is not assured.

6 The colorless alkali glaze appears "milky" due to bubbles. X-ray florescence (XRF), scanning electron microscopy with energy dispersive microanalysis (SEM-EDS), and Raman spectroscopy were carried out by Katherine Eremin at the Straus Center for Conservation and Technical Studies, Harvard Art Museums.

7 Compare Fukai 1981, 20–21; Moorey 1994, 180–86; Razmjou et al. 2004; Tite and Shortland 2008, 93–103, 187–98, with further references.

3

Dish with green splashed decoration
Iraq, Abbasid period, 9th century[1]
Buff-colored earthenware with patches of green (copper) running in clear lead glaze
4.1 × 21.2 cm (1⅝ × 8⅜ in.)
2002.50.104

Published: McWilliams 2002a, 13, fig. 4.

Although the collection contains important pre-Islamic antecedents in the Ziwiye wares (cats. 1 and 2), Norma Jean Calderwood's initial focus was on the glazed ceramics of the Islamic era. This green-splashed dish, the earliest Islamic ceramic vessel in the collection,[2] represents the glazed luxury wares being produced in Abbasid Iraq by the late eighth to early ninth century. The rounded walls and slightly everted rim of this dish recall those of Tang white wares. Whether the production of color-splashed ceramics in the Islamic world was an independent development or was also inspired by wares imported from China is still unresolved.[3]

A copper oxide was applied in patches on the exterior and interior rim of this dish before it was fired upright. The green patches flowed freely in the clear glaze, pooling at the center into a shape serendipitously resembling a lotus blossom.

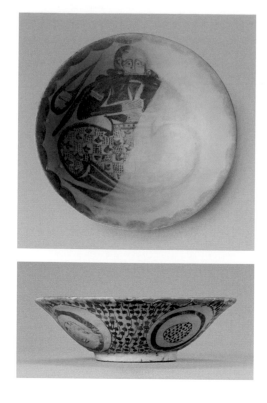

Ceramics with colorants running in a clear glaze were broadly popular and widely produced in the early Islamic era; wasters have been found from Afrasiyab, in Uzbekistan, to Fustat, in Egypt.[4] Because this visual effect could be achieved through various techniques, assigning place and time of production to these wares is often difficult.[5] Calderwood acquired this dish as an example of eastern Iranian splash ware, but on the basis of its well-formed foot, its finely potted profile with recurved rim, and its lack of secondary incised decoration, it is here attributed to Iraq.

MMcW

1 The bowl is of "ancient origin," according to the results of thermoluminescence analysis carried out at the Research Laboratory of the Museum of Fine Arts, Boston, in 1973.

2 Calderwood acquired a small dish, cat. 50, as an example of the green-glazed wares of the late Umayyad period, but it was more likely created in early modern Vietnam or China, according to Robert D. Mowry.

3 Watson 2004, 47, 171, 199.

4 Wilkinson 1973, 54.

5 See Grube 1994, 33.

4

Fragmentary bowl with seated figure holding a beaker
Iraq, Basra, Abbasid period, 10th century
Buff-colored earthenware painted with luster (silver and copper) over white lead alkali glaze opacified with tin
6.8 × 22.2 cm (2¹¹⁄₁₆ × 8¾ in.)
2002.50.84

Published: McWilliams, 2004, 11.

Luster painting is often cited as the greatest contribution of Islamic potters to the history of ceramics. This difficult and costly decorative technique, which requires two firings, appears to have originated in the late eighth or early ninth century in the Iraqi port town of Basra, where it flourished for some two centuries.[1] Abbasid lusterwares enjoyed immense success and prestige and have been found along trade routes from the Strait of Gibraltar to the Strait of Malacca.[2] The four monochrome luster bowls in the Calderwood Collection represent what is often considered the last phase of Basra luster production.[3] In the late tenth century, luster painting on ceramics spread outward from Iraq, with brilliant, albeit differing, manifestations in Egypt, Spain, and Italy to the west and Syria and Iran to the east.

Although slightly more than half plaster fill, this bowl retains the image of an arresting

figure, probably female, with a riveting gaze.[4] She has long, wavy locks of hair and is adorned with earrings, a necklace, a decorated textile band (*ṭirāz*) on her arm, and an elaborately checkerboard-patterned lower garment.[5] Her seated position and the triangular beaker that she holds at chest level (in a six-fingered hand) suggest the princely pastime of wine drinking.

This bowl, unlike most lusterwares of the same phase, shows the figure isolated against a plain white ground. The glazed base bears a fragmentary, illegible inscription in Kufic script.

MMcW

1 This discussion follows the developmental chronology proposed for luster ceramics in Mason 2004, 23–62 and 156–68.

2 Hallett 2010, 76.

3 For a divergent opinion, see Philon 1980, 73.

4 A very similar face appears on a monochrome luster fragment (Benaki Museum, Athens, 321) illustrated in Philon 1980, 159, fig. 356.

5 A similar checkerboard pattern appears on a monochrome luster fragment, a bowl base (Benaki Museum, Athens, 324) illustrated in Philon 1980, 144, fig. 315.

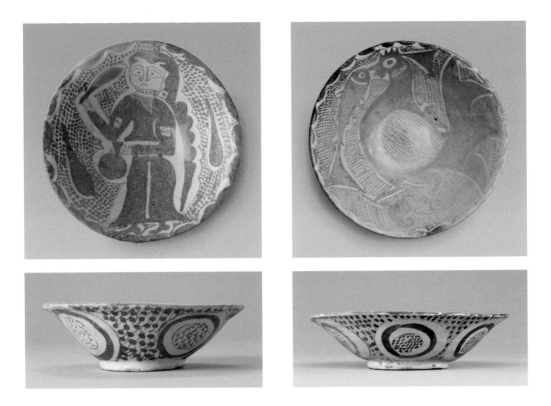

5

Bowl with standing figure holding a bottle
Iraq, Basra, Abbasid period, 10th century
Buff-colored earthenware painted with
luster (silver and copper) over white
lead alkali glaze opacified with tin
4.1 × 13.7 cm (1⅝ × 5⅜ in.)
2002.50.70

This small bowl, reconstructed from about
ten fragments, depicts a standing female
figure. Half of her head, starting at the wid-
ow's peak, and the top portion of the imple-
ment in her raised hand are now plaster fill.
Like the figure on the previous bowl (cat. 4),
this woman has long, wavy hair and wears
earrings and *ṭirāz* armbands. She carries a
globular bottle, which again signals the
courtly enjoyment of intoxicating beverages.
Leaves of elongated teardrop form and a
field of V-shaped marks fill the space around
her. The luster decoration on the exterior
consists of concentric circles amid dots and
dashes, which can also be seen on other
bowls in the collection (cats. 4, 6, and 7).
The bottom of the foot is glazed and marked
with four dabs of luster.

MMcW

6

Bowl with rooster and fish
Iraq, Basra, Abbasid period, 10th century[1]
Buff-colored earthenware painted with
luster (silver and copper) over white
lead alkali glaze opacified with tin
5.9 × 23.2 cm (2⁵⁄₁₆ × 9⅛ in.)
2002.50.72

Published: McWilliams 2004, 3, 11, fig 2.

Repaired from about twenty fragments,
but with only small losses, this bowl is deco-
rated with two startled-looking animals—
a rooster, and, in its beak, a fish. Their wide-
eyed energy is sustained by other sharply
angled elements of the design: fins and tail
feathers, coxcomb, and fluttering scarf.[2]

These creatures have long carried positive
associations: the rooster, as the harbinger
of dawn, symbolizes hope, while the fish
suggests bounty. In religious contexts, the
rooster also developed more specifically
auspicious connotations: according to a
popular epigram attributed to the Prophet
Muhammad, he crows when he sees an
angel; in Christian tradition, his invigorat-
ing sound recalls the faltering to their faith.

The glazed base of this bowl bears an un-
decipherable inscription in Kufic script.

MMcW

1 The bowl was last fired between 700 and 1200
 years ago, according to the results of thermo-
 luminescence analysis carried out by Oxford
 Authentication Ltd. in 2011.

2 In Grube 1994, 38, cat. 25, Peter Morgan, refer-
 ring to a bowl in the Khalili Collection, London,
 describes a similar adornment on a bird's head as
 "the classical Sasanian imperial ribbon."

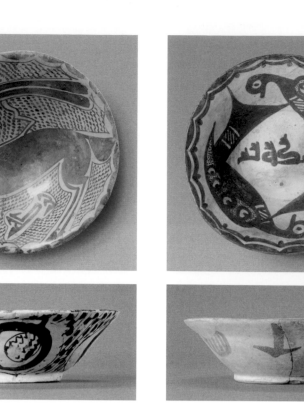

7

Small bowl with quadruped and inscription
Iraq, Basra, Abbasid period, 10th century[1]
Buff-colored earthenware painted with
luster (silver and copper) over white
lead alkali glaze opacified with tin
5.6 × 16.2 cm (2³⁄₁₆ × 6³⁄₈ in.)
2002.50.71

Published: McWilliams 2003, 235, 237, fig. 11;
McWilliams 2007, 14, fig. 1.

The Arabic word for "blessing" (*baraka*) is
written twice below the curious four-legged
beast that fills this small bowl. The slender
legs of the animal and its hooves with dew-
claws probably indicate that it was intended
to be a deer, a creature admired for its
beauty and prized by hunters as game. Its
neck, head, and upper back are an early
restoration, poorly painted on plaster fill.[2]

MMcW

1 This bowl is of "ancient origin," according to the
 results of thermoluminescence analysis carried
 out by the Research Laboratory of the Museum
 of Fine Arts, Boston, in 1973.

2 The original head probably resembled that of a
 beast on a monochrome luster fragment (Benaki
 Museum, Athens, 231) illustrated in Philon 1980,
 151, fig. 335. Philon identifies that animal as a hare.

8

Bowl with two birds circling an inscription
Iran, Nishapur, Samanid period, 10th century[1]
Reddish earthenware covered in whitish slip
and painted with green (chromium) slip
under clear lead glaze
5.9 × 20.7 cm (2⁵⁄₁₆ × 8¹⁄₈ in.)
2002.50.57

Published: McWilliams 2004, 11.

Potters working during the reign of the
Samanid dynasty (819–999) in northeastern
Iran and Central Asia produced some of the
most impressive and distinctive wares in the
history of Islamic art. One of their most suc-
cessful decorative techniques involved the
use of slips—colored clays in solution—both
to envelop the reddish earthenware body of
vessels and to add surface designs.

The body of this bowl, for example, is cov-
ered completely in a whitish slip, with a
lively design in olive green painted over it.
The green color is produced by fine particles
of a chromium compound. Within a rim
decorated with running crescents appear
two wide-eyed birds, positioned breast-
to-tail, who pinwheel around an Arabic
inscription in foliated Kufic that reads,
"Blessing to him" (*baraka lahu*). On the exte-
rior, three circles enclosing parallel diagonal
lines alternate with three downward-
pointing arrows.

The crescents, pop-eyed animals, benevo-
lent inscription, and circles echo designs
on tenth-century monochrome lusterwares
produced in Basra (see cats. 4–7). Slip-
painted imitations of Basra vessels seem
to have been a specialty of the potters of
Nishapur, in northeastern Iran.[2]

A clear glaze with a slight greenish tinge
covers the interior and exterior of this bowl,
including its beveled, slightly concave base.
The vessel has been put back together from
fragments, with painted plaster filling in
losses in the wing of the inverted bird.

MMcW

1 The bowl was last fired between 800 and 1300
 years ago, according to the results of thermo-
 luminescence analysis carried out by Oxford
 Authentication Ltd. in 2011.

2 Fehérvári 2000, 63.

9

Jug with inscription
Probably Uzbekistan, Samarkand,
Samanid period, late 9th–10th century[1]
Reddish earthenware covered in white slip
and painted with black (manganese and iron)
under clear lead glaze
Body: 10.6 × 9.8 cm. (4³⁄₁₆ × 3⁷⁄₈ in).
Handle and rim: 12.2 cm. (4¹³⁄₁₆ in.)
2002.50.91

Published: McWilliams 2004, 11.

Among the most impressive ceramics produced during the reign of the Samanids are
the epigraphic wares, so called because their
sole or main decoration consists of stately
Kufic script. An austere Arabic inscription,
which may be read as "The noblest thing is
the well-being of my guest" (*ashraf al-shay
nuzlī al-munā*), lends surprising majesty to
this small jug. Written in black, four words
are evenly spaced around the bulbous body,
with an almond-shaped lozenge marking
the end of the phrase. The tall ascending
letters curve gently to the left. The intersection of the neck and body is ringed by a
black line, which breaks into a looping motif
at the front of the jug, opposite the handle.
The black slip is raised slightly above the
white surface; a carving tool has been used
to sharpen its contours.

The jug has been reassembled from thirteen
fragments; small losses filled with plaster
have been painted white. The reddish earthenware body, including the flat base, is
covered entirely in white slip and a slightly
yellowish clear glaze.

MMcW

1 This jug is of "ancient origin," according to the
 results of thermoluminescence analysis carried
 out by the Research Laboratory of the Museum
 of Fine Arts, Boston, in 1973.

10

*Bowl inscribed with a saying of 'Ali ibn
Abi Talib*
Iran, Nishapur, Samanid period, 10th century
Reddish earthenware covered in white slip
and painted with black (manganese and iron)
under clear lead glaze
6.1 × 21.5 cm (2³⁄₈ × 8⁷⁄₁₆ in.)
2002.50.83

Written around the rim of this bowl in a
"new style" Kufic, with ascenders deflected
abruptly to the left, is an epigram in Arabic
attributed to 'Ali ibn Abi Talib, the son-in-
law of the Prophet Muhammad, praising
knowledge and manly virtue: "Knowledge is
the noblest of personal qualities, and love is
the highest of pedigrees" (*al-'ilm ashraf al-
aḥsāb w'al-mawadda ashbak al-ansāb*).[1] A
pear-shaped ornament rising out of the last
letter of the last word (*al-ansāb*) marks the
end of the inscription. Written across the
center is a single Arabic word, *aḥmad*, which
appears frequently on Samanid epigraphic
bowls. In this context it is usually construed
not as the signature of a potter but as a blessing: "most praiseworthy." Proverbs praising
knowledge and exhorting the owner to
various forms of virtuous conduct appear
frequently on these elegantly inscribed
epigraphic wares, suggesting that they were
appreciated by a class of users who placed
high value on learning and ethical behavior.
On the interior and exterior of this well-

potted bowl, the entire pinkish-buff ceramic body, including the beveled, slightly concave base, has been covered in white slip and clear glaze. The vessel is fragmentary; the last word of the inscription has been partially reconstructed on a plaster fill.

MMcW

1 Other Samanid epigraphic wares with the same saying are listed in Ghouchani 1986, 9.

11

Bowl with foliated and plaited inscription
Uzbekistan, Samarkand, Samanid period, 10th century[1]
Reddish earthenware covered in white slip and painted with black (manganese and iron) under clear lead glaze
8.6 × 25.5 cm (3⅜ × 10¹⁄₁₆ in.)
2002.50.89

Among the more extravagant developments in Samanid epigraphic wares is the elaboration of Arabic script—occasionally, as here, to the point of illegibility. The inscription on this bowl is a compendium of the major decorative devices and themes that embellish these wares, including the dramatic elongation or extension of letters and their ornamentation with plaiting, arcs, loops, knots, foliate terminals, and interlacings that seem to spring from their middles or the ligatures between them.[2] The most exuberant decorative devices occupy the upper zone of the inscription, that is, toward the center of the bowl.

Underlying the proliferation of ornament is an essentially rhythmic structure based on repetition of near-identical elements. Occurring three times in the band, and dividing it roughly into thirds, is a complicated and additive form of the letter *alif*, the tallest element in the inscription. Each *alif* bears three loops on its staff and at its top

deflects rightward in a foliate terminal. Its baseline stretches to the right and has been transformed into a split leaf, from which a tendril curls upward and rightward and terminates in another split leaf. The tendril in turn joins, or nearly joins, a curving and branching foliate outgrowth that reinforces the rhythm established by the *alif*. Less regularly spaced are three plaited ornaments that spring once from a ligature and twice from a closed rectangular letter. Small rosettes composed of four dots enliven the interstitial space of the inscription band and mark the center of the bowl.

This bowl is well and thinly potted of a fine-grained earthenware. The exterior and interior are covered in a creamy white slip under a clear glaze. The flat and very slightly concave base is partially slipped and glazed. Only the interior is decorated; its brownish-black slip stands slightly raised above the surface, and a carving tool has been used to sharpen contours and to articulate the plaiting, twisting, and overlapping of the letters. The bowl has been reassembled from numerous fragments, with one notable loss on the rim.

MMcW

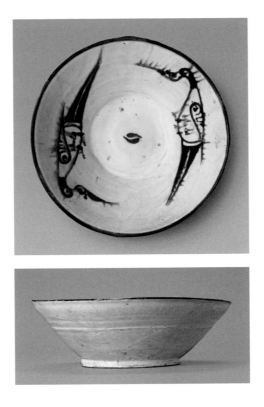

1 The bowl was last fired between 700 and 1200 years ago, according to the results of thermoluminescence analysis carried out by Oxford Authentication Ltd. in 2011.

2 The terminology here follows that used in Volov 1966.

12

Bowl with birds and inscriptions
Iran, probably Nishapur,
Samanid period, 10th century[1]
Reddish earthenware covered in white slip
and painted with black (manganese and iron)
under clear lead glaze
7.8 × 25 cm (3¹/₁₆ × 9¹³/₁₆ in.)
2002.50.115

A pair of inward-facing birds seeming to revolve counterclockwise occupies the walls in this bowl. Their wings are formed of split leaves articulated in reserve, and their tails recall the forked scarves (or tresses) of human figures on Samanid yellow-field wares (cats. 18 and 19) or the boots worn by the seated figure on an Abbasid bowl (cat. 4).

Each bird has the Arabic word for "blessing" (*baraka*) written in Kufic script across its body, and each holds in its beak a split leaf; one leaf is considerably blurred by the running of the black slip in the glaze. From the number of similar bowls that have survived, one can surmise that these motifs and their composition were highly favored in the early Islamic era.[2]

Overall, the bowl is sparsely decorated: the interior features only the birds, a black rim, and a pair of comma-like motifs in the center, and the outside is left entirely plain except for white slip and unevenly applied clear, greenish-tinged glaze. The slip and glaze only partially cover the beveled base. Sagger marks at the center, as well as the flow of the black pigment toward the rim, indicate that the bowl was fired upside down.

MMcW

1 The bowl was last fired between 700 and 1300 years ago, according to the results of thermoluminescence analysis carried out by Oxford Authentication Ltd. in 2011.

2 See the following examples: Tareq Rajab Museum, Kuwait, CER71TSR, illustrated in Fehérvári 2000, 54, no. 48; Freer Gallery of Art, Washington, DC, F1956.1, illustrated in Atıl 1973, 30–31, no. 9. See also Grube 1994, 88–89, nos. 79 and 80.

13

*Bowl inscribed with sayings of the
Prophet Muhammad and ʿAli ibn Abi Talib*
Uzbekistan, Samarkand, Samanid period,
10th century[1]
Reddish earthenware covered in white slip
and painted with black (manganese and iron)
and red (iron) under clear lead glaze
9.6 × 26.9 cm (3¾ × 10⁹⁄₁₆ in.)
2002.50.88

Published: McWilliams 2002a, 12, fig. 1; McWilliams 2002b, 44, fig. 1; AKPIA 2004, 7; McWilliams 2004, 4, 11, fig. 4; *HALI* 2004, 115; McWilliams 2007, 16, fig. 3; Harvard Art Museum and Wolohojian 2008, 39.

With its pure white slip, precise calligraphy, and perfectly clear glaze, this deep-walled bowl embodies the finest qualities of Samanid epigraphic wares. Most surviving examples of this class of ceramics reproduce benedictory phrases or popular proverbs. More rarely, as here and on one other bowl in the collection (cat. 10) they record sayings attributed to the Prophet Muhammad and his Companions. Beginning in his own lifetime, Muhammad's example was considered an important guide for how people should conduct their lives. In the early centuries of the Islamic era, sayings attributed to and anecdotes about him were collected and analyzed by numerous authors. The large and complex body of literature that resulted from this immense effort is known as hadith.

The outer inscription on this bowl is written in black slip and records a saying attributed to the Prophet: "Modesty is a branch of faith, and faith is in paradise" (*al-ḥayā shuʿba min al-īmān waʾl-īmān fiʾl-janna*). The inner inscription, in red slip, contains a similar dictum credited to ʿAli ibn Abi Talib, Muhammad's son-in-law and the fourth orthodox caliph of Islam: "Greed is a sign of poverty" (*al-ḥirṣ ʿalāniya al-faqr*).[2] Because each inscription is written in a ring, the calligrapher inserted a single-word invocation to mark the beginning: in the outer circle, "felicity"(*al-yumn*), and in the inner one, "health" (*al-salāma*).

This bowl has been reassembled from about fifteen fragments, with only minimal losses. The white slip and clear glaze completely cover the vessel, including its flat, slightly concave base.

MMcW

1 The bowl was last fired between 800 and 1400 years ago, according to the results of thermoluminescence analysis carried out by Oxford Authentication Ltd. in 2011.

2 The same proverb occurs in red slip on a closely related bowl offered at auction: see Sotheby's 2006b, 94, lot 92. See also the listing of vessels with these inscriptions in Ghouchani 1986, 8.

14

Small bowl with inscription in contour panels
Uzbekistan, Samarkand, Samanid period,
10th century
Reddish earthenware covered in white slip
and painted with black (manganese and iron)
and red (iron) under clear lead glaze
3.3 × 12.4 cm (1⁵⁄₁₆ × 4⁷⁄₈ in.)
2002.50.93

The bold decoration of this finely potted
bowl belies its diminutive size. A benevolent
Arabic inscription popular for ceramics of
the Samanid era is here rendered in impos-
ing, wedge-shaped Kufic script; it can be
interpreted as "Blessings and favor to its
owner" (*baraka wa niʿma li-ṣāḥibihi*).[1] Words
or parts of words are enclosed in contour
panels outlined in red and separated by
fields of black dots, a decorative treatment
typical of wares found in Samarkand.[2]
These panels surround slightly sketchy lines
in black and red slip, which in turn enclose a
motif of two circles joined at the center by
a black dot with cruciform protruding lines.
The black outline of the rim is alternately
smooth and dentate.

The exterior, including the flat, slightly con
cave base, is undecorated except for a cover-
ing of white slip and beautifully clear glaze.
The bowl has been put back together from
numerous fragments, with minimal plaster
fills.

MMcW

1 Although on a larger scale, the same inscription
 appears on a Samanid bowl (Harvard Art Muse-
 ums, 1979.375) illustrated in Pancaroğlu 2002,
 60, fig. 1.

2 See Watson 2004, 221, cat. Gb.2.

15

Bowl with inscription and birds
Iran, Nishapur, Samanid period,
10th century[1]
Reddish earthenware covered in white slip
and painted with black (manganese and
iron), red (iron), and yellow-staining black
(chromium) under clear lead glaze
5.8 × 18.8 cm (2⁵⁄₁₆ × 7⅜ in.)
2002.50.92

Published: McWilliams 2003, fig. 2; McWilliams
2004, 11; McWilliams 2007, 15, fig. 2.

Although painted with apparent dash, the
colorful decoration of this bowl is carefully
composed. The design is laid out in three
registers: an Arabic word meaning "har-
mony" (*al-wifāq*) occupies the middle, and
above and below it are long-necked birds
with outstretched wings. Like the beginning
and end letters of the inscription, the birds'
heads and leaf-like wingtips terminate at the
red circular boundary. Freely painted run-
ning crescents and a black line enclose the
lively composition. Combining Arabic
script with birds became popular among
potters in the early Islamic era. On this
bowl, where inscription and birds are
equally stylized and animated, the decora-
tive formula has proved especially felicitous.

179

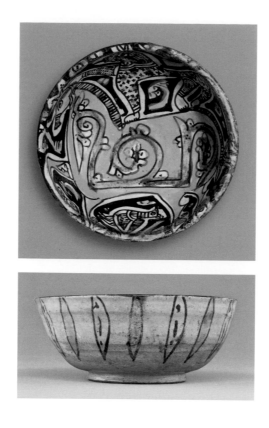

Most of the black decoration on the bowl is painted in a relatively inert black slip. By contrast, the contour panels are dotted with a black pigment containing chromite, which stains the surrounding glaze light yellow. To date, ceramic vessels with yellow-staining black have been excavated only in Nishapur.[2] The outside of the bowl is undecorated except for the white slip and clear glaze, which has a slight iridescence. The flat base is lightly covered in the slip and partially glazed.

MMcW

1 The bowl was last fired between 700 and 1200 years ago, according to the results of thermoluminescence analysis carried out by Oxford Authentication Ltd. in 2011.

2 Charles Wilkinson was the first scholar to recognize such wares as a separate group. See Fehérvári 2000, 61; Watson 2004, 48, 237–38.

16

Bowl with a cheetah standing on the back of a horse

Iran, Nishapur, Samanid period, 10th century[1]
Buff-colored earthenware painted with black (manganese and iron), yellow (lead-tin), and green (copper) under clear lead glaze
7.4 × 18.6 cm (2$^{15}/_{16}$ × 7$^{5}/_{16}$ in.)
2002.50.68

Published: Reed 2005, 1.

Figural designs on polychrome ceramics offer tantalizing and often puzzling glimpses into the complex society of the Samanid realm, now divided between northeastern Iran and Uzbekistan.[2] The majority of these wares are made of buff-colored earthenware decorated with lively, and often freely rendered, figural images painted in bright colors under clear glaze. The decoration of this small bowl has been executed with exceptional detail and care. Fluid and confident strokes of black slip delineate a crested bird, a spotted feline, and a well-groomed horse. These forms are filled or dotted with green and yellow. The feline and the horse raise their right forelegs; they both sport ankle bands and scalloped collars. The horse has a cropped mane, a knotted tail, and curling fetlocks. Filling its body is a bold pseudo-inscription in floriated and spiraling Kufic script. The top of its eye is defined by two extended parallel lines; this distinctive treat-

ment is occasionally found in figural wares excavated in Nishapur.[3] The feline may be identified as a cheetah by the black stripe descending from its eye.

The vignette of a collared feline on the back of an imposing horse may be a shorthand reference to the costly, prestigious, and ancient sport of hunting with cheetahs.[4] Capable of short bursts of extraordinary speed, cheetahs were usually set on gazelles, rabbits, and other fleet game, but because stamina was not one of their virtues, they had to be conveyed to the hunt. One of the cheetah trainer's more demanding tasks was to teach his charge to ride pillion on the back of a horse moving at any speed.

The exterior decoration of this bowl consists of pendant leaf shapes painted in an alternating pattern: a buff leaf with an interior dot-dash-dot device alternates with a colored leaf, sequentially yellow or green. No slip is detectable over the light buff ceramic body. The entire bowl, including the flat, slightly concave base, is covered in a clear glaze. The bowl has been reassembled from at least three large fragments and has minor losses and repairs along the rim.

MMcW

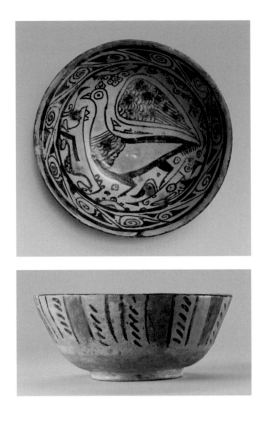

1 The bowl was last fired between 800 and 1300 years ago, according to the results of thermoluminescence analysis carried out by Oxford Authentication Ltd. in 2004.

2 See, in this catalogue, Oya Pancaroğlu's essay, "Feasts of Nishapur: Cultural Resonances of Tenth-Century Ceramic Production in Khurasan," 25–35.

3 See the discussion of this eye profile in Wilkinson 1973, 20–21, 45, cat. 62.

4 For other interpretations, see Wilkinson 1973, 20–22.

17

Small bowl with peacock
Iran, Nishapur, Samanid period, 10th century[1]
Buff-colored earthenware painted with black (manganese), yellow (lead-tin), and green (copper) under clear lead glaze
6.7 × 16.2 cm (2⅝ × 6⅜ in.)
2002.50.69

Published: McWilliams 2002a, 12, fig. 3; McWilliams 2004, 4, fig. 4.

A prominent bird facing left dominates the interior of this small bowl. The artist has whimsically concocted a creature with a trilobed crest, a cere (protrusion above the bill), rings of multicolored feathers around the neck and breast, and a yellow wing. The bird's salient feature, however, is a fan-shaped tail, which above all else suggests that it is a peacock.[2] There is a single, legible inscription in Syriac between the bird's back and tail: *'aynā*, meaning "eye" or "fount." On the upper walls beneath the rim, a band of scrolling triangular leaves is bordered by black lines.

No slip is detectable over the light buff ceramic body of the bowl. Except for its flat, slightly concave base, which is only partially glazed, it appears to have been covered in a clear glaze. Its condition is difficult to assess, because much of the interior surface is coated with a modern varnish. It is clearly fragmentary, reassembled from numerous small pieces, and has considerable overpainting along the rim, the scrolling band, and the lower body of the peacock.

MMcW

1 The bowl was last fired between 700 and 1200 years ago, according to the results of thermoluminescence analysis carried out by Oxford Authentication Ltd. in 2011.

2 See, in this catalogue, Oya Pancaroğlu's essay, "Feasts of Nishapur: Cultural Resonances of Tenth-Century Ceramic Production in Khurasan," 25–35.

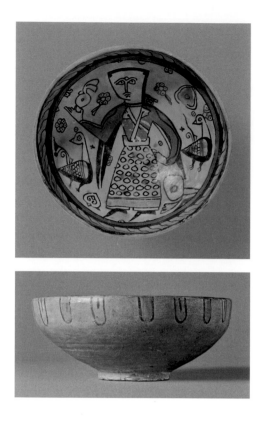

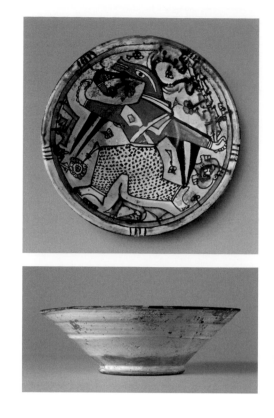

18

Bowl with standing figure
Iran, Nishapur, Samanid period, 10th century,[1]
with significant areas of modern overpainting
Buff-colored earthenware covered in pinkish
slip and painted with black (manganese and
iron), red (iron), yellow (lead-tin), and green
(copper) under clear lead glaze
8.1 × 21 cm (3³⁄₁₆ × 8¼ in.)
2002.50.50

Published: McWilliams 2003, 227, 231, fig. 8;
McWilliams 2004, 11.

Examination under ultraviolet light reveals
that almost two-thirds of this bowl has been
overpainted. Happily, most of the large
standing figure, from the top of the flattened
head to the tip of the pointed shoes, is origi-
nal. Details of the garment, such as neckline,
lapels, and pattern of the skirt, are original
ceramic surface. The figure's shoulders and
upper arms have been repainted, as has the
leafy projection from the piece of fruit he or
she holds in an upraised hand.[2] The bird on
the left is mostly original, but the other is
overpainted, as is almost eighty percent of
the upper walls and rim. The exterior is also
heavily resurfaced.

MMcW

1 The bowl was last fired between 700 and 1100
 years ago, according to the results of thermo-
 luminescence analysis carried out by Oxford
 Authentication Ltd. in 2004.

2 See, in this catalogue, Oya Pancaroğlu's essay,
 "Feasts of Nishapur: Cultural Resonances of
 Tenth-Century Ceramic Production in
 Khurasan," 25–35.

19

Bowl with masked dancing figure
Iran, Nishapur, Samanid period, 10th century[1]
Reddish earthenware covered in whitish
slip and painted with red (iron), black
(manganese), green (copper), and yellow
(stain from fine chromite particles) under
clear lead glaze
8 × 26.8 cm (3⅛ × 10⁹⁄₁₆ in.)
2002.50.49

White, curving horns appear to sprout from
the red head of the enigmatic figure whose
outstretched arms and running legs fill the
contours of this bowl. Perhaps a bull's head
is represented, but the blurring of the black
pigment in the glaze has obscured the
artist's intentions here and elsewhere. The
rendering of the hands is equally ambigu-
ous, possibly meant to suggest the thumb
and knuckles of a clenched fist. The hand
reaching backward appears to hold a leafy
branch.[2] The space around the figure is filled
with a miscellany of motifs, including a
flower, a palmette, fragmentary letters in
Kufic script, and a bird. Groups of four or
five short lines divide the rim into five
sections, colored either green or yellow.

This bowl closely resembles figural wares
with buff-colored bodies reported by
Charles Wilkinson to have come from exca-
vations at Nishapur.[3] Here, however, the off-
white background is obtained from slip

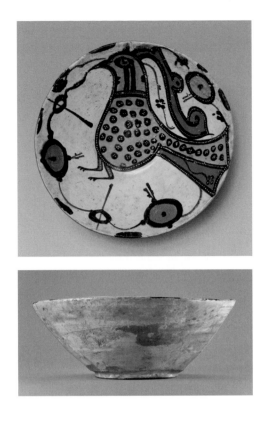

covering a reddish ceramic fabric, and the yellow background results from staining from fine chromite particles, rather than the more customary lead-tin or lead-antimony. The base, which is slightly concave and beveled, is only partially covered by the slip. The bowl, once broken, is in good condition, having been put back together from at least four major fragments. On the interior, over-painting is largely limited to the center: the figure's collar and shoulders, his groin, and the upper lapels of his torso.

MMcW

1 The bowl was last fired between 700 and 1200 years ago, according to the results of thermo-luminescence analysis carried out by Oxford Authentication Ltd. in 2004.

2 See, in this catalogue, Oya Pancaroğlu's essay, "Feasts of Nishapur: Cultural Resonances of Tenth-Century Ceramic Production in Khurasan," 25–35.

3 Wilkinson 1973, 3–53.

20

Bowl with bird and flowers
Iran, 10th–11th century
Red earthenware covered in off-white slip
and painted with black (manganese and
iron), green (chromium), and red (iron)
under clear lead glaze
8.7 × 23.8 cm (3⁷⁄₁₆ × 9⅜ in.)
2002.50.54

Published: McWilliams 2003, 227, 229, fig. 4.

The decoration on the interior of this vessel is characteristic of slip-painted wares now generally attributed to workshops in a region south of the Caspian Sea.[1] Typically, as here, the design of these bowls is dominated by a single large, leftward-facing bird with dis-tended belly, elaborately crested head, and two-colored, bifurcated tail. Birds and sur-rounding flowers are often outlined in a darker color that may be topped with tiny white dots; white dots also accent dark spots on the bird's body.

Off-white slip and green-tinged glaze completely coat the interior of this bowl. On the exterior, the slip only patchily covers the walls, and the glaze is restricted to the area around the rim. The concave base is uncoated. The bowl has been reassembled from about ten fragments, with plaster replacing losses in the lower left quadrant

of the center, and it retains earlier and rather awkward overpainting of the bird's lower belly and legs.

MMcW

1 Similar vessels have been known as Sari wares, after a town in northern Iran where they were said to have been produced. See Watson 2004, 243; Pancaroğlu 2007, 73; and Fehérvári 2000, 58–59.

21

Cup with lobed rim and human faces
Iran, Seljuk-Atabeg period, 12th century[1]
Fritware with molded relief decoration
under blue (cobalt) transparent alkali glaze
10.8 × 14.2 cm (4¼ × 5⁹⁄₁₆ in.)
2002.50.95

Published: McWilliams 2004, 5, fig. 6.

The development of fritware in the twelfth
century opened new paths in ceramics pro-
duction. By adding large quantities of quartz
to the clay, potters could make white-bodied
vessels with thinner walls, more delicate
shapes, and greater durability. Some of
these fine objects were coated with blue,
turquoise, purple, or colorless glazes.

This cup is decorated with repeated human
heads molded in relief.[2] The lobed rim
follows the contours of the projecting heads,
which feature large, almond-eyed faces.
The deep blue glaze covers the interior and
exterior body of the cup and has flowed onto
the base. On one side, it has deteriorated,
becoming iridescent.

AYY

1 The results of thermoluminescence analysis of
 this cup carried out by Oxford Authentication
 Ltd. in 2011 were inconclusive.

2 For lobed bowls with similar molded decoration,
 see Fehérvári 2000, 101 (Tareq Rajab Museum,
 Kuwait, CER 1750TSR) and Grube 1994, 176–77,
 cat. 173 (Khalili Collection, London, POT885).

22

Ewer with peacocks
Iran, Seljuk-Atabeg period, 12th century[1]
Fritware with molded decoration under
purplish-brown (manganese) transparent
alkali glaze
24.3 cm × 15.5 cm (9⁹⁄₁₆ × 6⅛ in.)
2002.50.87

Published: McWilliams 2003, 239, fig. 16.

This purple-glazed ewer has a bulbous body
and a tapering neck with a wide, flaring
mouth. Its relief decoration features a broad
band of confronting peacocks, their necks
intertwined, alternating with pear-shaped
floral motifs. Above this main band is a
narrower one with scrolling vines. The foot
of the ewer has been left unglazed. On one
section of the peacock band the glaze has
pooled, perhaps due to an error in the firing
process. The vessel has been repaired, espe-
cially in the area of the mouth.

Monochrome-glazed and luster ewers of
this shape are relatively common.[2] Although
peacocks are often represented on ceramics
and other forms of Islamic art, their
entwined stance on this ewer is unusual.

AYY

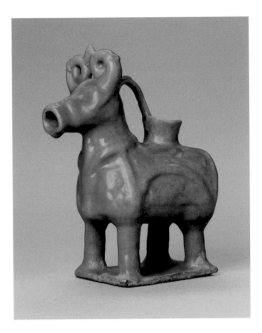

1 The ewer was last fired between 600 and 1000 years ago, according to the results of thermoluminescence analysis carried out by Oxford Authentication Ltd. in 2011.

2 Grube 1994, 171, 176, cats. 161, 162, 171. For a lusterware ewer very similar in shape (Hetjens Museum, Düsseldorf, 1963/26), see Hetjens Museum 1973, 101.

23

Pitcher with foliate carving
Iran, Seljuk-Atabeg period, 12th century
Fritware with carved decoration under
turquoise (copper) transparent alkali glaze
11.6 × 20.4 cm (4⁹⁄₁₆ × 8¹⁄₁₆ in.)
2002.50.98

The decoration on the body of this pitcher
is incised, rather than molded (see cats. 21
and 22), and consists of highly stylized leaf
forms. Squat in shape, the pitcher has a
lobed rim and three handles topped with
flower heads in relief. Although its decoration
is common on other monochrome
incised pitchers, its wide mouth and handles
are a rarity; the knobs above the handles
indicate that it follows a metal prototype.
The turquoise glaze that covers both interior
and exterior of the body terminates thickly
above the foot. Despite several repairs, particularly
around the base, the vessel retains
its original form.

AYY

24

Zoomorphic pitcher
Iran, Seljuk-Atabeg period, 13th century[1]
Molded fritware covered with turquoise
(copper) alkali glaze opacified with tin
18.4 × 10.2 cm (7¼ × 4 in.)
2002.50.99

This pitcher is molded in the shape of an ox;
the animal wears a harness defined in low
relief. Despite the thinness of the potting,
the vessel is intact. The glaze has deteriorated
in some areas, but the overall surface
is in very good condition.

Although its slender handle could have
made it difficult to carry when full,[2] this
pitcher may nevertheless have been used
to serve wine, since bull-shaped vessels are
known to have been employed for this purpose
in medieval Iran.[3] Similar examples in
different techniques can be found in public
collections in North America and Europe;
a near twin is in the Hetjens Museum in
Düsseldorf.[4]

AYY

1 The results of thermoluminescence analysis of this pitcher carried out by Oxford Authentication Ltd. in 2011 were inconclusive.

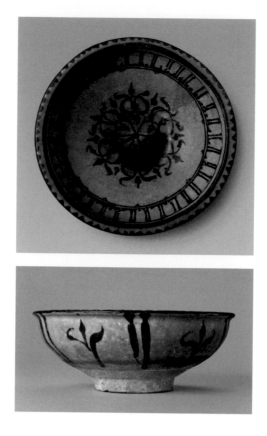

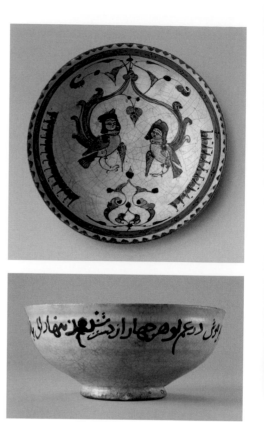

2 Such vessels may have been made mostly for
 display purposes: see Watson 1985, 120.

3 See, in this catalogue, Oya Pancaroğlu's essay,
 "Feasts of Nishapur: Cultural Resonances
 of Tenth-Century Ceramic Production in
 Khurasan," 25–35.

4 Hetjens Museum 1973, 129.

25

*Bowl with black foliate arabesque and
pseudo-inscription*
Iran, Seljuk-Atabeg period, 12th–13th century
Fritware painted in black (chromium) under
turquoise (copper) transparent alkali glaze
7.4 × 19.8 cm (2$\frac{15}{16}$ × 7$\frac{13}{16}$ in.)
2002.50.63

At the center of this bowl, a freely painted,
leafy arabesque grows out of a six-lobed
core. Around the walls a rhythmic pseudo-
epigraphic band radiates upward, and tri-
angular dabs of black ring the rim. On the
exterior, willow-reed motifs alternate with
pairs of tapering, vertical stripes.

At some point in the past, this bowl was
reassembled from fragments and over-
painted to integrate the plaster fills. The tur-
quoise glaze covers the interior and exterior,
stopping well short of the foot ring, which
has an unusual taper.

MMcW

26

Bowl with harpies
Iran, Seljuk-Atabeg period,
late 12th–early 13th century[1]
Fritware painted with black (chromium),
turquoise (copper), blue (cobalt), brownish-
red (iron), and pink (iron and tin) over white
lead alkali glaze opacified with tin
7 × 16 cm (2$\frac{3}{4}$ × 6$\frac{5}{16}$ in.)
2002.50.52

Mīnā'ī, meaning "enameled," is a Persian
word commonly used to designate wares
decorated in a polychrome overglaze tech-
nique. Like luster painting, *mīnā'ī* is a costly
process that requires a second firing. Seljuk-
Atabeg period *mīnā'ī* wares are tentatively
attributed to the city of Kashan, in central
Iran.[2] In the center of this bowl two harpies
(composite bird-women) are turned toward
each other, their tail feathers joining over-
head in an ogival arch. In Islamic lands
these mythical creatures were associated
astrologically with the planet Mercury
and were considered generally auspicious.
Foliate arabesques sprout from the harpies'
joined tails and fill the space below their
feet. Encircling the bowl on the exterior is
a single band of cursive script; it contains
four hemistichs of medieval Persian poetry,
which read,

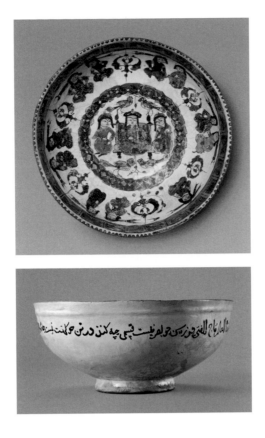

الحا رماخ اللغة ووزرسر جو لوطنست قسى جعد كنز ددير جو لحننت ينت رم

27

Beware, O friend, things have gotten out of hand.
In knowing you [my] days have been lost.
I had silver and gold, patience and sobriety.
In the grief inflicted by you all four have been lost.

(*Zēnhār ay yar kār az dast shudh*
dar ʿilm-i tu rōzgār az dast shudh.
Sēm zar būdhī marā u ṣabr u hōsh
dar ghamm-i tu har chahār az dast shudh.)[3]

The bowl has been reassembled from fragments with only minor losses and overpainting.

AYY

———

1 The bowl was last fired between 600 and 1000 years ago, according to the results of thermoluminescence analysis carried out by Oxford Authentication Ltd. in 2002.

2 See Watson 1985, 84; Mason 2004, 131.

3 We are grateful to Wheeler M. Thackston for this reading and transliteration.

Bowl with enthroned ruler and courtiers
Iran, Seljuk-Atabeg period,
late 12th–early 13th century
Fritware painted with black (chromium), turquoise (copper), blue (cobalt), brownish-red (iron), and pink (iron and tin) over white lead alkali glaze opacified with tin, and gilded.
8.2 × 19.1 cm (3¼ × 7½ in.)
2002.50.53

Published: McWilliams 2003, 243, 245, fig. 27; McWilliams 2004, 5, fig. 5.

An enthroned ruler with attendants occupies the center of this bowl. Pairs of birds are positioned above and below the group. On the walls of the vessel, encircling the central scene, are seated figures, also in pairs (the single individual results from a modern repair with an alien sherd). Parts of their headgear extend horizontally outward, as if lifted by a breeze.

Although birds are commonly shown near thrones on *mīnāʾī* wares,[1] the combination of birds, enthroned ruler, and windblown spectators on this bowl suggests a popular story from the great epic poem of Persian literature, the *Shāhnāma*. According to the tale, the foolish king Kay Kavus wished to fly through the air, so he attached to his throne hungry eagles and, just beyond their reach,

legs of lamb. In their effort to get at the meat, the powerful birds managed to lift the throne and its occupant into the air, but as soon as they tired, the whole contrivance fell back to earth. To the great astonishment of the spectators, the king escaped injury.[2]

The interior rim of the bowl is decorated with a repeating pseudo-inscription in Kufic script, and the plain white walls of the exterior with a cursive inscription, large portions of which are overpainted restoration, as can be seen in the profile view.[3] Supplementing the red, green, and blue *mīnāʾī* colors of the composition, gilding is used to highlight details such as the throne and the observers' armbands. The bowl has been assembled from several fragments, with painted plaster used to fill in the losses.

AYY

———

1 For a more conventional depiction on *mīnāʾī* ware of a seated ruler with attendants and birds above and under the throne, see Pancaroğlu 2007, 109, cat. 67.

2 Swietochowski and Carboni 1994, 91, cat. 15.

3 Even on the authentic part of the bowl, the surface and consistency of the black color over the deteriorated glaze suggest that the inscription has been heavily restored.

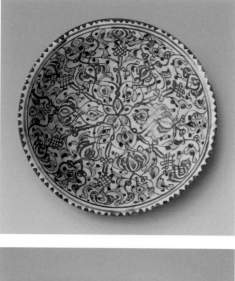

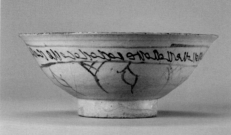

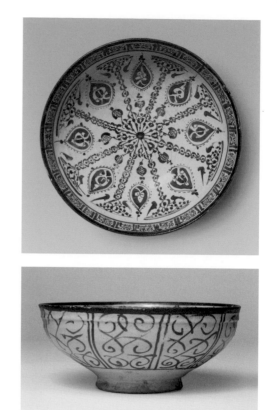

28

Bowl with radial interlace design
Iran, Seljuk-Atabeg period,
late 12th–early 13th century[1]
Fritware painted with black (chromium),
blue (cobalt), turquoise (copper), and
brownish-red (iron) over white lead alkali
glaze opacified with tin
8.5 × 22.1 cm (3⅜ × 8¹¹⁄₁₆ in.)
2002.50.114

Published: McWilliams 2003, 243, 247, fig. 29.

From the six-petaled ornament at the center
of this bowl radiates an exquisite maze of
arabesques and interlaced lines reminiscent
of the plaited ascending letters in some
Kufic inscriptions. Blue, black, light tur-
quoise, and brownish red are painted over
the opaque white glaze. The exterior bears a
scrawled cursive pseudo-inscription. There
are several cracks and repairs. Although
mīnāʾī bowls with abstract decoration are
rarer than those with figural designs,[2] simi-
lar examples can be found in the Khalili
Collection, London, and the Museum of
Fine Arts, Boston.[3]

AYY

1 The bowl was last fired between 400 and 800
 years ago, according to the results of thermo-
 luminescence analysis carried out by Oxford
 Authentication Ltd. in 2011.

2 Grube 1994, 216.

3 Ibid., 216, fig. 237; McWilliams 2003, 248, fig. 31.

29

Bowl with radial foliate design
Iran, Seljuk-Atabeg period, 12th–13th century[1]
Fritware painted with luster (copper and
silver) over white lead alkali glaze opacified
with tin
9 × 21.7 cm (3⁹⁄₁₆ × 8⁹⁄₁₆ in.)
2002.50.103

Published: McWilliams 2002b, 44, fig. 4;
McWilliams 2003, 243–44, fig. 23.

Luster painting on ceramics provided a
metallic golden sheen, first on earthenware
from ninth- and tenth-century Iraq (see
cats. 4–7) and later on fritware from Iran,
where it was used to great effect from the
twelfth to the fourteenth century. The luster,
applied after the first firing of a glazed tile
or vessel, consisted of oxides of copper and
silver. Different concentrations of these
metals, in addition to variations in the
reducing atmosphere of the kiln during the
second firing, resulted in tones ranging
from reddish to yellowish. In Iran, specifi-
cally in Kashan,[2] generations of potters
produced exquisite ceramics in the luster
technique. Due to the predominance of cop-
per, the luster of these ceramics appears
reddish.

The interior of this bowl is divided into
eight equal sections by lines, embellished
with dots and twining tendrils, that spring

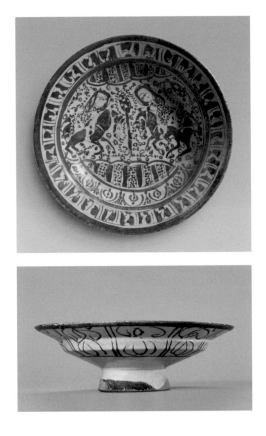

from triangular arabesques and terminate with pairs of small, silhouetted birds toward the rim. Each section contains a palmette-filled pendant. Around the rim runs an angular pseudo-inscription. Paired lines divide the exterior of the bowl into sections, which are filled with loosely painted scrolls.

The twining tendrils and the palmette-enclosing pendants on the interior of this bowl are very common in Persian luster-wares. The bowl is intact, and the quality of its luster is remarkable. The white glaze does not cover the foot, which the potter would have held when dipping the vessel into the glazing compound before firing.

AYY

1 The bowl was last fired between 600 and 1000 years ago, according to the results of thermo-luminescence analysis carried out by Oxford Authentication Ltd. in 2003.

2 For the attribution of Seljuk-Atabeg Persian lusterware to Kashan, see Watson 1985, 37–44; Mason 2004, 140, 164.

30

High-footed dish with two horsemen
Iran, Seljuk-Atabeg period, 12th–13th century[1]
Fritware painted with luster (copper and silver) over white lead alkali glaze opacified with tin
6.4 × 21.2 cm (2½ × 8⅜ in.)
2002.50.74

Two horsemen face each other from opposite sides of a central, checkered tree. The luster decoration on this bowl is so freely painted that the dotted pattern of the cavaliers' garments merges with the foliate background. The figural scene is bordered above and below by scalloped segments filled with vertical stripes and, at the bottom, by a frieze of cursory pendants. An angular pseudo-inscription runs around the rim.

The figural imagery of this bowl has close affinities with that of *mīnā'ī* wares. Its sketchily applied decoration and somewhat confused background details put it into the category of luster ceramics exhibiting the so-called miniature style (as do cats. 31 and 32).[2]

The loosely painted scrolls on the outside of this bowl closely resemble the exterior ornamentation of several other luster vessels in the collection (cats. 29, 31, and 32).[3] Glaze only partially covers the high foot, one area of which exhibits some blue staining. The

bowl has been reassembled from several pieces; its reddish luster has turned greenish in one section.

AYY

1 The bowl was last fired between 500 and 900 years ago, according to the results of thermo-luminescence analysis carried out by Oxford Authentication Ltd. in 2003.

2 See Watson 1985, 68–85, for the use of the term "miniature style" and other examples of Iranian luster ceramics in this category.

3 A bowl of similar size and decoration (Ashmolean Museum, Oxford, 1968-28) is illustrated in Watson 1985, 79, fig. 50.

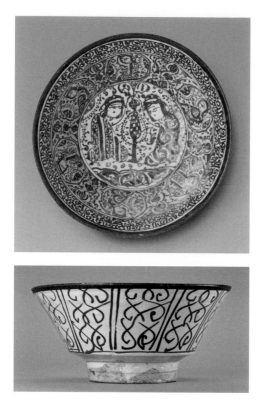

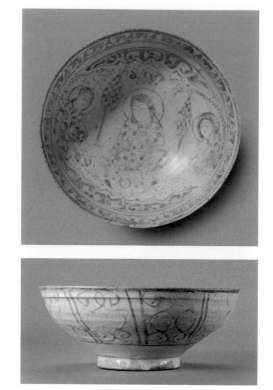

31

Bowl with seated couple
Iran, Seljuk-Atabeg period, 12th–13th century[1]
Fritware painted with luster (copper and
silver) over white lead alkali glaze opacified
with tin
9.5 × 21.1 cm (3¾ × 8⁵⁄₁₆ in.)
2002.50.73

1 This bowl is of "ancient origin," according to the
results of thermoluminescence analysis carried
out by the Research Laboratory of the Museum
of Fine Arts, Boston, in 1973.

On the interior of this bowl, a seated couple
flanks a central, checkered tree, which–
together with the fish swimming below
and a busy network of thin, curving vines–
conveys the idea of a garden setting. Along
the walls of the bowl are six roundels deco-
rated alternately with harpies and human
figures. Like birds, harpies are commonly
found in Persian Islamic ceramics and
usually carry auspicious connotations. The
area just below the rim is decorated with a
pseudo-inscription with plaited verticals.
The exterior features double vertical lines
bracketing loosely painted scrolls. Recent
museum conservation of the bowl has
showed it to be made up of fifteen major
fragments, but all join fairly smoothly,
indicating that nothing has been lost from
the original object. The luster is brilliant
and reddish in tone.

AYY

32

Bowl with three figures and checkered trees
Iran, Seljuk-Atabeg period, 12th–13th century
Fritware painted with luster (copper and
silver) over white lead alkali glaze opacified
with tin
8 × 20.5 cm (3⅛ × 8¹⁄₁₆ in.)
2002.50.64

On this bowl a single figure is shown seated
in the middle, with two smaller figures on
the sides. The hand gestures and eye contact
of the trio suggest that they are engaged in
a meeting; the trees between them hint
that it is taking place in a garden setting.
The rendering of the trio's physiognomy
and richly patterned garments is typical of
luster and *mīnāʾī* wares from Iran, as is
the checkerboard foliage of the trees. The
scalloped segments above and below the
figural scene are filled with thick, undulat-
ing vines, defined in reserve against a gold
ground. Around the inner rim runs an
angular pseudo-inscription. The exterior
of the bowl is decorated with double vertical
lines and loose scrolls.

The bowl has been put back together from
several pieces, with only minor losses. Its
pale-yellow luster surface has no sheen.

AYY

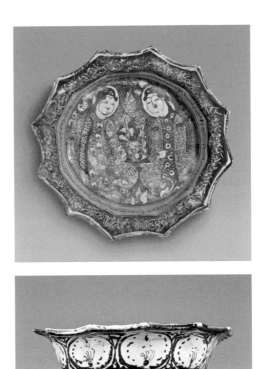

33

Jug with birds and inscription bands
Iran, Seljuk-Atabeg period,
late 12th–early 13th century[1]
Fritware painted with luster (copper and
silver) over white lead alkali glaze opacified
with tin
26.3 × 15.4 cm (10⅜ × 6¹/₁₆ in.)
2002.50.76

The lower part of this jug is decorated with
repeating arch-like forms enclosing long-
necked birds facing left. An illegible inscrip-
tion in Persian encircles the shoulder. Above
this are foliate designs and roundels con-
taining leftward-facing birds similar to
the others. Used either as filler or as part of
figural compositions, birds are a common
motif in Iranian lusterware. The neck of the
jug is decorated with two bands of illegible
Kufic script separated by a band of swirling
tendrils. White glaze covers the body of the
vessel but ends in thick droplets short of
the base. On one side of the jug the luster
retains a dark red cast; elsewhere it is yel-
lowish and, in the areas of the handle and
mouth, shows considerable abrasion.

AYY

1 The jug was last fired between 700 and 1200
 years ago, according to the results of thermo-
 luminescence analysis carried out by Oxford
 Authentication Ltd. in 2011.

34

Scallop-rimmed charger with courtly couple
Iran, Seljuk-Atabeg period, early 13th century
Fritware painted with luster (copper and
silver) over white lead alkali glaze opacified
with tin
6.3 × 26.4 cm (2½ × 10⅜ in.)
2002.50.56

Published: McWilliams 2002a, 12, fig. 2; Harvard
University Art Museums 2003, 19; McWilliams,
2003, 243, 245, fig. 25; Harvard Art Museum and
Wolohojian 2008, 45.

The interior of this impressive vessel is
decorated with two large-scale, seated
figures whose long-sleeved garments signal
their courtly status. Ṭirāz bands on the
upper arms of one figure's caftan offer an
additional indication of wealth and prestige.
A bird in the tree between the pair and a
second bird below them suggest a garden
setting. The background is decorated
with tiny spirals incised in the luster. These
background spirals, combined with the
representation of the figures in reserve,
are characteristic of the so-called Kashan
style of luster ceramics.[1]

Bands on the wall and rim of the vessel con-
tain Persian words that are mostly illegible
due to the compromised condition of the
dish. The inner inscription is written in
luster on a white ground; the one on the rim

is incised on a luster ground, now quite abraded. All that can be deciphered of the inner inscription is "Rustam from an infatuated heart . . ." (*Rustam zi dil-i shaydā dar nakard . . .*).[2]

A courtly couple with similar facial features and details of costume appears on a luster bowl dated to 1211 and signed by the artist Muhammad ibn Abi al-Hasan.[3]

Prior to its arrival at the Harvard Art Museums, cat. 34 was reconstructed from many small pieces and the entire inner surface covered in clear varnish. The rim and walls are nearly half recomposed from plaster and alien bits of ceramic. The center has been reassembled from original fragments, although the fish on the left side may come from another luster vessel. The exterior of the charger is decorated with loosely painted circles. The base is smoothed with a modern layer of clay.

AYY

1 See Watson 1985, 86–109, for the use of the term "Kashan style" and examples of ceramics belonging to this group.

2 We are grateful to Wheeler M. Thackston for this reading and transliteration.

3 Iran-i Bastan, Tehran, 8224, illustrated in Watson 1985, fig. F.

35

Sweetmeat dish
Iran, Seljuk-Atabeg period, c. 1200[1]
Fritware painted with luster (copper and silver) over blue (cobalt) transparent alkali glaze and white lead alkali glaze opacified with tin
7.2 × 30.7 cm (2¹³⁄₁₆ × 12¹⁄₁₆ in.)
2002.50.59

Published: McWilliams 2003, 241, fig. 21.

This sweetmeat dish was made from two joined components: a tray with small indentations for holding food, and, beneath that, a shallow bowl. The center well of the tray is decorated with a human figure; the six wells around it have vegetal designs. The size and depth of the indentations vary, as does the color of the luster, which is now mostly greenish but has some redder areas. The exterior of the bowl is covered with dark blue glaze and has illegible writing in luster close to the rim. The foot is very short, perhaps the result of a mishap in the kiln. The hollow cavity between tray and bowl would presumably have been filled with hot water through a small opening, but no such opening has been found on this vessel.[2]

AYY

1 The dish was last fired between 600 and 900 years ago, according to the results of thermoluminescence analysis carried out by Oxford Authentication Ltd. in 2003.

2 See, in this volume, the essay by Anthony B. Sigel, "History in Pieces: Conservation Issues in Islamic Ceramics," 37–49, discussing the condition and manufacturing method of this bowl.

36

Albarello
Iran, Seljuk-Atabeg period, c. 1200[1]
Fritware painted with luster (copper and silver) over blue (cobalt) transparent alkali glaze
20.2 × 12.4 cm (7¹⁵⁄₁₆ × 4⅞ in.)
2002.50.60

This albarello, or medicine jar, is glazed in deep cobalt blue and decorated in yellow luster with little sheen. A band of vertical lines and stripes—perhaps meant to evoke the upright letters of Kufic inscriptions—encircles the upper half of the body, and floral tendrils occupy the lower half; in certain areas this luster decoration can no longer be seen. Repeating circular forms embellish the shoulder of the jar; the neck features vertical stripes. The blue glaze ends thickly above the foot. Other Iranian luster albarellos of similar size and form are known.[2]

AYY

1 The jar was last fired between 500 and 900 years ago, according to the results of thermoluminescence analysis carried out by Oxford Authentication Ltd. in 2003.

2 Watson 1985, fig. A; Watson 2004, 361.

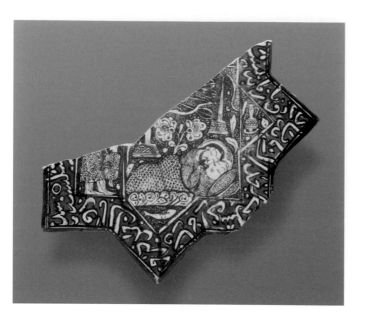

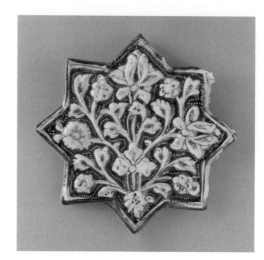

37

Fragmentary star tile with lovers
Iran, Ilkhanid period, 13th–14th century
Fritware painted with blue (cobalt) and
luster (copper and silver) over white
lead alkali glaze opacified with tin
23.2 cm (9⅛ in.) diagonally, point to point.
2002.50.125

Published: Sotheby Parke Bernet 1975, lot 122;
Watson 1985, 146; McWilliams 2004, 5, 11, fig. 7.

This fragmentary tile, reassembled from
four pieces, depicts a narrative scene closely
related to those in contemporary and later
manuscript paintings.[1] Through an archway,
a couple is shown in bed under a patterned
cover. A tall candle in a plaited metal candle-
stick illuminates the interior of the room,
and a similarly ornamented ewer appears
further to the right. The partially visible bow
and arrows likely belong to the man and in-
dicate his princely activities. The fish at the
bottom of the scene and the flowers sprout-
ing above the couple create a dreamlike
ambience. A figure, likely a servant, stands
at left, perhaps outside the room. Bordering
the scene, a Persian inscription, reserved in
white on a blue ground, is partially legible.
Starting at the break on the left, it reads,

> . . . wings were broken.
> . . . from the prince, felicity came to me.

Even if fate is not auspicious, give in to
your destiny.
(. . . *shikasta shud par u bāl.*
. . . *zi shāhzāda shudam saʿd.*
Agar zamāna nasāzad tu bā zamāna bisā[z].)[2]

Eight-pointed star tiles like this one were
combined with other tiles of cruciform
shape to create shimmering revetments for
palaces and religious buildings.[3] Although
figural tiles were used in both secular and re-
ligious contexts,[4] the intimate nature of the
scene depicted here would have made this
tile more appropriate for a palace interior.

AYY

1 See, in particular, the painting *Gulnar Comes to
 Ardashir's Pillow*, from the "Great Mongol" *Shāh-
 nāma*, Iran (probably Tabriz), 1330s, in which
 architectural details, furnishings, and the couple's
 position are markedly similar to those on this tile.
 The painting is reproduced in Grabar and Blair
 1980, 137.

2 We are grateful to Wheeler M. Thackston for this
 reading and transliteration.

3 For the full effect, see Watson 1985, 133, fig. 110;
 144, fig. 121; and fig. M.

4 Ibid, 154–55.

38

Star tile with lotus decoration
Iran, Ilkhanid period, 14th century
Fritware painted with blue (cobalt) and
luster (copper and silver) over white
lead alkali glaze opacified with tin
20.9 × 20.9 cm (8¼ × 8¼ in.)
2002.50.80

Molded in relief, this tile is decorated with
stylized lotuses. The background and inte-
rior details of the plants are painted in
brownish luster; the edge of the tile is out-
lined in cobalt blue.

The lotus motif, as developed in the arts of
East Asia, was introduced to the decorative
repertoire of the Islamic lands under the
Ilkhanids, who in the thirteenth and four-
teenth centuries ruled an area extending
from Central Asia to Asia Minor. The
Ilkhanids continued the practice estab-
lished by their predecessors of decorating
interior walls with revetments composed of
star- and cross-shaped tiles. Relief tiles with
related floral designs sometimes include
animals and feature inscription bands
around their rims.[1] A tile identical to this
one is in Hetjens Museum in Düsseldorf.[2]

AYY

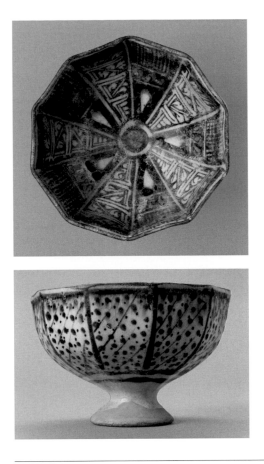

39

1 See Watson 1985, fig. M.

2 1941/44: see Hetjens Museum 1973, 108.

Ten-sided bowl with high foot
Iran, Ilkhanid period, 14th century[1]
Fritware painted with blue (cobalt),
turquoise (copper), and black (chromium)
under clear alkali glaze
9.7 × 13.6 cm (3¹³⁄₁₆ × 5⅜ in.)
2002.50.85

1 The bowl was last fired between 400 and 700
years ago, according to the results of thermo-
luminescence analysis carried out by Oxford
Authentication Ltd. in 2012.

2 A bowl with very similar exterior decoration is
in the Sackler Gallery, Washington, DC. See Cort
et al. 2000, 66.

On the interior, this bowl is divided into ten
radial sections, corresponding with its sides,
that feature two alternating designs. One is
pseudo-calligraphic, proceeding from the
center of the bowl to the rim, with horizon-
tal elements contracting and verticals ex-
panding. The other design is tripartite and
abstract. The intricacy and dark coloration
of the interior contrast with the cheerful
simplicity of the outside, where the white
ceramic body remains more visible through
a surface embellishment of lines and dots.[2]
The shape and decoration of this bowl are
common among wares attributed to the
Ilkhanid period, although their production
place has not been definitively established.

AYY

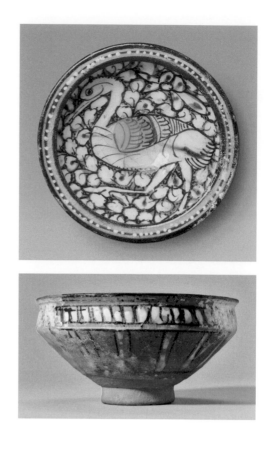

40

Flat-rimmed bowl with radial design
Iran, Ilkhanid period, 14th century[1]
Fritware painted with blue (cobalt),
turquoise (copper), and black (chromium)
under clear alkali glaze
11 × 22.3 cm (4⁵⁄₁₆ × 8¾ in.)
2002.50.78

Radial lines divide the interior of this bowl
into twelve sections, which are decorated
with three different designs—foliate motifs,
cursive forms, and series of dots and fine
lines. A narrow band encircles the bowl
just under the flat, patterned rim. Circling
the upper exterior is a cobalt-blue pseudo-
inscription; below this is another band
containing black scrollwork roundels.

The foliate and line-and-dot motifs of this
bowl, as well as the use and placement of
cobalt, recall the lusterwares of the Seljuk-
Atabeg period. Those prestigious vessels
likely provided design inspiration for less
expensive underglaze-painted wares like
this one, which typifies Ilkhanid bowls in
shape and decoration.[2] Although the glaze
has suffered abrasion and is cracked in
several places, the bowl itself is intact.

AYY

1 The bowl was last fired between 400 and 700
 years ago, according to the results of thermo-
 luminescence analysis carried out by Oxford
 Authentication Ltd. in 2012.

2 See Watson 1985, fig. H; Watson 2004, 378–86.

41

Flat-rimmed bowl with bird in foliage
Iran, Ilkhanid period, early 14th century
Fritware painted with white slip, blue (cobalt),
and black (chromium) under clear alkali glaze
10.6 × 20.7 cm (4³⁄₁₆ × 8⅛ in.)
2002.50.58

Published: McWilliams 2003, 227, 230, fig. 5.

A large crane-like bird with bent neck and
raised leg dominates the interior of this
bowl. The dense foliage around the bird
includes lotus blossoms, trademark motifs
of Ilkhanid wares (see cat. 38). Encircling
the exterior beneath the rim is a band of ver-
tical white stripes outlined in black; more
widely spaced white stripes decorate the
lower portion. The white slip decoration
stands slightly in relief; the interior is enliv-
ened with dots of cobalt blue, which have
run. The clear, greenish-tinged glaze has
pooled at the center of the bowl and has
deteriorated on the exterior. Once assigned
to Sultanabad, in western Iran, bowls with
this shape and dense foliate decoration were
common in the Ilkhanid period.[1]

AYY

1 A similar bowl, with two birds, is illustrated in
 Watson 2004, 384, cat. Q.13

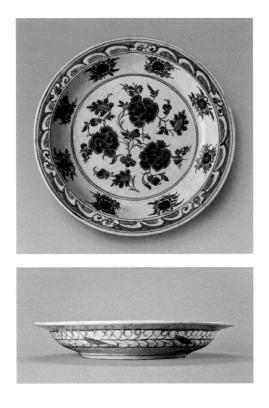

42

Dish with peonies
Iran, Nishapur, Timurid period, c. 1475
Fritware painted with blue (cobalt)
under clear alkali glaze
7.8 × 43 cm (3¹⁄₁₆ × 16¹⁵⁄₁₆ in.)
2002.50.66

Published: McWilliams 2004, 6, 11, fig. 8.

If the cobalt used to decorate Yuan and early Ming blue-and-white porcelains was initially imported from Iran, then Chinese potters more than repaid the favor in the form of exported decorative motifs.[1] Avidly collected in Islamic lands, Chinese blue-and-white porcelain wares exerted enormous influence on Muslim potters of the fifteenth through the seventeenth century.

Produced in northeastern Iran in the second half of the fifteenth century, this impressive dish combines decorative solutions developed during the reign of two dynasties in China.[2] Antecedents for the "wave and crest" motif along the rim and the "double scroll" on the outside wall can be found in Yuan (1271–1368) blue-and-white wares, while the fleshy peonies in the center derive from Ming (1368–1644) prototypes. The curiously restless and asymmetrical nature of the interior composition results from the zones of the circle being divided into odd and even units—three peonies in the center,

eight floral sprays along the wall, and six wave-and-crest motifs on the rim.[3]

Although the glaze has deteriorated somewhat, this dish is overall in fine condition. Put back together from a few large fragments, it has minimal losses.

MMcW

1 Golombek et al. 1996, 7.

2 The attribution of this large dish to Nishapur, circa 1475, follows suggestions put forth in Golombek et al. 1996. It has not been sampled for petrographic analysis but belongs stylistically to the "Peony" subgroup of their "Double-scroll" group.

3 The same proportions are used in a Nishapur "Peony" dish in the State Hermitage Museum, St. Petersburg (VG.728), illustrated in Golombek et al. 1996, 197, pl. 38. In contrast, a similar bowl in the Museum of Fine Arts, Boston (1972.8), which Calderwood would have known well, employs units of three throughout, as does a closely related dish in the Keir Collection (C45ii, now in the Museum für Islamische Kunst, Berlin), illustrated in Golombek et al. 1996, 196, pl. 37.

43

Tile with composite flowers and saz leaves
Turkey, Iznik, Ottoman period, c. 1585–95
Fritware painted with blue (cobalt),
turquoise (copper), green (copper and iron),
and red (iron) under clear lead alkali glaze
31.2 × 31 cm (12⁵⁄₁₆ × 12³⁄₁₆ in.)
2002.50.108

Production of ceramic tiles and vessels reached a peak under Ottoman court patronage in the sixteenth century. The court studio provided designs to semi-autonomous workshops in Iznik, which manufactured tiles for numerous large-scale imperial projects.

With its white ground and foliate decoration in brilliant cobalt blue, emerald green, turquoise, and slightly raised red, this square tile exemplifies the technical achievements of the second half of the century. The dominant motif is a composite flower, which alternates direction across the middle of the tile. Serrated leaves known as *saz* grow from the base of each palmette. Smaller bisected palmettes of a different form are horizontally positioned at the top and bottom edges of the tile. When this tile was juxtaposed with others of the same design, a continuous repeating pattern resulted.[1]

Identical tiles can now be seen under the pendentives on the north and south walls of

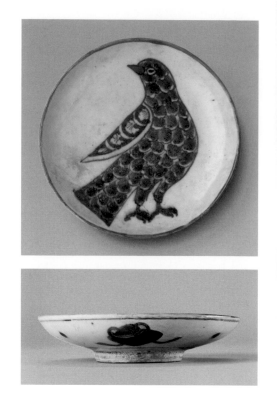

the chamber of Sultan Murad III (r. 1574–95), built in 1578–79 in the harem of Topkapı Palace by the illustrious architect Sinan.[2] It is likely, however, that these tiles are not original to the room itself[3] but were made for a different part of the harem, either later in Murad's reign[4] or during that of his successor Mehmed III (r. 1595–1603),[5] and were subsequently reinstalled in Murad's chamber, perhaps after damage caused by a fire or an earthquake.[6] Stylistically similar tiles are found in their original location in the 1585–86 mosque of Ramazan Efendi in Istanbul.[7]

AYY

———

1 A panel of these tiles, showing their continuous design, is in the Tareq Rajab Museum. See Fehérvári 2000, 314. Also see Rogers 2002, 196–97, cat. 133. Two smaller (25.4 × 25.4 cm) tiles with a very similar but asymmetrically placed design are in the Victoria and Albert Museum, London (447-1900 and 447A-1900).

2 Necipoğlu 1991, 165–71.

3 See Bilgi 2009, 204, for the original, smaller (25 × 25 cm) tiles covering the rest of the room.

4 The contemporary Ottoman historian Selânikî mentions a tiled room, pools, and a bath rebuilt in the harem in 1585: see Selânikî 1989, 1:157.

5 Additionally, eight tiled rooms and a bath were rebuilt in 1595, during the reign of Mehmed III: see Selânikî 1989, 2:490, 525, and especially 539.

6 Restorations undertaken in the twentieth century did not include these walls: see Anhegger-Eyüboğlu, 1986, 81–86. I am thankful to Dr. Filiz Çağman, former director of the Topkapı Palace Museum, for discussing these tiles and their possible history within the palace.

7 Bilgi 2009, 206.

44

Small dish with stylized rock dove
Iran, Safavid period, c. 1675–1725[1]
Fritware painted with blue (cobalt) and brown (chromium) under clear alkali glaze
3.2 × 15.5 cm (1¹⁵⁄₁₆ × 6⅛ in.)
2002.50.94

Except for the brown rim, all the decoration on this small, round dish is painted in shades of cobalt blue. A rotund bird with backward-turning head neatly fills the interior. Around the exterior, a band defined by two painted lines encloses single dots alternating with beribboned fans; paired lines circle the inside and outside of the foot ring. The bowl has been put back together from fragments; plaster fills shaped like half-moons complete the rim.

Along with the fans and floating ribbons, the brown rim points to the influence of Chinese export porcelain wares known as Kraak, which were produced in vast quantities to meet international demand. Potters working in late Safavid Iran painted an imitation of the colored rim dressing that in the second half of the seventeenth century was applied to these Chinese export wares to guard against chipping.[2]

Elegantly or hastily painted, birds are a common motif on blue-and-white ceramics from China and Iran.[3] In the late Safavid

period, artists produced beautiful drawings and paintings of birds. These works on paper usually feature generic songbirds perched on flowering branches; only rarely can their species be identified. The combination of bird and flowering branch was also rendered in luxury textiles, with an occasional butterfly or moth added to the mix.[4]

The squat bird on this bowl lacks a perch. With wings embellished by veined lotus leaves, it was clearly not intended as a botanical study. Nevertheless, its potbelly, square tail, banded and slightly lifted wings, and large feet suggest that it is a rock dove (feral pigeon), perhaps of a checkered variety. These omnipresent bluish-gray birds were much valued in Safavid Iran, where large mud-brick towers were constructed to house them by the thousands. Such pigeon towers served as collecting points for bird droppings, which, when mixed with soil and ash, were for centuries a prized fertilizer.[5]

MMcW

1 This dish was sampled for thermoluminescence testing in 1973 by the Research Laboratory of the Museum of Fine Arts, Boston. The result was inconclusive, possibly due to a contaminated sample or because thermoluminescence testing is less accurate for relatively modern ceramics.

2 Lally 2009, 12.

3 Large, potbellied birds that fancifully suggest quails or partridges dominate the interiors of two late Safavid blue-and-white bowls with beribboned fans on their exteriors: see Crowe 2002, 239, cats. 420 (2749-1876) and 421 (2748-1876). Crowe assigns the two bowls to the last decades of Safavid reign, circa 1666-1738. Quail-like birds surrounded by veined leaves also appear on a series of bottles in the Victoria and Albert Museum that Crowe assigns to the reign of Shah 'Abbas II (1642-66): ibid., 148-49, cats. 226-30. Similar birds also appear on a large plate in the Ashmolean Museum (EA1978.1783).

4 See, for example, a painting of a backward-facing bird by Yusuf Zaman, dated 1109 (1696-97), in the State Hermitage Museum, St. Petersburg (VR-707, fol. 6), published in Lukonin and Ivanov 1996, 214-15, cat. 242; a painting of a bird, butterflies, and blossoms by Shafi 'Abbasi, dated 1062 (1651-52), in the Cleveland Museum of Art, published in A. Welch 1973, 90, 99, cat. 58; and a white thrush by Mu'in Musavvir, dated 1100 (1689-90), in the Museum of Fine Arts, Boston, also published in A. Welch 1973, 109, 119, cat. 79. For the appearance of birds in Safavid luxury textiles, see Bier 1987, 172, 176-78, cats. 18, 20, 21.

5 Beazley 1966 surveys pigeon towers constructed during the seventeenth century and cites the major European primary sources that describe the attitudes toward and uses of pigeons in late Safavid Iran.

45

Spouted ewer with curving handle
Iran, Kirman, Safavid period, late 17th century
Fritware painted with blue (cobalt)
under clear alkali glaze
Body: 25.3 × 16 cm (9¹⁵⁄₁₆ × 6⁵⁄₁₆ in.)
Handle to spout: 18.5 cm (7¼ in.)
2002.50.67

Published: McWilliams 2004, 11.

Breezily rendered Chinese decorative motifs in two shades of cobalt blue decorate the surface of this ewer. A border composed of cloudlike *ruyi* motifs separates chrysanthemum scrolls painted freely around the pear-shaped belly and rendered in reserve on the shoulder. Crisscrossing lines—possibly vestigial plantain leaves—pattern the tapering neck. Hash marks resembling the Chinese character *shou* (longevity) are evenly spaced along the spout. Except for the loss of the tip of the spout (now restored), the vessel is in fine, unbroken condition, retaining a glossy surface.

Although varying in proportion, the general form of this ewer, with its pear-shaped body, tapering spout, curving handle, neck ringed by torus molding, and flaring mouth, was rendered in metal or ceramic in Iran, India, and Turkey from the sixteenth through the nineteenth century.[1] The particular variant seen here, in which the curving handle joins

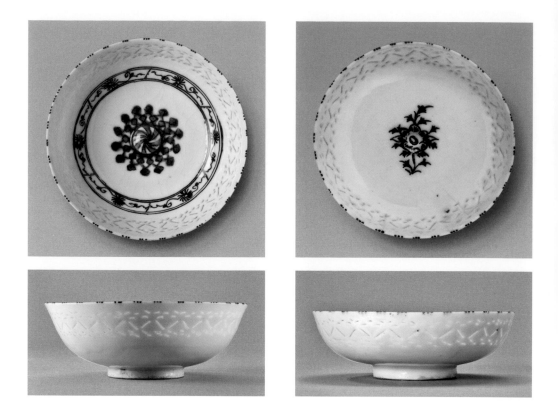

46, 47, 48

a cup-shaped mouth above a prominent knob, appears to have been popular in late Safavid ceramics; ewers with these features have survived in a range of decorative techniques including monochrome relief, luster, and underglaze painting.[2] The imitation *shou* mark appears as decorative fill on a handful of late Safavid blue-and-white wares attributed to the reign (1666–94) of the Safavid ruler Shah Sulayman.[3]

MMcW

———

1 Jean Soustiel dates a ewer of similar shape with blue-and-white floral and imbricate patterning to the second half of the fifteenth century: see Soustiel 1985, 215, fig. 238. It was more likely made a century later.

2 See, for example, ewers in the Ashmolean Museum, Oxford (EAX3035); the Metropolitan Museum of Art, New York (17.120.27); and the British Museum, London (G.351.a).

3 Now in the Victoria and Albert Museum, London: see Crowe 2002, 176, 186, 219. These are two brown-rimmed bowls of medium size painted in different shades of blue (1256-1876 and 1202-1876) and a ewer painted in blue and black (2644-1876).

Three small bowls of "Gombroon ware"
Iran, Safavid period,
late 17th–early 18th century
Fritware pierced and painted with
blue (cobalt) and black (chromium)
under clear alkali glaze
6.7 × 18.5 cm (2⅝ × 7⁵⁄₁₆ in.)
2002.50.116
Fritware pierced and painted with
black (chromium) under clear alkali glaze
4.5 × 14.1 cm (1¾ × 5⁵⁄₁₆ in.)
2002.50.117
Fritware pierced and painted with
black (chromium) under clear alkali glaze
4.2 × 12.6 cm (1⅝ × 4¹⁵⁄₁₆ in.)
2002.50.118

With their exceptionally thin potting and near-translucent, pure white fabric, these three small bowls belong to a category of fine ceramics popularly known as "Gombroon wares." Each bowl has rounded walls, a slightly everted rim, and a low foot ring glazed in the center. A small depression inside the foot ring perfectly fits the middle finger, ensuring that the bowl balances easily in the user's hand. On the interior of the bowl, this depression forms a small boss, on or around which the underglaze painting is applied. The delicate potting is emphasized by openwork patterns pierced through the walls and filled with clear glaze, reviving a technique practiced in the late twelfth and

thirteenth centuries (and see also cat. 139).[1] The two smaller bowls were broken and have been put back together, with small plaster fills in the walls.

The designation "Gombroon wares" reflects the impact of European trade in the seventeenth and eighteenth centuries. These vessels were exported to Europe from an Iranian port town at the entrance to the Persian Gulf, Bandar Abbas, which was known to the European trading companies as Gombroon, Gamrun, or Gamru.[2] From European primary sources and a handful of dated objects, it can be deduced that the production period for Gombroon wares stretched from at least the 1690s into the early 1800s.[3]

Bandar Abbas served as the terminal point of trade routes originating at Yazd and Kirman to the north and Lar, Shiraz, and Isfahan to the northwest.[4] It has been suggested that the production site for these wares was Nain (a small town due east of Isfahan), where a similar highly vitrified fritware was made in the nineteenth century.[5]

MMcW

1 For an early discussion of what is often called "rice-grain" patterning and its relationship to Islamic, Chinese, and Japanese ceramics, see Hobson 1907, 84, 89.

2 Lane 1957, 109–11. More exacting, Lane termed these ceramics "unidentified fine white wares."

3 Fehérvári 2000, 292; Lane 1957, 122–23. Hobson 1907, 89, does not, however, associate these wares with Gombroon.

4 Lockhart 1960.

5 This was proposed by Géza Fehérvári (see Fehérvári 2000, 292).

49

Bowl with foliate arabesque on rim
Iran, Safavid period or later,
18th–19th century[1]
Grayish fritware covered in white slip,
with pierced, incised, and carved design
under clear alkali glaze
9.7 × 26.9 cm (3¹³⁄₁₆ × 10⁹⁄₁₆ in.)
2002.50.48

A graceful foliate arabesque band, composed of twelve separate S curves terminating in five-lobed palmettes, runs just below the rim on the interior of this bowl. This decoration is subtly rendered with pierced dots and incised lines that reveal the grayish body of the bowl beneath its white slip coating. A clear glaze fills the piercings and covers the entire vessel with the exception of the concave base.

Assigning this bowl to the eighteenth or nineteenth century runs counter to the results of the thermoluminescence analysis noted below, which suggest modern manufacture. The earlier dating is proposed for two reasons: first, the existence of two vessels acquired in Iran in the late nineteenth or very early twentieth century that also feature a decorative play between a grayish ceramic fabric and a white slip,[2] and second, the fact that thermoluminescence is generally not as reliable for dating early modern ceramics as it is for medieval or

ancient material.[3] Despite numerous cracks, this bowl is intact.

MMcW

1 The bowl was last fired within the past 100 years, according to the results of thermoluminescence analysis carried out by Oxford Authentication Ltd. in 2004.

2 These objects, in the Victoria and Albert Museum, London, are a basin with pierced walls (463-1874) and a globular vessel with incised decoration imitating Chinese blue-and-white ware (1362-1901). Perhaps related to this group is a "baluster vase" attributed to seventeenth-century Iran: see Christie's 2010, lot 217. No production site is yet known for the group.

3 See Bassett 2007.

50

Small dish with foliated rim and chrysanthemum, geometric, and stylized-wave décor
Probably Vietnam, Later Lê (1533–1788),
Tây Sơn (1778–1802), or Nguyễn (1802–1945)
dynasty, 17th–19th century; or possibly
China, Ming (1368–1644) or Qing (1644–1911)
dynasty, 17th–19th century
Buff-colored earthenware with green
(copper) lead glaze
1.9 × 9.7 cm (¾ × 3¹³⁄₁₆ in.)
2002.50.82

The concave walls of this small dish rise from the broad, flat floor to the bracketed lip, which terminates in a raised edge with eight points. A stylized chrysanthemum blossom embellishes the floor; it is set in a circular medallion and enclosed within the wide band of symmetrically disposed, geometric strapwork that enlivens the walls. Facing each other across the dish, two *taotie*, or ogre, masks interrupt the strapwork. Representing stylized waves, short, opposing bands of hatching, each arranged in a triangular configuration, decorate the everted lip. The dish rests on a low, wide, circular foot ring. Thin and transparent, the lead-fluxed, emerald-green glaze covers the interior of the dish but coats only the upper half of the undecorated exterior.

The kilns that produced this type of ware have not yet been discovered. Concurring that such ceramics reflect Chinese aesthetic canons but were made for the Southeast Asian market, scholars nonetheless disagree on the location of manufacture, some ascribing them to Vietnam, others to southeastern China. They also disagree about the dating of such pieces, some assigning them to the seventeenth century, others to the eighteenth or nineteenth.

The form and glaze color of this dish distantly recall the celadon-glazed chargers with barbed rims and raised edges produced at the Longquan kilns, Zhejiang Province, during the Yuan dynasty (1279–1368).[1] The form also echoes that of blue-and-white porcelain chargers produced at Jingdezhen, Jiangxi Province, in the mid-fourteenth century.[2]

Doubtless inspired by geometric decoration on Yuan- and Ming-dynasty carved lacquers and on so-called later Chinese bronzes—those produced from the Song dynasty (960–1279) onward—the strapwork decoration on this dish finds distant kinship in the decorative schemes of ceramics produced at the Putian kilns, in Fujian Province, in the thirteenth and fourteenth centuries.[3] The debased *taotie* masks that interrupt the strapwork find close parallels among

the masks on bronze vessels cast during the Ming and Qing dynasties.

A typical motif of Chinese ceramic decoration, the chrysanthemum symbolizes both autumn and literary pursuits. By the mid-fourteenth century, stylized waves comprising a series of concentric arcs had become a staple border motif in blue-and-white porcelain chargers produced at Jingdezhen.[4]

This dish was created through the use of a hump, or single-faced, mold—a hollow mound of fired stoneware that was placed at the center of the potter's wheel. As the potter pressed prepared clay against the mold on the rotating wheel, the mold shaped the interior of the vessel and imparted its relief decoration, while the potter's hands shaped the exterior and regulated the thickness of the walls.

Although Chinese potters began the widespread use of lead-fluxed glazes during the Eastern Han period (25–220), such low-firing lead glazes enjoyed their greatest popularity during the Tang dynasty (618–907).[5] Lead glazes generally fell from favor after the mid-eighth century but enjoyed a revival, first in the Liao (907–1125) and Jin (1115–1234) dynasties and then again in the late Ming and Qing periods; they also found

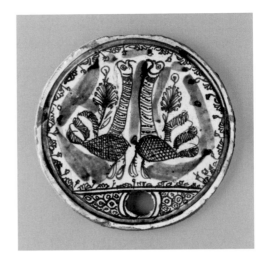

favor in Vietnam from the thirteenth century onward. Vietnamese pieces typically mimic the forms and decorative schemes of Chinese stonewares and porcelains finished with high-fired, clear glazes rather than earthenwares embellished with lead glazes.[6] The unusual Calderwood dish likely falls into this category of wares.

RDM

1 See Mikami et al. 1981, 49, cat. 35.

2 Such as a charger with foliate rim and peacock decoration in the Harvard Art Museums (1961.112). For further examples, see Lee 1968, cat. 150; Mortimer 1985, 41, cat. 40.

3 For examples of stoneware vessels from the Putian kilns, see Krahl 1994, 1:286–87, cats. 531–34. For examples of *tixi* lacquers, see Metropolitan Museum 1991, 49–62, cats. 6–15. For a later Chinese bronze with geometric strapwork decoration, see Kerr 1990, 46, cat. 34 (right).

4 See J. Pope 1956, pl. 7 (29.38). Note that John Pope refers to such waves as "concentric waves."

5 As a fluxing agent, a compound of lead added to the glaze slurry in small measure intensifies the glaze color. Its primary function, though, is to lower the firing temperature, so that low-firing earthenwares can be coated with colorful glazes.

6 See Stevenson and Guy 1997, 276–77, cats. 189–92.

51

Beehive cover
Iran, 19th or 20th century
Reddish earthenware covered in white slip and painted with brownish black (chromium, iron, and manganese) and blue (cobalt) under clear alkali glaze
21 cm (8¼ in.)
2002.50.65

This ceramic disk was used to cover one end of a beehive; its round hole admitted bees to a cylinder made of mud and reeds or cane, which was laid horizontally in a stack with other hives to protect them from winter weather.[1] Such beehive covers have been used in Iran at least since the early eighteenth century.[2]

Talismanic designs or inscriptions, thought to aid the art of beekeeping, decorated these disks.[3] This example features two long-necked birds, perhaps peacocks, facing each other. Their bodies are crosshatched, and flowering plants appear to sprout from their elaborate tails. Repeating floral motifs surround the birds, and the segment below them, containing the hole, is decorated to suggest a pool of water.[4] Light cobalt is casually applied in the empty white areas and around the periphery. The beehive cover is intact except for chipped edges.

AYY

1 See Savage-Smith 1997.

2 Cort et al. 2000, 68, 70.

3 Savage-Smith 1997, figs. 204–6.

4 For a similarly decorated beehive cover dated
 to circa 1950, see Gluck 1977, 84.

52

*Albarello with inscription, arabesques,
and figures*
Probably Iran, 20th century[1]
Pink fritware covered in plaster and painted
with black (chromium) under turquoise
(copper) translucent lead alkali glaze
25.8 × 12.6 cm (10 3/16 × 4 15/16 in.)
2002.50.55

The decoration on this tall albarello, or
medicine jar, is carefully painted and har-
moniously composed in horizontal regis-
ters. These bands vary in width, and the
backgrounds alternate between black and
turquoise. The wide neck bears an inscrip-
tion in tall Kufic letters, repeating the Arabic
word *al-mulk* (sovereignty). Scrolling, leafy
tendrils run along three bands. Two others
are occupied by figural motifs: just below
the shoulder, seven haloed sphinxes, facing
left, appear on a black ground, and, below
them, five figures sit cross-legged among
scrolling tendrils with kidney-shaped
leaves. Some of the figures are bearded
and others clean shaven, but all are haloed
and wear black robes patterned in reserve.

Although Calderwood acquired this
albarello as a work of medieval Persian art,
it is more likely the product of a revival of
traditional styles and media that took place
in Iran during the Pahlavi reign (1925–79).[2]
In form and decoration, it evokes without
exactly replicating ceramics from the
Seljuk-Atabeg period.[3] Had the jar been
intended as a forgery, the potter would have
made it of white rather than plaster-covered
pink fritware.

The albarello is intact, but in many places
the glaze has deteriorated to a matte surface.
The ceramic body is fine grained but soft.
The plaster and turquoise glaze cover the jar
inside and out, stopping short of the foot ring.

MMcW

1 The albarello was last fired within the past
 100 years, according to the results of thermo-
 luminescence analysis carried out by Oxford
 Authentication Ltd. in 2004.

2 Jay Gluck, for example, notes a revival ware pro-
 duced by the Iranian potter Abdul Zohad Ilya:
 not intended to deceive, it nevertheless made its
 way onto the Tehran antique market in the 1950s.
 The author also describes the revival of luxury
 ceramics at the Hunaristan of Isfahan (a school
 of arts and crafts) during the middle decades of
 the twentieth century: see Gluck 1977, 52, 94.

3 Almost all the decorative elements on this
 albarello could have been derived from illustra-
 tions in Bahrami 1949.

53

Mirror case with birds and flowers
Iran, Qajar period, 18th–19th century
Opaque and semi-opaque watercolor
on prepared pasteboard under varnish[1]
15.4 × 19 cm (6¹⁄₁₆ × 7½ in.)
2002.50.106.A–B

Among the most characteristic and com-
pelling art forms of the Qajar period (1779-
1924) in Iran are works in "lacquer." Tech-
nically distinct from East Asian lacquers,
these are essentially an extension of tradi-
tional opaque watercolor painting on paper
to three-dimensional forms; their general
structure consists of a pasteboard support
covered by a white ground, over which the
decoration is painted in opaque watercolor,
with a final coating of transparent shellac.[2]

Fashioned as an irregular octagon, this
lidded mirror case depicts the popular pair-
ing of rose and nightingale (*gul va bulbul*).
This theme, which embraced bird-and-
flower compositions more generally, prolif-
erated during the Zand (1750-94) and Qajar
dynastic eras, when it was represented in
both paintings and ceramics. As in Persian
poetry, it signified the Sufi concept of the
lover (nightingale) who declares his longing
for the beloved (rose)—a signification that
could be taken literally, as an expression of
earthly love, or metaphorically and spiritu-
ally, as the soul's yearning for union with God.

The singing nightingale on the cover of this
mirror case is positioned amid a dense spray
of mixed flowers, a full-blown rose towering
above all others. Interwoven with the stem
of the rose is the woody branch of a fruit
tree, studded with pink buds and blossoms.
A small, winged insect hovers next to one of
the rosebuds. The base of the case features
the same design as the lid, but the absence
of a border offers a larger field for the image,
to which slight compositional differences
have been introduced—a bud that is closed
where its counterpart on the lid is open, for
instance, and an insect that has now grown
full wings.

On the dark brown inner surface of the
cover—which does not appear to have been
hinged to the case—a floral spray, painted
in golden washes and stippling, is rendered
coppery beneath an orange-red varnish.
In contrast to the full-color images on the
outer surfaces, this vignette has a nocturnal
and spectral quality. Such emphasis on
creating formal contrast between inner and
outer surfaces despite their shared imagery
had been a feature of bookbinding since
the early Safavid period or before.

Ironically, the mirror case, however delight-
ful, fosters melancholy and longing: while it
fixes beauty as a miniature garden preserved
from the destructive forces of nature and
gives visual form to the eternal dimension of

love and desire, the repeated use of the mirror within it only underscores the transience of physical loveliness. Its opposing temporal dimensions, eternal and transient, are hinted at in the contrasting designs of the outer and inner cover. In this way, the mirror case carries a message comparable to that of the poetic *ghazal*, in which the thorn of the rose "provides a symbol of the unpleasant fact of mortality" and directs the beholder to focus on "the pursuit of true riches, stored in the heart and incorruptible."[3]

DJR

1 This mirror case was recently restored with a thick coating of varnish that was spray applied, according to Narayan Khandekar, Senior Conservation Scientist, Straus Center for Conservation and Technical Studies, Harvard Art Museums.

2 See, in this volume, David Roxburgh's essay, "The Qajar Lacquer Object," 65–75.

3 Meisami 1987, 294.

54

Mirror-case cover with mother, child, and angel
Iran, Qajar period, 19th century
Opaque and semi-opaque watercolor on prepared pasteboard under shellac varnish
12.3 × 10 cm (4¹³⁄₁₆ × 3¹⁵⁄₁₆ in.)
2002.50.107

The outer surface of this mirror-case cover, like that of cat. 53, features a rose-and-nightingale theme. Here the bulbul appears among flowers—roses and hydrangeas—against a reddish-brown ground enclosed by a ruled border. At the top right, above the hydrangeas, a small inscription in white *nastaʿlīq* reads *yā Imām Ḥasan* (O Imam Hasan), invoking the second Shiʿi Imam, son of ʿAli ibn Abi Talib and Fatima. The presence of this text suggests that a related theme, such as a devotional image of ʿAli and his sons Hasan and Husayn, will be found on the inner surface of the lid, so what actually appears there delivers a surprise: a grouping, derived from Christian sources, of a mother, her child, and an angel in a landscape setting. The Qajar rendition of this scene conflates the iconography of the Annunciation, where the angel Gabriel, bearing a lily, appears before the Virgin Mary, with that of Mary holding the infant Jesus, from whose head radiates a subtle halo. Although Mary's red and blue clothing follows the standard color convention, she

is dressed as a modern, bejeweled European lady. In a form of immodest modesty, the bodice of her dress is cut so low that it exposes her breasts, which are barely concealed by a diaphanous silky covering. The same gauzy fabric makes up her long but revealing sleeves.

The painting technique of this scene differs from that of the outer surface: here the underlying ivory-colored pasteboard is not completely covered with pigment. Rather, washes of bright paint dominated by red, blue, green, and gold, as well as extremely fine stippling, are applied to the paper, producing an effect that resembles ceramic glazing. The tinted monochrome palette of the landscape is typical of Qajar lacquer objects that, in adopting subject matter from European prints, mimic the effects of engraving.

The treatment of Mary's bosom is reminiscent of the fusion of profane and Christian subjects developed in Mughal painting during the reign of Akbar (1556–1605) and fostered by his son and successor Jahangir (r. 1605–27).[1] The eroticized image of the European woman, common in Qajar art, represents an appropriation of various European sources mediated through Indian artworks.[2]

DJR

1 See Findly 1993, 66–86.

2 Traffic of artists and their art between the royal
 courts of India and Iran was brisk from the mid-
 1500s onward. For the Mughal use of European
 images, see Bailey 1998. On the erotic image in
 Qajar art, see Najmabadi 1998, 76–89.

55

*Pen box with birds, flowers, and
butterflies*
Iran, Qajar period, 18th–19th century
Opaque and semi-opaque watercolor
and shell-gold flakes on prepared
pasteboard under shellac varnish
4.4 × 24.2 × 3.7 cm (1¾ × 9½ × 1⁷⁄₁₆ in.)
2002.50.111

The upper surface of this pen box (*qalam-
dān*) is divided into three lobed cartouches
outlined in gold, their interstices filled with
golden palmettes and flowers. A bird-and-
flower composition uniting nightingale,
rose, and blossoming branch dominates the
center cartouche. The flanking compart-
ments, one broadly mirroring the other save
for changes in palette, contain prunus blos-
soms, a tulip, and hovering butterflies that
gather nectar from and pollinate the plants.
The background of the pen box is a deep
reddish brown flecked with particles of gold;
it provides the ideal contrast for the bright
colors used in the bird-and-flower designs.
The coloristic effect of the palette—greens,
white, blues, pinks, browns, and reds—has
been unified by the layers of shellac varnish
applied to the surface as a final stage. The
sides of the pen box continue the subject
matter of the upper face, similarly struc-
tured in three compositional groupings; the
principal difference is that the birds directly
confront the winged insects amid miniature
floral thickets.

DJR

56

Haydar ʿAli
Pen box with flowers, birds, and portraits
Iran, Qajar period, dated 1290 (1873–74)
Opaque and semi-opaque watercolor on
prepared pasteboard under shellac varnish
4 × 21.7 × 3.3 cm (1⁹⁄₁₆ × 8⁹⁄₁₆ × 1⁵⁄₁₆ in.)
2002.50.110

Published: McWilliams 2004, 10, fig. 13.

On the dark brown upper surface of this pen case, European portrait roundels of a man and a woman are separated by three bird-and-flower vignettes. These unite different flora, with the rose predominating at the center, its branching stem inhabited by a solitary red-crested bird and insects fluttering around it. Haydar ʿAli's signature, *raqam-i Ḥaydar ʿAlī* (work or design of Haydar ʿAli) and the date of production appear in miniature white script in the spaces between the central bird-and-flower grouping and the flanking portraits.[1] To add texture, the artist has used a technique combining wash and stippling in fine dots of pigment. The long sides of the pen case continue the bird-and-flower theme, expanding the botanical repertoire to include carnations, hazelnuts, and tulips. There are occasional, and presumably intentional, instances of visual ambiguity where what appear to be plants and flowers could be interpreted as insects.

The base is painted in a solid red pigment with an overlying elegant scroll of flowers and palmettes executed in gold. The outer body of the extractable drawer follows the pattern of the base, while its end, built up to be flush with the surface of the outer case when the drawer is closed, is decorated with daisies, poppies, and an iris. The unadorned inner surface of the case reveals the method of construction through many layers of paper glued one upon another. A single word, *muḥkam* (robust, strong), written at an indeterminate time, attests the physical integrity of the object.

Haydar ʿAli, son of Muhammad Ismaʿil, was active in the 1860s and 1870s and worked in the style of Najaf ʿAli. Several works signed by him are known.[2]

DJR

1 In its most common usage, *raqm* (or *raqam*) means "writing" or "figuring," but in this context "work" or "design" makes better sense. Earlier usages of the noun *raqm* or *raqam*, as well as the derivatives of the trilateral root *m-sh-q, mashq* (literally, specimen, exercise, model) and *mashaqa* (literally, to copy), suggest a conflation of the acts of writing and drawing and appear most frequently in the signatures of the Safavid artist Riza ʿAbbasi (c. 1560s–1635). For a catalogue of that artist's works and signatures, see Canby 1996b, 179–200.

2 Signed and attributed examples and further biographical details on Haydar ʿAli are provided in Khalili et al. 1997, 2:25–26, 46; cats. 236, 282, and 283–85.

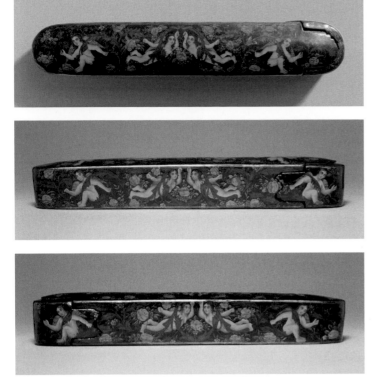

57

Lutf ʿAli [Khan Shirazi]
Pen box with flowers and putti
Iran, Qajar period, 19th century
Opaque and semi-opaque watercolor on prepared pasteboard under non-original varnish[1]
3.8 × 22 × 3 cm (1½ × 8¹¹⁄₁₆ × 1³⁄₁₆ in.)
2002.50.112

A roughly symmetrical composition of putti cavorting among acanthus leaves and blooming roses decorates the upper surface of this pen box. The same scheme appears on the sides, except that there the nudes are clearly female. The figures float through the air, suspended among the foliage, and grasp at the twisting stalks. On each of the three surfaces, scrolling gold acanthus leaves edged in dark brown intersect at the center to form a heart-shaped motif; this shape is more pronounced on the sides. A rose vine laden with blooms and a plant bearing smaller, pale blue flowers is interwoven with the gilded scrolls. The ground, a dark brownish black, offers the perfect contrast to the pale, luminescent torsos of the putti, the golden tone of the acanthus, and the green and pink of the rose vines. As in other examples of Persian lacquer, an application of tinted varnish—in this case not the original coating—warms the whole and has a unifying effect on the palette.

The brownish black base and sliding drawer of the pen box are decorated with gold floral sprays, while the end of the drawer features two more putti. The paint on the sides of the exterior is considerably thinner than on the upper surface. In raking light it is possible to see pin-pricked outlines around the principal motifs, evidence of the use of a pounced design. Such designs, intended for transferring motifs and compositions from one medium to another, survive in albums of artists' technical materials from the Qajar era.[2]

The painter's signature appears in tiny white script on the upper surface of the pen case, to the right of center at the top edge. Lutf ʿAli (d. 1871–72) was one of several accomplished lacquer artists active in Shiraz in the middle years of the 1800s, although he may have spent part of his career in Isfahan or Tehran.[3]

DJR

1 The heavy surface coating on this pen box is non-original and is not shellac (it did not match any library spectra), according to Narayan Khandekar, Senior Conservation Scientist, Straus Center for Conservation and Technical Studies, Harvard Art Museums.

2 One example is a Qajar album of sketches and other materials in the Harvard Art Museums (1960.161). See also, in this volume, cat. 152 and David Roxburgh's essay, "The Qajar Lacquer Object," 65–75.

3 For further discussion and comparative signed materials, see Khalili et al. 1997, 1:206–19; 2:124.

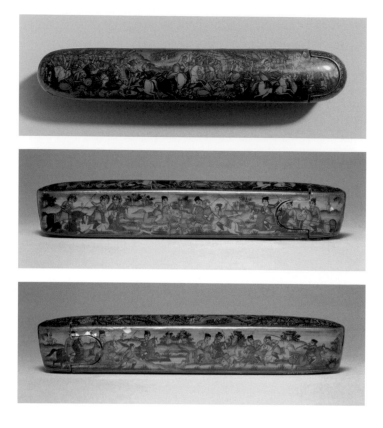

58

Asad Allah Dizfuli
Pen box with battle and hunting scenes
Iran, Qajar period, dated 1337 (1918–19)
Opaque and semi-opaque watercolor on
prepared pasteboard under shellac varnish
4 × 22.7 × 3.6 cm (1⁹⁄₁₆ × 8¹⁵⁄₁₆ × 1⁷⁄₁₆ in.)
2002.50.109

On its upper surface, this late example of
a Qajar lacquer pen case, signed by Asad
Allah Dizfuli, displays a scene of epic battle.
Densely packed cavalry troops flank groups
of dueling warriors in the foreground, and
a clustered mass of stationary cavalry stands
at the farthest remove from the action. The
expansive scope of the combat is conveyed
by receding lines of cavalry stretching toward
the horizon, resembling in effect the infinite
reflections of a room of mirrors.

Without any clear direction of movement or
indication of a dominant group that might
leave the field victorious, the scene conveys
the melee of battle as a series of skirmishes
between individuals, some victorious over
their foes, others less fortunate. Observing
men falling from their horses and awaiting
their final dispatch, the viewer's eyes are
drawn to the decapitated heads of victims
who have already met death, an image that
recalls the longstanding trope from Persian
historical sources of battlefields littered
with heads like balls on polo fields.

The sides and base of the pen box continue
the theme of martial prowess, though here
men mounted on horses and armed with
swords, lances, and firearms hunt deer and
a lion for sport. The artist unifies these com-
positionally varied scenes by setting them
in developed landscapes of receding planes
of grass and other vegetation, with horizons
given over to trees and small buildings,
each one different from the next, depicted
in perspective.

DJR

59

Figurine of a horse and rider
Iran, probably Gilan, 12th–8th century BCE
Bronze
2 × 2.3 × 0.8 cm (¹³⁄₁₆ × ⅞ × ⁵⁄₁₆ in.)
2002.50.100

During the Iron Age (c. 1450–500 BCE)
bronze smiths in western Iran produced
a wide array of tools, vessels, and personal
ornaments with animal decor, as well as
various animal figurines. The bronzes from
Luristan are the best known, but animal
figurines also come from the province of
Gilan, on the southwestern shores of the
Caspian Sea.

The delicate rendering of this minute
bronze horse and rider from the Calderwood
Collection captures all the essential details.
The horse has a narrow midsection, short
legs that taper to a point with no articulation
of joints, and a tail that protrudes as a
pointed stump. Ears, mane, and reins are
indicated on its head. The rider sits far for-
ward on the horse, forming a unit with
its neck. His arms hold the reins; he has
stubby legs and a prominent chin or nose.

Similar statuettes of horses with riders astride them can be found in a number of collections.[1] Their precise find spots are unknown, but like other bronzes, they tend to be labeled "Amlash," after a small town in Gilan that served as a market for antiquities. A bronze horse or mule with a figure riding sidesaddle, another with just a saddle, and four horses without tack were excavated with other animal figurines from a rich Iron Age cemetery at the site of Marlik, in a fertile valley of the Elburz Mountains in Gilan.[2] Most of them larger but with similar stylistic features, the Marlik animal bronzes indicate that the Calderwood figurine was indeed made in the southwestern Caspian region, probably in the late second or early first millennium BCE. The animal figures from Marlik—including humped bulls, sometimes yoked to plows, as well as stags, goats, rams, dogs, boars, and felines—seem inspired by the natural and domestic environments of ancient Gilan. Placed in a tomb, they, like the horse and rider, would have represented for eternity the wealth and status of the deceased.

This diminutive statuette was cast solid and in one piece. It is covered in black patina with some pale green patches and a very thin layer of red copper oxide underneath.[3] Analysis has revealed that the metal contains between 2 and 2.5 percent of both tin and arsenic.[4] Arsenic has been found in Iranian copper-based artifacts made as early as the fifth millennium BCE; its presence was due at first to the use of polymetallic ores and later also to the addition of arsenic to the smelted copper. Early metalworkers appear to have been aware that arsenic—like the tin of a typical bronze—facilitated the casting, increased the hardness, and affected the color of copper-based objects.[5] In the case of the horse and rider, the desired quality of the metal seems to have been achieved by adding low percentages of tin and arsenic in combination.

SE

1 See, for instance, the following examples: Museum of Fine Arts, Boston, 59.734, illustrated in Terrace 1962, no. 31 (upper right); Foroughi Collection, Tehran, in Ghirshman 1964, 35, 420, fig. 39; Bomford Collection, in Ashmolean Museum 1966, 47, cat. 236, pl. 21. For couples on horseback, see Ghirshman 1964, 57, 431, fig. 69; and 382, 440, fig. 569. For a chariot team, see Moorey 1971, 170, no. 216, pl. 40.

2 For the rider, see Negahban 1996, 113, no. 80, pl. 35; for horses and other animals, see ibid., 126–35, nos. 115–52, pls. xxv and 42–48. For a rider from nearby Kaluraz, see Hakemi 1968, 81, fig. xxxvii.

3 Technical observations were provided by Carol Snow and Henry Lie at the Straus Center for Conservation and Technical Studies, Harvard Art Museums.

4 ICP-MS analysis was carried out by Josef Riederer, then of the Rathgen-Forschungslabor of the Staatliche Museen zu Berlin.

5 Moorey 1994, 240, 242, 250–51; Thornton 2009 and 2010.

60, 61

Ellipsoid stamp seal: seated woman holding a flower
Iran or Mesopotamia, Sasanian period,
4th–5th century
Brown chalcedony
2.3 × 2.9 × 2 cm (⅞ × 1⅛ × ¹³⁄₁₆ in.)
2002.50.101

Ellipsoid stamp seal with carved back: hand
Iran or Mesopotamia, Sasanian period,
4th–5th century
Opaque gray chalcedony
2 × 2.5 × 1.7 cm (¹³⁄₁₆ × 1 × ¹¹⁄₁₆ in.)
2002.50.102

Seals played an important role in ancient Near Eastern administrative, economic, and legal transactions. Their impressions secured goods, and cylinder seals were rolled onto the still-malleable clay of tablets with cuneiform texts to guarantee their contents. By the period of Sasanian rule (224–642), which preceded the rise of Islam, cuneiform writing had long been abandoned, and documents written on parchment or other materials were sealed with bullae, or lumps of clay impressed with stamp seals. Sasanian seals include ring bezels as well as ellipsoid and dome-shaped stamps with string holes

drilled through their sides. Carved of semiprecious stones and worn as rings or neck pendants, seals could also function as jewelry and amulets. Their intaglio designs preserve a rich corpus of Sasanian imagery, ranging from human busts and figures to animals to inanimate objects and monograms.[1]

The ellipsoid stamp seal of brown chalcedony from the Calderwood Collection (cat. 60) depicts a seated woman shown in profile, holding a flower close to her nose. Broad lines of diagonal hatching indicate the folds of her long garment; two horizontal lines suggest the seat. The line running parallel to the woman's lower back might be the end of a braid. The sides of the seal are slightly chipped and the edges of the string hole worn. Women, often with braided hair, already appear on seals from the Achaemenid Persian empire of the sixth to fourth centuries BC, where they are shown serving wine, working wool, or enjoying the scent of a flower.[2] On Sasanian seals, women are usually shown standing, holding a flower or a large ring and sometimes accompanied by one or two children.[3] They have been interpreted as representing the fertility goddess Anahita or as depicting women from well-to-do families, their rings indicating their married status.[4] Female names inscribed

on Sasanian seals attest that women as well as men owned seals.[5] It should not surprise us, then, that seals could bear their image.

The opaque gray chalcedony seal (cat. 61) is also ellipsoid but has a larger string hole and a leaf pattern carved on the back. It is engraved with a hand, a small crescent moon, and a hatched ribbon. The seal shows traces of wear, including surface abrasion around the image. Like the woman with flower, the raised hand was a popular device on Sasanian seals. It was usually rendered with thumb and forefinger touching, and occasionally holding a flower, in a gesture that could represent a greeting and was probably auspicious.[6] A small crescent moon occurs frequently on Sasanian seals and coins, often with a star.

Surviving Sasanian seals exhibit a number of carving styles. There are finely engraved examples with almost naturalistic-looking figures, and many—mostly smaller—specimens whose designs are even more linear than those of the Calderwood seals.[7]

SE

1 See Bivar 1969; Brunner 1978; Azarpay and
 Zerneke 2002; Gyselen 2006.

2 See the contributions of Maria Brosius, Judith
 Lerner, and Lloyd Llewellyn-Jones in J. Curtis
 and St. J. Simpson 2010.

3 For example, Horn and Steindorff 1891, 6–7, pl. 2;
 Bivar 1969, 61–65, pls. 7–8; Brunner 1978, 60–63;
 Gignoux 1978, 35–36, nos. 4.27–30, 4.37–38, pl.
 10; Harper 1978, 145–46, 148, nos. 69–70, 73;
 Gignoux and Gyselen 1982, 36–38, 46, 50–51,
 nos. 10.1–4, 10.7, 10.41, 10.44, 11.4, 11.6, pls. 3, 5–6;
 Gignoux and Gyselen 1987, 159–91, 222, 242–43,
 285, nos. AMO 10.1–9, IBT 10.1–2, MCB 10.1–4,
 MFAB 1–2, pls. 4, 14, 17, 23; Gyselen 1997, xxxiv–
 xxxix, 5–6, 33, nos. KPK 10.1–4, KPK 11.1, RMO
 10.A.2–7, pls. 1, 8; Azarpay and Zerneke 2002,
 nos. 10.A.01–03; Gyselen 2007, 96–97, nos. 10.1–
 2, 10.5–6.

4 There was disagreement on interpretation as
 early as 1891: see Horn and Steindorff 1891, 6, 32
 no. 23 (1115); see also Bivar 1969, 25; Brunner
 1978, 61.

5 A number of the seals listed above carry female
 names; see also Gignoux and Gyselen 1989.

6 Compare Brunner 1978, 121–22; Bivar 1969, 25,
 67–69, pl. 9; Gignoux and Gyselen 1982, 44–46,
 nos. 10.35–40, pl. 4; Gignoux and Gyselen 1987,
 163, 212, 286, nos. AMO 10.19–20, YU 1, MFAB 4,
 pls. 5, 13, 23; Gyselen 2006, 206, no. 153; Gyselen
 2007, 96–97, nos. 10.8–9.

7 Brunner 1978, 131–34.

Works on Paper

62

Fineleaf Fumitory
Folio from a manuscript of Khawāṣṣ al-ashjār
(De materia medica) *by Dioscorides*
Recto: text and illustration of rupturewort
and an unidentified plant
Verso: text and illustration of fineleaf fumitory
Iraq, 13th century
Ink and opaque watercolor on paper
Folio: 29.7 × 20.2 cm (11¹¹⁄₁₆ × 7 ¹⁵⁄₁₆ in.)
2002.50.140

De materia medica, the great treatise on the therapeutic properties of natural substances —plants, minerals, and animals—was written, probably during the third quarter of the first century BCE, by Dioscorides Pedanius, a Greek author from Anzarba (now Anavarza), in southeastern Turkey.[1] Originally comprising some 1,007 chapters, the text was rearranged and supplemented over the centuries as it was translated into several languages and copied across Western Europe and the Middle East, where, until the end of the sixteenth century, it served as the basis for pharmaceutical and herbal writing. First translated into Arabic in the ninth century, Dioscorides' treatise became one of the most frequently copied books in Islamic lands, laying a foundation for the further work of Muslim physicians, scientists, and pharmacists.

This folio probably once belonged to a now-fragmentary and dispersed manuscript known as the Vignier-Densmore Dioscorides.[2] Containing most of Book III of the treatise and parts of the remaining books, the known folios of this manuscript preserve neither colophon nor date. Characteristics of the Vignier-Densmore manuscript include the letter *sīn* written with three diacritical dots below it; fifteen to seventeen lines of text per page; the loss of, or damage to, the outer bottom corners of the folios; a purplish-black discoloration of the paper caused by the ink bleeding through from the opposite side; and Western-style numbering in the outer top corners.[3]

The stylized image follows the conventions of herbal illustration in depicting the plant from leaf tips to bare roots. The rubric *qāfunūs* identifies the plant as fineleaf fumitory (*Fumaria parvifolia*), which, according to the text, has small, grayish leaves and purple flowers; its sharp juice makes the eyes water and, when mixed with glue, can be used to discourage the growth of eyebrows. When eaten, the herb causes the patient to excrete bile.[4]

MMcW

63

Isfandiyar Captures Gurqsar in Combat
Folio from a manuscript of the *Shāhnāma*
by Firdawsi
Recto: text
Verso: text and illustration, with titles
"Battle between Arjasp and Isfandiyar" and
"Capture of Gurgsar by Isfandiyar"
Iran, Shiraz, Inju period, 1341
Black ink, gold, and opaque watercolor on
beige paper
Folio: 37.1 × 29.3 cm (14⅝ × 11⁹⁄₁₆ in.)
2002.50.12

Published: McWilliams 2002a, 14, fig. 7.

As related in Firdawsi's *Shāhnāma*, the
mighty Isfandiyar, son of King Gushtasp,
led the Iranian army to victory against the
Turanians, commanded by Gurgsar. The
fight between the two champions ended
when Isfandiyar lassoed Gurgsar and pulled
him to the ground. In its figural style, treat-
ment of ground line, and restricted space,
this fourteenth-century painting recalls the
aesthetic conventions of Iranian *mīnāʾī* and
luster ceramics (see, for instance, cats. 27
and 30). The figures are arrayed symmetri-
cally in a frieze, and loosely drawn foliage
fills the background. This folio was part of
a now-dispersed illustrated *Shāhnāma*

commissioned in 1341 by the vizier of the
Inju governor in Fars.[1]

MMN

1 According to M. S. Simpson 2000, 241. Another
 folio from this manuscript, unlocated at the time
 of Simpson's reconstruction, is currently in the
 Harvard Art Museums (2011.493).

1 Titled *Peri hylēs iatrikēs* in the original Greek,
 Dioscorides' treatise is best known in modern
 literature by the title of the sixth-century Latin
 translation, *De materia medica* (The Materials
 of Medicine). An introduction to the immense
 scholarly literature on Dioscorides can be found
 in the footnotes to Touwaide 2009, 557–80.

2 I am grateful to Alain Touwaide (Institute for the
 Preservation of Medical Traditions, Washington,
 DC) for identifying the Calderwood folio with
 the Vignier-Densmore Dioscorides. Touwaide
 is researching the history of this manuscript for
 future publication. See also Sadek 1983, 18; Grube
 1959, 179–80, fig. 18. According to Sadek and
 Grube, the bulk of the manuscript was formerly
 on loan to the Bibliothèque nationale de France,
 Paris (collection particulière). Whatever the case,
 folios of the manuscript are now in several col-
 lections across the world. Grube lists additional
 bibliography for some of the dispersed folios.

3 The following thirteen folios appear to be dis-
 persed from the same manuscript: Aga Khan
 Collection, Toronto (five folios, A.M. 2/A–E);
 Metropolitan Museum of Art, New York (two
 folios, 65.271.1, 65.271.2); private collection,
 Princeton; University of Michigan Museum of
 Art, Ann Arbor (1957/2.1); Walters Art Museum,
 Baltimore (Ms. W 750, four consecutive folios).

4 For the translation of the rubric and the summary
 of the Arabic text, I am grateful to Wasma'a
 Chorbachi and Nawal Nasrallah. For the place
 of this plant in other Arabic Dioscorides manu-
 scripts, see the Table of Concordance in Sadek
 1983, 113.

64

The Constellation Cassiopeia as Seen on a Globe
Folio from a manuscript of the *Kitāb ṣuwār al-kawākib al-thābita* (Book of the Fixed Stars) by ʿAbd al-Rahman al-Sufi
Recto: text, with title "Image of the Enthroned One as seen in the sky and on a globe"
Verso: text and illustration, with title "Image of the Enthroned One as seen on a globe"
Iran, late 15th–early 16th century
Ink, gold, and opaque watercolor on paper
Folio: 21.3 × 14.9 cm (8⅜ × 5⅞ in.)
2002.50.145

Gold disks scattered across this seated figure mark the major stars of the constellation Cassiopeia. Named "The Enthroned One" (*dhāt al-kursī*) in Arabic, this constellation of the Northern Hemisphere was pictured in antiquity as the beautiful, but tragically vain, Queen Cassiopeia of Greek mythology.

The painting was part of a now-dispersed manuscript of al-Sufi's *Book of the Fixed Stars*, a tenth-century astronomical manual that expanded and updated Ptolemy's *Almagest*, integrating it with the rich star lore and nomenclature of the *Anwāʿ*, the pre-Islamic Arabic tradition.[1] For each of the forty-eight constellations, al-Sufi provided a description, a star chart, and two images, the first as seen on a celestial globe and the second as it appeared in the heavens.

The rubric above her states that the queen in this painting represents the constellation as viewed on a celestial globe. She wears a Persian crown topped by a fluttering plume, rather than the diadem of classical precedent.[2] Although rendered in awkward perspective, the Western-style throne on which she perches adheres more closely to classical sources than does her crown, allowing the figure to sit "with her feet outstretched," as the text requires.

This painting and six others that can be associated with it suggest that the manuscript from which they were removed emphasized aesthetic over scientific aims.[3] Whereas illustrations in astronomical texts are usually line drawings with, at most, translucent touches of color, these paintings employ the opaque pigments preferred for illustrating poetic narratives. More telling, perhaps, is the fact that none of the stars are labeled.

Examined against transmitted light, this folio is revealed to be composed of two sheets of paper. The image of Cassiopeia is painted on a fragmentary sheet that has been pasted onto a larger text folio. It appears that there is a star chart on the reverse of the fragmentary sheet.[4]

MMcW

1 Arguably the most popular classical text on astronomy, *Mathēmatikē syntaxis* was compiled about 150 in Alexandria by the Greek scholar Claudius Ptolemy. This mathematical and astronomical work is best known in English as the *Almagest*, a corruption of the word *megistē* (the greatest) as it appeared in Arabic translation (*al-majisṭī*). The *Almagest* was first translated into Arabic in the early ninth century; Al-Sufi (903–986) retranslated and expanded it around the year 964 for Adud al-Dawla, ruler of the Iranian Buyyid dynasty. Translated into Persian, Latin, and Spanish, *Book of the Fixed Stars* exerted considerable influence well into the seventeenth century.

2 When this painting came to the Harvard Art Museums, Cassiopeia's face was markedly darkened due to discoloration by the lead white component of the pigment. By using hydrogen peroxide, Sara Bisi, Craigen W. Bowen Fellow in the Straus Center for Conservation and Technical Studies from 2010 to 2011, was able to lighten the face significantly, though a slightly dark cast remains.

3 In order of their probable appearance in the manuscript, these folios depict the following constellations: Perseus (David Collection, Copenhagen, 37/2006); Serpentarius and Ophiuchus (Harvard Art Museums, 1919.131); Andromeda and Pisces (Aga Khan Museum, Toronto, AKM00043); Gemini (David Collection, Copenhagen, 4/2000); Sagittarius the Archer (Nelson-Atkins Gallery of Art, Kansas City, 35-30/1); and Capricornus the Kid (Nelson-Atkins, 35-30/5). With the exception of Sagittarius in the Nelson-Atkins Gallery, which appears to have been cut down, these folios all measure

approximately 21.5 × 14.5 cm. Red double-line rulings enclose images and diagrams. The rubrics are written in a rounded *naskh* in red or black ink; the text, in black ink, is in a distinctive hand that features the letters *wāw* and terminal *yāʾ* written as straight lines slanting in the Z-direction.

4 The fragmentary sheet measures approximately 19.3 × 11.6 cm (7⅝ × 4⁹⁄₁₆ in.) and is slightly darker in color than the larger text folio on which it is pasted. The painting is also marred by a pair of brownish feet appearing in Cassiopeia's lap; these are probably a chemical alteration to her yellow robe caused by a painting that had been on a facing page. The feet depicted on the facing page may have been painted with a copper green pigment (as are the feet of Cassiopeia); this pigment often discolors areas with which it is in direct contact. For these observations, we are grateful to Penley Knipe, Philip and Lynn Straus Conservator of Works of Art on Paper, Straus Center for Conservation and Technical Studies.

Cats. 65–71

Seven folios, probably from a single manuscript of the Shāhnāma *by Firdawsi*
Iran, Shiraz, paintings from the late 15th and 16th centuries
Black ink, opaque watercolor, gold, and silver on off-white gold-flaked paper; with underdrawing in black ink
23 lines per page
Average folio: 34.1 × 22 cm (13⁷⁄₁₆ × 8¹¹⁄₁₆ in.)

These seven folios of the *Shāhnāma* are grouped together because several features suggest either that they have been detached from one manuscript or that they were produced at the same atelier. The seven have consistent folio and text-block dimensions, the same number of text lines, and similar decorative treatment of rulings and titles. All the pages have been remargined. The illustrations seem to have been executed in two stages: one dating to the late fifteenth century, when Shiraz was controlled by Aq Qoyunlu rulers, and a later one datable to the Safavid period. Differences in headgear, costume style, and spatial rendering in the compositions suggest that the paintings were created during a time of shifting taste and fashion.[1]

MMN

1 Similar illustrated *Shāhnāma* folios from Shiraz are in the Brooklyn Museum of Art: 86.227.173, 86.227.174, and 86.227.175.

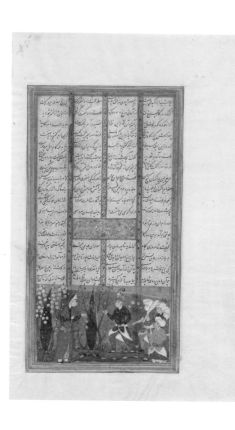

65

Qaydafa Recognizes Iskandar from
His Portrait
Recto: text and illustration, with title
"Qaydafa recognizes Iskandar"
Verso: text
Aq Qoyunlu period, c. 1480
Folio: 34 × 21.5 cm (13⅜ × 8⁷⁄₁₆ in.)
2002.50.21

Published: McWilliams 2002a, 14, fig. 8.

Queen Qaydafa was the ruler of Andalusia.
She was wise, just, prosperous, and admired
by her subjects. Upon hearing of the victo-
ries and success of Iskandar (Alexander the
Great), she ordered her painter to gain sur-
reptitious access to the eminent king, study
him carefully, and produce a detailed, full-
length portrait of him, to supplement the
portraits of great rulers she already pos-
sessed. Following his conquests in the east,
Iskandar sent Qaydafa a letter demanding
her immediate and unconditional submis-
sion, which she refused. When Iskandar,
disguised as his own messenger, appeared
at her court, the queen recognized him and
countered his denials of his royal identity
with the portrait made by her artist. After
the two conversed and recognized their
mutual wisdom and talents, Iskandar
returned to his land with gifts, having
learned an invaluable lesson.

The illustration captures the moment when
Iskandar, shown sitting on a golden seat
in front of Qaydafa, sees his portrait. Even
though the text calls for him to be in dis-
guise as a messenger, he wears a crown like
the one in the painting he is examining.
The queen, in a golden diadem, gestures
toward Iskandar from her large throne. The
protagonists are surrounded by the queen's
female retinue, who peek at the painting
and talk to one another. Although, accord-
ing to the text, the episode takes place at
the Andalusian court, the illustration has
transformed the setting into a fifteenth-
century Iranian or Central Asian palace.

MMN

66

Shapur with the Daughter of Mihrak
Recto: text
Verso: text and illustration, with title
"Ardashir sends a message to Kayd of India"
Safavid period, second half 16th century
Folio: 34 × 22 cm (13⅜ × 8¹¹⁄₁₆ in.)
2002.50.11

According to Firdawsi's narrative, Prince
Shapur, on a hunting trip, stopped to rest
in a charming village where, at a well in a
splendid garden, he saw a beautiful young
woman drawing water. She offered to water
his horses, but Shapur refused her help, say-
ing that his men could perform the task. As
they struggled to bring up the heavy bucket,
the prince asked the woman about her
family. When he learned that she was the
daughter of his enemy Mihrak Nushzad and
had been brought to the village for safekeep-
ing, he decided to marry her immediately.

In this illustration, Shapur and the daughter
of Mihrak, standing in a blooming garden,
gesture toward each other, while Shapur's
men are grouped on the right. Absent here
are depictions of the well and of vessels for
carrying water, which appear in other illus-
trations of the same story.[1]

MMN

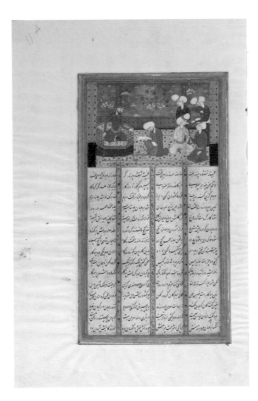

1 See, for example, the Tahmasp *Shāhnāma*, fol. 527v, reproduced in Dickson and S.C. Welch 1981a, vol. 2, no. 219; Canby 2011, 239.

67

Buzurgmihr Counsels Anushirvan
Recto: text and illustration
Verso: text
Safavid period, second half 16th century
Folio: 34.1 × 22.3 cm (13⁷⁄₁₆ × 8¾ in.)
2002.50.10

Firdawsi's text here relates an exchange between the Sasanian ruler Khusraw Anushirvan (d. 578) and his vizier Buzurgmihr. Invited to join Anushirvan's court after interpreting a dream of the king, the young Buzurgmihr became a trusted royal vizier, famous for his intelligence and wisdom. When an Indian envoy brought the game of chess to court to test the Iranians' intelligence, it was Buzurgmihr who solved the mystery of how to play the game and in response invented backgammon.

In the illustration, an enthroned Khusraw Anushirvan has gathered his advisors and ministers. Buzurgmihr has come forward; in the center of the composition, he kneels before the gesturing Anushirvan and writes his advice for the king. To the right, behind Buzurgmihr, the others are engaged in lively discussion.

MMN

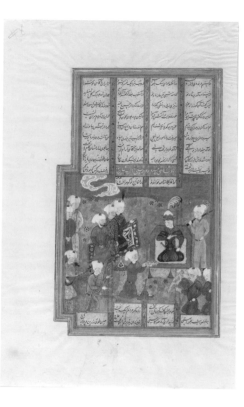

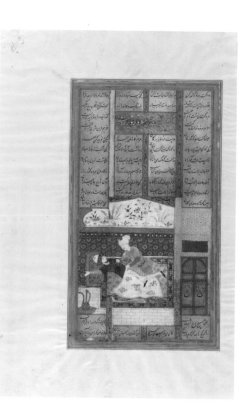

68

Khusraw Parviz Enthroned in a Garden
Recto: text and illustration, with title
"Khusraw Parviz, thirty-eight years"
Verso: text
Aq Qoyunlu period, c. 1480
Folio: 34.1 × 22.2 cm (13⅞₁₆ × 8¾ in.)
2002.50.20

Khusraw Parviz (r. 591–628) was the last
major ruler of the Sasanian dynasty before
the Muslim conquest of Iran. The scene
shows the young ruler on a throne in an
open garden, surrounded by his retinue.
Three high-ranking officials are seated on
a carpet at the left, while two others stand
behind them. The king's sword bearer
and falconer are depicted on the right,
and servants and musicians appear in the
foreground. This illustration reflects the
standard iconography of Central Asian
and Persian audience scenes or official
celebrations.

The doll-like, apple-cheeked figures and
robustly curling clouds are characteristic
of the late fifteenth-century painting style
favored by the Aq Qoyunlu Turkman rulers
of Shiraz. Unfortunately, a later hand has
largely obliterated the finely textured, grassy
ground cover.

MMN

69

*Khusraw Parviz Murdered on the Order
of Shiruy*
Recto: text and illustration, with title
"The killing of Khusraw Parviz by the hand
of Shiruy"
Verso: text
Aq Qoyunlu period, c. 1480
Folio: 34.1 × 22.3 cm (13⅞₁₆ × 8¾ in.)
2002.50.45

Courtiers who supported prince Shiruy's
bid for the throne pressured him to slay his
father, the captive Khusraw Parviz. Shiruy,
although distressed by the idea, was too
weak to stand up to his nobles; they hired
an assassin, whom Firdawsi describes as a
hideous man named Mihr Hurmuzd. When
Mihr Hurmuzd entered the palace where
Khusraw Parviz was imprisoned, the king
was appalled by the repellent creature who
would bring about his death. He ordered
his servant to bring fresh clothes and water
and, after washing and praying, put on the
clothes and covered his face with a cloak to
avoid seeing his ugly murderer. Immedi-
ately Mihr Hurmuzd, dagger in hand, locked
the chamber doors and stabbed the king in
the chest.

The painting captures the dramatic climax
of the story, showing Khusraw on his bed

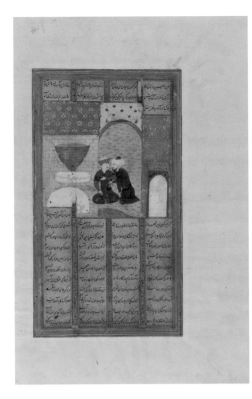

and, atop him, Mihr Hurmuzd in the act of stabbing. Khusraw wears a crown; his face, contrary to what the text says, is not covered. The appearance of the assassin likewise diverges from the textual description: he wears ordinary fifteenth-century court dress, and only his exposed legs indicate his lowly status. The royal chamber in which the scene takes place is decorated with wall paintings, tilework, a carpet, and various types of geometric ornament.

MMN

70

Yazdigird Murdered by Khusraw the Miller
Recto: text
Verso: text and illustration
Aq Qoyunlu period, c. 1480
Folio: 34.2 × 22.2 cm (13⁷⁄₁₆ × 8¾ in.)
2002.50.44

Yazdigird III (d. 651) was the last Sasanian king, ruling an empire rapidly losing territories and political power due to constant attacks by the Muslim Arab armies, the Byzantines, and the Turks. He met his end at the behest of the governor of Merv, Mahuy Suri, who learned that the fugitive king had taken refuge in a mill and ordered the miller to execute him. Firdawsi narrates in great detail the shah's tragic death and laments the extinction of the dynasty, underscoring the treachery and greed of Mahuy and his unworthiness to wear the Iranian crown.

The painting shows the miller as he approaches the king —"as if," in Firdawsi's words, "to whisper a secret in his ear"—and then stabs him with a dagger. Yazdigird wears colorful, gold-ornamented clothing and a crown, in contrast to the plain brown dress of the miller. The mill, with its grinding equipment and storage room, is illustrated in considerable detail.

MMN

71

Text folio
Recto: text
Verso: text, with titles "The Emperor of Rum leads the army against Iran" and "Fariburz [?] writes a letter to the Khaqan of China"
Aq Qoyunlu period, c. 1480
Folio: 34.2 × 22.5 cm (13⁷⁄₁₆ × 8⅞ in.)
2002.50.141

Like the illustrated folios from this manuscript, this text folio is written in *nasta'līq* script, with titles inscribed in white on gold backgrounds ornamented with floral motifs. In addition to being decorative, the slanted lines of text in the middle of the page are arranged to take up extra space, probably so that a subsequent illustration will be nearer the relevant text.

MMN

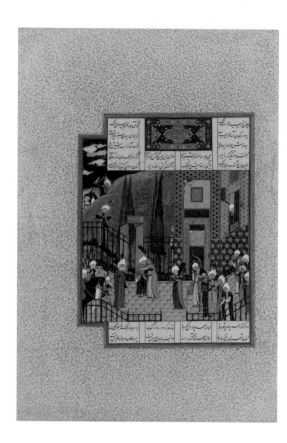

72

Afrasiyab and Siyavush Embrace
Folio from a manuscript of the *Shāhnāma*
by Firdawsi
Recto: text and illustration, with title
"Afrasiyab receives Siyavush in Turan"
Verso: text
Iran, Tabriz, Safavid period, 1520–40
Black ink, opaque watercolor, gold, and
silver on off-white paper, with underdrawing
in black ink
Folio: 47.1 × 31.8 cm (18⁹⁄₁₆ × 12½ in.)
2002.50.13

Published (selected list): Dickson and S.C. Welch
1981a, vol. 2, no. 114; Christie's 1988, lot 1; Davis
2000, 47, 82, 297; McWilliams 2002a, 13, fig. 5;
Harvard University Art Museums 2003, 19; Blair
and Bloom 2003, 178, fig. 16; McWilliams 2004, 7,
fig. 9; Canby 2011, 134.

In this part of Firdawsi's epic, the Iranian
king Kay Kavus decided to wage war against
Turan (Turkestan), even though his son,
prince Siyavush, had signed a treaty with
the Turanian king, Afrasiyab. Siyavush
chose to disregard his father's orders and
accept Afrasiyab's invitation to visit Turan
and take refuge in the realm, thereby avert-
ing yet another war between Iran and Turan.

This folio was part of a famous illustrated
manuscript of the *Shāhnāma* produced at
the Safavid court during the 1520s and
1530s. Known as the *Shāhnāma* of Shah
Tahmasp, after the ruler (r. 1524–76) for
whom it was made, the book originally con-
sisted of 759 text folios and 258 paintings
of superb quality.[1] This illustration portrays
a moment of optimism and brotherhood
between the Turanians and the Iranians.
Having dismounted from their horses,
Afrasiyab and Siyavush embrace, to the
delight of their attendants and supporters.
Piran, Afrasiyab's aged advisor, who has
played an important role in fostering a rela-
tionship of trust between the former foes,
stands on the left, a white-bearded figure
witnessing the exchange of affection. The
emotional scene takes place in front of a
colorfully decorated palatial structure that
likely reflects contemporary Safavid archi-
tecture. The headgear of all the figures,
Iranians and Turanians alike, consists of
turbans folded around caps with tall red
projections (*tāj-i Ḥaydarī*). These distinctive
turbans were worn by the followers of
Tahmasp and suggest a sense of identifica-
tion with the *Shāhnāma* at the Safavid court.

MMN

1 For monographs on this work, see Dickson and
 S.C. Welch 1981a and Canby 2011. The manu-
 script is now dispersed.

Cats. 73–93

Muhammad al-Qivam al-Shirazi (scribe)
Thirty-seven folios from a manuscript of the Shāhnāma *by Firdawsi*
Iran, Shiraz, Safavid period, dated
Ramadan 969 (May–June 1562)
Black ink, opaque watercolor, gold, and
silver on beige paper, with underdrawing
in red ink and probably charcoal
25 lines per page
Average folio: 37.1 × 23.8 cm (14⅝ × 9⅜ in.)

Published: Christie's 1995, lot 79.¹

The thirty-seven folios grouped here once
belonged to a codex copied in Shiraz by
Muhammad al-Qivam al-Shirazi.²

MMN

———

1 The intact manuscript from which these folios
 were subsequently removed was sold at auction
 in 1995: see Christie's 1995, lot 79.

2 See, in this catalogue, Marianna Shreve
 Simpson's essay, "The Illustrated Shāhnāma in
 Sixteenth-Century Shiraz," 77–113. It is possible
 that this scribe is the father of the calligrapher
 who transcribed the so-called Peck *Shāhnāma*
 (now in the Princeton University Library), who
 was called Qivam ibn Muhammad and was also
 from Shiraz.

73

Introduction to the Shāhnāma
Recto: half of double-page illumination,
with text
Verso: text
Folio: 37.2 × 23.3 cm (14⅝ × 9³⁄₁₆ in.)
2002.50.27

This is the left-hand side of an illuminated
double page. The text, written in white
within the central medallion, begins the
introduction to Firdawsi's *Shāhnāma* com-
posed by the Timurid prince Baysunghur
Mirza.¹ The page is densely decorated with
geometric motifs in blue and gold, layered
with intricate floral vines and cloudbands.
The design and palette are characteristic
of frontispieces produced in the second
half of the sixteenth century in Iran and
Central Asia.

MMN

———

1 See Riyāḥī 1993, 364.

74

Text folio
Recto and verso: text
Folio: 37 × 23.5 cm (14⁹⁄₁₆ × 9¼ in.)
2002.50.137

This text folio includes both poetry and
prose written in *nastaʿlīq* script. The poetry
is divided into four columns and is sepa-
rated by colorful lines. The text concerns
Mahmud of Ghazni, who was Firdawsi's
patron.

MMN

75

*Illuminated title page: opening verses
of the* Shāhnāma
recto: text and illuminated panels
verso: illuminated titles and text
Folio: 37 × 23.5 cm (14⁹⁄₁₆ × 9¼ in.)
2002.50.123

The verso of this folio features a richly illu-
minated *tāj*, or crown-like element, at the
top and a cartouche below it that contains
the title of the work, inscribed in white:
"Book of the *Shāhnāma*." The text, with the
beginning of Firdawsi's prologue to the
epic, is written in black *nastaʿlīq* in "cloud"
reserves against a gold background filled
with tiny flowers. The illumination style on
this page echoes that of the introductory
folio (cat. 73).

MMN

76 A–B

Double page: The Court of Gayumars
A. Verso: text, with title "Words in praise of
Sultan Mahmud [of Ghazni]"
Folio: 37 × 23.5 cm (14⁹⁄₁₆ × 9¼ in.)
2002.50.151
B. Recto: text and illustration,
with title "King Gayumars"
Folio: 37.2 × 23.4 cm (14⅝ × 9³⁄₁₆ in.)
2002.50.150

Gayumars was the legendary first king of
Iran, associated with the beginning of civi-
lization and an organized social order. He
and his people lived in the mountains and
wore clothes made of leopard skins. The
court was prosperous and his subjects con-
tent: animals and humans alike obeyed the
king, who was blessed with divine power
(*farr*). Gayumars had a son, Siyamak, whom
he adored and who was loved by all save
a jealous creature called Ahriman.

The large and densely detailed illustration
shows the king, seated on a tiger skin,
attended by his court; like him, they are
dressed in leopard pelts. Siyamak sits to the
left of Gayumars, and the two are encircled
by courtiers and animals. The rocks of their
mountain home have human faces, as does
a sun that shines from behind a crag in the
upper left corner. Near the sun, a demonic
figure peers at a bear hurling a rock. Such
playful vignettes are characteristic of

Persianate painting of the time and can also
be found in the illustrations of the *Shāhnāma*
made for the Safavid ruler Shah Tahmasp.[1]
The red demon may represent Ahriman,
the enemy of humankind.

MMN

———

1 See, for example, a bear throwing a rock on fol.
 22v, The Feast of Sada, Metropolitan Museum
 of Art, New York (1970.301.2), illustrated in
 Dickson and S. C. Welch 1981a, vol. 2, no. 9;
 Canby 2011, 29.

77 A–B

Double page: The Murder of Iraj
A. Verso: text, with titles
"Iraj visits his brothers" (above) and
"Iraj is killed by his brothers" (below)
Folio: 37.2 × 23.6 cm (14⅝ × 9⁵⁄₁₆ in.)
2002.50.166
B. Recto: text and illustration
Folio: 37.2 × 23.6 cm (14⅝ × 9⁵⁄₁₆ in.)
2002.50.165

Published: McWilliams 2004, 8, fig. 11.

The painting depicts a decisive moment in
the *Shāhnāma* and provides the explanation
for the bitter enmity between the Iranians
and the Turanians (Turks) that pervades the
subsequent narrative of the epic. Firdawsi
tells us that the conflict between the two
groups began after King Faridun divided his
empire among his three sons. Rum (Byzan-
tine territory) and the western lands were
assigned to Salm, China and Central Asia to
Tur, and Iran and Arabia to Iraj. Over the
years, Salm and Tur grew jealous of Iraj and
plotted to murder him.

The tragic episode took place in Iraj's
encampment. Having learned of his broth-
ers' intent, Iraj vainly begged Tur to spare
his life, but Tur, with Salm looking on,
stabbed Iraj with a poisoned dagger, cut off
his head, and sent it to their father, Faridun.

The illustration shows a marvelous tent
complex crowded with high officials and
noblemen, looking on as Tur severs Iraj's
head. Whereas in the text Firdawsi details
the youngest brother's wounds and spilled
blood, the artist of this illustration focuses
on his final, vain attempt to fend off the
knife at his throat. His crown has fallen to
the ground, likely knocked off during Tur's
attack. Salm stands on the right, seemingly
taken aback by the violent action unfolding
before his eyes.

By the sixteenth century, the iconography
and composition of this scene were well
established and appear in numerous illus-
trated *Shāhnāma* manuscripts.[1]

MMN

1 See, for example, Dickson and S.C. Welch 1981a,
 vol. 2, no. 36; Canby 2011, 55.

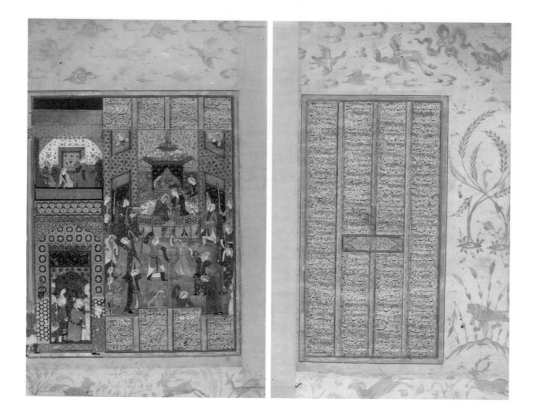
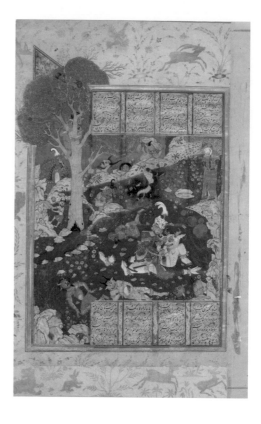

78 A–B

*Double page: The Marriage of Zal
and Rudaba*
A. Verso: text, with title "The wedding feast of
Zal and Rudaba"
Folio: 37.2 × 23.6 cm (14⅝ × 9⁵⁄₁₆ in.)
2002.50.129
B. Recto: text and illustration
Folio: 37.2 × 23.9 cm (14⅝ × 9⁷⁄₁₆ in.)
2002.50.28

This festive painting depicts the marriage of
the Iranian prince Zal to Rudaba, daughter
of Mihrab, the king of Kabul. The vibrantly
colored and dynamically composed scene is
filled with lively vignettes, including a circle
of female musicians and dancers who wave
their long sleeves as they circle in front of
the newly wedded couple. The palace interior
is brightly tiled in various geometric pat-
terns. In the lower left corner, Mihrab, in the
company of Zal's father, Sam, is about to
join the celebratory party. The numerous
torches and candles held by attendants and
servants indicate that the event takes place
at night.

MMN

79 A–B

Double page: Rustam Kills the White Div
A. Verso: text, concerning Rustam's fifth and
sixth trials
Folio: 37.2 × 23.8 cm (14⅝ × 9⅜ in.)
2002.50.134
B. Recto: text and illustration
Folio: 37.1 × 23.8 cm (14⅝ × 9⅜ in.)
2002.50.42

The great hero Rustam had to perform
a series of labors to free the king of Iran,
Kay Kavus, who had been captured by
the evil Ahriman. This illustration depicts
Rustam's seventh and last feat, in which he
vanquished the fearsome demon known as
the White Div.[1] Advised by his captive guide,
Awlad, to ambush the monster in his cave
during the day (since demons prefer to sleep
when the sun is hot), Rustam tied Awlad to
a tree for safekeeping, drew his sword, and
killed the lesser demons who were guarding
the White Div's lair. In the darkness of the
cave, the hero encountered the monstrous
demon, and the two fought fiercely until
Rustam managed to maim the creature and
plunge a dagger into his chest, extracting
his liver.

The painting focuses on Rustam's moment
of triumph. At the center, the hero, wearing
his famous tiger-skin coat and leopard
helmet, stabs his enemy. All around him lie
the scattered body parts of the dead demons

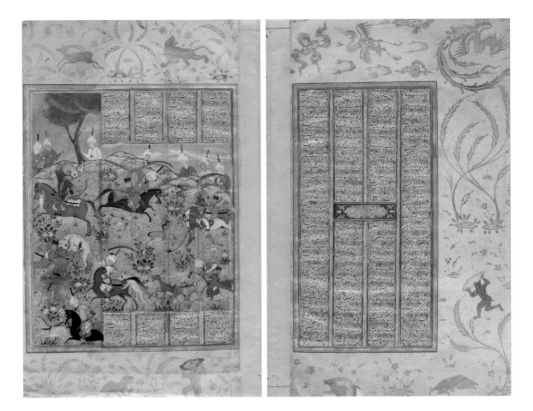

and the severed limbs of the White Div himself. Rustam, in contrast, appears unharmed, even though the text states that he was wounded. Around the cave are a number of surviving demons, as well as Awlad, tied to a tree. Rustam's magnificent horse, Rakhsh, awaits his master at the left.

MMN

1 For further discussion of this painting, see, in this volume, Marianna Shreve Simpson's essay, "The Illustrated *Shāhnāma* in Sixteenth-Century Shiraz," 77–113.

80 A–B

Double page: Rustam and the Iranians Hunt in Afrasiyab's Preserves
A. Verso: text, with title "Rustam banquets and goes to the hunting ground"
Folio: 37.2 × 24 cm (14⅝ × 9⁷⁄₁₆ in.)
2002.50.156
B. Recto: text and illustration
Folio: 37.2 × 23.8 cm (14⅝ × 9⅜ in.)
2002.50.155

While Rustam was resting and feasting during a break from battle, one of his mighty companions, known as champions, suggested that they go hunting in the territory of their enemy, Afrasiyab, the king of Turan. After a week spent enthusiastically poaching animals and birds, Rustam fully expected retribution from the king, and he was unconcerned when Afrasiyab bore down on the Iranian interlopers with an army of thirty thousand men. Each of his champions, Rustam said, was the equal of five hundred of Afrasiyab's men.

The lively illustration shows the Iranians hunting, before Afrasiyab's arrival compels them to resume battle. A group of riders, wearing distinctive Safavid headgear, pursues a host of animals: deer, leopards, rams,

and wild onagers. The archer at the upper left is identified as Rustam by his characteristic tiger-skin coat and leopard helmet.

MMN

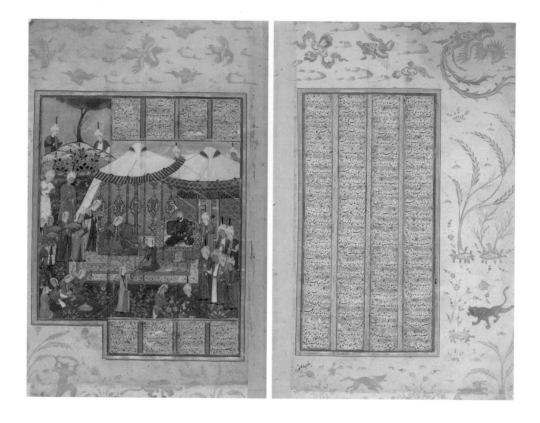

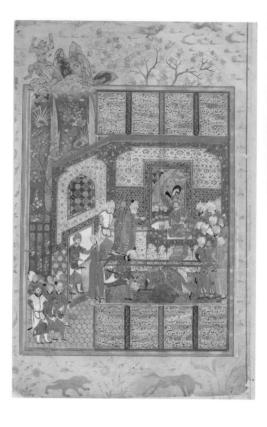

81 A–B

Double page: Preparations for the Marriage of Siyavush and Farangis
A. Verso: text, concerning Piran's effort to convince Siyavush to take Farangis as his wife
Folio: 37.2 × 23.8 cm (14⅝ × 9⅜ in.)
2002.50.128
B. Recto: text and illustration
Folio: 37.1 × 23.8 cm (14⅝ × 9⅜ in.)
2002.50.25

Published: McWilliams 2002a, 15, fig. 9.

Estranged from his father, the king of Iran, Prince Siyavush temporarily enjoyed the hospitality of Afrasiyab, the ruler of Turan (see cat. 72). At the urging of the Turanian commander-in-chief, Piran, Siyavush asked for the hand of the king's daughter, Farangis. Despite his misgivings, Afrasiyab agreed to give the beautiful princess to Siyavush.

In this painting, Farangis is receiving lavish wedding presents from Gulshahr, Piran's wife, who kneels before her. Afrasiyab observes the gift giving from his throne. Attended by court officials, servants, musicians, and a dancer, the festive celebration takes place in two lavish tents pitched in a blooming garden.

MMN

82 A–B

Double page: Guruy Executes Siyavush
A. Verso: text, concerning Farangis
Folio: 37.2 × 23.9 cm (14⅝ × 9⁷⁄₁₆ in.)
2002.50.154
B. Recto: text and illustration
Folio: 37.3 × 24 cm (14¹¹⁄₁₆ × 9⁷⁄₁₆ in.)
2002.50.153

Succumbing to his own foreboding and the envy of his courtiers toward Siyavush, Afrasiyab eventually ordered the execution of the Iranian prince whom he had welcomed into his family. Happy to oblige the monarch, jealous Guruy cut the prince's throat, catching his blood in a golden basin. Siyavush met death bravely, knowing that his wife Farangis would soon give birth to a son, Kay Khusraw, who would unite the lands of Turan and Iran under one crown.

While the text indicates that the execution took place in a wasteland outside Siyavush's capital city, the illustration sets the scene within the confines of a palace crowded with figures, including an enthroned Afrasiyab, court officials, and Farangis, who is being seized as a captive. The illustration shows the dramatic moment when Siyavush's blood gushes forth into the basin.

MMN

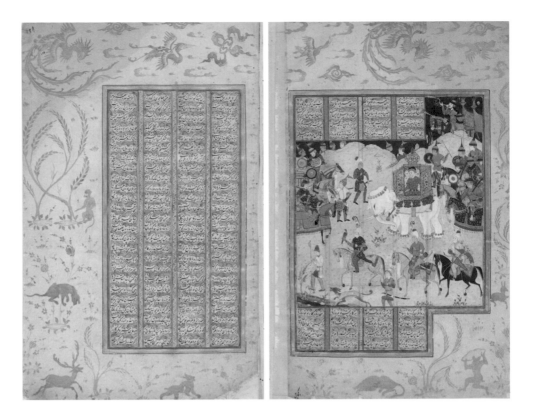

83 A–B

Double page. Kay Khusraw Reviews
His Troops
A. Verso: text and illustration
Folio: 37.2 × 23.9 cm (14⅝ × 9⁷⁄₁₆ in.)
2002.50.148

Published: Reed 2005, 44.

B. Recto: text, concerning Kay Khusraw
preparing the army and Tus, with his
troops, marching on Turan
Folio: 37.3 × 24 cm (14¹¹⁄₁₆ × 9⁷⁄₁₆ in.)
2002.50.149

Kay Khusraw, grown to manhood and
now king of Iran, prepared to mount a
campaign against the Turanian murderers
of his father, Siyavush. Seated on a jeweled
throne atop his mammoth war elephant,
he rode out to review his army. The great
imperial warriors, including Fariburz and
Gudarz, filed past.

The illustration portrays Kay Khusraw
in a lavish howdah; he is surrounded by
mounted soldiers with colorfully capari-
soned horses and gold and silver weapons
and helmets.

MMN

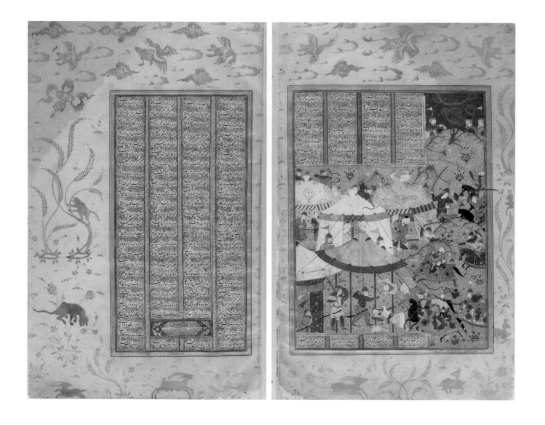

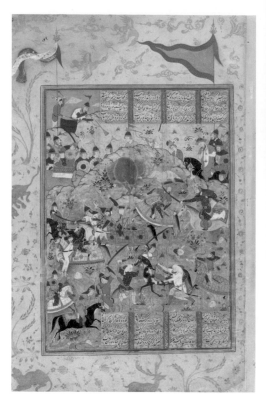

84 A–B

*Double page: Piran Attacks the Iranians
at Night*
A. Verso: text and illustration
Folio: 37 × 24 cm (14⁹⁄₁₆ × 9⁷⁄₁₆ in.)
2002.50.159
B. Recto: text, with title "Letter of Kay
Khusraw to Fariburz"
Folio: 37 × 24 cm (14⁹⁄₁₆ × 9⁷⁄₁₆ in.)
2002.50.160

Following successful attacks on Turan by
the Iranians, Afrasiyab appointed Piran
to lead the Turanian army and defeat the
invaders. Learning that the Iranians had
let down their guard and were carousing
drunkenly, Piran rallied thirty thousand
soldiers and attacked their encampment
in the hours of darkness, soundly defeating
them. Although this painting shows the
attack, its scenes of slaughter are subordi-
nated to the beauty of the floral landscape
and embellished tents and the rhythmic
placement of the figures with their swinging
scimitars. Sharing the restraint and delicacy
of many Safavid paintings, it does not fully
convey the bloody tumult and chaos that
Firdawsi describes.

MMN

85 A–B

*Double page: The Iranians Repel Afrasiyab's
Night Attack*
A. Verso: text, concerning the battle between
Afrasiyab and Kay Khusraw
Folio: 37.1 × 24.1 cm (14⁵⁄₈ × 9½ in.)
2002.50.168
B. Recto: text and illustration
Folio: 37.3 × 24 cm (14¹¹⁄₁₆ × 9⁷⁄₁₆ in.)
2002.50.167

The war between Iran and Turan contin-
ued, finally bringing about the defeat of
Afrasiyab's forces by those of Kay Khusraw.
This illustration shows Rustam, who can be
identified by his animal-skin garb, helping
rout the Turanians, while Afrasiyab looks on
in consternation, his emotion indicated by
his finger-to-mouth gesture. This painting
falls within the textual description of a night
attack by the Turanians, although it depicts
a daytime event. Despite the overall delicacy
and refinement of the Safavid style, the
artist has convincingly conveyed the grue-
someness of combat by littering the flowery
landscape with dismembered bodies and
severed heads.

MMN

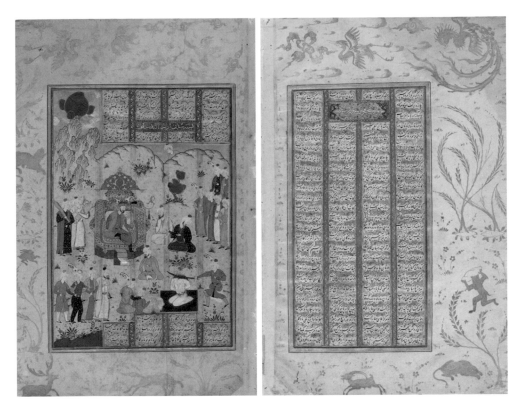

86 A–B

Double page: The Execution of Afrasiyab
A. Verso: text, with title "Kay Khusraw asks about Garsivaz"
Folio: 37.2 × 24.1 cm (14⅝ × 9½ in.)
2002.50.162
B. Recto: text and illustration, with title "The execution of Afrasiyab before Kay Khusraw"
Folio: 37.2 × 23.8 cm (14⅝ × 9⅜ in.)
2002.50.161

The Turanians were at last defeated in battle, but their king, Afrasiyab, escaped. Eventually Hum, a recluse, discovered Afrasiyab hiding in a cave in the mountains and brought him to Kay Khusraw. In revenge for Siyavush's murder, the Iranian king put Afrasiyab to death in the same manner, beheading him with a sword and collecting his blood in a basin. Afrasiyab's brother Garsivaz, who had been present at Siyavush's execution, was also put to death.

The illustration shows the beheading of the old Turanian king, witnessed rather than performed by Kay Khusraw, who sits on a throne surrounded by his retinue. Afrasiyab's severed head rolls leftward off the carpet. In another departure from the text, the artist has omitted the basin used to catch Afrasiyab's blood.

MMN

231

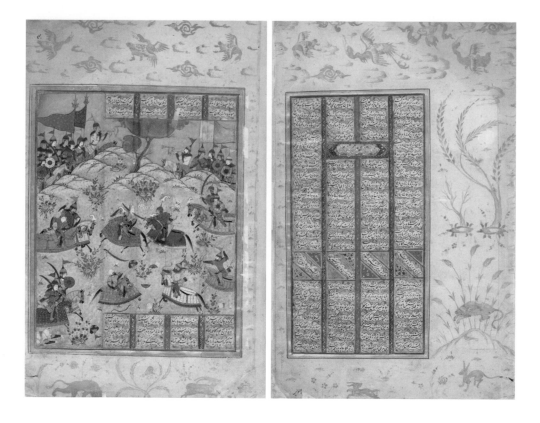

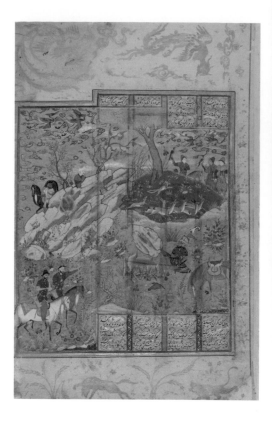

87 A–B

Double page: The Death of Luhrasp in Battle against the Forces of Arjasp
A. Verso: text, with title "Kuhram comes to Balkh with the king"
Folio: 37 × 24 cm (14⁹⁄₁₆ × 9⁷⁄₁₆ in.)
2002.50.133
B. Recto: text and illustration
Folio: 37.2 × 24.1 cm (14⅝ × 9½ in.)
2002.50.41

Luhrasp, Kay Khusraw's successor as king of Iran, ceded the throne to his son Gushtasp and became a Zoroastrian devotee in the city of Balkh. But when the new Turanian king, Arjasp, ordered his son Kuhram to lead the Turanians against Iran, the elderly former king met them in battle and was slain.

According to the text, Luhrasp fends off individual attackers and is killed only when surrounded by his foes. Not until they remove the fallen warrior's helmet and see his white hair do the Turanians realize that he is an old man. The artist has composed this scene symmetrically, crowding the background with two groups of warriors who proudly fly their banners and sound their trumpets.

MMN

88 A–B

Double page: Rustam Kicks Aside the Rock Thrown by Bahman
A. Verso: text, with title "Bahman arrives at the hunting ground of Rustam and Zal" and a second title, now illegible
Folio: 37.1 × 24.1 cm (14⅝ × 9½ in.)
2002.50.164
B. Recto: text and illustration
Folio: 37 × 24.1 cm (14⁹⁄₁₆ × 9½ in.)
2002.50.163

King Gushtasp sent his son Isfandiyar to bring the mighty hero Rustam to court in chains, promising Isfandiyar the throne if he could accomplish this feat. Searching for Rustam, Isfandiyar's son Bahman came upon the hero roasting an onager in his hunting grounds and decided to kill him immediately, sparing his father a dangerous confrontation. From the top of a mountain he pried loose a large boulder and sent it rolling downhill toward Rustam, whose brother Zavara heard the noise and cried out in warning. Rather than move, however, the hero calmly waited until the stone was nearly upon him and then kicked it away. Impressed by Rustam's power, Bahman approached him and told him of Isfandiyar's mission.

In the painting, Rustam is shown at the crucial moment of danger, yet, as the text describes, he remains seated, roasting his

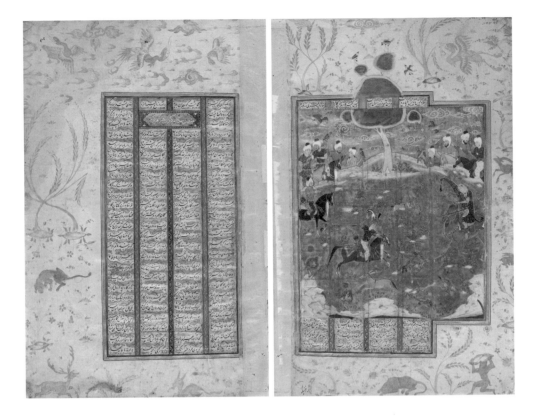

supper on a spit and merely stretching out his leg to kick away the large rock. Next to him his horse, Rakhsh, grazes undisturbed. Rustam's hunting party rounds the horizon at the upper right, unaware of the incident, but two figures at the lower left witness and point at the scene. From behind the rocky ridge on the left, Bahman looks on, his finger to his mouth in astonishment. Animals, birds, and flowers rendered in delicate detail provide a soothing contrast to this tense moment of drama.

MMN

89 A–B

Double page: Bahram Gur Hunts with Azada
A. Verso: text and illustration
Folio: 37.2 × 24 cm (14⅝ × 9⁷⁄₁₆ in.)
2002.50.157
B. Recto: text, with title "Bahram Gur hunting"
Folio: 37.2 × 24 cm (14⅝ × 9⁷⁄₁₆ in.)
2002.50.158

Bahram Gur, a son of Yazdigird III, took his slave girl, a harpist named Azada, on a hunt. As they rode together on his camel, Azada challenged Bahram to do the seemingly impossible: to transform a male gazelle into a female and a female into a male, and to pierce a gazelle's foot and ear with a single shot. Bahram immediately shot the horns from a buck and sent two arrows into the head of doe; he then grazed a third gazelle's ear with a stone and, when the animal scratched the nick, pinned its leg to its ear with one arrow.

The artist of the painting has departed from the text, showing a harp-playing Azada, by herself on a camel, watching Bahram Gur hunt on horseback. Between them are a "horned" doe and an unfortunate buck shot through leg and ear. A large hunting party, uncalled for by the text, can be seen in the background, witnessing Bahram's prowess.

MMN

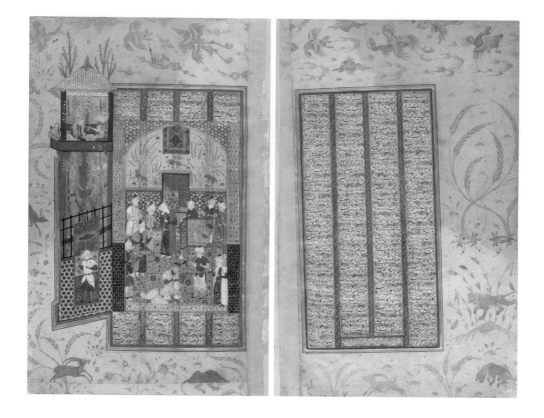

90 A–B

Double page: Gushtaham and Banduy Blind Hurmuzd
A. Verso: text, with title "A brand is applied to King Hurmuzd's eyes"
Folio: 37.1 × 23.7 cm (14⅝ × 9⁵⁄₁₆ in.)
2002.50.132
B. Recto: text and illustration
Folio: 37.1 × 24 cm (14⅝ × 9⁷⁄₁₆ in.)
2002.50.40

King Hurmuzd was deceived into suspecting his son, Khusraw Parviz, of rebellion. Forewarned of his father's plan to put him to death, Khusraw escaped from Iran. Hurmuzd, suspecting his brothers Gushtaham and Banduy of siding with Khusraw, imprisoned them. With the king dispirited and in seclusion, however, the prisoners escaped, armed themselves, and rode to the royal palace, where their troops blinded the king.

The illustration depicts the gruesome moment when hot iron rods are put to Hurmuzd's eyes. Instead of armed rebels, those who observe this scene are court officials, who display little emotion. Moreover, three women on the palace balcony seem entirely unaware of the event.

MMN

91 A–B

Double page: The Burial of Yazdigird
A. Verso: text and illustration
Folio: 37 × 23.9 cm (14⁹⁄₁₆ × 9⁷⁄₁₆ in.)
2002.50.122
B. Recto: text, with titles "How Mahuy was informed of Yazdigird's death and ascended the throne" and "Mahuy's consultation with the minister and his answer to him"
Folio: 36.7 × 23.7 cm (14⁷⁄₁₆ × 9⁵⁄₁₆ in.)
2002.50.136

In Firdawsi's epic, Yazdigird III (d. 651) was assassinated in a mill by order of Mahuy, the treacherous governor of Merv (see cat. 70). Two religious ascetics discovered the king's body, stripped and thrown in a stream. Their fellow monks retrieved it, respectfully anointed it with wine, musk, camphor, and rosewater, clothed it in linen and gold brocade, and placed it in a lofty tomb.

The painting shows a priest blessing the open grave as Yazdigird's coffin is carried into the mausoleum, followed by a crowd of mourners. The casket, with Yazdigird's crown at the head, is wrapped in textile strips. In design and decoration, the tomb reflects sixteenth-century Central Asian and Iranian architectural interiors.

MMN

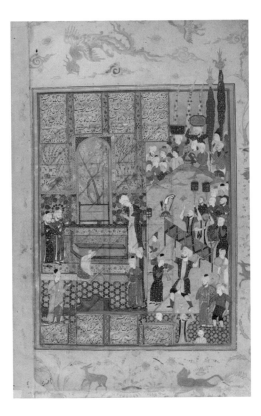

92

Text folio, with epilogue to the Shāhnāma
Recto and verso: text
36.9 × 23.9 cm (14½ × 9⁷⁄₁₆ in.)
2002.50.124

93

Text folio, with colophon of the manuscript
Recto: text
Verso: blank
36.9 × 23.9 cm (14½ × 9⁷⁄₁₆ in.)
2002.50.138

The colophon, written in the tapering
area at the bottom of the page, reads, "The
end of the book, with the aid of God and
divine blessings. Prayers and praise upon
Muhammad, Seal of the Prophets, and
[upon God] of the pious and the chaste.
With continuous and eternal prayers of
submission to the Greatest of Greats, on
the [?] day of the month of Ramadan the
blessed in the year 969, by the effort of
Muhammad al-Qivam al-Katib al-Shirazi,
may God forgive him. May you [God]
forgive any offenses and hide any errors.
So be it, O Lord!"

MMN

Cats. 94–101

*Ten illustrated folios from a manuscript of
the* Shāhnāma *by Firdawsi*
Iran, Shiraz, Safavid period, c. 1575–90
Black ink, opaque watercolor, gold, and
silver on beige paper, with underdrawing
in red and black ink
25 lines per page
Average folio: 42.7 × 27.5 cm (16¹³⁄₁₆ × 10¹³⁄₁₆ in.)

The following ten illustrated folios were
originally part of a single Shiraz-style
Shāhnāma manuscript of impressive dimen-
sions and lavish ornamentation.[1] The paint-
ings are visually related to those of the
so-called Peck *Shāhnāma*, which according
to its colophon was produced in Shiraz in
998 (1589–90).[2] Like the Peck manuscript,
the copy of the *Shāhnāma* from which these
folios come included both single- and
double-page paintings, the latter featuring
intricate and sumptuously illuminated
borders.[3]

MMN

1 Several folios of this manuscript were sold at
Spink & Son, London, in 1992. We are grateful
to Simon Ray for this information.

2 The Peck *Shāhnāma* is housed at Firestone
Library, Princeton University (Peck 310, Prince-
ton Islamic MSS., Third Series, no. 310). It was
copied by Qivam ibn Muhammad of Shiraz.
See Clinton and M. S. Simpson 2006b.

3 See, in this volume, the essays "The Illustrated
Shāhnāma in Sixteenth-Century Shiraz," by
Marianna Shreve Simpson, 77–113; and "Tech-
nical Observations on a *Shāhnāma* Manuscript,"
by Penley Knipe, 115–33.

94

Frontispiece: Solomon Enthroned
Recto: seals with pious inscriptions
Verso: illustration
Folio: 42.5 × 26.5 cm (16¾ × 10⁷⁄₁₆ in.)
2002.50.37

Published: McWilliams 2002a, 15, fig. 11.

This folio is half of what was a double-page
frontispiece depicting King Solomon on the
right and Bilqis, the Queen of Sheba,
on the left.[1] The Calderwood painting rep-
resents Solomon and his court, including
his vizier Asaf, surrounded by animals,
birds, angels, and divs. This scene is not
linked to the text of the *Shāhnāma* per se,
but rather reflects concepts of the ideal
ruler. Similar depictions of Solomon appear
as frontispieces in many Safavid illustrated
manuscripts, merging the image of the just
king with that of a prophet who is close to
God.

The rich detail, bright colors, and lively
composition of this frontispiece would have
made it visually suitable for introducing
the kingly adventures narrated and depicted
in the following pages of the manuscript.
The painting is surrounded by a wide band
of illumination, in blue and gold with deli-
cate floral tracery.

MMN

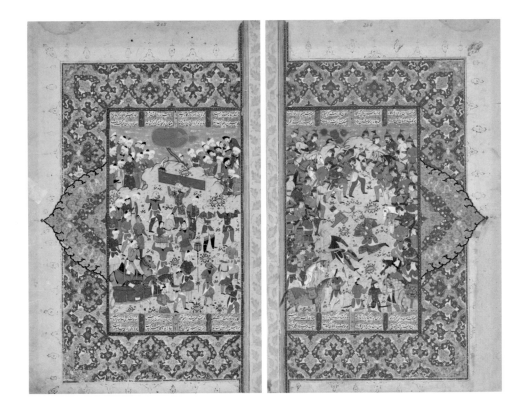

95 A–B

1 For the facing folio, depicting Bilqis enthroned in a palace, see, in this volume, the essay by Marianna Shreve Simpson, "The Illustrated *Shāhnāma* in Sixteenth-Century Shiraz," 77–113, specifically 89, fig. 7b.

Double page: Rustam Mourns Sohrab and Carries His Coffin

A. Verso: text and illustration (of Rustam mourning Sohrab)
Folio: 42.7 × 27.1 cm (16¹³⁄₁₆ × 10¹¹⁄₁₆ in.)
2002.50.32
B. Recto: text and illustration (of Rustam carrying Sohrab's coffin)
Folio: 42.7 × 27.1 cm (16¹³⁄₁₆ × 10¹¹⁄₁₆ in.)
2002.50.131

The paintings of this double page represent two final moments in the tragic tale of Rustam, the great Iranian hero, and his son, Sohrab. Rustam had departed the kingdom of his bride, Tahmina, before Sohrab's birth. He was unaware of his son's existence until they met, years later, on the battlefield, where Sohrab was leading the Turanian army against the Iranians. Not recognizing each other, the two champions fought in fierce single combat on three successive days. Only after Rustam managed to wrestle Sohrab to the ground and fatally stab him was the identity of the mighty young warrior revealed to his distraught father.

The painting on the right depicts Rustam kneeling next to his dying son, who lies mortally wounded. Sohrab's coat has been partially pulled off to reveal on his arm the amulet that Rustam gave Tahmina the night Sohrab was conceived. Warriors of the two armies, looking on in shock, encircle the two heroes. The painting on the left shows Rustam singlehandedly carrying the coffin of his son. The mourners around him raise their arms in the air, beat their chests, and undo their turbans in grief.

The double-page composition is surrounded by lavish gold-and-blue illuminated borders consisting of curvilinear trefoils and floral tracery.

MMN

237

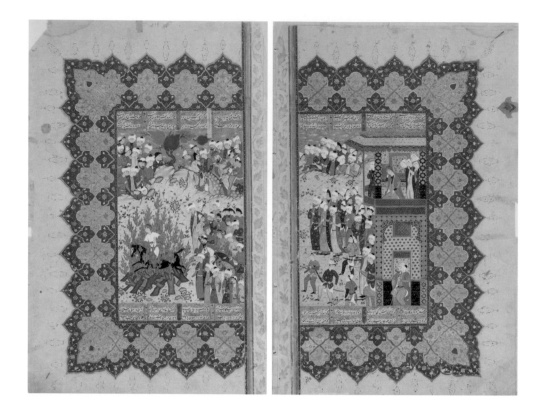

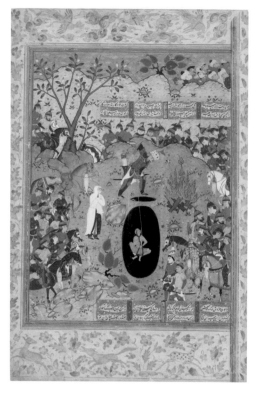

96 A–B

Double page: The Trial by Fire of Siyavush
A. Verso: text and illustration (of Sudaba watching from palace)
Folio: 42.8 × 28.3 cm (16⅞ × 11⅛ in.)
2002.50.142
B. Recto: text and illustration (of Siyavush riding through the fire)
Folio: 42.8 × 28.3 cm (16⅞ × 11⅛ in.)
2002.50.143

This double-page composition depicts the redemption of prince Siyavush, son of the Iranian king Kay Kavus. When Siyavush rebuffed the advances of his stepmother, Sudaba, she accused him of attempting to rape her. The king, after conducting an inconclusive investigation, asked both Sudaba and Siyavush to undergo a trial by fire. Sudaba refused; Siyavush agreed and emerged from the burning pyre unscathed and triumphant.

The painting on the left shows Siyavush galloping on his black horse through the engulfing flames. The king, also mounted, watches intently from the rocks above. On the right is the brightly tiled royal palace, from which Sudaba, finger to mouth, peers down in amazement.

Wide illuminated borders, here consisting of geometric compartments, surround the composition.

MMN

97

Rustam Rescues Bizhan from the Pit
Recto: text and illustration
Verso: text, with title "Rustam attacks the palace of Afrasiyab at night"
Folio: 43.1 × 28 cm (16¹⁵⁄₁₆ × 11 in.)
2002.50.35

This painting represents the conclusion of a tale of forbidden love between the Iranian warrior Bizhan and the princess Manizha, daughter of the Turanian king Afrasiyab. Crossing the border to see the fair maidens of Turan encamped at a spring festival, Bizhan encountered Manizha, and the two were so powerfully attracted to each other that they trysted in her tent for three days. When Afrasiyab learned of the affair, he arrested Bizhan and imprisoned him in a dark pit covered by a heavy stone, with only the dishonored Manizha to keep him alive. Eventually, Bizhan was saved by the Iranian hero Rustam, who was the only one strong enough to remove the stone from the mouth of the pit.

The painting shows the moment of rescue. Rustam, dressed in his tiger-skin coat, has cast away the stone and with a rope pulls the chained, half-naked Bizhan up from the depths. On the left stands Manizha, in white

robe and veil. Encircling the main scene, a crowd of admiring soldiers witnesses the rescue mission.

MMN

98

Gudarz Pays Homage to Kay Khusraw and Shows Him the Enemy Corpses
Recto: text, with title "Kay Khusraw arrives at the camp"
Verso: text and illustration
Folio: 42.9 × 27.1 cm (16⅞ × 10¹¹⁄₁₆ in.)
2002.50.38

After assuming the throne, Kay Khusraw summoned his best warriors, heroes, and chieftains to battle Afrasiyab and the Turanians. When the war was nearly won, the king came to join his forces. In the painting he and the hero Rustam appear on horseback at the left. The Iranian warrior Gudarz and his sons have dismounted, and one of them kneels in front of Rustam and Kay Khusraw. Four severed heads on the ground between the two groups and five more on spikes at upper right represent the enemy corpses mentioned in the text and offer proof of the Iranians' success. The composition is studded with soldiers, mounted or on foot, observing the event.

MMN

99

Iskandar Mourns the Dying Dara
Recto: text, with title "Dara slain by his vizier"
Verso: text and illustration
Folio: 42.9 × 27.6 cm (16⅞ × 10⅞ in.)
2002.50.34

Iskandar (Alexander the Great) and Dara (Darius, ruler of the Achaemenid empire), had waged war against each other for three years. While the Iranian forces were in retreat, Dara was stabbed by two of his ministers, Mahiyar and Janusiyar, who expected a reward from Iskandar. But Iskandar, who had just learned that he was Dara's half-brother, rushed to the scene of the attack and tenderly comforted his mortally wounded opponent.

In the center of this painting, Dara lies dying, his head cradled by Iskandar, who holds a blue handkerchief to his eyes and weeps. At left the two traitorous officers, Mahiyar and Janusiyar, are shown bound, with their heads shaved; Iskandar has assured Dara that he will have them executed. Encircling the death scene are the mournful and bewildered entourages of the two rulers. These military men are depicted not only in the usual profile and three-quarter views but also frontally and from behind. Although Dara is the elder brother, in this painting it is the lamenting Iskandar who has the white beard.

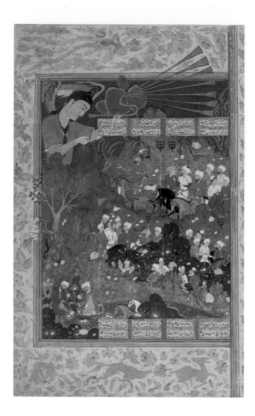

The tragic scene takes place against a colorful background painted in light blue, mauve, and ochre; the flowers, grass, rocks, and trees of the landscape offset the grimness of the human drama. Figures and landscape have both been delineated in exceptional detail.

MMN

100

Iskandar Meets the Angel Israfil and Khizr Finds the Water of Life
Recto: text and illustration
Verso: text, with title "Iskandar goes to the eastern lands"
Folio: 42.8 × 27.6 cm (16⅞ × 10⅞ in.)
2002.50.36

In his existential quests and search for the Water of Life, Iskandar went with his men to explore the western regions. Entering the Land of Darkness, the king asked a local leader and mystic, Khizr, to be their guide, but, taking a wrong turn, they became separated from him and had to continue on their own in the gloom. Alone, Khizr found the magical spring, whose waters he bathed in and drank. Meanwhile, Iskandar came to a mountain; at its summit was Israfil, the Angel of Death, holding a trumpet and awaiting God's orders to blow it. Upon seeing Iskandar, the angel warned him to be less concerned for crown and throne, since the ruler himself would someday hear the trumpet call.

The painting depicts three separate occurrences in the story. An enormous Israfil, holding a seven-belled horn, dominates the upper left corner of the composition, dwarfing Iskandar, with whom the angel converses. Behind and below Iskandar, members of his army struggle through the rocky landscape, their torches lighting the winding route; they turn to one another and gesture with their hands, enlivening the composition. In the lower left corner, Khizr and a second man, Ilyas, have found the Water of Life. According to tradition, these two prophets never died; hence they are shown drinking from the spring of immortality while all others seek their way in the dark.

MMN

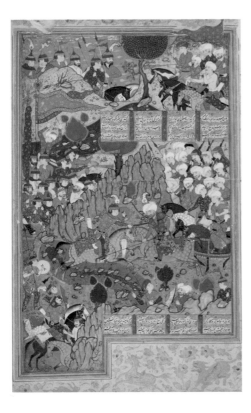

101

Bahram Chubina Slays Kut of Rum
Recto: text and illustration
Verso: text, with title "Battle between Bahram
Chubina and the Iranians"
Folio: 42.5 × 28.2 cm (16¾ × 11⅛ in.)
2002.50.14

The Iranian military commander Bahram
Chubina had rebelled against his king,
Hurmuzd; forced Hurmuzd's son and right-
ful heir, Khusraw Parviz, to flee to Rum;
and usurped the throne. When Khusraw
returned to Iran with reinforcements from
the Byzantine emperor, Bahram gathered
his army and prepared to do battle against
him. One brave Byzantine, Kut of Rum,
volunteered to ride to Bahram's camp and
challenge him to single combat. Khusraw
and the rest of his men watched the ensuing
contest from a mountaintop.

The illustration shows the climax of the epi-
sode, when Bahram Chubina cleaves Kut's
chest with his sword. The pair battle in a
rocky landscape, surrounded by warriors,
banging kettledrums, and blaring horns.
Soldiers just below the upper text box wear
long, drooping headgear similar to that of
Ottoman Janissaries, which probably iden-
tifies them as the Byzantine soldiers men-
tioned in Firdawsi's text.

MMN

102 A–B

*Double page: Illuminated frontispiece from
a manuscript of the* Khulāṣat al-akhbār
by Khvandamir
Central Asia or Iran, 16th century
Black ink, opaque watercolor, gold leaf,
and gold on paper
A. Verso: 29.5 × 17.5 cm (11⅝ × 6⅞ in.)
2002.50.127
B. Recto: 28.8 × 17.5 cm (11⁵⁄₁₆ × 6⅞ in.)
2002.50.126

These pages served as the opening to a
manuscript of the *Khulāṣat al-akhbār*
(Quintessence of Histories), the first his-
torical work of Ghiyath al-Din ibn Humam
al-Din Khvandamir, composed in 1499–
1500 in Herat. The work is an abridged
version of the *Rawḍat al-ṣafāʾ* (Garden
of Purity), by the famous Timurid histo-
rian Mirkhvand, who was Khvandamir's
grandfather.[1]

The text of this frontispiece, written in
white *nastaʿlīq* script, conveys blessings and
gives the title of the work and a very short
description of its nature: that it presents,
"in the best words of historians, the annals
of prophets and kings, starting with Adam."[2]

The rich illumination combines floral
scrollwork, cloudbands, and abstract
medallion-and-pendant and trefoil forms

on a blue-and-gold ground. The pages
mirror each other, forming a lavish intro-
duction to the manuscript.

MMN

————

1 Browne 1929, 3:434.

2 Adam's story begins on 2002.50.126v, which
has twenty lines to the page, written in black ink
with gold decoration and set within an orange,
blue, and gold composite frame.

103

Illuminated folio from an unidentified manuscript
Recto: blank except for later inscriptions, now illegibly blurred
Verso: *shamsa*
Iran or Central Asia, Safavid or Shaybanid period, 16th–17th century
Black ink, opaque watercolor, and gold on beige paper
Folio: 26.5 × 14.6 cm (10⁷⁄₁₆ × 5¾ in.)
2002.50.24

This page features a *shamsa* (sun), an illuminated medallion in which the title of a book or chapter was often inscribed. This *shamsa* is composed of abstract and floral forms in gold and blue surrounding a plain gold circular center, which has been repainted. An underlying inscription is detectable via X-ray, but unfortunately only one word can be read: *aṣḥabi* (lords or possessors).

Repainting aside, the *shamsa* is executed with delicate brushwork and careful attention to detail. Balanced and symmetrical in composition and palette, it compares well with other illumination produced in Central Asia and Iran during the sixteenth and seventeenth centuries.

MMN

Cats. 104–11

Eight illustrated folios from a manuscript of the Khamsa *(Quintet) by Nizami*
Iran, Shiraz, Safavid period, dated Dhu'l-Qaʿda 992 (November 1584)
Black ink, opaque watercolor, gold, and silver on off-white paper; with underdrawing in red and black ink
20 lines per page
Average folio: 40 × 26.3 cm (15¾ × 10⅜ in.)

Composed in Persian in the second half of the twelfth century by Nizami of Ganja (1141–1209), the five poems illustrated in the following folios were gathered after the author's death into a collection known as the *Khamsa* (Quintet). Nizami wrote these poems—*Makhzan al-asrār* (The Treasury of Mysteries), *Khusraw va Shīrīn* (Khusraw and Shirin), *Laylā va Majnūn* (Layla and Majnun), *Haft paykar* (Seven Beauties, or Seven Portraits), and *Iskandarnāma* (Book of Alexander)—at different times and did not himself link them to one another.[1]

The following eight folios once belonged to a single manuscript, dated November 1584 on the recto of the first folio.[2] Although consistent in page and text-block dimensions, number of text lines, and decorative treatment of rulings, margins, and titles, the folios have multiple numbering systems, made by later hands. The text on illustrated pages is written in cloud reserves with

floral-and-gold grounds; vertical bands between the text columns are colored and often illuminated.

MMN

1 Parrello 2010.

2 Christie's 1994a, lot 25. The sales catalog does not illustrate the colophon but notes that it is dated to the end of Dhu'l-Qaʿda 992. For eight folios from this manuscript, see Christie's 1994a, lots 25–32. For twenty-two text folios from the same manuscript, see Christie's 1994b, lot 291.

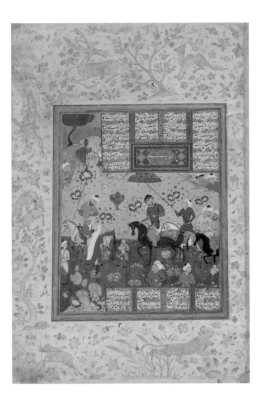

104

Sultan Sanjar and the Old Woman,
from Makhzan al-asrār
Recto: text and illustration, with title "Story,"
indicating the beginning of a new episode
Verso: text
Folio: 40 × 26.2 cm (15¾ × 10⁵⁄₁₆ in.)
2002.50.146

Published: Christie's 1994a, lot 31.

Makhzan al-asrār contains stories dealing
with religious and moral values, worldly
power, and spiritual concerns. This episode
of Nizami's poem tells of an old woman who
complained to the Seljuk ruler Sultan Sanjar
(d. 1157) about the harsh treatment that she
had received from his police. After recount-
ing the physical and mental suffering
inflicted on her by Sanjar's men, she pro-
ceeded to describe the immoral conduct of
the ruler himself and the disapproval of his
subjects throughout the empire, warning
him that his tyranny and lack of justice
would lead to his demise.

In this illustration, the sultan is shown
astride his horse and surrounded by the
men of his retinue, one of whom shades
him with a parasol. The old woman
approaches, and she and the sultan gesture
with extended arms, indicating that they
are conversing. Although she is the subject
of Nizami's story, she is a minor figure in

this painting, which is dominated by the
image of Sultan Sanjar. The episode takes
place in a flowery green meadow, behind
which is a hill with rocky outcroppings that
suggest human faces—a common convention
in Safavid painting.

MMN

105

Caliph Harun al-Rashid in the Bath,
from Makhzan al-asrār
Recto: text and illustration, with title
"Harun al-Rashid being shaved"
Verso: text
Folio: 40.1 × 26.1 cm (15¹³⁄₁₆ × 10¼ in.)
2002.50.43

Published: Christie's 1994a, lot 29.

While shaving the Abbasid caliph Harun
al-Rashid (d. 809) in the bathhouse, a barber
impertinently professed his love for the
ruler's daughter and asked to marry her.
Astounded at the barber's audacity, the
caliph consulted his vizier, who speculated
that the barber might have been standing
atop a treasure, which would generate inor-
dinate confidence in any man. The next day,
the vizier suggested, the caliph should
choose another spot in the bathhouse and
observe the barber's behavior. Standing in a
different place to minister to the caliph, the
barber behaved in a polite and appropriate
manner, not mentioning the ruler's daugh-
ter. Harun al-Rashid immediately ordered
the original location excavated, and indeed
a treasure was found there.

The illustration represents a lively genre
scene of men in a bathhouse being washed,
massaged, shaved, and entertained.
Depicted at the right of the main chamber

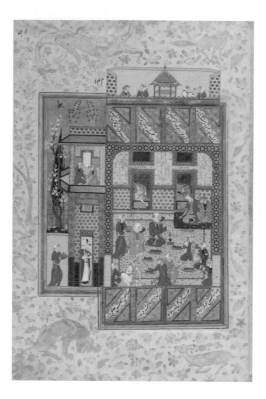

are a seated man, his lower body draped in blue, and a standing man in red who shaves his head. These two probably represent the caliph and the barber.

MMN

106

Khusraw and Shirin,
from Khusraw va Shīrīn
Recto: text and illustration
Verso: text
Folio: 40.2 × 26.3 cm (15¹³⁄₁₆ × 10⅜ in.)
2002.50.2

Published: Christie's 1994a, lot 30.

Nizami's romance *Khusraw va Shīrīn* involves historical figures of pre-Islamic Iran, principally the Sasanian king Khusraw II Parviz (r. 590–628) and the Armenian princess Shirin. Young Prince Khusraw, enticed by his friend Shapur's description of a beautiful and virtuous princess he had seen in Armenia, sent Shapur off to find her and bring her to Iran. Shapur, a skilled artist, drew a series of portraits of Khusraw, and, upon viewing them, Shirin fell in love with the handsome prince and set out for his kingdom, while Khusraw himself left Iran to seek the princess in Armenia. Following a series of failed encounters, the couple met, but their marriage was postponed for many years by a series of obstacles.

In this painting the soon-to-be newlyweds are shown seated in a lavishly decorated architectural setting with male courtiers or sages and female attendants. The illuminated text boxes form part of the palace structure, contributing to the elaboration of the pictorial surface. Four maidens stand on the tiled roof, and two more are seated on a balcony. In the main hall, where the wedding reception will take place, the figures gesture in animated conversation. Several trays of pomegranates—symbolic of love, sexuality, and procreation—are placed on the carpet beside the guests.

MMN

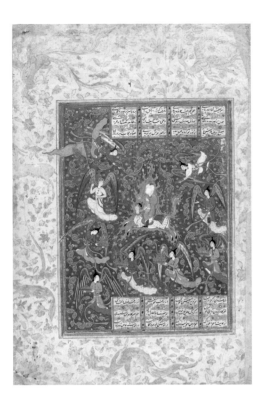

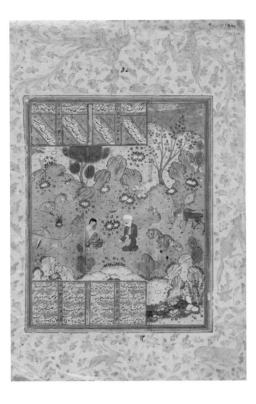

107

The Prophet's Ascent,
from Laylā va Majnūn
Recto: text and illustration
Verso: text
Folio: 40.2 × 26.5 cm (15¹³⁄₁₆ × 10⁷⁄₁₆ in.)
2002.50.3

Published: Christie's 1994a, lot 26; McWilliams, 2004, 9, fig.12; Raguin and Bangdel 2010, 290, fig. 1.

The story of the miraculous night journey of the Prophet Muhammad is based on passages from the Qur'an (17:1, 53:1–18, and 81:19–25), as well as later hadith that describe his travel (*isrā'*) from "the holy mosque" to "the farthest mosque" as well as his ascent to heaven (*mi'rāj*) and what he experienced there. Paintings of this wondrous event sometimes appear in illustrated manuscripts of Persian epic and romantic poetry, such as the *Khamsa* of Nizami, even though they are not directly related to the stories told in these works.

In this illustration, the Prophet is shown in mid-journey, riding his human-headed steed, Buraq. Rainbow-winged angels hover around him and proffer golden vessels. Among them is Archangel Gabriel: holding a banner of green, the color associated with the Prophet, he leads Muhammad on his mystical journey. Although earlier depic-

tions of the Prophet reveal his face, here he is shown veiled, in accord with iconography adopted at the beginning of the Safavid period, in the early 1500s.[1]

MMN

——————

1 Gruber 2009a.

108

Majnun in the Wilderness,
from Laylā va Majnūn
Recto: text
Verso: text and illustration
Folio: 40.1 × 27.3 cm (15¹³⁄₁₆ × 10¾ in.)
2002.50.152

Published: Christie's 1994a, lot 32.

In the tragic romance between Layla and Qays (later known as *majnūn*–"mad" or "possessed"), the two met and fell in love as schoolchildren. Layla's father rejected Qays's marriage proposal and separated the pair, and, on his orders, Layla married another man. Majnun, suffering the pain of unfulfilled love, felt that he could no longer be part of human society and became a recluse in the desert wilderness, living among the animals, who accepted his behavior and understood his agony. Although married, Layla remained faithful to Majnun and confined herself to writing poetry. In the tragic conclusion to the story, Majnun died on his beloved's grave.

The artist of this painting has illustrated an episode in which Majnun's maternal uncle, Shaykh Salim, visits the love-stricken man in the desert and pleads with him to return to his former life and family. Majnun is shown half naked, a piece of blue cloth tied around his waist, embracing and talking to

109

The Prophet's Ascent,
from the Iskandarnāma
Recto: text
Verso: text and illustration
Folio: 39.5 × 26.2 cm (15⁹⁄₁₆ × 10⁵⁄₁₆ in.)
2002.50.33

Published: Christie's 1994a, lot 27; McWilliams 2002, 15, fig. 10.

This depiction of the miraculous night journey of Muhammad shows him facing right, following the lead of Gabriel. As in the previous version of the scene (cat. 107), Gabriel holds a green banner, and the Prophet, his face veiled, rides his mystical steed, Buraq. Colorful, vessel-bearing angels gather around them. In the upper right corner of this painting appear two motifs absent from the other illustration: lion and sun, which traditionally are Shiʻi symbols associated with the house of the Prophet.[1]

MMN

―――――

1 For further information on this symbolism, see Farhad 2009, 118, cat. 22, and 320n8; Shahbazi 1999.

110

Bahram Gur in the Black Pavilion,
from the Haft paykar
Recto: text
Verso: text and illustration,
with title "Bahram goes on Saturday to the black pavilion"
Folio: 40.2 × 26.2 cm (15¹³⁄₁₆ × 10⁵⁄₁₆ in.)
2002.50.1

Published: Christie's 1994a, lot 28.

The *Haft paykar* (Seven Beauties, or Seven Portraits) is a romantic epic poem of about 5130 couplets that narrates the life of the Sasanian king Bahram Gur. A substantial section of the poem relates how Bahram Gur discovered portraits of princesses from the seven climes, fell in love with these beauties, searched them out, and wed them all. For his brides he had an architect construct seven domed pavilions with colors corresponding to the seven climes and the planets that ruled them. On each day of the week, the king visited one princess, who would tell him a story in keeping with her color and mood.

This painting depicts Bahram Gur's visit on Saturday to the Indian princess, who occupies a black pavilion (governed by Saturn). The king and his bride, wearing black and dark gray robes patterned in gold, sit in a black-domed palatial structure,

a deer. Salim, fully clothed in a long brown coat and a white turban, gestures to his nephew. The landscape setting represents a desert oasis with a stream, trees, grass, and flowers. Majnun and Salim are surrounded by animals, most of them in pairs whose members interact with each other, reinforcing the viewer's impression of Majnun's lonely solitude.

MMN

drinking wine as female servants and entertainers attend them. The illuminated text boxes are embedded in the palace architecture, becoming part of the densely ornamental painted surface. As is typical of these illustrations, the color of the protagonists' clothing matches that of the architecture around them.

MMN

111

Bahram Gur in the Sandalwood Pavilion, from the Haft paykar
Recto: text and illustration, with title "Bahram goes on Thursday to the Sandalwood pavilion"
Verso: text
Folio: 40 × 26.1 cm (15¾ × 10¼ in.)
2002.50.147

This painting depicts Bahram Gur's visit, on the sixth day, to the sandalwood pavilion of Princess Yaghme, the daughter of the emperor of China. The couple is dressed in garments that match the color of the pavilion, here articulated in pale yellow and washed peach. The princess offers her husband pomegranates on a golden tray; he holds a winecup. They are attended by Yaghme's ladies-in-waiting, female musicians, and other servants. Although the text describes a pavilion furnished with Chinese treasures, it is depicted here as richly decorated with tiles, wall paintings, and carpets in Persianate style.

MMN

112

Qasim
Left half of an illuminated double-page frontispiece
Folio from a manuscript of the *Shāhnāma* by Firdawsi
Recto: illumination, with text from Baysunghur Mirza's introduction
Verso: text
Iran or Central Asia, 16th–17th century
Black ink, opaque watercolor, and gold on off-white paper
Folio: 38.2 × 25.6 cm (15⅟₁₆ × 10⅟₁₆ in.)
2002.50.4

The recto of this folio is the left half of a frontispiece from a copy of the *Shāhnāma*. Written in white *nastaʿlīq* script within the central medallion are lines of Baysunghur Mirza's introduction to Firdawsi's epic.[1] The illumination consists of abstract curvilinear motifs in blue and gold overlaid with sinuous cloudbands and colorful floral scrolls. To the right of the inner rectangle, at the midpoint of the blue ruling, a tiny inscription in white reads, *amal-i Qāsim* (made by Qasim), probably referring to the illuminator.

In design and palette, this frontispiece is comparable to others produced in Iran and Central Asia in the second half of the sixteenth century (see, for instance, cat. 102 A–B).

MMN

1 See Riyāḥi 1993, 364.

Cats. 113–14

Three folios from a manuscript of the Shāhnāma *by Firdawsi*
Iran, Safavid period,
late 16th–early 17th century
Black ink, opaque watercolor, gold,
and silver with punch work on beige paper
25 lines per page
Average folio: 34.1 × 21.4 cm (13¼ × 8⁷⁄₁₆ in.)

Many shared features suggest that these three folios of Firdawsi's *Shāhnāma* were once part of a single manuscript. The dimensions of folios and text blocks, the number of text lines, the calligraphic hand, and the style and the size of the paintings are consistent. Furthermore, all three folios have wormholes in the same places.

MMN

113

Gushtasp Slays a Dragon
Recto: text and illustration
Verso: text
Folio: 34.4 × 21.5 cm (13⁹⁄₁₆ × 8⁷⁄₁₆ in.)
2002.50.31

Gushtasp was a son of the Iranian king Luhrasp. When his father refused to abdicate in his favor, the impatient young prince left Iran for the capital city of Rum (Constantinople). There the emperor's eldest daughter fell in love with him despite his guise of a lowly workman; having been promised her choice of a husband, she married him against her father's wishes. The emperor then decreed that only men of tested valor could marry his two younger daughters. The daughters' suitors both sought Gushtasp's help with their assigned feats; secretly taking their places, the prince killed two fearsome monsters.

In this image, Gushtasp acts on behalf of Ahran, the suitor of the youngest daughter, in slaying a terrifying dragon. Although his horse turns away in fear, the prince boldly thrusts his dagger into the dragon's gaping mouth. The craggy landscape, dead tree, and gusting clouds contribute to the ominous atmosphere of the painting.

MMN

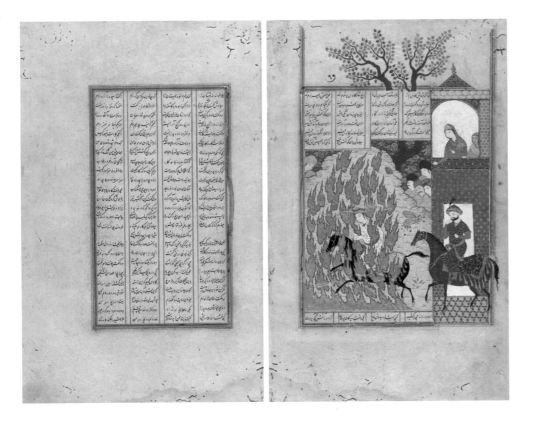

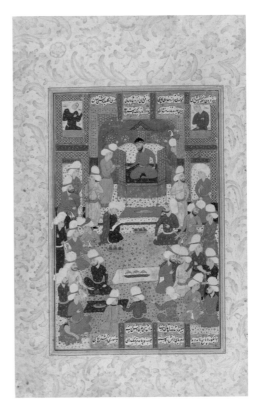

114 A–B

Double page: The Trial by Fire of Siyavush
A. Verso: text and illustration
Folio: 34 × 21.4 cm (13⅜ × 8⁷⁄₁₆ in.)
2002.50.30
B. Recto: text
Folio: 34 × 21.5 cm (13⅜ × 8⁷⁄₁₆ in.)
2002.50.130

The depiction of Prince Siyavush's test by fire is here confined to a single page, rather than spread over two as in cat. 96 A–B. The scene is therefore predictably condensed, with Siyavush shown galloping into the fire while his father, also mounted, watches anxiously from the forecourt of his nearby palace. Peering from the window above is the would-be seductress, Sudaba, who gestures toward Siyavush. The handsome prince, his black mount, and the towering golden flames that engulf them are here closer to the center of the composition.

Although hairstyles and headgear differ, the two versions of this scene in the Calderwood Collection feature similar architectural decoration. Furthermore, the compositional elements that they share irrespective of format suggest the existence of an established iconographic convention for illustrating this episode of the *Shāhnāma*.

MMN

115

Burzuy Brings Anushirvan the Book
Kalila and Dimna
Folio from a manuscript of the *Shāhnāma*
by Firdawsi
Recto: text and illustration
Verso: text
Iran, Safavid period, late 16th–17th century
Black ink, opaque watercolor, and gold on off-white paper, with underdrawing in red ink
Folio: 37.2 × 22.7 cm (14⅝ × 8¹⁵⁄₁₆ in.)
2002.50.5

The tale of how the collection of fables *Kalila and Dimna* was transmitted from India to Iran appears in the *Shāhnāma* in the section recounting the life and rule of Khusraw Anushirvan.[1] Given leave by the king, the learned physician Burzuy journeyed to India in search of the plant of eternal life. After arriving at the Indian court, however, Burzuy came to understand that it was not a magical plant but rather a book called *Kalila and Dimna* that contained the transformative wisdom he sought. Forbidden to take notes as he read, he memorized parts of the book by day and transcribed them secretly by night, sending his transcriptions back to Anushirvan. Upon his return to Iran, Burzuy was received with great honor at the court. Free to choose his reward, he asked that the story of his adventure be included as a preface in the vizier

Buzurgmihr's translation into Pahlavi (Middle Persian) of the *Kalila and Dimna*.

This painting, of a seemingly generic reception scene at the Safavid court, focuses only subtly on the story of Burzuy. King Anushirvan is shown seated on his throne, surrounded by attendants and officials; courtiers engage in animated conversations and women watch from their apartments. At center left, however, a young man is busy writing: he probably represents Buzurgmihr, Anushirvan's brilliant vizier, who is copying either the text of *Kalila and Dimna* or Burzuy's story. Burzuy is likely the bearded man sitting opposite him on the right.

The exaggerated white turbans worn by the male courtiers and attendants in this painting reflect Iranian headgear fashionable in the early seventeenth century.[2]

MMN

1 De Blois 1990, 56–57.

2 See, for example, the artist Riza 'Abbasi's double-page painting *Picnic with Nobleman*, executed in 1612, reproduced in Canby 1996b, cat. 55.

116

Siyavush Enthroned in a Garden Pavilion with Attendants
Folio from a manuscript of
the *Shāhnāma* by Firdawsi
Recto: text and illustration
Verso: blank
Iran, Safavid period, first half 17th century
Black ink, opaque watercolor, and gold on beige paper, with underdrawing in black ink
Folio: 37.3 × 24.6 cm (14¹¹⁄₁₆ × 9¹¹⁄₁₆ in.)
2002.50.26

The Iranian prince Siyavush is here shown seated on a golden throne after his marriage to Farangis (see cat. 81 A–B) and the festivities that followed the event. As a wedding gift, Farangis's father, King Afrasiyab, granted Siyavush vast territories stretching to the Sea of China, as well as a golden throne and crown. The painting clearly shows these objects, and the red curtains ornamented with Chinese cloud forms emphasize the proximity of China. In style, the painting can be related to works following the visual tradition of Riza 'Abbasi from the 1630s.[1]

MMN

1 We are grateful to Massumeh Farhad for this information (personal communication, March 18, 2011).

117 A–B

İsma'il bin İbrahim Bosnavi (d. 1748)
Double page with a calligraphic portrait
(hilye) *of the Prophet Muhammad*
A. Verso: right half of the *hilye*
Folio: 22.2 × 13.6 cm (8¾ × 5⅜ in.)
2002.50.119
B. Recto: left half of the *hilye*
Folio: 22.2 × 13.6 cm (8¾ × 5⅜ in.)
2002.50.135
Turkey, probably Istanbul, Ottoman period,
first half of the 18th century
Black ink, gold, and opaque watercolor on
(now tarnished) silver-flaked, off-white paper

Copied in *naskh* script by İsma'il Bosnavi,
these two folios contain a *hilye* (Arabic
ḥilya), or calligraphically rendered descrip-
tion in Arabic of the Prophet Muhammad.
The text of the *hilye*, attributed to 'Ali, the
prophet's cousin and son-in-law, describes
both the physical qualities of the Prophet
and his good character. On these pages,
this classic text, placed in three roundels
(two on the right page and one at the top of
the left page) is followed by that of another
early Muslim, Jabir ibn Samura: "I saw the
Prophet Muhammad at night wearing a red
garment and, as I looked at him and at the
moon, he appeared more beautiful than the
moon." Beside the large roundels are twelve
smaller ones: the one at upper right is in-
scribed *Allāh* (God), and the rest contain the
names of Muhammad (the Prophet); of Abu

Bakr, 'Umar, 'Uthman, and 'Ali (the rightly
guided caliphs), and of the Prophet's six
companions who first accepted Islam as the
true religion. Inscribed in the square enclo-
sures that border the two pages are the
ninety-nine names of the Prophet. Both
pages are decorated with gilded rulings and
freehand floral designs.

The back (verso) of the left-hand page
records the patrilineal ancestors of the
Prophet, starting with 'Adnan (122 BCE),
arranged in the form of a tree. 'Adnan's
name appears at the base of the trunk and
Muhammad's at the top of the tree, within
a domed frame suggestive of an Ottoman
mosque. The branches of the tree terminate
in ten roundels that contain the names
of companions who shared Muhammad's
ancestors. Gold floral designs fill the area
beneath the branches. The calligrapher's
name appears at the bottom of the page.

The calligrapher İsma'il [bin Ibrahim]
Bosnavi (from Bosnia) was the son of
Noktacı-zade, the top finance officer (*defter-
dar*) of Eger, in Hungary.[1] He received his
training at the Ottoman court school for the
gifted (*enderun*), in the *seferli* division, a
teaching center for various arts. Specializing
in *thuluth* and *naskh* scripts, İsma'il received
his calligraphic education and license from
Ressam Ömer Efendi.[2] He signed his name
İsma'il Muhasib, since after his training at

the court school he was sent to the prov-
inces as a bookkeeper (*muhasib*) of the court
eunuchs. He copied a Qur'an on the order of
Ahmed III (r. 1703–30) and was generously
rewarded. His surviving work consists of
individual calligraphic specimens and
others contained in albums (*muraqqa'*).[3]

Originally, the *hilye* text was simply written
on paper and carried as a protective amulet.
In the last quarter of the seventeenth
century, the renowned calligrapher Hafiz
Osman transformed it into a circular calli-
graphic composition and included it in a
copy of *al-An'ām*, the sixth chapter of the
Qur'an. With representational images of,
for instance, Mecca and Medina, *hilye*s
began to be included in various prayer
books that contained Qur'anic chapters and
prayers.[4] Believed to bring succor in times
of difficulty, such prayer books had wide-
spread public appeal.[5] *Hilye*s created as
independent calligraphic compositions
became very popular in Ottoman lands
during the nineteenth century, and large-
format examples were often hung on the
walls of Ottoman houses.

AYY

1 Müstakimzade 1928, 116–17.

2 A coin designer: ibid., 350, 438.

3 Huart 1908, 166–67.

4 Derman 2004, 115; Bain 1999, 70–73; and see
 Gruber 2009b for a discussion of prayer books
 with representational images.

5 Gruber 2009b, 117–20, 142.

118

Recumbent Lioness
Iran, Safavid period, early to mid-16th century
Ink, opaque watercolor, and gold on paper
Folio: 14.5 × 20.8 cm (5¹¹⁄₁₆ × 8³⁄₁₆ in.)
2002.50.6

Appreciation for works of art that can be
characterized as "single-page compositions"
intensified during the reign in Iran of the
Safavid dynasty (1501–1722).[1] Collectors
assembled paintings, drawings, and speci-
mens of calligraphy and mounted them onto
the folios of albums (*muraqqaʿ*). In some
instances, these items had originally been
created for manuscripts; in other cases, they
had been made as models or as autonomous
works of art.

The subject of the recumbent lioness is
known from a corpus of drawings and paint-
ings executed during the late Timurid and
Safavid periods. With slight variations,
these artworks depict the lioness in a pose
of relaxation, tethered by a chain attached
to a belled collar.[2] The drawings share a
technique that uses stippling or short lines
(without hatching) to convey the contours
and mass of the lioness as well as the texture
of her coat. In this example, fine lines and
dots of reddish brown, black, and white have
been applied over the ivory-colored paper.
Around the muzzle, ear tips, belly, and rump,
white opaque watercolor is introduced, con-

trasting with the lines and dots and lending
the drawing greater depth. The lioness's
eyes, collar, and chain are accented with
gold.

Now mounted on a sheet of modern paper,
the drawing lacks any trace of a signature or
attribution, but it can be linked through a
sequence of closely related works to a proto-
type originated by the renowned artist
Kamal al-Din Bihzad (d. 1535–36). Two
extant examples carry credible attributions
to Bizhad, and more are either ascribed to
him or signed by other artists, such as Murad
or Shah Muhammad Isfahani.[3] Judging by
the number of imitative responses, the re-
cumbent lioness was one of Bihzad's most
appreciated artworks, whose resonance
endured into the seventeenth century.[4]

DJR

1 See, in this volume, David Roxburgh's essay
 "Beyond Books: The Art and Practice of the
 Single-Page Drawing in Safavid Iran," 135–45.

2 See Martin 1912, vol. 2, pl. 86; Roxburgh 2000,
 131–36 and accompanying notes.

3 One example bearing an attribution to Bihzad
 is in an album assembled by Dust Muhammad
 in 1544–45 for Safavid prince Bahram Mirza:
 see Roxburgh 2000, 134, fig. 9; the other is
 reproduced in Martin 1912, vol. 2, pl. 86. For the
 other examples, see Roxburgh 2000, 131–36.

4 See B. W. Robinson 1992, 286, cat. 263.

119

Courtiers with a Horse and Attendant
Folio from an album
Iran, probably Tabriz, Safavid period,
second quarter 16th century
Ink and opaque watercolor on paper
Folio: 33.2 × 20.5 cm (13¹⁄₁₆ × 8¹⁄₁₀ in.)
2002.50.144

Might it be possible to talk of a pastoral pictorial genre—defined through subject and theme—in the tradition of Persianate drawing? This drawing is one of several examples that take members of the Safavid court into the country, here a landscape divided into two parts by the meandering profile of a craggy brown rock. Emphasized by its deep blue color, a pool of water, or perhaps a mountain brook, is set near the center of the composition; behind it is a smaller rock, tinted pale blue as if cooled by the adjacent water. Two trees, one with birds perched in its branches, grow from the main rock; they are defined by delicate line drawing in black ink, augmented by the selective use of gray and red washes. Two men flank the pool: one, with a youthful, trim physique, can be identified as a Safavid prince or ruler. Facing him is an older, bearded, heavy-set man—most likely a guardian and instructor (*lālā*)—who, unlike the royal figure, has a sword and dagger attached to his belt. In their hands, the prince and guardian hold thin objects, depicted with attenuated, taut lines and at

first sight suggesting walking sticks or canes. But these objects extend into the water.

Although scenes of game hunting with sword, spear, and bow-and-arrow abound in Persianate paintings and drawings, and although references to this sport dominate the written sources, fishing was also practiced and enjoyed by the Safavid elite.[1] The historian Khvandamir mentions the youthful predilection for fishing of Shah Ismaʿil (r. 1501–24) and identifies the River Talvar—near Maragha and the meadows of Surluq—as a preferred site.[2] The Venetian envoy Michele Membré recounts the details of a fishing excursion by Shah Ismaʿil's son and successor, Shah Tahmasp (r. 1524–76), to the "pools of sweet water" in the mountains near Maragha. Membré describes Tahmasp's attire, fishing tackle (thin canes with hooks), and how the catch of the day was collected and divided;[3] the ruler seems to have spent the entire month of October 1539 in this pursuit. Tahmasp himself also mentions fishing, which he terms "fish-hunting" (*shikār-i māhī*), in his memoirs.[4]

Another figure in the composition is an attendant who stands to the right of the prince, at a lower elevation reflective of his lesser status. He carries two objects: a bag suspended on a cord, useful for holding fish, and a second object with a handle, perhaps used to stun and kill them. The foreground

scene, fully half the composition, is given over to the prince's horse and groom. As in other passages of the drawing, a minute black ink line delineates the forms, while other colors of ink—here red and blue—are used sparingly to highlight components of the horse's tack and caparison and the kerchief knotted around the groom's belt.

In its pastoral theme, technique of execution, and figural components (especially the groom, guardian, and horse), this drawing may be productively compared to *An Incident at the Court*, a drawing often identified as depicting the young Tahmasp, who has climbed into a tree and is being urged to leave it by a host of figures.[5]

DJR

1 Images of fishing are rare but are also found in Safavid textiles. See a satin lampas published in Bier 1987, cat. 24.

2 Khvāndamīr 1954, 3:559, 569. See, in this volume, David Roxburg's essay, "Beyond Books: The Art and Practice of the Single-Page Drawing in Safavid Iran," 135–45, specifically 138, fig. 4.

3 Membré 1993, 25 and 27–28. Membré emphasizes Shah Tahmasp's preference for fishing over hunting with birds and dogs.

4 The roles under Shah Tahmasp of the hunt and of fishing are discussed in Soudavar 1999, 52.

5 Musée du Louvre, Paris, OA 7124: see Bahari 1996, 216–17; Melikian-Chirvani 2007, cat. 93.

120

Attributed to Mirza 'Ali
Two Eminences Observed
Folio from an album
Iran, Safavid period, c. 1535–40
Ink on paper
Folio: 29 × 18.9 cm (11⁷⁄₁₆ × 7⁷⁄₁₆ in.)
2002.50.15

Published: S. C. Welch 2000, 322, fig. 1.

This self-assured drawing depicts a detailed landscape occupied by three figures: an old man and a princely figure facing each other at the center, and a youth watching them from behind a low hillock. The older figure—a man of learning and possibly an advisor—adopts a deferential pose, with his turbaned head tilted forward and down and his hands withdrawn into the long sleeves of his robe as a sign of respect. The princely man, who, as his beard indicates, has reached maturity, looks directly at his companion and gestures with both arms. His turban is elegantly wrapped, the cloth gathered in artful folds around a Safavid baton (*tāj-i Ḥaydarī*); he wears a ring on his left hand, carries a small bound book tucked inside his shirt, and holds a rounded object—a cushion, book, or container—between his arm and torso. The visual language of the poses suggests that he is inviting the older man to converse.

The landscape conjures a hospitable setting for this subtle human interaction. The tree around which the two figures stand offers shelter to songbirds; from its roots flow a branching rivulet edged with rocks and flowering plants. Above the high horizon, the sky is full of clouds.

The artist, who has been identified as Mirza ʿAli,[1] has carefully modulated his use of line—whether uniform or varying in thickness—throughout the drawing. The hierarchy of thick and thin is logical: the figures and landscape elements are positioned in their respective spaces by firm delineation, while their individuality is defined by thinner lines or occasional washes that supply the details.

An attribution at the lower edge of the drawing could be read as the name Manuchihr.

DJR

1 By Stuart Cary Welch: see S.C. Welch 2000. Mirza ʿAli was the son of Sultan Muhammad, one of the most important artists working for Safavid patrons in the formative period of Safavid art. For an expanded discussion by Welch of his reasoning in attributing manuscript paintings and other works on paper to Mirza ʿAli, see Dickson and S.C. Welch 1981a, 1:129–51. Further discussion of Mirza ʿAli is available in Soudavar 1992, 164, 167, and 170–72.

121

Old Man with a Cane in a Rocky Landscape
Folio from an album
Recto: drawing and calligraphy
Verso: calligraphy
Iran, Safavid period, late 16th century
Ink on paper
Folio: 31.5 × 20.2 cm (12⅜ × 7¹⁵⁄₁₆ in.)
2002.50.16

Set between lines of Persian poetry in black *nastaʿlīq*, the drawing on the recto of this album folio is framed by multiple rulings and a stenciled margin of exuberant lotus palmettes, rosettes, and curled leaves drawn in gold, the spaces between them tinted with a fine spray of crimson pigment. The drawing itself, executed in black ink using line and wash, depicts an elderly man traversing a landscape of rocky outcroppings, scattered boulders, and plants. Hunched forward, he uses a cane to prop himself up and navigate the uneven terrain. The draftsmanship is accomplished overall, but the rendering of the old man's expressive facial features and the detail of his ear pressed under the weight of a fat turban are especially fine.

An inscription at the bottom reads, *ʿamal-i kamīna Riżā-yi ʿAbbāsī* (work of/done by the humble Riza ʿAbbasi). Because the vast majority of Riza's signatures begin with *raqm* or *raqam* (design) or *mashaqahu* (drew it), this inscription is likely to be an

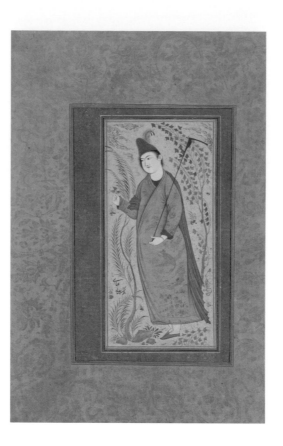

122

Aqa Riza (Riza 'Abbasi)
Young Dervish
Folio from an album
Iran, Safavid period, c. 1630
Ink, opaque watercolor, and gold on paper
Folio: 32.3 × 20.4 cm (12¹¹⁄₁₆ × 8¹⁄₁₆ in.)
2002.50.19

Published: Sotheby's 1976, lot 30; Soudavar 1992,
263, fig. 43; McWilliams 2002a, 13, fig. 6A;
Harvard University Art Museums 2003, 20;
McWilliams 2004, 7, fig. 9; Tan 2010, 13–14.

A youthful dervish, his clothing rendered in
uniformly dark hues of cool green, purple,
and brown that contrast with the warm
pink of his face and hands, is posed against
a ground of ivory-colored paper, unpainted
save for a common repertoire of golden
landscape elements. He wears a plumed
wool cap, carries a staff over his shoulder,
and offers a sprig of yellow, red, and gray
leaves to a companion beyond the picture
frame.[1] An inscription that reads, *raqm/
raqam-i kamīna Riżā-yi 'Abbāsī* (work of the
humble Riza 'Abbasi)—the customary word-
ing of the artist's signed works—appears at
the lower left. Although *raqm* or *raqam* ordi-
narily means "writing" or "figuring," here it
makes more sense translated as "work" or
"design." Riza's frequent use of this term in
his signatures suggests a conceptual blur-
ring of the boundaries between the arts of

attribution. Moreover, the manner in
which it is written differs from authentic
specimens of Riza's handwriting. While
certain details of the drawing might mimic
Riza's work, it is not by him, nor does it
directly copy one of his known studies.
The intent of the attribution is difficult to
judge: it could be an approving assertion
that this work is equivalent in quality to
works by Riza or, alternatively, a knowingly
false claim of Riza's direct authorship.

The verso of the album folio features a
calligraphic specimen mounted within a
blue border decorated with gold palmettes,
rosettes, and leaves. The calligraphy, copied
in black *nasta'līq* on brown paper, consists
of two couplets of Persian poetry and is
signed by Khalil Allah. A line of minute
script between the couplets notes that the
"writing occurred" (*taḥrīr yāft*) in the "abode
of the sultanate Herat" (*bi-dār al-sulṭāna
Harāt*).

DJR

writing and of depicting and, in addition,
may represent a claim of entitlement to the
high status accorded to calligraphers.

DJR

1 For comparative materials, see Soudavar 1992,
 263, figs. 42, 44; 292, cat. 118.

123

Young Woman Offering a Cup
Folio from an album
Iran, Safavid period, early 17th century
Ink on paper
Folio: 26.4 × 16 cm (10⅜ × 6⁵⁄₁₆ in.)
2002.50.17

The drawing depicts a solitary woman offering a cup to someone outside the picture frame; other vessels for holding liquids are shown at her feet. The woman's facial features, which include rounded cheeks, arched eyebrows, and a beauty spot, accord with contemporary standards of female comeliness. She is outfitted in elegant clothes, which emphasize her broad hips and slim torso, and a graceful headdress decorated with feathers. Wisps of curly hair frame her face and blow in the wind. The long, tapered strokes that delineate the profile of her hips and right shoulder seem to vibrate; the horizontal undulation of her hair indicates movement; and the staccato lines used to define the fluttering fabric of her skirt and the clouds in the sky above further increase the sense of animation. The drawing, which in several details reflects the style of Riza 'Abbasi (see cat. 122), has been attributed to Habib Allah Savaji, an artist who was invited to work for the future ruler Shah 'Abbas (r. 1587–1629) in Herat and then Isfahan. Habib Allah's oeuvre includes

drawings, single-page paintings, and manuscript illustrations.[1]

Framing the drawing is a decorated border, drawn in gold on ivory paper. Layers of pink wash have been applied to the figures, which include Chinese phoenixes and qilins assimilated into Persianate art since the early 1400s, a vase with flowers, and landscape and floral elements. A series of colored ruled lines separates drawing from border.

DJR

———

1 For a discussion of the oeuvre and career of Habib Allah Savaji, see Schmitz 2002; Swietochowski 2000, 283–99.

124

Lovers Embracing
Iran, probably Isfahan, Safavid period, c. 1650
Ink, opaque watercolor, and gold on paper
Folio: 33.5 × 22 cm (13³⁄₁₆ × 8¹¹⁄₁₆ in.)
2002.50.23

To make this drawing, the artist used three colors of ink: black and red for the figures, and gold for the wispy, swaying trees and flowering plants of the outdoor setting. Gold also highlights robe lapels and buttons, trouser hems, turban trim, and the accoutrements of wine drinking—a small cup and a tall-necked ewer. The lining of the woman's robe is filled in with blue; used together with white, this pigment defines the bowl behind the ewer as a blue-and-white ceramic (likely Iranian-made imitation porcelain).

The primary subject of the drawing is one of intimate, private bliss: a man lovingly embraces a woman, hugging her around the waist and lifting her from the ground, while she in turn snatches the turban from his head and carelessly upends her wine cup.

Despite its individualized charm, this depiction of a loving couple represents a fairly common type.[1] It shares with other drawings of the period, also classifiable by their human subjects,[2] key elements of artistic execution—sinuous, carefully weighted

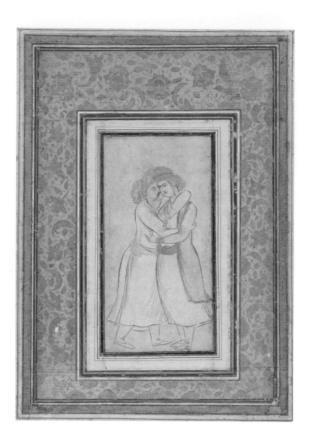

contour outlines, "check marks" terminating knotted and bunched textiles, and fine stippling applied only to faces and hair—each element showing the artist's fluency in a particular drafting technique.

DJR

1 See, for example, Farhad 1987, cats. 10, 24.

2 For instance, standing, sitting, or reclining single figures, male (cats. 121, 122) or female (cat. 123); paired men in conversation (cats. 119, 120) or amorous embrace (cat. 125); grooms with horses (cat. 119).

125

Two Men Embracing
Folio from an album
Iran, Safavid period, 17th century
Ink and watercolor on paper
Folio: 22.8 × 16.1 cm (9 × 6⁵⁄₁₆ in.)
2002.50.8

This drawing depicts two men in affectionate and intimate embrace. Differences in their age and stature are conveyed principally through hair: the older man has an impressive mustache, whereas the younger man's face is bare, and a boyish ringlet falls from his turban. Both men wear relatively simple robes cinched at the waist with wide sashes; their turbans are large, with complicated pleating and draping. Some passages of the drawing are tinted in pale washes of yellow, green, and white watercolor to set them off from the background of the ivory paper sheet.

Surrounding the drawing is a complex border consisting of ruled lines of gold and other colors, a band of yellow paper, and an outer margin dominated by a floral pattern executed in two tones of gold over a pinkish-yellow ground.

The theme of male affection occurs in many single-sheet studies from the Safavid period.[1]

DJR

1 A good comparative example is in the Freer and Sackler Gallery, Smithsonian Institution, Washington, DC (F1954.28).

126

Portrait of a Youth
Folio from an album
Iran, Qajar period, mid-19th century
Opaque watercolor on paper
Folio: 23.8 × 14.2 cm (9⅜ × 5⁹⁄₁₆ in.)
2002.50.9

Published: McWilliams 2002a, 16, fig. 12.

The composition of this portrait study was first outlined in pencil and then blocked out with fields of watercolor, as is evidenced in the sitter's chair. Next, the artist added opaque watercolor in layers, using fine lines and stippling to replicate the designs and textures of fabrics, most prominently those of the young man's patterned coat and its gray fur trim. In contrast to his brightly colored clothing, his face is generally pallid, but blues beneath his chin and mouth suggest the hint of a beard. The play on near monochrome is continued in the silhouetted, inky locks that frame his face and give way to a tall black hat. The subject's position in the composition and aspects of painterly execution such as the modeling of his face and hands suggest that the image was based at least in part on a photograph, a practice common among Qajar artists from the mid-nineteenth century onward, photography having been introduced in Iran in the 1840s.

The painting reflects the "new realism" introduced by Abu'l-Hasan Ghaffari, also known as Sani' al-Mulk, in the middle years of the nineteenth century, during the reign of Nasir al-Din Shah (r. 1848–96), and disseminated by his contemporaries. Ghaffari's work combined physiognomic likeness with the psychology of the subject to produce an often intense pictorial effect—a "real" presence—undiminished by rich decorative details, which in some artists' hands might emphasize surface at the expense of illusionistic volume and depth.[1] Although this portrait lacks the overall impact of a work by Ghaffari, it demonstrates its painter's participation in what was new at the time.

On the lower right side of the sheet, a barely visible inscription, which reads, *taṣvīr-i dukhtar-i Shāhrukh* (depiction [by] the daughter of Shahrukh), is tantalizing because it suggests a female artist. Unfortunately, however, this notation is too perfunctory and too uncertain in date to permit further conclusions.

DJR

1 See Raby 1999, 56 and cats. 119–21. For other comparative materials, see Diba 1998, cats. 74, 78, 79, 80, 88.

127

Courtier with Attendants in a Garden
Folio from an album
Central Asia, Shaybanid period,
first half 16th century
Black ink, opaque watercolor, gold,
and silver on paper, with underdrawing
in red ink
Folio: 33.2 × 21.1 cm (13¹⁄₁₆ × 8⁵⁄₁₆ in.)
2002.50.22

This painting depicts three youths in a garden. The aristocratic central figure, wearing an ornamented robe and holding a wine cup, leans against a blossoming tree. One of his attendants, kneeling on the left, offers him flowers and a golden tray, while the other carries his quiver of arrows. The languid and lyrical scene is rendered with delicate brushwork and sensitivity to detail evident in the figures' communicative gestures and gazes and in the variety of naturalistic flowering plants. A long-necked ceramic vase on a golden stand bears traces of an inscription added at a later time and now illegible.

The setting of this painting, with its patterned wall, flowering tree, meandering stream, and blooming ground plants, is typical of garden scenes produced in Uzbek ateliers. The young men's facial features and squat turbans further support a Shaybanid Central Asian attribution.

128

The painting is currently mounted as an album page. Examined under a microscope, its paper support is shown to be very thin and to have many creases and cracks, possibly because the folio on which the painting was executed was removed from its original context and split into two sheets. At the upper right is a reversed seal-impression, transferred from a facing album page.

MMN

A Nath Yogi with Two White Dogs
Folio from the Salim Album
India, Mughal period, c. 1600
Black ink and opaque watercolor on beige paper, with underdrawing in black ink
Folio: 23.3 × 15 cm (9 3/16 × 5 7/8 in.)
2002.50.29

Published: Sotheby's 1967, lot 121.

The man represented here has attributes of a Nath yogi.[1] As is customary for members of this group, he wears large, round earrings,[2] a black sacred thread (*janeo*) with a small horn pendant, and a coral- or salmon-colored robe. His face and hands are covered with ashes, and he possesses a begging bowl and a crutch (*acal*) for supporting his chin or arm during meditation.[3] Accompanied by two white dogs, he is shown sitting in an outdoor landscape, hugging his legs and looking at one of the animals. The dogs frolic around him, their playfulness enlivening the otherwise meditative composition.

The painting is executed with extremely delicate brushwork (best seen under magnification) that conveys the artist's visual sensitivity: textures and facial features are rendered with fine lines and subtle hues, and minute details are articulated with great precision.

This page was part of a now-dispersed album of painting and calligraphy. Known as the Salim Album, it was made for Prince Salim, the future Mughal emperor Jahangir (r. 1605–27), at a time when he was in rebellion against his father, Akbar (r. 1556–1605).[4] Several paintings from the album illustrate non-Islamic religious subjects that were of interest to both Akbar and Jahangir;[5] some also represent known figures at the Mughal court.[6] The particular features of this yogi— his round face, full cheeks, small nose, thin lips, and slanted eyes—may be seen as an attempt to render him in a personalized manner even if the artist was not intending to portray a specific individual.

The painting is bordered above and below by couplets of Persian poetry that refer to the poet-lover who, separated from his beloved, has become an ascetic.[7] A similarly composed page depicting a Nath yogi with a single dog has also been identified as having belonged to the Salim Album.[8] Considering their related subject matter, composition, setting, and poetic inscriptions, one can surmise that the two pages faced each other in the album.[9]

MMN

129

Equestrian Portrait of Raja Karan Singh of Bikaner
Folio from an album
India, Rajasthan, Bikaner,
second half 17th century
Black ink on beige paper
Folio: 26 × 19 cm (10¼ × 7½ in.)
2002.50.39

This fragmentary drawing portrays Raja Karan Singh of Bikaner (r. 1631–69) on horseback.[1] Shown in profile, the ruler wears an elaborate turban and gem-studded jewelry. Detailed brushwork and shading give a sense of volume to the bodies of horse and rider; the animal's galloping stance and the flying bands of the raja's clothing create the impression of lively motion. Because Raja Karan Singh was alternately an ally and a foe of Mughal emperor Aurangzeb (r. 1658–1707), this portrait, like other art produced in Bikaner during his reign, merges local artistic traditions with Mughal idioms, reflecting both the self-identity of the house of Bikaner and its complex relations with the Mughals.

MMN

1 The order of yogis is called Nath Sampradaya, or sometimes Kanphata (split-eared) or Gorakhnath: see White 1996, 7-9.

2 Such earrings identify members of the Nath order. During the initiation ceremony, the master, or guru, cuts the initiate's earlobes; the large earrings are inserted later. Briggs 1973, 1-2, 6-7.

3 Ibid., 11-12.

4 During this period Prince Salim established himself at Allahabad: see Wright 2008, 55, 64, 270. Two other paintings from this album are in the collection of the Harvard Art Museums/Arthur M. Sackler Museum: *Woman Applying Kohl*, 2009.202.251, and *Muslim Nobleman in White*, 2009.202.254.

5 Wright 2008, 58-59.

6 Ibid.

7 See, in this catalogue, Sunil Sharma's essay, "The Sati and the Yogi: Safavid and Mughal Imperial Self-Representation in Two Album Pages," 147-55.

8 Ibid., fig 5. This album page is now housed in the Chester Beatty Library, Dublin (CBL In 44.3): see Wright 2008, cat. 29, 270-71. Linda Leach (in Chester Beatty Library and Leach 1995, 1:303-4) notes the existence of another yogi painting from the same album, which is the one catalogued here (cat. 128). See also Wright 2008, 55, 64, and 456, no. 9.

9 Elaine Wright, however, entertains the possibility that the Salim Album was never bound but consisted of separate folios: Wright 2008, 58.

1 Compare, also from the Harvard Art Museums/Arthur M. Sackler Museum collection, *A Portrait of Raja Karan Singh of Bikaner Holding a Sword* (2011.95).

130

Woman Committing Sati
Folio from an album
Iran, Safavid period, second half 17th century
Black ink, opaque watercolor, gold, and
silver on paper with underdrawing in
black ink
Folio: 32 × 20.7 cm (12⅝ × 8⅛ in.)
2002.50.7

This painting dramatically represents
a young woman about to commit sati, or
self-immolation. The literary subject of a
woman's sacrificing herself on the funeral
pyre of her dead husband was popularized
in seventeenth-century Iran through the
poet Naw'i Khabushani's narrative *Sūz u
Gudāz* (Burning and Melting).[1] Set in India,
the poem tells of a Hindu bride who vows
to cast herself on her bridegroom's pyre and
will not be dissuaded, even by the Mughal
emperor himself.[2]

In many ways, however, this painting does
not correspond to Naw'i's text: the inscrip-
tion beneath the painting is unrelated to the
poem,[3] the body of the bridegroom is miss-
ing from the pyre, key figures (such as the
Mughal prince who accompanies the bride
to the pyre) have been omitted, and the
bride's disrobing is uncalled for. Moreover,
examination under transmitted light reveals
no traces of text on the reverse side of the

folio, indicating that it was not part of a
manuscript.[4]

In this illustration the young woman kneels
next to a small pyre. She rends her gown in
grief, exposing her naked torso, and pulls
out locks of her hair, which she casts into
the fire. Two other women try to restrain
her; below them a man crouches, his turban
undone and his facial features contorted
with grief. Opposite the fire, an older man
sits hunched over, his eyes closed. At the
horizon is a group of male observers, the
one on the right wearing a European hat.
Dramatic clouds bracket a tree with leaves
similar to those found in early seventeenth-
century Mughal paintings.[5]

One may conclude that this painting, which
blends Persian and Indian elements with
European techniques of modeling and
shading and demonstrates knowledge of
and interest in the female body, was created
as a single-page work illustrating the exotic
topic of sati and eroticizing the foreign
(here Hindu) woman. This hybrid style is
characteristic of Safavid painting in the
second half of the seventeenth century.[6]

MMN

1 Farhad 2001, 122–23.

2 See Sharma 2007; see also, in this catalogue,
 Sharma's essay, "The Sati and the Yogi: Safavid
 and Mughal Imperial Self-Representation in
 Two Album Pages," 147–55.

3 The text reads, "I will seize the kingdoms of the
 West and the East." The text box is pasted onto
 the painted surface.

4 Transmitted light further reveals changes in the
 hand position of the bride and in the facial fea-
 tures of the woman behind her. Quickly sketched
 underdrawing is visible.

5 See, for example, Farrukh Beg's 1615 painting
 after *Dolor* of Cornelis de Vos, reproduced in
 S. C. Welch 1985, 221–22, cat. 147a.

6 Farhad 2001, 122–23.

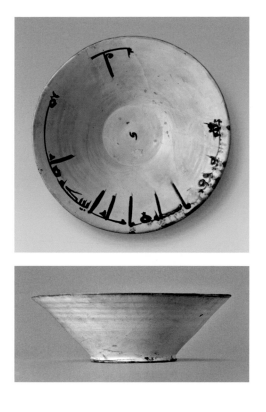

131

Fragmentary bowl with inscription
Eastern Iran or Central Asia,
Samanid period, 10th century[1]
Reddish earthenware covered in white slip
and painted with black (manganese and iron)
under clear lead glaze
11.4 × 32.8 cm (4½ × 12¹⁵⁄₁₆ in.)
2002.50.61

The inscription painted around the rim
of this fragmentary bowl has thus far defied
reading. It is possible that the many sherds
from which the bowl was reconstructed
before Norma Jean Calderwood purchased
it were positioned incorrectly. During its
subsequent cleaning and reassembly, several
"alien" sherds were removed and retained
for study.[2] In a few areas, the brownish-black
slip has run slightly in the glaze towards
the center of the bowl, which is decorated
with a small revolving motif resembling
the modern symbol for a hurricane. Except
for the beveled base, which is only partially
covered, the reddish ceramic fabric is envel-
oped in white slip under a clear glaze.

MMcW

1 The bowl was last fired between 700 and
 1200 years ago, according to the results of
 thermoluminescence analysis carried out by
 Oxford Authentication Ltd. in 2002.

2 See, in this volume, the discussion of recon-
 structing ceramic vessels from unrelated sherds
 in Anthony B. Sigel's essay, "History in Pieces:
 Conservation Issues in Islamic Ceramics,"
 37–49.

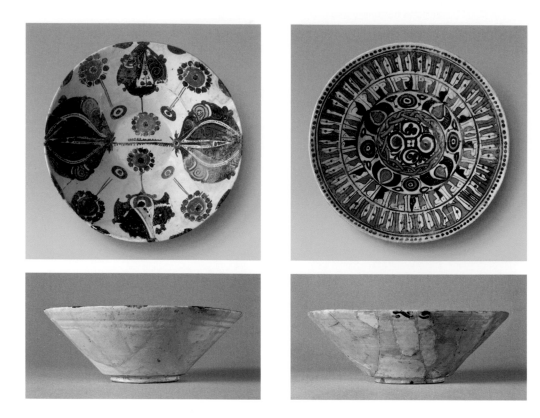

132

Bowl with palmettes and rosettes
Eastern Iran or Central Asia, 10th–11th century
Reddish earthenware covered in
whitish slip and painted in red (iron),
black (manganese and iron), and
green (chromium) under clear lead glaze
9.6 × 27.3 cm (3¾ × 10¾ in.)
2002.50.46

In profile, this bowl has straight, flaring
sides and a low foot ring. The reddish
ceramic fabric is completely covered in
whitish slip, and the decoration is painted in
red, purplish black, and olive green. Except
for the inner surface of the foot ring, the
vessel is covered in a clear glaze, sections
of which have turned iridescent. The bowl
has been reassembled from numerous
fragments, most of which appear to belong
to a single vessel; in the two areas decorated
with small palmettes, however, alien frag-
ments have been introduced. Overpainting
that formerly disguised the joins between
unrelated fragments has been removed.

MMcW

133

*Bowl with concentric bands of inscriptions,
palmettes, and braided strapwork*
Uzbekistan, Samarkand, 10th–11th century
Reddish earthenware covered in
white slip and painted with red (iron),
black (manganese and iron), and green
(chromium) under clear lead glaze
11.7 × 34.4 cm (4⅝ × 13⁹⁄₁₆ in.)
2002.50.47

An accurate assessment of the state of this
bowl, "damaged but all original," appears in
a note in Calderwood's handwriting pasted
inside the foot ring. On the exterior, the
bowl has lost much of its glaze and slip-
painted decoration. Most of the present
interior decoration is overpainting, but
the remaining original surfaces provide evi-
dence that the restorer has reconstructed
the design with reasonable accuracy.[1] The
outermost inscription, in red, could be read
as *al-yumn* (felicity). At the center, a band
of braided strapwork encircles an elaborate
composite motif of a diamond-shaped
flower with four coiling arms that terminate
in red disks and black trefoils. The reddish
ceramic fabric was originally covered in a
whitish slip and decorated in red, purplish

black, and olive green. Straight, flaring walls
rise from a low foot ring, which is covered
in slip but unglazed.

MMcW

1 Compare, for example, the bowl illustrated
 in "Polychrome on White Ware," Group 4,
 nos. 19–22, in Wilkinson 1973, 151.

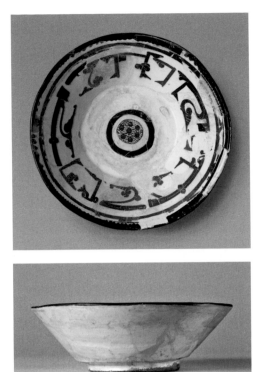

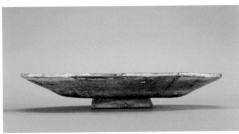

134

Fragmentary bowl
Modern assemblage from fragments
attributed to eastern Iran or Central Asia,
Samanid period, 10th century
Reddish earthenware covered in
white slip and painted with red (iron)
and black (manganese and iron)
under clear lead glaze
7.2 × 23.4 cm (2¹³⁄₁₆ × 9³⁄₁₆ in.)
2002.50.90

This bowl is a modern pastiche, pieced
together from fragments of eleven different
vessels, all probably dating to the Samanid
period.¹ The reconstruction has given the
bowl an uncharacteristically squat profile.
The inscription, recomposed from a hodge-
podge of fragments, is indecipherable.
Heavy overpainting that formerly disguised
the joins between unrelated fragments has
been removed.

MMcW

———

1 See, in this catalogue, the essay by Anthony B.
 Sigel, "History in Pieces: Conservation Issues
 in Islamic Ceramics," 37–49.

135

*Fragmentary bowl with seated figure
surrounded by inscriptions*
Modern assemblage from fragments
attributed to Iran, Kashan,
Seljuk-Atabeg period, 12th–13th century
Fritware painted with luster (copper and
silver) over white lead alkali glaze opacified
with tin
9.7 × 22.3 cm (3¹³⁄₁₆ × 8¾ in.)
2002.50.75

This bowl is an ingeniously constructed
pastiche that has been skillfully put together
from fragments of five different vessels.¹

MMcW

———

1 For further explication of the process, see,
 in this catalogue, the essay by Anthony B. Sigel,
 "History in Pieces: Conservation Issues in
 Islamic Ceramics," 37–49 and figs. 2–3.

136

Dish with horseman and arabesque
Probably Iran, 20th century¹
Reddish earthenware covered in white slip,
carved, and painted with green (copper),
yellow (iron), and dark brown (manganese)
under clear lead glaze (with zinc and barium)
4.4 × 28 cm (1¾ × 11 in.)
2002.50.62

Published: McWilliams 2003, 238, fig. 14.

The off-white slip that covers this dish
has been incised with a complicated design
further elaborated in green, yellow, and
purplish brown. An equestrian image fills
the center of the dish: a crowned horseman
wears a garment decorated with vertical
stripes and an overlying arabesque, and his
yellow horse is embellished with scribbled
lines. A vigorous arabesque fills the back-
ground behind horse and rider. Running
along the rim is an angular guilloche enclos-
ing crosshatched segments of alternating
yellow and green. Except for the base, the
dish is entirely covered with a white slip and
a clear glaze. It has been reassembled from
eight fragments, with no significant losses.

The horseman steals a glance backward—as
did the potter who made this dish. Although
dated to the twentieth century by thermo-
luminescence testing, the dish imitates a
type of sgraffito vessels traditionally known

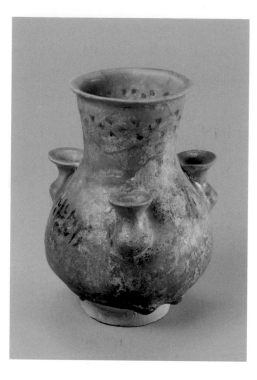

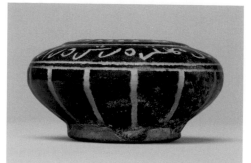

as Aghkand wares, which are said to have been found at Aghkand, in northwestern Iran, and usually assigned to the twelfth century. In 1938, an influential exponent of Persian art, Arthur Upham Pope, singled Aghkand wares out for praise, labeling them "more intellectual, more Persian, and ultimately more interesting" than any comparable ceramics of the period.[2]

MMcW

————

1 The dish was last fired within the past 100 years, according to results of thermoluminescence analysis carried out by Oxford Authentication Ltd. in 2002. Together with cats. 137–42, this vessel is placed in the Calderwood Study Collection because thermoluminescence analysis has indicated a last firing considerably later than the period to which it belongs stylistically.

2 A. U. Pope 1938–39, 2:1526. See also McWilliams 2003, 237–39.

137

Small multi-necked vase
Probably Iran, 20th century[1]
Pinkish fritware, pierced, under turquoise (copper) transparent alkali glaze with black overpaint
14.8 × 10.5 cm (5^{13}⁄$_{16}$ × 4¼ in.)
2002.50.113

Three miniature vases are attached to the pear-shaped body of this wide-mouthed vessel. The primary neck is elaborated by a band of triangular cutouts, which are filled with the turquoise glaze that covers the body of the vase and ends in thick drips just above the foot ring. Several aspects of the vase are atypical: it is unusually small, the mouths of the smaller vases are filled with glaze, and the ceramic fabric is uncommonly soft for fritware.[2]

MMcW

————

1 The vase was last fired within the past 100 years, according to the results of thermoluminescence analysis carried out by Oxford Authentication Ltd. in 2011.

2 See, for example, larger examples of this type in the Walters Art Museum, Baltimore (48.1278), and in the Khalili Collection, London (POT525): Grube 1994, 184–85, cat. 191.

138

Alms bowl
Probably Iran, modern period[1]
Fritware with design carved and incised through black (chromium) slip under turquoise (copper) transparent alkali glaze
5.9 × 11.2 cm (2^{5}⁄$_{16}$ × 4^{7}⁄$_{16}$ in.)
2002.50.86

Published: McWilliams 2003, 237–40, fig. 18.

This small bowl imitates so-called silhouette wares of the Seljuk-Atabeg period (twelfth to thirteenth century), on which black slip was applied directly to the white ceramic body and the pattern carved or incised through the slip before the vessel was covered in glaze (turquoise, as here, or colorless). Original bowls of this shape were purportedly used for collecting alms.[2]

Incised in cursive script on the upper part of this bowl are the words ʿizz (glory), iqbāl (good fortune), and mihtar (prince); the other words in the inscription do not make sense together.[3] On the lower body, carved lines separate the black slip into segments. The glaze has flowed heavily onto and under the foot, so that the vessel does not sit evenly.

AYY

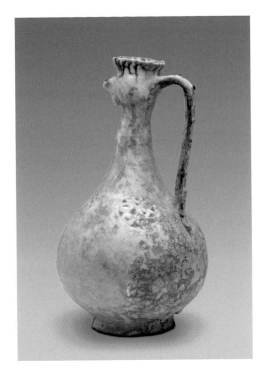

139

Pear-shaped ewer with rooster-head spout
Probably Iran, modern period[1]
Fritware incised, pierced, and painted with
blue (cobalt) under clear alkali glaze
26.6 × 14.6 cm (10½ × 5¾ in.)
2002.60.51

For millennia, humans have delighted in
transforming vessels through the addition
of animal heads or appendages. From
greater Iran, numerous examples similar
to this one, dated or datable to the twelfth
through the fourteenth century, have sur-
vived. Their precedents—silver ewers from
Sasanian Iran and high-fired ceramics
from the Tang and Song periods in China—
demonstrate the ongoing dialogue between
artists in western and eastern Asia. If the
thermoluminescence analysis for this ewer
is correct, then the dialogue likely continued
into the twentieth century.

Most of the known Iranian rooster-head
ewers use linear decoration, in luster or
underglaze painting, to articulate eye,
coxcomb, wattle, beak, and neck ring. In
contrast, the features of this bird are sug-
gested only sculpturally. The white body
of the ewer is embellished by three circular
medallions with incised and pierced inter-
lace motifs that remained watertight
because they were filled with glaze. The
once-clear glaze has degraded and become

iridescent across large areas, partially
obscuring the medallions and their pierced
openings. Enlivening the otherwise subtle
decoration, dabs of cobalt appear set like
cabochon sapphires along the handle and
run down from the coxcomb.

A ewer of similar shape in the Louvre[2] bears
an inscription around the base suggesting
that it was intended to hold wine. Put to this
use, the Calderwood ewer would have been
striking—the red liquid appearing dramati-
cally through its pierced medallions.

MMcW

1 This ewer was last fired less than 350 years ago,
 according to the results of thermoluminescence
 analysis carried out by Oxford Authentication
 Ltd. in 2012.

2 Musée du Louvre, Paris, MAO 442, reproduced
 and discussed in Bernus-Taylor and Musée du
 Louvre 1989, 277–78, cat. 211.

1 The bowl was last fired less than 350 years ago,
 according to the results of thermoluminescence
 analysis carried out by Oxford Authentication
 Ltd. in 2012. Dating analysis for fritware is com-
 plicated, because it is low fired and contains little
 natural radioactivity.

2 See McWilliams 2003, 239, for the use of the
 term "alms bowl" as proposed by A. U. Pope.

3 We are grateful to Wheeler M. Thackston for this
 reading and transliteration.

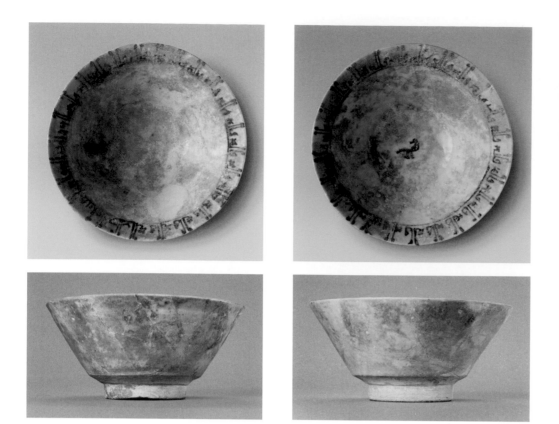

140, 141

Two bowls with inscribed rims
Probably Iran, 19th or 20th century[1]
Fritware painted in blue (cobalt) under
clear alkali glaze
8.4 × 19.3 cm (3⁵⁄₁₆ × 7⁵⁄₈ in.)
9.2 × 20.2 cm (3⁵⁄₈ × 7¹⁵⁄₁₆ in.)
2002.50.79; 2002.50.81

These two bowls are nearly identical in
shape and have on their rims the same
repeated words in stylized Kufic script—
perhaps interpretable as the Arabic *al-dawla*
(wealth). One bowl also has a small bird in
the center. Similarly shaped and decorated
bowls are attributed to late twelfth- or
thirteenth-century Iran;[2] although both
of these bowls are reassembled from many
fragments and show degradation of the
glaze, the results of thermoluminescence
analysis on one of them suggest that they
are both of relatively recent manufacture.

AYY

1 The bowl tested, 2002.50.81, was last fired less
 than 200 years ago, according to the results
 of thermoluminescence analysis carried out
 by Oxford Authentication Ltd. in 2011.

2 See, for instance, a bowl in the Khalili Collection,
 London, reproduced in Grube 1994, 200,
 cat. 216.

142

Small vase with stripes
Probably Iran, 19th or 20th century[1]
Fritware painted in blue (cobalt) under
clear alkali glaze
9.2 cm × 8.4cm (3⁵⁄₈ × 3⁵⁄₁₆ in.)
2002.50.77

This small vase is decorated with vertical
cobalt-blue stripes under a transparent glaze
that ends above the foot. Probably due to
an accident in the kiln, part of another vessel
is attached to the vase at its widest point.
To judge from the many surviving blue-
striped vessels in a range of shapes, this
form of decoration was highly popular on
early thirteenth-century Iranian ceramics.[2]
Its appearance on this vase suggests a
deliberate revival.

AYY

1 The vase was last fired less than 200 years ago,
 according to the results of thermoluminescence
 analysis carried out by Oxford Authentication
 Ltd. in 2011.

2 See, for instance, Cort et al. 2000, 82; Grube
 1994, 201.

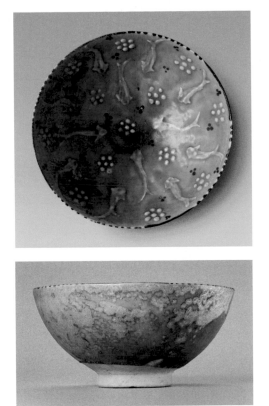

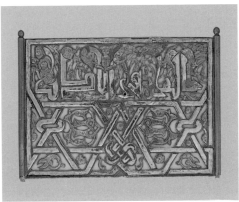

143

Bowl with relief decoration of fish and flowers
Probably Iran, 20th century[1]
Pinkish fritware with beaded and trailed
slip relief, painted with black (chromite)
under turquoise (copper) transparent
alkali glaze
9.2 × 19.9 cm (3⅝ × 7¹³⁄₁₆ in.)
2002.50.105

Acquired as a fourteenth-century example
of East Asian influence on Persian ceramics,
this bowl in fact echoes Yuan-dynasty cela-
don dishes with molded fish decoration
from a far greater distance in time. The
irregularly formed relief motifs—fish and
rosettes—appear to have been built up with
beaded and trailed slip. In finer examples
of this design, the bodies of the fish curve
to create a swirling movement; here the
motifs are positioned along radii, yielding
a static effect.

With the exception of two chips at the foot
and a blind crack in the base, the bowl is
intact. Turquoise glaze covers the body of
the vessel, stopping well short of the low
foot ring; iridescence clouds the glaze along
the wall on both interior and exterior.

MMcW

1 The bowl was last fired within the past 100 years,
 according to the results of thermoluminescence
 analysis carried out by Oxford Authentication
 Ltd. in 2004.

144

Openwork panel with inscription
Possibly Iran, combining elements from
earlier and modern eras
Sheet-worked brass, with inlay and overlay
in silver and copper
11 × 14.5 cm (4⁵⁄₁₆ × 5¹¹⁄₁₆ in.)
2002.50.120

This curious object has so far defied identi-
fication. A small rectangular sheet of brass
was pierced to produce an intricate open-
work design, and brass rods topped by
round finials were soldered to the sides.
The front face was then inlaid with silver
and copper (both 99 percent pure). Bold
strapwork divides the design into three
horizontal registers. The upper and largest
zone carries a Kufic pseudo-inscription set
against a foliate scroll. The letters are ani-
mated with two bust-length human figures
and a variety of animals and animal heads.[1]
In the two lower registers, the strapwork is
interlaced in nearly symmetrical fashion,
creating geometric interstices that are filled
with leaves, rosettes, and round bosses.

In accord with traditional metalworking
technique, the brass sheet was incised and
textured to receive the copper inlay, as can
be seen where this inlay is missing. The
attachment of the silver, however, is unusual
and may reflect modern restoration: it
appears to have been positioned in parallel

strips (usually three) and hammered to make it adhere to the underlying sheet. Both silver and copper inlays are partly decorated with fine incised lines and punch marks.

MMcW

1 Animated inscriptions, in both Kufic and cursive scripts, enjoyed a vogue on inlaid metalwork made in Iran, Syria, and Iraq during the twelfth and thirteenth centuries. See, for instance, Baer 1983, 200–207.

145

Qurʾan or amulet box
Possibly North Africa, 19th or 20th century
Approximately 20 sheets of brass, steel, and nickel silver joined with gray lead-tin solder
16 × 18.2 × 2.4 cm (6⁵⁄₁₆ × 7³⁄₁₆ × ¹⁵⁄₁₆ in.)
2002.50.121

Small boxes like this one were used to hold small Qurʾans, prayer manuals, or talismanic texts, which were written on long sheets of paper and folded repeatedly or rolled to fit the confines of their containers. The front of the box is decorated with a non-monetary coin surrounded by stylized vine-and-leaf motifs in relief. The coin features a six-pointed star popularly known as the Seal of Solomon, which—since Solomon was believed to have authority over supernatural powers—often adorns talismanic objects and texts. An arched lid closes the box; cords passed through its two handles would have allowed it to be suspended, providing protection to a place or a person.

AYY

Cats. 146–50

Five ornaments in the shape of Karagöz shadow puppets
Probably Turkey, Istanbul, 20th century
Painted leather
2002.50.169–73

Shadow plays were first performed in the Ottoman Empire during the sixteenth century, with the popular form known as Karagöz (Black Eye) developing in the 1600s. These plays were put on mainly in the evenings during Ramadan, the month of fasting, as popular entertainment. Although Karagöz theater was essentially comedic, political satire was an important component; the stories and characters represented a broad cross-section of Ottoman culture in Istanbul. The popularity of shadow plays declined in the twentieth century with the advent of cinema, radio, and television.

A single puppeteer assisted by one or two apprentices performed the Karagöz shadow play, moving the puppets behind a screen of white cloth. When the puppeteer pressed the painted, translucent-leather figures to the screen, oil lamps or candles behind them would cast their colorful shadows. The puppets were usually made in three parts—head, body, and feet—and joined together with pieces of gut threaded through holes. The single or double horizontal rods by which

they were moved were attached to reinforced socket-like holes in their necks or upper bodies. While performing, the puppeteer, behind the cloth screen, could hear but not see his audience. He would be the voice of each figure regardless of its age, gender, or regional accent and would sing, recite poetry, and improvise all the lines, since there was no written script.[1]

The five figures catalogued here represent major characters in the Karagöz stories. They are considered ornamental replicas, because they lack the holes necessary for the attachment of the puppeteer's rods, have no moving parts, and are appreciably smaller than authentic puppets, which range in height from twenty-five to thirty-five centimeters.

AYY

1 And 1975, 40–70; Tietze 1977.

146

Karagöz
14.7 × 8.7 cm (5¹³⁄₁₆ × 3⁷⁄₁₆ in.)
2002.50.172

Karagöz (Black Eye) is the main character, lending his name to the play itself. He is a bold personality, depicted with a large black eye, a curly black beard, and, often, a large turban. He represents a man of the people, who is usually unemployed and embarking on doomed moneymaking ventures. He is illiterate but witty, nosy, tactless, often deceitful, and inclined to bawdy talk.

AYY

147

Hacivat
14 × 6.8 cm (5½ × 2¹¹⁄₁₆ in.)
2002.50.171

Hacivat acts as the foil for Karagöz. With a pointed, turned-up beard, he represents a learned man who uses Arabic and Persian prose and professes encyclopedic knowledge of music, spices, gardening, and etiquette, although his erudition is regularly proven to be superficial. His reasoning limits his actions, often leading a frustrated Karagöz to beat him with an oversized arm.

AYY

148

Zenne
14.7 × 6.4 cm (5¹³⁄₁₆ × 2½ in.)
2002.50.169

Zenne, who is characteristically engaged in gossip, is a stock female character from Karagöz's neighborhood. Holding a bouquet of flowers, she is dressed in her household attire of short vest and baggy pants.

AYY

149

Bebe Ruhi
14.1 × 7.2 cm (5 ⁹⁄₁₆ × 2¹³⁄₁₆ in.)
2002.50.170

Bebe Ruhi is an eccentric dwarf, usually depicted as a hunchback with a comically long nose. Fidgety, talkative, and boastful, he has a speech impediment that causes him to pronounce *r* and *s* as *y*. He wears a clown hat, a coat, and long boots.

AYY

150

Laz
14.4 × 5.3 cm (5¹¹⁄₁₆ × 2¹⁄₁₆ in.)
2002.50.173

Laz represents a boatman, wool beater, or tinsmith from the Black Sea coast of Anatolia. He talks too much and too fast, and his speech is strongly accented. He wears local headgear and attire, including tight pants that bulge in the back. He plays the *kemençe*, a small fiddle of the region, and often dances the *horon*, a native dance with sudden rapid movements befitting his tense character.

AYY

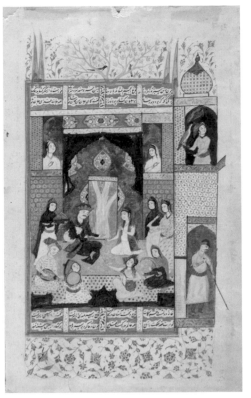

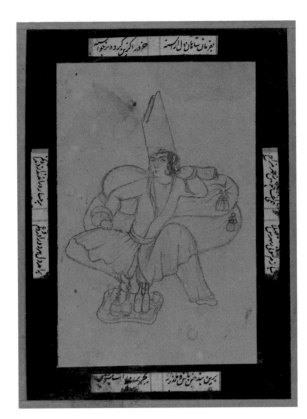

151

Bahram Gur in the Sandalwood Pavilion
Folio from a manuscript of the *Haft paykar*
by Nizami
Recto: text
Verso: text and illustration
Iran, Safavid period, early 17th century
Black ink, opaque watercolor, gold,
silver, and punch work on off-white
paper, with underdrawing in black ink
Folio: 26.2 × 16.1 cm (10�5/16 × 6�5/16 in.)
2002.50.18

This work illustrates the same episode as
cat. 111: Bahram Gur visiting the Chinese
princess Yaghme in her sandalwood pavil-
ion. Here, too, the king and his bride sit
together, served and entertained by female
attendants and musicians, and colors of
their clothing—gold and white—correspond
with those of the pavilion dome. Although
the figures are now larger in scale and their
hair and headdress styles somewhat differ-
ent, this painting, in comparison with the
earlier one, shows the iconographic conti-
nuity of Safavid-period illustrations of the
Haft paykar. Due to pigment deterioration,
the appearance of the painting is seriously
compromised.

MMN

152

Youth Seated against Cushions
Folio from an album
Iran, Qajar period, 19th century
Ink, black chalk, and graphite on paper
Folio: 27.4 × 20.2 cm (10¹³/16 × 7¹⁵/16 in.)
2002.50.139

This drawing depicts a young man in Qajar
attire leaning back against plump, tasseled
cushions; a tray laden with bottles, decant-
ers, and drinking cups is set at his feet.
These forms are delineated in ink on the
dark ivory paper, and additional definition
is provided by traces of black chalk and
by shading and line in graphite, probably
added with a pencil.

The principal contours of the design have
been pricked with a pin. Given the absence
of traces of pouncing chalk on the drawing
itself, it is likely that a transparent sheet of
paper was laid over it and that the pin was
used to make holes in the upper sheet, along
the design contours. The pricked sheet of
transparent paper was then laid on another
sheet of paper and a pounce bag full of
powdered chalk or charcoal tapped over it.
When the transparent sheet was removed,
particles of chalk or charcoal remained on
the paper beneath and served as a guide for
drawing the lines in a permanent medium,
thus accomplishing the transfer of the origi-
nal design.[1]

After serving its preliminary purpose, this
drawing was mounted on an album page
assembled from strips of colored papers
and fragments of Persian poetry.

DJR

1 The various techniques of pouncing are
 discussed in Roxburgh 2002b, 61-62.

Bibliography

Abdullaeva and Melville 2008
Firuza Abdullaeva and Charles Melville. *The Persian Book of Kings: Ibrahim Sultan's* Shahnama. Oxford: Bodleian Library, University of Oxford, 2008.

Adle 1993
Chahryar Adle. "Les artistes nommés Dust-Mohammad au XVIe siècle." *Studia Iranica* 22 (1993): 219–96.

Akimushkin and Ivanov 1979
Oleg F. Akimushkin and Anatol A. Ivanov. "The Art of Illumination." In Gray 1979a, 35–57.

AKPIA 2004
Aga Khan Program for Islamic Architecture. Brochure. Cambridge, MA: Aga Khan Program for Islamic Architecture, Mar. 2004.

Alam 1999
Muzaffar Alam. "The Pursuit of Persian: Language in Mughal Politics." *Modern Asian Studies* 32 (1999): 317–49.

Allan 1973
James Allan. "Abū'l-Qāsim's Treatise on Ceramics." *Iran* 11 (1973): 111–20.

Amanat 2006
Abbas Amanat. "Divided Patrimony, Tree of Royal Power, and Fruit of Vengeance: Political Paradigms and Iranian Self-Image in the Story of Faridun in the *Shahnama*." In Melville 2006, 49–70.

And 1975
Metin And. *Karagöz: Turkish Shadow Theatre.* Ankara: Dost, 1975.

Andrews 1962
R. W. Andrews. *Cobalt.* London: H. M. Stationery Office, 1962.

Anhegger-Eyüboğlu 1986
Mualla Anhegger-Eyüboğlu. *Topkapı Sarayı'nda Padişah Evi (Harem).* Istanbul: Sandoz Kültür, 1986.

Arberry 1974
A. J. Arberry. *Hāfiz: Fifty Poems.* Cambridge: Cambridge University Press, 1974.

Ashmolean Museum 1966
Ashmolean Museum, Department of Antiquities. *Exhibition of Ancient Persian Bronzes: Presented to the Department of Antiquities by James Bomford, Esquire, and Other Selected Items of Ancient Art from the Collection of Mrs. Brenda Bomford.* Oxford: Ashmolean Museum, 1966.

Aslanapa and Naumann 1969
Oktay Aslanapa and Rudolf Naumann, eds. *Forschungen zur Kunst Asiens: In Memoriam Kurt Erdmann.* Istanbul: İstanbul Üniversitesi Edebiyat Fakültesi, 1969.

Atasoy and Raby 1989
Nurhan Atasoy and Julian Raby. *Iznik: The Pottery of Ottoman Turkey.* London: Alexandria Press, 1989.

Atıl 1973
Esin Atıl. *Ceramics from the World of Islam.* Washington, DC: Freer Gallery of Art, Smithsonian Institution, 1973.

Atıl 1978
Esin Atıl. *The Brush of the Masters: Drawings from Iran and India.* Washington, DC: Freer Gallery of Art, Smithsonian Institution, 1978.

Atıl 1987
Esin Atıl. *The Age of Sultan Süleyman the Magnificent.* Washington, DC: National Gallery of Art; New York: Harry N. Abrams, Inc., 1987.

Azarpay and Zerneke 2002
Guitty Azarpay and Jeanette Zerneke. *A Sasanian Seal Collection in Context.* University of California, Berkeley: Electronic Cultural Atlas Initiative, May 2002, *http://escholarship.cdlib.org/ecai/sasanian/sasanian_intro.html.*

Babaie 1994
Sussan Babaie. "Shah 'Abbas II, the Conquest of Qandahar, the Chihil Sutun, and Its Wall Paintings." *Muqarnas* 11 (1994): 125–42.

Babaie 2001
Sussan Babaie. "The Sound of the Image, the Image of the Sound: Narrativity in Persian Art of the 17th Century." In Grabar and C. Robinson 2001, 143–62.

Babaie et al. 2004
Sussan Babaie, Kathryn Babayan, Ina Baghdiantz-McCabe, and Massumeh Farhad. *Slaves of the Shah: New Elites of Safavid Iran.* London and New York: I. B. Tauris, 2004.

Babayan 2002
Kathryn Babayan. *Mystics, Monarchs, and Messiahs: Cultural Landscapes of Early Modern Iran.* Cambridge, MA: Harvard University Press; London: Kegan Paul, 2002.

Baer 1983
Eva Baer. *Metalwork in Medieval Islamic Art.* Albany: State University of New York Press, 1983.

Bağcı 1995
Serpil Bağcı. "A New Theme of the Shirazi Frontispiece Miniatures: The *Dīvān* of Solomon." *Muqarnas* 12 (1995): 101–11.

Bahari 1996
Ebadollah Bahari. *Bihzad, Master of Persian Painting.* London and New York: I. B. Tauris, 1996.

Bahrami 1949
Mehdi Bahrami. *Gurgan Faïences*. Cairo: Le Scribe égyptien, 1949.

Bailey 1998
Gauvin A. Bailey. *The Jesuits and the Grand Mogul: Renaissance Art at the Imperial Court of India, 1580–1630*. Washington, DC: Freer Gallery of Art and Arthur M. Sackler Gallery, Smithsonian Institution, 1998.

Bain 1999
Alexandra Bain. "The Late Ottoman *En'am-ı şerif*: Sacred Text and Images in an Islamic Prayer Book." PhD diss., University of Victoria, 1999.

Bassett 2007
Jane Bassett. "Thermoluminescence Dating for European Sculpture: A Consumer's Guide." *American Institute for Conservation Objects Specialty Group Postprints* 14 (2007): 32–46.

Bayānī 1966–69
M. Bayānī. *Aḥvāl va āsār-i khushnivīsān*. 3 vols. Tehran: Dānishgāh-i Tihran, 1345–48 (1966–69).

Beazley 1966
Elizabeth Beazley. "The Pigeon Towers of Iṣfahān." *Iran* 4 (1966): 105–9.

Beck 2002
Roger Beck. "Mithraism." In *Encyclopaedia Iranica*, Online Edition, 20 July 2002, available at *http://www.iranicaonline.org/articles/mithraism*.

Behzad 1939
H. T. Behzad. "The Preparation of the Miniaturist's Materials." In A. U. Pope 1938–39, 3:1921–27.

Benjamin 1887
S. G. W. Benjamin. *Persia and the Persians*. Boston: Ticknor, 1887.

Bernheimer 2005
Teresa Bernheimer. "The Rise of *sayyids* and *sādāt*: The Āl Zubāra and Other 'Alids in Ninth-to Eleventh-Century Nishapur." *Studia Islamica* 101 (2005): 43–69.

Bernus-Taylor and Musée du Louvre 1989
Marthe Bernus-Taylor and Musée du Louvre. *Arabesques et jardins de paradis: Collections françaises d'art islamique*. Paris: Éditions de la Réunion des musées nationaux, 1989.

Best et al. 1992
Stephen P. Best, Robin J. H. Clark, and Robert Withnall. "Non-Destructive Analysis of Artefacts by Raman Microscopy." *Endeavour*, n.s., 16, no. 2 (1992): 66–73.

Bier 1987
Carol Bier, ed. *Woven from the Soul, Spun from the Heart: Textile Arts of Safavid and Qajar Iran, 16th–19th Centuries*. Washington, DC: Textile Museum, 1987.

Bilgi 2009
Hülya Bilgi. *Dance of Fire: Iznik Tiles and Ceramics in the Sadberk Hanım Museum and Ömer M. Koç Collections*. Istanbul: Vehbi Koç Foundation, 2009.

Bivar 1969
A. D. H. Bivar. *Catalogue of the Western Asiatic Seals in the British Museum*. Part 2, *Stamp Seals*. Vol. 2, *The Sassanian Dynasty*. London: Trustees of the British Museum, 1969.

Blair 2006
Sheila S. Blair. *Islamic Calligraphy*. Edinburgh: Edinburgh University Press, 2006.

Blair and Bloom 2003
Sheila S. Blair and Jonathan M. Bloom. "The Mirage of Islamic Art: Reflections on the Study of an Unwieldy Field." *Art Bulletin* 85, no. 1 (2003): 152–84.

Blankinship 1989
Khalid Yahya Blankinship, trans. *The End of Expansion*. Vol. 25 of *The History of al-Ṭabarī*. Albany: State University of New York Press, 1989.

Bosworth 2010
C. E. Bosworth. "Nishapur i. Historical Geography and History to the Beginning of the 20th Century." In *Encyclopaedia Iranica*, Online Edition, 17 Sept. 2010, available at *http://www.iranicaonline.org/articles/nishapur i*.

Boyce 1970
Mary Boyce. "On the Calendar of Zoroastrian Feasts." *Bulletin of the School of Oriental and African Studies* 33 (1970): 513–39.

Boyce 1975a
Mary Boyce. "Mihragān among the Irani Zoroastrians." In *Mithraic Studies: Proceedings of the First International Congress of Mithraic Studies*, 2 vols., edited by John R. Hinnells, 1:106–18. Manchester: Manchester University Press, 1975.

Boyce 1975b
Mary Boyce. *A History of Zoroastrianism*. Vol. 1, *The Early Period*. Leiden: Brill, 1975.

Boyce 1983a
Mary Boyce. "Iranian Festivals." In *Cambridge History of Iran*, vol. 3, part 2, *The Seleucid, Parthian and Sasanian Periods*, edited by Ehsan Yarshater, 792–815. Cambridge: Cambridge University Press, 1983.

Boyce 1983b
Mary Boyce. "Ādur Burzēn-Mihr." In *Encyclopaedia Iranica*, Online Edition, 15 Dec. 1983, available at *http://www.iranicaonline.org/articles/adur -burzen-mihr-an-atas-bahram-see-atas-i*.

Brend and Melville 2010
Barbara Brend and Charles Melville. *Epic of the Persian Kings: The Art of Ferdowsi's* Shahnameh. London and New York: I. B. Tauris, 2010.

Briggs 1973
George Weston Briggs. *Gorakhnāth and the Kānphata Yogīs.* Delhi: Motilal Banarsidass, 1973.

Browne 1929
Edward Granville Browne. *A Literary History of Persia.* 4 vols. Cambridge: Cambridge University Press, 1929.

Brunner 1978
Christopher J. Brunner. *Sasanian Stamp Seals in the Metropolitan Museum of Art.* New York: Metropolitan Museum of Art, 1978.

Bulliet 1972
Richard W. Bulliet. *The Patricians of Nishapur: A Study in Medieval Islamic Social History.* Cambridge, MA: Harvard University Press, 1972.

Bulliet 1992
Richard W. Bulliet. "Pottery Styles and Social Status in Medieval Khurasan." In *Archaeology, Annales, and Ethnohistory,* edited by A. Bernard Knapp, 75–82. Cambridge: Cambridge University Press, 1992.

Çağman and Tanındı 2002
Filiz Çağman and Zeren Tanındı. "Manuscript Production at the Kāzarūnī Orders in Safavid Shiraz." In *Safavid Art and Architecture,* edited by Sheila R. Canby, 43–48. London: British Museum Press, 2002.

Calmard 1993
J. Calmard. "Mihragān." In *Encyclopaedia of Islam,* 2nd ed., 7:15–20. Leiden: Brill, 1993.

CAMEO
Museum of Fine Arts, Boston, CAMEO (Conservation and Art Materials Encyclopedia Online), *http://cameo.mfa.org.*

Cammann 1972
Schuyler van Renselaar Cammann. "Symbolic Meanings in Oriental Rug Patterns." *Textile Museum Journal* 3, no. 3 (1972): 5–54.

Canby 1996a
Sheila R. Canby. "Farangi Saz: The Impact of Europe on Safavid Painting." In Tilden 1996, 46–59.

Canby 1996b
Sheila R. Canby. *The Rebellious Reformer: The Drawings and Paintings of Riza-yi Abbasi of Isfahan.* London: Azimuth Editions, 1996.

Canby 2000a
Sheila R. Canby. *The Golden Age of Persian Art, 1501–1722.* New York: Harry N. Abrams, Inc., 2000.

Canby 2000b
Sheila R. Canby. "The Pen or the Brush? An Inquiry into the Technique of Late Safavid Drawings." In Hillenbrand 2000, 75–82.

Canby 2009
Sheila R. Canby. *Shah 'Abbas: The Remaking of Iran.* London: British Museum Press, 2009.

Canby 2011
Sheila Canby. *The Shahnama of Shah Tahmasp.* New York: Metropolitan Museum of Art; New Haven: Yale University Press, 2011.

Carboni 2002
Stefano Carboni. "Synthesis: Continuity and Innovation in Ilkhanid Art." In Komaroff and Carboni 2002, 197–225.

Carswell 2000
John Carswell. *Blue & White: Chinese Porcelain Around the World.* London: British Museum Press, 2000.

Chardin 1988
Sir John Chardin. *Travels in Persia 1673–1677.* New York: Dover, 1988.

Chester Beatty Library and Leach 1995
Chester Beatty Library and Linda York Leach. *Mughal and Other Indian Paintings from the Chester Beatty Library.* 2 vols. London: Scorpion Cavendish, 1995.

Chloros 2008
Jessica Chloros. "An Investigation of Cobalt Blue Pigment on Islamic Ceramics at the Harvard Art Museums." Thesis (Certificate in Conservation), Harvard Art Museums, Straus Center for Conservation and Technical Studies, 2008.

Choksy 1997
Jamsheed K. Choksy. *Conflict and Cooperation: Zoroastrian Subalterns and Muslim Elites in Medieval Iranian Society.* New York: Columbia University Press, 1997.

Christie's 1988
Christie's, London. *Fourteen Folios from the Houghton Shahnameh.* 11 Oct. 1988.

Christie's 1994a
Christie's, London. *Islamic Art and Indian Miniatures.* 18 Oct. 1994.

Christie's 1994b
Christie's, London (South Kensington). *Oriental Ceramics and Works of Art.* 20 Oct. 1994.

Christie's 1995
Christie's, London. *Islamic Art, Indian Miniatures, Rugs and Carpets.* 17 Oct. 1995.

Christie's 2010
Christie's, London. *Art of the Islamic and Indian Worlds.* 5 Oct. 2010.

Clark and Mirabaud 2006
Robin J. H. Clark and Sigrid Mirabaud. "Identification of the Pigments on a Sixteenth Century Persian Book of Poetry by Raman Microscopy." *Journal of Raman Spectroscopy* 37 (2006): 235-39.

Clauss 2000
Manfred Clauss. *The Roman Cult of Mithras: The God and His Mysteries.* Translated by Richard Gordon. New York: Routledge, 2000.

Clinton 1984
Jerome W. Clinton. "The Tragedy of Sohrab." In *Logos Islamikos: Studia Islamica in Honorem Georgii Michaelis Wickens,* edited by Roger H. Savory and Dionisius A. Agius, 63-77. Toronto: Pontifical Institute of Medieval Studies, 1984.

Clinton 1987
Jerome W. Clinton, trans. *The Tragedy of Sohrab and Rostam from the Persian National Epic: The Shahname of Abol-Qasem Ferdowsi.* Seattle and London: University of Washington Press, 1987.

Clinton 2001
Jerome W. Clinton. "Ferdowsi and the Illustration of the *Shahnameh.*" In Grabar and C. Robinson 2001, 57-74.

Clinton and M. S. Simpson 2006a
Jerome W. Clinton and Marianna S. Simpson. "Word and Image in Illustrated *Shahnama* Manuscripts: A Project Report." In Melville 2006, 219-37.

Clinton and M. S. Simpson 2006b
Jerome W. Clinton and Marianna S. Simpson. "How Rustam Killed White Div: An Interdisciplinary Inquiry." *Iranian Studies* 39 (June 2006): 171-97.

Cort et al. 2000
Louise Allison Cort, Massumeh Farhad, and Ann Clyburn Gunter. *Asian Traditions in Clay: The Huage Gifts.* Washington, DC: Freer Gallery of Art and Arthur M. Sackler Gallery, Smithsonian Institution, 2000.

Cowell and Fukang 2001
M. Cowell and Z. Fukang. "Analyses and Source of the Cobalt-Blue Pigments Employed on Chinese Ceramics." In *Catalogue of Late Yuan and Ming Ceramics in the British Museum,* edited by Jessica Harrison-Hall, 601-5. British Museum Press, London, 2001.

Crowe 1996
Yolande Crowe. "The Chiselled Surface: Chinese Lacquer and Islamic Design." In Tilden 1996, 60-69.

Crowe 2002
Yolande Crowe. *Persia and China: Safavid Blue and White Ceramics in the Victoria & Albert Museum 1501-1738.* London: Thames and Hudson, 2002.

J. Curtis and St. J. Simpson 2010
John Curtis and St. John Simpson, eds. *The World of Achaemenid Persia: History, Art and Society in Iran and the Ancient Near East; Proceedings of a Conference at the British Museum 29th September-1st October 2005.* London: I. B. Tauris and Iran Heritage Foundation, 2010.

V. Curtis and St. J. Simpson 1998
Vesta Sarkhosh Curtis and St. John Simpson. "Archaeological News from Iran: Second Report." *Iran* 36 (1998): 185-94.

Daniel 1979
Elton Daniel. *The Political and Social History of Khurasan under Abbasid Rule, 747-820.* Minneapolis and Chicago: Bibliotheca Islamica, 1979.

Dānishpazhūh 1970
Muḥammad Taqī Dānishpazhuh. "Qanun al-ṣuvar." *Hunar va mardum* 90 (1349 [1970]): 13-20.

Davis 1992
Dick Davis. *Epic & Sedition: The Case of Ferdowsi's Shahnameh.* Washington, DC: Mage, 1992.

Davis 2000
Dick Davis, trans. *Fathers and Sons.* Vol. 2 of *Stories from the Shahnameh of Ferdowsi.* Washington, DC: Mage, 2000.

Dawud and Coomaraswamy 1912
Mirza Y. Dawud and Ananda K. Coomaraswamy, trans. *Burning and Melting, Being the Sūz-u-Gudāz of Muhammad Rizā Nau'ī of Khabūshān.* London: Old Bourne Press, 1912.

De Blois 1990
François de Blois. *Burzōy's Voyage to India and the Origin of the Book of Kalilah wa Dimnah.* London: Royal Asiatic Society, 1990.

De Jong 1997
Albert de Jong. *Traditions of the Magi: Zoroastrianism in Greek and Latin Literature.* Leiden: Brill, 1997.

De Jong 2003
Albert de Jong. "Sub Specie Maiestatis: Reflections on Sasanian Court Rituals." In *Zoroastrian Rituals in Context,* edited by Michael Stausberg, 345-65. Leiden: Brill, 2003.

Denny 1974
Walter B. Denny. "Blue and White Islamic Pottery on Chinese Themes." In *Boston Museum Bulletin* 72, no. 368 (1974): 76–99.

Denny 1983
Walter B. Denny. "Dating Ottoman Turkish Works in the Saz Style." *Muqarnas: An Annual on Islamic Art and Architecture* 1 (1983): 103–21.

Denny 2004
Walter B. Denny. *Iznik: The Artistry of Ottoman Ceramics*. London and New York: Thames & Hudson, 2004.

Derman 1998
M. Uğur Derman. *Letters in Gold: Ottoman Calligraphy from the Sakıp Sabancı Collection, Istanbul*. New York: Metropolitan Museum of Art, 1998.

Derman 2004
M. Uğur Derman. *Masterpieces of Ottoman Calligraphy from the Sakıp Sabancı Museum*. Istanbul: Sabancı Üniversitesi, 2004.

De Rochechouart 1867
M. le Comte Julien de Rochechouart. *Souvenirs d'un voyage en Perse*. Paris: Challamel Aîné, 1867.

Diba 1989
Layla S. Diba. "Persian Painting in the Eighteenth Century: Tradition and Transmission." *Muqarnas* 6 (1989): 147–60.

Diba 1994
Layla S. Diba. "Lacquerwork of Safavid Persia and Its Relationship to Persian Painting." PhD diss., Harvard University, 1994.

Diba 1998
Layla S. Diba, ed. *Royal Persian Paintings: The Qajar Epoch, 1785–1925*. London: I. B. Tauris in association with Brooklyn Museum of Art, 1998.

Dickson and S. C. Welch 1981a
Martin Bernard Dickson and Stuart Cary Welch. *The Houghton Shahnameh*. 2 vols. Cambridge, MA: Harvard University Press, 1981.

Dickson and S. C. Welch 1981b
Martin Bernard Dickson and Stuart Cary Welch, trans. and annot. "Appendix 1: The Canons of Painting by Ṣādiqī Bek." In Dickson and S. C. Welch 1981a, 1:259–69.

Doostkhah 2002
Jalil Doostkhah. "Gorz." In *Encyclopaedia Iranica*, Online Edition, 15 Dec. 2002, available at *http://www.iranicaonline.org/articles/gorz*.

Dyson 1968
Robert H. Dyson. "Hasanlu and the Solduz and Ushnu Valley: Twelve Years of Discovery." *Archaeologia Viva* 1 (1968): 82–101.

Dyson 1989
Robert H. Dyson. "Rediscovering Hasanlu." *Expedition* 31, nos. 2–3 (1989): 3–11.

Esin 1965
Emel Esin. "The Horse in Turkish Art." *Central Asiatic Journal* 10 (1965): 167–227.

Esin 2004
Emel Esin. *Orta Asya'dan Osmanlıya: Türk Sanatında İkonografik Motifler*. Compiled by Ergun Kocabıyık. Istanbul: Kalbacı Yayınevi, 2004.

Ettinghausen 1965
Richard Ettinghausen. "The Dance with Zoomorphic Masks and Other Forms of Entertainment Seen in Islamic Art." In *Arabic and Islamic Studies in Honor of Hamilton A. R. Gibb*, edited by George Makdisi, 211–24. Leiden: E. J. Brill, 1965.

Ettinghausen 1969
Richard Ettinghausen. "A Case of Traditionalism in Iranian Art." In Aslanapa and Naumann 1969, 88–110.

Ettinghausen 1974
Richard Ettinghausen. "Stylistic Tendencies at the Time of Shah ʿAbbas." *Iranian Studies* 7, nos. 3–4 (1974): 593–628.

Farhad 1987
Massumeh Farhad. "Safavid Single Page Painting, 1629–1666." PhD diss., Harvard University, 1987.

Farhad 1992
Massumeh Farhad. "An Artist's Impression: Muʿin Musavvir's *Tiger Attacking a Youth*." *Muqarnas* 9 (1992): 116–23.

Farhad 2001
Massumeh Farhad. "'Searching for the New': Later Safavid Painting and the *Sūz u Gawdaz* (Burning and Melting) by Nauʿi Khabushani." *The Journal of the Walters Art Museum* 59 (2001): 115–30.

Farhad 2009
Massumeh Farhad, with Serpil Bağcı. *Falnama: The Book of Omens*. Washington, DC: Arthur M. Sackler Gallery, Smithsonian Institution, 2009.

Fehérvári 2000
Géza Fehérvári. *Ceramics of the Islamic World in the Tareq Rajab Museum*. London and New York: I. B. Tauris, 2000.

Fiey 1973
Jean Maurice Fiey. "Chrétientés syriaques du Ḫorāsān et du Ségestān." *Le Muséon: Revue d'études orientales* 86 (1973): 75–104.

Findly 1993
Ellison Banks Findly. "The Pleasure of Women: Nur Jahan and Mughal Paintings." *Asian Art* 6, no. 2 (1993): 66–86.

Finlay 2010
Robert Finlay. *The Pilgrim Art: Cultures of Porcelain in World History*. Berkeley: University of California Press, 2010.

Fitzhugh 1988
Elizabeth West Fitzhugh. "Study of Pigments on Selected Paintings from the Vever Collection." In Lowry and Beach 1988, 425-32.

Floor 1999
Willem Floor. "Art (*Naqqashi*) and Artists (*Naqqashan*) in Qajar Persia." *Muqarnas* 16 (1999): 125-54.

Floor 2005
Willem Floor. *The History of Theater in Iran*. Washington, DC: Mage, 2005.

Fowden 2004
Garth Fowden. *Art and the Umayyad Elite in Late Antique Syria: Quṣayr ʿAmra*. Berkeley: University of California Press, 2004.

France Diplomatie 2008
http://www.diplomatie.gouv.fr/en/france-priorities/ education-research/archaeology/archaeology -notebooks/ancient-east/iran-nishapur (online 9 Sept. 2008).

Frye 1966
Richard Frye. *The Heritage of Persia*. New York: New American Library, 1966.

Frye 1974
Richard Frye. "Islamic Book Forgeries from Iran." In *Islamwissenschaftliche Abhandlungen: Fritz Meier z. 60. Geburtstag*, edited by Richard Gramlich, 106-11. Wiesbaden: Steiner Verlag, 1974.

Fukai 1981
Shinji Fukai. *Ceramics of Ancient Persia*. New York: Weatherhill; Kyoto: Tankosha, 1981.

Gaffary 1984
Farrokh Gaffary. "Evolution of Rituals and Theater in Iran." *Iranian Studies* 17, no. 4 (1984): 361-89.

Gershevitch 1959
Ilya Gershevitch. *The Avestan Hymn to Mithra*. Cambridge: Cambridge University Press, 1959.

Ghirshman 1964
Roman Ghirshman. *The Arts of Ancient Iran: From Its Origins to the Time of Alexander the Great*. New York: Golden Press, 1964.

Ghouchani 1986
Abdullah Ghouchani. *Inscriptions on Nishabur Pottery*. Tehran: Reza Abbasi Museum, 1986.

Gignoux 1978
Philippe Gignoux. *Catalogue des sceaux, camées et bulles sasanides de la Bibliothèque nationale et du Musée du Louvre*. Vol. 2, *Les sceaux et bulles inscrits*. Paris: Bibliothèque nationale, 1978.

Gignoux and Gyselen 1982
Philippe Gignoux and Rika Gyselen. *Sceaux sasanides de diverses collections privées*. Leuven: Peeters, 1982.

Gignoux and Gyselen 1987
Philippe Gignoux and Rika Gyselen. *Bulles et sceaux sasanides de diverses collections*. Studia Iranica Cahier 4. Paris: Association pour l'Avancement des Études Iraniennes, 1987.

Gignoux and Gyselen 1989
Philippe Gignoux and Rika Gyselen. "Sceaux de femmes à l'époque sassanide." *Archaeologia Iranica et Orientalis: Miscellanea in Honorem Louis Vanden Berghe*, edited by Leon De Meyer and Ernie Haerinck, 877-96. Ghent: Peeters, 1989.

Gluck 1977
Jay Gluck and Sumi Hiramoto Gluck. *A Survey of Persian Handicraft: A Pictorial Introduction to the Contemporary Folk Arts and Art Crafts of Modern Iran*. Tehran and New York: Survey of Persian Art, 1977.

Godard 1950
André Godard. *Le trésor de Ziwiyè*. Haarlem: Joh. Enschedé en Zonen, 1950.

Golombek et al. 1996
Lisa Golombek, Robert B. Mason, and Gauvin A. Bailey. *Tamerlane's Tableware: A New Approach to Chinoiserie Ceramics of Fifteenth- and Sixteenth-Century Iran*. Costa Mesa, CA: Mazda Publishers in association with Royal Ontario Museum, 1996.

Grabar and Blair 1980
Oleg Grabar and Sheila Blair. *Epic Images and Contemporary History: The Illustrations of the Great Mongol Shahnama*. Chicago: University of Chicago Press, 1980.

Grabar and C. Robinson 2001
Oleg Grabar and Cynthia Robinson, eds. *Islamic Art and Literature*. Princeton: Markus Wiener, 2001.

Gray 1979a
Basil Gray, ed. *The Arts of the Book in Central Asia, 14th-16th Centuries*. Boulder, CO: Shambhala Publications, 1979.

Gray 1979b
Basil Gray. "The School of Shiraz from 1392 to 1453." In Gray 1979a, 121-45.

Gray 1986
Basil Gray. "The Pictorial Arts in the Timurid Period." In *The Cambridge History of Iran*, Vol. 6: *The Timurid and Safavid Periods*, edited by Peter Jackson and Laurence Lockhart, 843-72. Cambridge: Cambridge University Press, 1986.

Grube 1959
Ernst J. Grube. "Materialien zum Dioskurides Arabicus." In *Aus der Welt der Islamischen Kunst: Festschrift für Ernst Kühnel*, edited by Richard Ettinghausen. Berlin: Mann, 1959.

Grube 1968
Ernst J. Grube. *The Classical Style in Islamic Painting*. Venice: Edizione Oriens, 1968.

Grube 1994
Ernst J. Grube. *Cobalt and Lustre: The First Centuries of Islamic Pottery*. Nasser D. Khalili Collection of Islamic Art, vol. 9. London: Nour Foundation in association with Azimuth Editions and Oxford University Press, 1994.

Gruber 2009a
Christiane J. Gruber. "Meʿrāj ii. Illustrations." In *Encyclopaedia Iranica*, Online Edition, 20 Feb. 2009, available at *http://www.iranicaonline.org/articles/meraj-ii-illustrations*.

Gruber 2009b
Christiane Gruber. "A Pious Cure-All: The Ottoman Illustrated Prayer Manual in the Lilly Library." In *The Islamic Manuscript Tradition: Ten Centuries of Book Arts in Indiana University Collections*, edited by Christiane Gruber, 116-53. Bloomington: Indiana University Press, 2009.

Guest 1949
Grace Dunham Guest. *Shiraz Painting in the Sixteenth Century*. Washington, DC: Freer Gallery of Art, 1949.

Gyselen 1997
Rika Gyselen. *L'art sigillaire sassanide dans les collections de Leyde*. Leiden: Rijksmuseum van Oudheden, 1997.

Gyselen 2006
Rika Gyselen. "L'art sigillaire: Camées, sceaux et bulles." In *Les Perses sassanides: Fastes d'un empire oublié (224-642)*, 199-213. Paris: Musée Cernuschi, 2006.

Gyselen 2007
Rika Gyselen. *Sasanian Seals and Sealings in the A. Saeedi Collection*. Acta Iranica 44. Leuven: Peeters, 2007.

Hakemi 1968
Ali Hakemi. "Kaluraz and the Civilization of the Mardes." *Archaeologia Viva* 1 (1968): 63-66, 80-81.

HALI 2004
"Exhibitions in Brief." *HALI* 133 (Mar.-Apr. 2004): 115.

Hallett 2010
Jessica Hallett. "Pearl Cups Like the Moon: The Abbasid Reception of Chinese Ceramics." In *Shipwrecked: Tang Treasures and Monsoon Winds*, edited by R. Krahl, J. Guy, J. K. Wilson, and J. Raby, 75-81. Washington, DC: Smithsonian Institution, 2010.

Hallett et al. 1988
Jessica R. Hallett, Michael Thompson, Edward J. Keall, and Robert B. Mason. "Archaeometry of Medieval Islamic Glazed Ceramics from North Yemen." *Canadian Journal of Chemistry* 66 (1988): 266-72.

Hanaway 1988
William L. Hanaway. "Sacrifice and Celebration in Manūchihrī's Wine Poetry." *Iran* 26 (1988): 69-80.

Harley 1982
R. D. Harley. *Artists' Pigments c. 1600-1835: A Study in English Documentary Sources*. Boston: Butterworth Scientific, 1982.

Harper 1978
Prudence Oliver Harper. *The Royal Hunter: Art of the Sasanian Empire*. New York: Asia House Gallery, 1978.

Harvard Art Museum and Wolohojian 2008
Harvard Art Museum and Stephan Wolohojian. *Harvard Art Museum Handbook*. Cambridge, MA: Harvard Art Museum and Harvard University Press, 2008.

Harvard University Art Museums 2003
Harvard University Art Museums Annual Report 2001-2. Cambridge, MA: Harvard University Art Museums, 2003.

Hassanzadeh 2006
Yousef Hassanzadeh. "The Glazed Bricks from Bukan (Iran): New Insights into Mannaean Art." *Antiquity* 80, no. 307 (Mar. 2006), *http://www.antiquity.ac.uk/projgall/hassanzadeh307/*.

Hassanzadeh and Mollasalehi 2011
Yousef Hassanzadeh and Hekmatollah Mollasalehi. "New Evidence for Mannean Art: An Assessment of Three Glazed Tiles from Qalaichi (Izirtu)." In *Elam and Persia*, edited by Javier Álvarez-Mon and Mark B. Garrison, 407-17. Winona Lake, IN: Eisenbrauns, 2011.

Hayez et al. 2004
V. Hayez, S. Denoël, Z. Genadry, and B. Gilbert. "Identification of Pigments on a 16th century Persian Manuscript by Micro-Raman Spectroscopy." *Journal of Raman Spectroscopy* 35 (2004): 781-85.

Henderson 1989
Julian Henderson. "Iznik Ceramics: A Technical Examination." In Atasoy and Raby 1989, 65-69.

Hetjens Museum 1973
Hetjens Museum. *Islamische Keramik*. Dusseldorf: Hetjens Museum, 1973.

Hillenbrand 2000
Robert Hillenbrand, ed. *Persian Painting: From the Mongols to the Qajars; Studies in Honour of Basil W. Robinson*. London and New York: I. B. Tauris in association with the Centre of Middle Eastern Studies, University of Cambridge, 2000.

Hillenbrand 2002
Robert Hillenbrand. "The Arts of the Book in Ilkhanid Iran." In Komaroff and Carboni 2002, 135–67.

Hillenbrand 2004
Robert Hillenbrand, ed. Shahnama: *The Visual Language of the Persian Book of Kings*. Aldershot, Eng., and Burlingon, VT: Ashgate Publishing Limited, 2004.

Hillenbrand 2007
Robert Hillenbrand. "The *Shahnama* and the Persian Illustrated Book." In *Literary Cultures and the Material Book*, edited by Simon Eliot, Andrew Nash, and Ian Willison, 95–119. London: British Library, 2007.

Hobson 1907
R. L. Hobson. "Notes on an Early 'Persian' Bowl and 'Rice-Grain' Wares. *Burlington Magazine for Connoisseurs* 11, no. 50 (1907): 83–85.

Holod 1974
Renata Holod, ed. *Studies on Isfahan: Proceedings of the Isfahan Colloquium Sponsored by the Fogg Museum of Art*. Chestnut Hill, MA: Society for Iranian Studies, 1974.

Horn and Steindorff 1891
Paul Horn and Georg Steindorff, eds. *Sassanidische Siegelsteine*. Königliche Museen zu Berlin: Mittheilungen aus den Orientalischen Sammlungen, vol. 4. Berlin: W. Spemann, 1891.

Houtum-Schindler 1896
Albert Houtum-Schindler. *Eastern Persian Irak*. London: Royal Geographical Society, 1896.

Huart 1908
Clément Huart. *Les calligraphes et les miniaturistes de l'Orient musulman*. Paris: E. Leroux, 1908.

Hunter 1992
Erica C. D. Hunter. "Syriac Christianity in Central Asia." *Zeitschrift für Religions- und Geistesgeschichte* 44 (1992): 362–68.

Jackson and Yohannan 1914
A. V. Williams Jackson and Abraham Yohannan, eds. *A Catalogue of the Collection of Persian Manuscripts including also Some Turkish and Arabic: Presented to the Metropolitan Museum of Art, New York, by Alexander Smith Cochran*. New York: Columbia University Press, 1914.

Jenkins 2006
Marilyn Jenkins. *Raqqa Revisited: Ceramics of Ayyubid Syria*. New York: Metropolitan Museum of Art; New Haven: Yale University Press, 2006.

Jurado-López et al. 2004
Alicia Jurado-López, Ornela Demko, Robin J. H. Clark, and David Jacobs. "Analysis of the Palette of a Precious 16th Century Illuminated Turkish Manuscript by Raman Microscopy." *Journal of Raman Spectroscopy* 35 (2004): 119–24.

Kawami 1992
Trudy S. Kawami. *Ancient Iranian Ceramics from the Arthur M. Sackler Collections*. New York: Arthur M. Sackler Foundation, 1992.

Kerr 1990
Rose Kerr. *Later Chinese Bronzes*. London: Bamboo Publishing in association with the Victoria and Albert Museum, 1990.

Kessler 2002
Rochelle Kessler. "In the Company of the Enlightened: Portraits of Mughal Rulers and Holy Men." In Sackler Museum 2002, 17–41.

Khaleghi-Motlagh 1987–2008
Djalal Khaleghi-Motlagh. *Abu'l-Qasem Ferdowsi: The Shahnameh*. 8 vols. New York: Bibliotheca Persica, 1987–2008.

Khaleghi-Motlagh 1989a
Djalal Khaleghi-Motlagh. "Bāysongörī Šāh-Nāma." In *Encyclopaedia Iranica*, Online Edition, 15 Dec. 1989, available at http://www.iranicaonline.org/articles/baysongori-sah-nama.

Khaleghi-Motlagh 1989b
Djalal Khaleghi-Motlagh. "Bozorgmehr-e Boḵtagān." In *Encyclopaedia Iranica*, Online Edition, 15 Dec. 1989, available at http://www.iranicaonline.org/articles/bozorgmehr-e-boktagan.

Khalili et al. 1997
Nasser D. Khalili, B. W. Robinson, and Tim Stanley. *Lacquer of the Islamic Lands*. 2 vols. Nasser D. Khalili Collection of Islamic Art, vol. 22. London and New York: Nour Foundation in association with Azimuth Editions and Oxford University Press, 1997.

Khvāndamīr 1954
Ghiyāth al-Dīn b. Humām al-Dīn Ḥusaynī Khvāndamīr. *Tārīkh-i ḥabīb al-siyar fī akhbār afrād bashar*. Edited by Jalāl al-Dīn Humā'ī. 4 vols. Tehran: Khayyām, 1333 (1954).

Kiyānī 2001
Muḥammad Yūsuf Kiyānī. *Pīshīnah-i sufāl va sufālgarī dar Īrān*. Tehran: Nasīm-i Dānish, 1380 (2001).

Koch 2001
Ebba Koch. "Introduction." In *Mughal Art and Imperial Ideology: Collected Essays*. New Delhi: Oxford University Press, 2001.

Komaroff 2006
Linda Komaroff, ed. *Beyond the Legacy of Genghis Khan*. Leiden: Brill, 2006.

Komaroff 2011
Linda Komaroff, ed. *Gifts of the Sultan: The Arts of Giving at the Islamic Courts*. Los Angeles: Los Angeles County Museum of Art, 2011.

Komaroff and Carboni 2002
Linda Komaroff and Stefano Carboni, eds. *The Legacy of Genghis Khan: Courtly Art and Culture in Western Asia 1256-1353*. New York: Metropolitan Museum of Art; New Haven and London: Yale University Press, 2002.

Koob 1999
Koob, Stephen. "Restoration Skill or Deceit: Manufactured Replacement Fragments on a Seljuk Lustre-Glazed Ewer." In *The Conservation of Glass and Ceramics: Research, Practice and Training*, edited by Norman H. Tennent, 156-66. London: James & James, 1999.

Koss et al. 2009
K. Koss, B. McCarthy, E. Salzman Chase, and D. Smith. "Analysis of Persian Painted *Minai* Ware." In McCarthy 2009, 33-47.

Krahl 1986
Regina Krahl. *Chinese Ceramics in the Topkapi Saray Museum, Istanbul: A Complete Catalogue*. London: Sotheby's Publications, 1986.

Krahl 1994
Regina Krahl. *Chinese Ceramics from the Meiyintang Collection*. 2 vols. London: Azimuth Editions, 1994.

Lally 2009
Jessica Lally. "Analysis of the Chinese Porcelain Associated with the 'Beeswax Wreck,' Nehalem, Oregon." Master's thesis, Central Washington University, 2009, *http://www.nagagroup.org/BeesWax/publications/PorcelainAnalysis.pdf*.

Lamm 1965
Carl Johan Lamm. *Carpet Fragments: The Marby Rug and Some Fragments of Carpets Found in Egypt*. Stockholm: National Museum, 1965.

Lane 1947
Arthur Lane. *Early Islamic Pottery: Mesopotamia, Egypt and Persia*. London: Faber and Faber, 1947.

Lane 1957
Arthur Lane. *Later Islamic Pottery: Persia, Syria, Egypt, Turkey*. London: Faber and Faber, 1957.

Lee 1968
Sherman E. Lee. *Chinese Art under the Mongols: The Yüan Dynasty, 1279-1368*. Cleveland: Cleveland Museum of Art, 1968.

Le Strange 1905
Guy Le Strange. *Lands of the Eastern Caliphate*. New York: Barnes and Noble, 1905.

Lewis and Sharma 2007
Franklin D. Lewis and Sunil Sharma, eds. *The Necklace of the Pleiades: Studies in Persian Literature Presented to Heshmat Moayyad on His 80th Birthday*. Amsterdam: Rosenberg; West Lafayette, IN: Purdue University Press, 2007.

Limbert 2004
John Limbert. *Shiraz in the Age of Hafez: The Glory of a Medieval Persian City*. Seattle and London: University of Washington Press, 2004.

Lockhart 1960
Laurence Lockhart. "Bandar 'Abbas." In *Encyclopaedia of Islam*, 2nd ed., 1:1013. Leiden: Brill, 1960.

Loveday 2001
Helen Loveday. *Islamic Paper: A Study of the Ancient Craft*. London: Archetype Publications, 2001.

Lowry and Beach 1988
Glenn D. Lowry and Milo Cleveland Beach. *An Annotated Checklist of the Vever Collection*. Washington, DC: Arthur M. Sackler Gallery, Smithsonian Institution, 1988.

Lukonin and Ivanov 1996
Vladimir Grigor'evich Lukonin and Anatoli Ivanov. *Lost Treasures of Persia: Persian Art in the Hermitage Museum*. London: Mage, 1996.

Maddison and Savage-Smith 1997
Francis Maddison and Emilie Savage-Smith. *Science, Tools & Magic*. 2 vols. Nasser D. Khalili Collection of Islamic Art, vol. 12. London: Nour Foundation in association with Azimuth Editions and Oxford University Press, 1997.

Malandra 2000
Willam W. Malandra. "Gāw ī Ēwdād." In *Encyclopaedia Iranica*, Online Edition, 15 Dec. 2000, available at *http://www.iranicaonline.org/articles/gaw-iewdad*.

Martin 1912
F. R. Martin. *The Miniature Painting and Painters of Persia, India and Turkey, from the 8th to the 18th Century*. 2 vols. London: B. Quaritch, 1912.

Marzolph 2001
Ulrich Marzolph. *Narrative Illustration in Persian Lithographed Books*. Leiden: Brill, 2001.

Mason 2004
Robert B. Mason. *Shine Like the Sun: Lustre-Painted and Associated Pottery from the Medieval Middle East*. Costa Mesa, CA: Mazda Publishers in association with Royal Ontario Museum, 2004.

Mason et al. 2001
R. B. Mason, M. S. Tite, S. Paynter, and C. Salter. "Advances in Polychrome Ceramics in the Islamic World of the 12th century AD." *Archaeometry* 43, no. 2 (2001): 191–209.

Masuya 2002
Tomoko Masuya. "Ilkhanid Courtly Life." Chap. 4 in Komaroff and Carboni 2002, 75–103.

McCarthy 2009
Blythe Ellen McCarthy, ed. *Scientific Research on Historic Asian Ceramics: Proceedings of the Fourth Forbes Symposium at the Freer Gallery of Art*. London: Archetype Publications in association with the Freer Gallery of Art, Smithsonian Institution, 2009.

McWilliams 2002a
Mary McWilliams. "With Quite Different Eyes: The Norma Jean Calderwood Collection of Islamic Art." *Apollo* 155, no. 489 (Nov. 2002): 12–16.

McWilliams 2002b
Mary McWilliams. "Islamic Ceramic Traditions." *The Studio Potter* 31, no. 1 (Dec. 2002): 43–46.

McWilliams 2003
Mary McWilliams. "Collecting by the Book: The Shaping of Private and Public Collections." *Muqarnas* 20 (2003): 225–51.

McWilliams 2004
Mary McWilliams. *Closely Focused, Intensely Felt: Selections from the Norma Jean Calderwood Collection of Islamic Art*. Harvard University Art Museums Gallery Series no. 42. Cambridge, MA: Harvard University Art Museums, 2004.

McWilliams 2007
Mary McWilliams. "Baraka: Blessings in Clay." *The Studio Potter* 35, no. 2 (Summer/Fall 2007): 14–19.

McWilliams and Roxburgh 2007
Mary McWilliams and David J. Roxburgh. *Traces of the Calligrapher: Islamic Calligraphy in Practice, c. 1600–1900*. New Haven and London: Yale University Press, 2007.

Meisami 1987
Julie Scott Meisami. *Medieval Persian Court Poetry*. Princeton: Princeton University Press, 1987.

Melikian-Chirvani 1991
A. S. Melikian-Chirvani. "Les taureaux à vin et les cornes à boire de l'Iran islamique." In *Histoire et cultes de l'Asie Centrale préislamique*, edited by Paul Bernard and Frantz Grenet, 101–25. Paris: Éditions du CNRS, 1991.

Melikian-Chirvani 1992
A. S. Melikian-Chirvani. "The Iranian *Bazm* in Early Persian Sources." In *Banquets d'Orient*, edited by R. Gyselen, Res Orientales 4, 95–119. Leuven: Peters, 1992.

Melikian-Chirvani 2007
A. S. Melikian-Chirvani. *Le chant du monde: L'art de l'Iran safavide, 1501–1736*. Paris: Musée du Louvre, 2007.

Melville 2006
Charles Melville, ed. *Shahnama Studies I*. Cambridge: Centre of Middle Eastern and Islamic Studies, 2006.

Membré 1993
Michele Membré. *Mission to the Lord Sophy of Persia (1539–1542)*. Translated by A. H. Morton. London: School of Oriental and African Studies, University of London, 1993.

Metropolitan Museum 1991
Metropolitan Museum of Art. *East Asian Lacquer: The Florence and Herbert Irving Collection*. New York: Metropolitan Museum of Art, 1991.

Middleton and Cowell 1993
A. P. Middleton and M. R. Cowell. "Appendix 1. Report on the Examination and Analysis of Some Porcelains from Longton Hall and West Pans." Technical Appendix in "Excavations at the Longton Hall Porcelain Manufactory. Part III: The Porcelain and Other Ceramic Finds," by B. M. Watney. *Post-Medieval Archaeology* 27 (1993): 57–109.

Mikami et al. 1981
Tsugio Mikami, Kiyotari Tsuboi, Shōichi Narasaki, Tadanari Mitsuoka, Naoshige Okuda, Seizō Hayashiya, Takeshi Nagatake, et al. *Ryō, Kin, Gen = Liao, Chin and Yüan Dynasties*. Tokyo: Shōgakkan, 1981.

Minorsky 1959
V. Minorsky, trans. *Calligraphers and Painters: A Treatise by Qāḍī Aḥmad, Son of Mīr-Munshī (circa A.H. 1015/A.D. 1606)*. Washington, DC: Freer Gallery of Art, Smithsonian Institution, 1959.

Moorey 1971
Peter Roger Stuart Moorey. *Catalogue of the Ancient Persian Bronzes in the Ashmolean Museum*. Oxford: Clarendon Press, 1971.

Moorey 1994
Peter Roger Stuart Moorey. *Ancient Mesopotamian Materials and Industries: The Archaeological Evidence*. Oxford: Oxford University Press, 1994.

Moreh 1992
Shmuel Moreh. *Live Theatre and Dramatic Literature in the Medieval Arabic World.* Edinburgh: Edinburgh University Press, 1992.

Morrison 1972
George Morrison, trans. *Vis and Ramin: Translated from the Persian of Fakhr ud-Dīn Gurgānī.* New York and London: Columbia University Press, 1972.

Mortimer 1985
Kristin A. Mortimer. *Harvard University Art Museums: A Guide to the Collections.* Cambridge, MA: Harvard University Art Museums; New York: Abbeville Press, 1985.

Muscarella 1977
Oscar White Muscarella. "'Ziwiye' and Ziwiye: The Forgery of a Provenience." *Journal of Field Archaeology* 4 (1977): 197–219.

Muscarella 1988
Oscar White Muscarella. *Bronze and Iron: Ancient Near Eastern Artifacts in the Metropolitan Museum of Art.* New York: Metropolitan Museum of Art, 1988.

Muscarella 2000
Oscar White Muscarella. *The Lie Became Great: The Forgery of Ancient Near Eastern Cultures.* Groningen: Styx Publications, 2000.

Müstakimzade 1928
Müstakimzade Süleyman Sadeddin. *Tuhfe-yi hattatin.* Türk Tarih Encümeni Külliyatı, vol. 12. Istanbul: Devlet Matbaası, 1928.

Najmabadi 1998
Afsaneh Najmabadi. "Reading for Gender Through Qajar Painting." In Diba 1998, 76–85.

Naw'ī 1969
Muḥammad Riżā Naw'ī Khabūshānī. *Sūz u Gudāz.* Edited by Amīr Ḥusayn 'Ābīdī. Tehran: Bunyād va Farhang-i Īrān, 1348 (1969).

Naw'ī 1995
Muḥammad Riżā Naw'ī Khabūshānī. *Dīvān-i Mullā Naw'ī Khabūshānī.* Edited by Amīr Ḥusayn Ẕākirzāda. Tehran: Mā, 1374 (1995).

Necipoğlu 1991
Gülru Necipoğlu. *Architecture, Ceremonial, and Power: The Topkapı Palace in the Fifteenth and Sixteenth Centuries.* New York: Architectural History Foundation; Cambridge, MA: MIT Press, 1991.

Negahban 1996
Ezat O. Negahban. *Marlik: The Complete Excavation Report.* Philadelphia: University Museum, University of Pennsylvania, 1996.

Newman 2009
Andrew J. Newman. *Safavid Iran: Rebirth of a Persian Empire.* London and New York: I. B. Tauris, 2009.

Norman 2004
Kirsty Norman. "Restoration and Faking of Islamic Ceramics: Case Histories." In Watson 2004, 69–90.

Okada 1992
Amina Okada. *Indian Miniatures of the Mughal Court.* Translated by Deke Dussinberre. New York: Harry N. Abrams, Inc., 1992.

O'Kane 2006
Bernard O'Kane. "The Iconography of the *Shahnama,* Ms. Ta'rikh Farisi 73, Dar al-Kutub, Cairo (796/1393-4)." In Melville 2006, 171–88.

Pancaroğlu 2002
Oya Pancaroğlu. "Serving Wisdom: The Contents of Samanid Epigraphic Pottery." In Sackler Museum 2002, 59–75.

Pancaroğlu 2007
Oya Pancaroğlu. *Perpetual Glory: Medieval Islamic Ceramics from the Harvey B. Plotnick Collection.* Chicago: Art Institute of Chicago, 2007.

Pancaroğlu 2012
Oya Pancaroğlu. "Potter's Trail: An Abu Zayd Ewer in the Saint Louis Art Museum." In *Metalwork and Material Culture in the Islamic World: Art, Craft and Text,* edited by Venetia Porter and Mariam Rosser-Owen, 397–409. London: I. B. Tauris, 2012.

Parrello 2010
Domenico Parrello. "Ḵamsa of Neẓāmi." In *Encyclopedia Iranica,* Online Edition, 10 Nov. 2010, available at *http://www.iranicaonline.org/articles/kamsa-of-nezami.*

Parry 1996
Ken Parry. "Images in the Church of the East: The Evidence from Central Asia and China." *Bulletin of the John Rylands Library* 78 (1996): 160–80.

Pérez-Arantegui et al. 2009
J. Pérez-Arantegui, B. Montull, M. Resano, and J. M. Ortega. "Materials and Technological Evolution of Ancient Cobalt-Blue-Decorated Ceramics: Pigments and Work Patterns in Tin-Glazed Objects from Aragon (Spain) from the 15th to 18th Century AD. *Journal of the European Ceramic Society* 29 (2009): 2499–509.

Philon 1980
Helen Philon. *Early Islamic Ceramics: Ninth to Late Twelfth Centuries.* London: Islamic Art Publications; Totowa, NJ: distributed by Sotheby Parke Bernet Publications, 1980.

A. U. Pope 1938–39
Arthur Upham Pope, ed. *A Survey of Persian Art: From Prehistoric Times to the Present*. 6 vols. London and New York: Oxford University Press, 1938–39.

J. Pope 1956
John Alexander Pope. *Chinese Porcelains from the Ardebil Shrine*. Washington, DC: Freer Gallery of Art, Smithsonian Institution, 1956.

Porter 1988
Yves Porter. "Notes sur le 'Golestān-e honar' de Qāzī Ahmad Qomi." *Studia Iranica* 17, no. 2 (1988): 207–23.

Porter 1992
Yves Porter. *Peinture et arts du livre: Essai sur la littérature technique indo-persane*. Paris and Tehran: Institut Français de Recherche en Iran, 1992.

Porter 2000
Yves Porter. "From the 'Theory of the Two Qalams' to the 'Seven Principles of Painting': Theory, Terminology, and Practice in Persian Classical Painting." *Muqarnas* 17 (2000): 109–18.

Pourshariati 2008
Parvaneh Pourshariati. *Decline and Fall of the Sasanian Empire*. London: I. B. Tauris, 2008.

Purinton and Watters 1991
Nancy Purinton and Mark Watters. "A Study of the Materials Used by Medieval Persian Painters." *Journal of the American Institute for Conservation* 30, no. 2 (1991): 125–44.

Quinn 1996
Sholeh A. Quinn. "The Historiography of Safavid Prefaces." In *Safavid Persia*, edited by Charles Melville, 1–25. London and New York: I. B. Tauris in association with the Centre of Middle Eastern Studies, University of Cambridge, 1996.

Raby 1986
Julian Raby. "Looking for Silver in Clay: A New Perspective on Sāmānid Ceramics." In *Pots & Pans: A Colloquium on Precious Metals and Ceramics*, edited by Michael Vickers, 179–203. Oxford: Oxford University Press, 1986.

Raby 1989
Julian Raby. "The Making of an Iznik Pot." In Atasoy and Raby 1989, 50–64.

Raby 1999
Julian Raby. *Qajar Portraits*. London: Azimuth Editions in association with the Iran Heritage Foundation, 1999.

Raguin and Bangdel 2010
Virginia C. Raguin and Dina Bangdel, eds. *Pilgrimage and Faith: Buddhism, Christianity and Islam*. Chicago: Serindia Publications, 2010.

Rashid 1969
A. Rashid. *Society and Culture in Medieval India, 1206-1556 A.D.* Calcutta: Firma K. L. Mukhopadhyay, 1969.

Rawson 1984
Jessica Rawson. *Chinese Ornament: The Lotus and the Dragon*. London: British Museum Publications, 1984.

Razmjou et al. 2004
Shahrokh Razmjou, Michael S. Tite, Andrew J. Shortland, Marion Jung, and Andreas Hauptmann. "Glazed Bricks in the Achaemenid Period." In *Persiens antike Pracht: Bergbau, Handwerk, Archäologie*, edited by Thomas Stöllner, Rainer Slotta, and Abdolrasool Vatandoust, 382–93. Bochum: Deutsches Bergbau-Museum, 2004 (English version included on CD).

Reed 2005
Christopher Reed. "Art of the Hunt." *Harvard Magazine* (May–June 2005): 1, 44–47.

Rezvani and Rustaei 2007
Hasan Rezvani and Kourosh Roustaei. "A Preliminary Report on Two Seasons of Excavations at Kul Tarike Cemetery, Kurdestan, Iran." *Iranica Antiqua* 42 (2007): 139–84.

Riyāḥī 1993
Muḥammad Amīn Riyāḥī. *Sarchashmahā-yi Firdawsī-shināsī: Majmūʿa-i nivishtahā-yi kuhan dar bāra-i Firdawsī va Shāhnāma va naqd-i ānhā*. Tehran: Muʾassasa-i Muṭālaʿāt va Taḥqīqāt-i Farhangī, 1372 (1993).

B. W. Robinson 1954
B. W. Robinson. "Origin and Date of Three Famous *Shāhnāma* Illustrations." *Ars Orientalis* 1 (1954): 105–112.

B. W. Robinson 1958
B. W. Robinson. *A Descriptive Catalogue of the Persian Paintings in the Bodleian Library*. Oxford: Oxford University Press, 1958.

B. W. Robinson 1979
B. W. Robinson. "The Turkman School to 1503." In Gray 1979a, 215–47.

B. W. Robinson 1982
B. W. Robinson. "A Survey of Persian Painting (1350-1896)." In *Art et société dans le monde iranien*, edited by C. Adle, 13–89. Paris: Éditions Recherche sur les Civilisations, 1982.

B. W. Robinson 1983
B. W. Robinson. *Persian Painting and the National Epic*. London: Oxford University Press, 1983.

B. W. Robinson 1989
B. W. Robinson. "Qajar Lacquer." *Muqarnas* 6 (1989): 131–46.

B. W. Robinson 1991
B. W. Robinson. *Fifteenth-Century Persian Painting: Problems and Issues.* New York and London: New York University Press, 1991.

B. W. Robinson 1992
B. W. Robinson. *L'Orient d'un collectionneur: Miniatures persanes, textiles, céramiques, orfèvrerie rassemblés par Jean Pozzi.* Geneva: Musée d'art et d'histoire, 1992.

B. W. Robinson 2002
B. W. Robinson. *The Persian Book of Kings: An Epitome of the* Shahnama *of Firdawsi.* London and New York: RoutledgeCurzon, 2002.

Roemer 1989
H. R. Roemer. "Bāysonḡor, Ḡīāt̲ al-Dīn." In *Encyclopaedia Iranica,* Online Edition, 15 Dec. 1989, available at *http://www.iranicaonline.org/articles/baysongor-gia-al-din-b.*

Rogers 2002
J. M. Rogers. *Empire of the Sultans: Ottoman Art from the Collection of Nasser D. Khalili.* Geneva: Musée d'art et d'histoire; London: Nour Foundation in association with Azimuth Editions, 2002.

Rosenthal 1971
Franz Rosenthal. *Four Essays on Art and Literature in Islam.* Leiden: Brill, 1971.

Roxburgh 2000
David J. Roxburgh. "Kamal al-din Bihzad and Authorship in Persianate Painting." *Muqarnas* 17 (2000): 119–46.

Roxburgh 2001a
David J. Roxburgh. "The Aesthetics of Aggregation: Persian Anthologies of the Fifteenth Century." *Princeton Papers: Interdisciplinary Journal of Middle Eastern Studies* 8 (2001): 119–42.

Roxburgh 2001b
David J. Roxburgh. *Prefacing the Image: The Writing of Art History in Sixteenth-Century Iran.* Leiden: Brill, 2001.

Roxburgh 2002a
David J. Roxburgh. "The Pen of Depiction: Drawing in 15th- and 16th-Century Iran." In Sackler Museum 2002, 43–57.

Roxburgh 2002b
David J. Roxburgh. "Persian Drawing, ca. 1400–1450: Materials and Creative Procedures." *Muqarnas* 19 (2002): 44–77.

Roxburgh 2005
David J. Roxburgh. *The Persian Album: From Dispersal to Collection, 1400–1600.* New Haven: Yale University Press, 2005.

Roxburgh 2008
David J. Roxburgh. "'The Eye Is Favored for Seeing the Writing's Form': On the Sensual and the Sensuous in Islamic Calligraphy." *Muqarnas* 25 (2008): 275–98.

Sachau 1879
C. Eduard Sachau, ed. and trans. *The Chronology of Ancient Nations: An English Version of the Arabic Text of the Athār-ul-Bākiya of Albīrūnī.* London: W. H. Allen and Co., 1879.

Sackler Museum 2002
Arthur M. Sackler Museum. *Studies in Islamic and Later Indian Art from the Arthur M. Sackler Museum, Harvard University Art Museums.* Cambridge, MA: Harvard University Art Museums, 2002.

Sadek 1983
M. M. Sadek. *The Arabic Materia Medica of Dioscorides.* Québec: Éditions du Sphinx, 1983.

Saʿdī 1988
Saʿdī. *Dīvān-i ghazaliyāt-i ustād-i sukhan Saʿdī Shīrāzī.* Edited by Khalīl Khaṭīb-Rahbar. Tehran: Intishārāt-i Saʿdī, 1367 (1988).

Sakisian 1936
Armenag Sakisian. "Persian Drawings." *Burlington Magazine* 69, no. 400 (1936): 14–20.

Savage-Smith 1997
Emilie Savage-Smith. "Beekeeping." In Maddison and Savage-Smith 1997, 2: 320–23.

Savory 1978
Roger M. Savory, trans. *History of Shah ʿAbbas the Great* (Tārīk-i ʿĀlamārā-ye ʿAbbāsī) *by Eskandar Beg Monshi.* 3 vols. Boulder, CO: Westview Press, 1978.

Schafer 1963
Edward H. Schafer, *The Golden Peaches of Samarkand: A Study of T'ang Exotics.* Berkeley: University of California Press, 1963.

Schimmel 1992
Annemarie Schimmel. *A Two-Colored Brocade: The Imagery of Persian Poetry.* Chapel Hill: University of North Carolina Press, 1992.

Schmidt 2006
Hanns-Peter Schmidt. "Mithra i. Mitra in Old Indian and Mithra in Old Iranian." In *Encyclopaedia Iranica,* Online Edition, 15 Aug. 2006, available at *http://www.iranicaonline.org/articles/mithra-i.*

Schmitz 2002
Barbara Schmitz. "Ḥabīb-Allāh Sāvaji." In *Encyclopaedia Iranica,* Online Edition, 15 Dec. 2002, available at *http://www.iranicaonline.org/articles/habib-allah-savaji.*

Schmitz 2004a
Barbara Schmitz. "India. xx. Persian Influences on Indian Painting." In *Encyclopaedia Iranica*, Online Edition, 15 Dec. 2004, available at *http://www.iranicaonline.org/articles/india-xx-persian-influences-on-indian-painting*.

Schmitz 2004b
Barbara Schmitz. "India. xxi. Indian Influences on Persian Painting." In *Encyclopaedia Iranica*, Online Edition, 15 Dec. 2004, available at *http://www.iranicaonline.org/articles/india-xxi-indian-influences-on-persian-painting*.

Selânikî 1989
Mustafâ Selânikî. *Tarih-i selânikî*. Edited by Mehmed İpşirli. 2 vols. Istanbul: İstanbul Üniversitesi Edebiyat Fakültesi, 1989.

Shahbazi 1999
A. Shapur Shahbazi. "Flags i. Of Persia." In *Encyplopaedia Iranica*, Online Edition, 15 Dec. 1999, available at *http://www.iranicaonline.org/articles/flags-i*.

Shahbazi 2004
A. Shapur Shahbazi. "Shiraz i. History to 1940." In *Encyclopaedia Iranica*, Online Edition, 20 July 2004, available at *http://www.iranicaonline.org/articles/shiraz-i-history-to-1940*.

Shahbazi 2005
A. Shapur Shahbazi. "Sasanian Dynasty." In *Encyclopaedia Iranica*, Online Edition, 20 July 2005, available at *http://iranicaonline.org/articles/sasanian-dynasty*.

Sharma 2007
Sunil Sharma. "Novelty, Tradition and Mughal Politics in Nauʿī's *Sūz u Gudāz*." In Lewis and Sharma 2007, 251–65.

Sharma 2011
Sunil Sharma. "'If There Is a Paradise on Earth, It Is Here': Urban Ethnography in Indo-Persian Poetic and Historical Texts." In *Forms of Knowledge in Early Modern Asia: Explorations in the Intellectual History of India and Tibet, 1500–1800*, edited by Sheldon Pollock, 240–56. Durham: Duke University Press, 2011.

Sharma 2012
Sunil Sharma. "Representation of Social Groups in Mughal Art and Literature: Ethnography or Trope?" In *Indo-Muslim Cultures in Transition*, edited by Karen Leonard and Alka Patel, 17–36. Leiden: Brill, 2012.

Shepherd 1960
Dorothy Shepherd. "Bacchantes in Islam." *Bulletin of the Cleveland Museum of Art* 47 (1960): 43–49.

Shortland et al. 2006
A. J. Shortland, M. S. Tite, and I. Ewart. "Ancient Exploitation and Use of Cobalt Alums from the Western Oases of Egypt." *Archaeometry* 48, no. 1 (2006): 153–68.

M. S. Simpson 1993
Marianna Shreve Simpson. "The Making of Manuscripts and the Workings of the *Kitab-Khana* in Safavid Iran." In *The Artist's Workshop*, edited by Peter Lukehart, 105–21. Washington, DC: National Gallery of Art, 1993.

M. S. Simpson 1997
Marianna Shreve Simpson. *Sultan Ibrahim Mirza's Haft Awrang: A Princely Manuscript from Sixteenth-Century Iran*. Washington, DC: Freer Gallery of Art, Smithsonian Institution; New Haven: Yale University Press, 1997.

M. S. Simpson 2000
Marianna Shreve Simpson. "A Reconstruction and Preliminary Account of the 1341 *Shahnama*, with Some Further Thoughts on Early *Shahnama* Illustration." In Hillenbrand 2000, 217–47.

M. S. Simpson 2004
Marianna Shreve Simpson. "*Shahnama* as Text and *Shahnama* as Image: A Brief Overview of Recent Studies, 1975–2000." In Hillenbrand 2004, 9–23.

M. S. Simpson 2009
Marianna Shreve Simpson. "Šāh-nāma iv. Illustrations." In *Encyclopaedia Iranica*, Online Edition, 21 Apr. 2009, available at *www.iranicaonline.org/articles/sah-nama-iv-illustrations*.

Sims 1983
Eleanor Sims. "The European Print Sources of Paintings by the Seventeenth-Century Persian Painter Muhammad Zamān ibn Hājī Yusūf of Qum." In *Le stampe e la diffusione delle immagini e degli stili*, edited by Henri Zerner, 73–83. Bologne: CLUEB, 1983.

Sims 1992
Eleanor Sims. "The Illustrated Manuscripts of Firdausi's *Shāhnāma* Commissioned by Princes of the House of Tīmūr." *Ars Orientalis* 22 (1992): 43–68.

Sims 2006
Eleanor Sims. "Thoughts on a *Shāhnāma* Legacy of the Fourteenth Century: Four Īnjū Manuscripts and the Great Mongol *Shāhnāma*." In Komaroff 2006, 269–86.

Smith 1981
Walter Smith. "Hindu Ascetics in Mughal Painting under Akbar." *Oriental Art* 27, no. 1 (1981): 67–75.

Snyder 1988
Janet G. Snyder. "Study of the Paper of Selected Paintings from the Vever Collection." In Lowry and Beach 1988, 433–40.

Sotheby Parke Bernet 1975
Sotheby Parke Bernet, New York. *The Lester Wolfe Collection of Persian Pottery and Metalwork.* Mar. 14, 1975.

Sotheby's 1967
Sotheby's, London. *Highly Important Oriental Manuscripts and Miniatures, the Property of the Kevorkian Foundation.* 6 Dec. 1967.

Sotheby's 1976
Sotheby's, London. *Catalogue of Important Oriental Manuscripts and Miniatures, the Property of the Kevorkian Foundation.* 12 Apr. 1976.

Sotheby's 2006a
Sotheby's, London. *Arts of the Islamic World.* 5 Apr. 2006.

Sotheby's 2006b
Sotheby's, London. *Arts of the Islamic World.* 11 Oct. 2006.

Sotheby's 2008
Sotheby's, London. *Arts of the Islamic World.* 8 Oct. 2008.

Soucek 1987
Priscilla P. Soucek. "Persian Artists in Mughal India: Influences and Transformations." *Muqarnas* 4 (1987): 166–81.

Soucek 2000
Priscilla P. Soucek. "The Ann Arbor *Shahnama* and Its Importance." In Hillenbrand 2000, 267–81.

Soudavar 1992
Abolala Soudavar. *Art of the Persian Courts: Selections from the Art and History Trust Collection.* New York: Rizzoli, 1992.

Soudavar 1999
Abolala Soudavar. "Between the Safavids and the Mughals: Art and Artists in Transition." *Iran* 37 (1999): 49–66.

Soudavar 2000
Abolala Soudavar. "The Age of Muhammadi." *Muqarnas* 17 (2000): 53–72.

Soustiel 1985
Jean Soustiel. *La céramique islamique.* Fribourg: Office du Livre, 1985.

Stanley 2004
Tim Stanley. "The Kevorkian-Kraus-Khalili *Shahnama*: The History, Codicology and Illustrations of a Sixteenth-Century Shirazi Manuscript." In Hillenbrand 2004, 85–98.

Stapleton 2003
Colleen P. Stapleton. "Geochemical Analysis of Glass and Glaze from Hasanlu, Northwestern Iran: Constraints on Manufacturing Technology." PhD diss., University of Georgia, 2003.

Stchoukine 1959
Ivan Stchoukine. *Les peintures des manuscrits safavis de 1502 à 1587.* Paris: Paul Geuthner, 1959.

Stevenson and Guy 1997
John Stevenson and John Guy. *Vietnamese Ceramics: A Separate Tradition.* Chicago: Art Media Resources with Avery Press, 1997.

Stillman 2003
Yedida K. Stillman. *Arab Dress from the Dawn of Islam to Modern Times.* Edited by Norman A. Stillman. 2nd ed. Leiden: Brill, 2003.

Swietochowski 2000
Marie L. Swietochowski. "Habib Allah." In Hillenbrand 2000, 283–99.

Swietochowski and Babaie 1989
Marie Lukens Swietochowski and Sussan Babaie. *Persian Drawings in the Metropolitan Museum of Art.* New York: Metropolitan Museum of Art, 1989.

Swietochowski and Carboni 1994
Marie Lukens Swietochowski and Stefano Carboni. *Illustrated Poetry and Epic Images: Persian Painting in the 1330s and 1340s.* New York: Metropolitan Museum of Art, 1994.

Szántó 2010
Ivan Szántó. "Qajar Lacquerware and the Related Art Forms." In *Artisans at the Crossroads: Persian Arts of the Qajar Period (1796–1925)*, edited by Béla Kelényi and Iván Szántó, 51–55. Budapest: Ferenc Hopp Museum of Eastern Asiatic Arts, 2010.

Tafazzoli 1994
Ahmad Tafazzoli. "Dehqān." In *Encyclopaedia Iranica*, Online Edition, 15 Dec. 1994, available at *http://www.iranicaonline.org/articles/dehqan*.

Tan 2010
Yvonne Tan. "Strolling through Isfahan: Seventeenth-Century Paintings from Safavid Iran." *The Asian Art Newspaper* 13, issue 6 (2010): 13–14.

Tarkiam et al. 1983
W. Tarkiam, D. Bock, and M. Newman. "Geology and Mineralogy of the Cu-Ni-Co-U Ore Deposits at Talmessi and Meskani, Central Iran." *Tschermaks Mineralogische und Petrographische Mitteilungen* 32 (1983): 111–33.

Terrace 1962
Edward L. B. Terrace. *The Art of the Ancient Near East in Boston.* Boston: Museum of Fine Arts, 1962.

Thackston 1989
Wheeler M. Thackston. *A Century of Princes: Sources on Timurid History and Art.* Cambridge, MA: The Aga Khan Program for Islamic Architecture, 1989.

Thackston 1990
Wheeler M. Thackston. "Treatise on Calligraphic Arts: A Disquisition on Paper, Colors, Inks, and Pens by Simi of Nishapur." In *Intellectual Studies on Islam: Essays Written in Honor of Martin B. Dickson,* edited by Michel M. Mazzaoui and Vera B. Moreen, 219-28. Salt Lake City: University of Utah Press, 1990.

Thackston 1996
Wheeler M. Thackston, trans. and annot. *Mirza Haydar Dughlat's* Tarikh-i Rashidi: *A History of the Khans of Moghulistan.* Cambridge, MA: Harvard University, Department of Near Eastern Languages and Civilizations, 1996.

Thackston 2001
Wheeler M. Thackston. *Album Prefaces and Other Documents on the History of Calligraphers and Painters.* Leiden: Brill, 2001.

Thornton 2009
Christopher P. Thornton. "The Emergence of Complex Metallurgy on the Iranian Plateau: Escaping the Levantine Paradigm." *Journal of World Prehistory* 22-23 (2009): 301-27.

Thornton 2010
Christopher P. Thornton. "The Rise of Arsenical Copper in Southeastern Iran." *Iranica Antiqua* 45 (2010): 31-50.

Tietze 1977
Andreas Tietze. *The Turkish Shadow Theater and the Puppet Collection of the L. A. Mayer Memorial Foundation.* L. A. Mayer Memorial Studies in Islamic Art and Civilization, vol. 4. Berlin: Mann, 1977.

Tilden 1996
Jill Tilden, ed. *Silk and Stone: The Art of Asia.* London: *HALI* Publications, 1996.

Tite and Shortland 2008
Michael S. Tite and Andrew J. Shortland. *Production Technology of Faience and Related Early Vitreous Materials.* Oxford University School of Archaeology Monograph 72. Oxford: School of Archaeology, 2008.

Titley 1983
Norah M. Titley. *Persian Miniature Painting and Its Influence on the Art of Turkey and India.* London: British Library, 1983.

Touwaide 2009
A. Touwaide. "Translation and Transliteration of Plant Names in Ḥunayn b. Isḥāq's and Iṣṭifān b. Bāsil's Arabic Version of Dioscorides, *De materia medica." Al-Qanṭara* 30, no. 2 (2009): 557-80.

Uluç 1994
Lâle Uluç. "A Persian Epic, Perhaps for the Ottoman Sultan." *Metropolitan Museum Journal* 29 (1994): 57-69.

Uluç 2000a
Lâle Uluç. "Arts of the Book in Sixteenth-Century Shiraz." PhD diss., Institute of Fine Arts, New York University, 2000.

Uluç 2000b
Lâle Uluç. "Selling to the Court: Late-Sixteenth-Century Manuscript Production in Shiraz." *Muqarnas* 17 (2000): 73-97.

Uluç 2006
Lâle Uluç. *Turkman Governors, Shiraz Artisans and Ottoman Collectors: Sixteenth-Century Shiraz Manuscripts.* Istanbul: Türkiye İş Bankası, 2006.

Uluç 2007
Lâle Uluç. "A Group of Artists Associated with the 'Āsitāna' of Ḥusām al-Dīn Ibrāhīm." *Artibus Asiae* 67, no. 1 (2007): 113-45.

Uluç 2011
Lâle Uluç. "Gifted Manuscripts from the Safavids to the Ottomans." In Komaroff 2011, 144.

Vernoit 2006
Stephen Vernoit. "The Visual Arts in Nineteenth-Century Muslim Thought." In *Islamic Art in the 19th Century: Tradition, Innovation, and Eclecticism,* edited by Doris Behrens-Abouseif and Stephen Vernoit, 19-35. Leiden: Brill, 2006.

Volov 1966
Lisa Volov. "Plaited Kufic on Samanid Epigraphic Pottery." *Ars Orientalis* 6 (1966): 107-33.

Watson 1985.
Oliver Watson. *Persian Lustre Ware.* London and Boston: Faber and Faber, 1985.

Watson 2004
Oliver Watson. *Ceramics from Islamic Lands.* London: Thames & Hudson, 2004.

A. Welch 1972
Anthony Welch. *Collection of Islamic Art: Prince Sadruddin Aga Khan.* 4 vols. Geneva: Chateau de Bellerive, 1972.

A. Welch 1973
Anthony Welch. *Shah 'Abbas & the Arts of Isfahan.* New York: Asia Society, 1973.

A. Welch 1974
Anthony Welch. "Painting and Patronage under Shah 'Abbas I." *Iranian Studies* 7, nos. 3-4 (1974): 458-507.

A. Welch 1976
Anthony Welch. *Artists for the Shah: Late Sixteenth-Century Painting at the Imperial Court of Iran.* New Haven: Yale University Press, 1976.

A. Welch 1995
Anthony Welch. "Ṣafawids, v. Arts and Architecture." In *Encyclopaedia of Islam*, 2nd ed., 8:787-89. Leiden: Brill, 1995.

S. C. Welch 1985
Stuart Cary Welch. *India: Art and Culture*, 1300-1900. New York: Metropolitan Museum of Art, 1985.

S. C. Welch 2000
Stuart Cary Welch. "Two Eminences Observed: A Drawing by Mirza 'Ali." In Hillenbrand 2000, 319-23.

Wen 2012
Rui Wen. "The Cobalt Blue Pigment Used on Islamic Ceramics and Chinese Blue and White Porcelains." PhD diss., Research Laboratory for Archaeology and the History of Art, Keble College, University of Oxford, 2012.

Wen et al. 2007
R. Wen, C. S. Wang, Z. W. Mao, Y. Y. Huang, and A. M. Pollard. "The Chemical Composition of Blue Pigment on Chinese Blue-and-White Porcelain of the Yuan and Ming Dynasties (AD 1271-1644)." *Archaeometry* 49, no. 1 (2007): 101-15.

Wen and Pollard 2009
R. Wen and A. M. Pollard. "Comparative Study of Cobalt Blue Pigment on Chinese Blue-and-White Porcelain and Islamic Glazed Pottery, Thirteenth-Seventeenth Centuries." In McCarthy 2009, 24-32.

White 1996
David Gordon White. *The Alchemical Body: Siddha Traditions in Medieval India.* Chicago: University of Chicago Press, 1996.

White 2009
David Gordon White. *Sinister Yogis.* Chicago: University of Chicago Press, 2009.

Wilkinson 1969
Charles K. Wilkinson. "Christian Remains from Nishapur." In Aslanapa and Naumann 1969, 79-87.

Wilkinson 1973
Charles K. Wilkinson. *Nishapur: Pottery of the Early Islamic Period.* New York: Metropolitan Museum of Art, 1973.

Wilkinson 1986
Charles K. Wilkinson. *Nishapur: Some Early Islamic Buildings and Their Decoration.* New York: Metropolitan Museum of Art, 1986.

Wood et al. 2007
N. Wood, M. S. Tite, C. Doherty, and B. Gilmore. "A Technological Examination of Ninth-Tenth Century AD Abbasid Blue-and-White Ware from Iraq, and Its Comparison with Eighth Century AD Chinese Blue-and-White *Sancai* Ware." *Archaeometry* 49, no. 4 (2007): 665-84.

Wright 1997
Elaine Julia Wright. "The Look of the Book: Manuscript Production in the Southern Iranian City of Shiraz from the Early-14th Century to 1452." PhD diss., Faculty of Oriental Studies, Oxford University, 1997.

Wright 2003
Elaine Julia Wright. "The Calligraphers of Šīrāz and the Development of *Nastaʿlīq* Script." *Manuscripta Orientalia* 9, no. 3 (2003): 16-26.

Wright 2004
Elaine Wright. "Firdausi and More: A Timurid Anthology of Epic Tales." In Hillenbrand 2004, 65-84.

Wright 2006
Elaine Wright. "Patronage of the Arts of the Book under the Injuids of Shiraz." In Komaroff 2006, 248-68.

Wright 2008
Elaine Wright. *Muraqqaʿ: Imperial Mughal Albums from the Chester Beatty Library, Dublin.* Alexandria, VA: Art Services International, 2008.

Wulff 1966
Hans E. Wulff. *The Traditional Crafts of Persia: Their Development, Technology, and Influence on Eastern and Western Civilizations.* Cambridge, MA: MIT Press, 1966.

Yarshater 1988
Ehsan Yarshater. "The Indian or Safavid Style: Progress or Decline?" In *Persian Literature*, edited by Ehsan Yarshater, 249-88. Albany, NY: Bibliotheca Persica 1988.

Zakeri 1995
Mohsen Zakeri. *Sāsānid Soldiers in Early Muslim Society: The Origins of ʿAyyārān and Futuwwa.* Wiesbaden: Harrassowitz, 1995.

Contributors

Mary McWilliams is the Norma Jean Calderwood Curator of Islamic and Later Indian Art at the Harvard Art Museums.

Jessica Chloros, Assistant Objects Conservator at the Isabella Stewart Gardner Museum, Boston, was Samuel H. Kress Objects Conservation Fellow at the Straus Center for Conservation and Technical Studies, Harvard Art Museums, 2007–8.

Walter Denny, Professor of Art History at the University of Massachusetts, Amherst, received his PhD in art history from Harvard University in 1971.

Katherine Eremin is the Patricia Cornwell Conservation Scientist at the Straus Center for Conservation and Technical Studies, Harvard Art Museums.

Penley Knipe is the Philip and Lynn Straus Conservator of Works on Paper at the Straus Center for Conservation and Technical Studies, Harvard Art Museums.

Oya Pancaroğlu, Associate Professor of History, Boğaziçi University, Istanbul, received her PhD in art history from Harvard University in 2000.

David J. Roxburgh is the Prince Alwaleed Bin Talal Professor of Islamic Art History at Harvard University.

Sunil Sharma, Associate Professor of Persianate and Comparative Literature at Boston University, is an Affiliate of the Department of South Asian Studies, Harvard University.

Anthony B. Sigel is Conservator of Objects and Sculpture at the Straus Center for Conservation and Technical Studies, Harvard Art Museums.

Marianna Shreve Simpson, independent scholar, received her PhD in art history from Harvard University in 1978.

Concordance of Accession and Catalogue Numbers

Accession (2002.50...)*	Catalogue		Accession	Catalogue
.1	110		.36	100
.2	106		.37	94
.3	107		.38	98
.4	112		.39	129
.5	115		.40	90B
.6	118		.41	87B
.7	130		.42	79B
.8	125		.43	105
.9	126		.44	70
.10	67		.45	69
.11	66		.46	132
.12	63		.47	133
.13	72		.48	49
.14	101		.49	19
.15	120		.50	18
.16	121		.51	139
.17	123		.52	26
.18	151		.53	27
.19	122		.54	20
.20	68		.55	52
.21	65		.56	34
.22	127		.57	8
.23	124		.58	41
.24	103		.59	35
.25	81B		.60	36
.26	116		.61	131
.27	73		.62	136
.28	78B		.63	25
.29	128		.64	32
.30	114A		.65	51
.31	113		.66	42
.32	95A		.67	45
.33	109		.68	16
.34	99		.69	17
.35	97		.70	5

Accession	Catalogue	Accession	Catalogue	Accession	Catalogue
.71	7	.106.A–B	53	.141	71
.72	6	.107	54	.142	96A
.73	31	.108	43	.143	96B
.74	30	.109	58	.144	119
.75	135	.110	56	.145	64
.76	33	.111	55	.146	104
.77	142	.112	57	.147	111
.78	40	.113	137	.148	83A
.79	140	.114	28	.149	83B
.80	38	.115	12	.150	76B
.81	141	.116	46	.151	76A
.82	50	.117	47	.152	108
.83	10	.118	48	.153	82B
.84	4	.119	117A	.154	82A
.85	39	.120	144	.155	80B
.86	138	.121	145	.156	80A
.87	22	.122	91A	.157	89A
.88	13	.123	75	.158	89B
.89	11	.124	92	.159	84A
.90	134	.125	37	.160	84B
.91	9	.126	102B	.161	86B
.92	15	.127	102A	.162	86B
.93	14	.128	81A	.163	88B
.94	44	.129	78A	.164	88A
.95	21	.130	114B	.165	77B
.96	1	.131	95B	.166	77A
.97	2	.132	90A	.167	85B
.98	23	.133	87A	.168	85A
.99	24	.134	79A	.169	148
.100	59	.135	117B	.170	149
.101	60	.136	91B	.171	147
.102	61	.137	74	.172	146
.103	29	.138	93	.173	150
.104	3	.139	152		
.105	143	.140	62		

* Numbers in the column are the final digits of the accession number.

Index

Page numbers in italics indicate illustrations. All catalogue entries, cited as "(cat....)," are illustrated.

Illustration Credits